CH'AEKKŎRI PAINTING

A Korean Jigsaw Puzzle

CH'AEKKŎRI PAINTING
A Korean Jigsaw Puzzle

Kay E. Black
with contributions by Edward W. Wagner and Gari Ledyard

SAHOIPYOUNGNON ACADEMY

Sahoipyoungnon Academy Co., Inc.
56 World Cup buk-ro 6-gil, Mapo-gu, Seoul, 03993, Korea
http://www.sapyoung.com

ISBN 979-11-89946-52-4 93600

FRONT COVER A panel of an eight-panel still life type *ch'aekkŏri* screen in the Leeum, Samsung
 Museum of Art (Figure 27.2)
BACK COVER Eight-panel trompe l'oeil type *ch'aekkŏri* screen by Yi Ŭng-nok, 1864–1866, in the
 Asian Art Museum of San Francisco (Figure. 13.7)

To Andrews D. Black

Foreword

It was in the fall of 1996 that I first met Kay E. Black while I spent a sabbatical at the University of California, Berkeley. I had heard much about her long, enthusiastic work on Korean *ch'aekkŏri* through Juhyung Rhi, her close friend and my former student and then-junior colleague in the Department of Archaeology and Art History at Seoul National University, where I worked. Both she and her husband, Andrews D. Black, were a highly intelligent and pleasant couple with good manners, wit, and humor, the kind that I fondly remember among Americans from the upper-middle class during the 1960s and 1970s, when I studied for a PhD in the U.S. During my stay at Berkeley, for a year, I was able to see them on several other occasions, and these experiences still vividly remain delightful memories for me and my wife.

In meeting with Kay Black, I was no less impressed by her genuine love for Korean art and ardent dedication to studying Korean *ch'aekkŏri*. Despite the importance of the subject, which is now highly and widely appreciated by both specialists and art lovers, Korean *ch'aekkŏri* had been scarcely known to the public, and received little serious attention by scholars as well by the 1980s, even in Korea. Acquainted and fascinated with the subject during her first visit to Korea in the mid-1970s, she started academic work by enrolling in the graduate program in art history at the University of Denver, with the sole intention of studying Korean *ch'aekkŏri*. Thus, in her late forties, she began to learn the Chinese language and diverse technical skills required for academic work, though she always regretted not having been able to afford time to master Korean. In the 1980s, she painstakingly visited numerous collections in Korea, the U.S., and Europe, and meticulously studied and photographed all the major works of *ch'aekkŏri* before any other scholars ever attempted it. Simultaneously in this period, she started a collaboration with the late Edward W. Wagner, then a Professor of Korean Studies at Harvard University, who provided her with immense help in identifying the complex lineages of painters of Korean *ch'aekkŏri*. They began to present the result of their research in the 1990s with the publication of the article "Ch'aekkŏri Paintings: A Korean Jigsaw Puzzle" in 1993, which was followed by another one, "Court Style *Ch'aekkŏri*," in 1998. I would like to note that the former was the first serious work on *ch'aekkŏri* that appeared in scholarly journals both in and outside Korea. With the passing of Wagner in 2001, Kay Black had to complete the work on *ch'aekkŏri* by herself and, as I heard, finished the manuscript of this book by the mid-2000s. Unfortunately, the work for its publication has taken more than ten years due to the complications she had to deal with in the process, and I was glad to see the book finally in shape about to go to press.

This book is significant as an important contribution to the study of Korean painting in many ways. First, it is no doubt the first serious, comprehensive study of Korean *chʾaekkŏri*. During the research that spanned two decades, she thoroughly examined as many as some 150 examples of *chʾaekkŏri* in diverse collections for herself, and this itself is a remarkable feat no one has been able to achieve so far. Based on this, she presents a comprehensive picture of their intricate relationships, and in a convincing manner. Second, Korean paintings conventionally called *chʾaekkŏri* had been classified within the so-called "Folk Painting" category since the proposition by Yanagi Muneyoshi (1889–1961) and mainly collected and commented on by those whose major concerns were folk paintings. Thus, they had been commonly understood as works by anonymous painters that reflect the folk taste. However, the author broke the old preconception, with the help of Edward Wagner, by discovering the facts that a number of court painters worked on the paintings, and that these paintings were extensively favored by the ruling elite and even royalty. Third, in identifying the *chʾaekkŏri* painters, Black and Wagner were able to disclose the complex family lineage of professional *chungin* painters, and the vital transmission of painting themes and styles within those families. Fourth, the author successfully applies the art historical method of visual analysis, focusing on the perspective and the creation of space and convincingly classifies numerous works of *chʾaekkŏri* into three major types: (1) isolated, (2) trompe l'oeil, and (3) still life.

Since the publication of the earlier articles by Kay Black and Edward Wagner, a number of studies by Korean scholars, which treat the subject based on a better command of more extensive literary materials, have appeared. Although the ideas presented by Black and Wagner were sometimes corrected and refuted, many of their major points still remain valuable. It is now clearly established that the *chʾaekkŏri* was an important theme among court paintings, even favored by the kings. With regard to the court painters who engaged in the creation of *chʾaekkŏri*, as well as their family practices, new findings continue to pile up. The classification of the three types of *chʾaekkŏri* can be considered as a useful frame in treating these works. Since most of its text was written by the 1990s, Kay Black's book incorporates more recent scholarship on *chʾaekkŏri* by Korean scholars to a limited extent.

However, her book, though finally being published at this point, should be considered as reflecting an earlier phase of serious scholarship on *chʾaekkŏri* than most of the works by Korean scholars, and be read as a record of her pioneering research mainly done during the 1980s and 1990s. This book is obviously a seminal contribution to the study of this important theme in Korean painting and should not be ignored in any further scholarly pursuit of this subject, both in and outside Korea. I would like to conclude this with a warm gratitude for and heartfelt congratulation on her admirable dedication to the research on this subject for more than four decades.

Ahn Hwi-joon
Professor Emeritus
Seoul National University

Acknowledgements

My admiration for the *ch'aekkŏri* genre took root in 1973, when I visited the Emille Museum in Seoul with a group from the Denver Art Museum. Such was my fascination with Korea's brightly colored folding screens introduced to me by the late Zo Zayong, the founder of the Emille Museum, that it sent me back to the University of Denver for ten long years in order to study Asian art history.

Ch'aekkŏri Painting: A Korean Jigsaw Puzzle is a collaborative work. I was privileged to have worked with the late Edward W. Wagner (1924–2001), professor and founder of Korean Studies at Harvard University, for twelve years on the project. Wagner and I met because Gari Ledyard, King Sejong Professor Emeritus, Columbia University, suggested that I write to Wagner, as the one and only person knowledgeable enough to help in finding some information regarding two *ch'aekkŏri* artists. Excerpts from Wagner's response to my initial query in July 1986 follow:

> Your intriguing (and inspiriting—see below) letter awaited me when I went to the University this afternoon to meet with a graduate student who has been helping me with the compilation of—a roster of *chungin* calligraphers and painters!! You certainly have written to the right person at the right time—and most importantly, with the right kind of question. I don't mean to tantalize, but please allow me to give you some background before coming to specific grips with your two painters … Finally, why was your letter so inspiriting? Simply because, as I invested more and more of my precious sabbatical time in this project, I increasingly wondered whether the final product really would be of much use to anyone. After all, without the *hao* [pen name] they presumably in most cases signed their paintings with, and presumably without the paintings themselves (for otherwise wouldn't the painters' names, even just the *hao*, by now have been picked up by someone?), my LIST would be only an academic curiosity. Your inspiriting letter, however, goes to demonstrate otherwise.

Thus, began what became a twelve-year collaboration: three co-authored papers presented at the Association for Korean Studies in Europe, two publications, and a book in progress. I had images of over 150 *ch'aekkŏri* in my study; they contained an array of clues that I was unable to decipher in the context of Chŏson period (1392–1910) painters. Without Wagner's participation, the *ch'aekkŏri* project would have gone nowhere. His extensive genealogical researches are legendary; only he could have discovered that Yi Hyŏng-nok and Yi Ŭng-nok were one and the same

artist. Thanks to his scholarship and patience with my shortcomings, the needle-in-the-haystack search took on hope, and here are the results. Posthumously, his participation in the *ch'aekkŏri* project continues today with a triangular Wagner/Ledyard/Black interface in the organization and interpretation of his notes and lists.

I have many reasons to thank Gari Ledyard: he introduced me to Wagner in 1986; helped and encouraged me all along the way; and read my manuscript. Ledyard assembled Wagner's Kim Ki-hyŏn and Kang Tal-su genealogical information into a Western-style format, completed Wagner's and my work on the titles of books depicted in *ch'aekkŏri*, and summarized their contextual meaning within the genre. Furthermore, he has always been at the other end of the telephone to answer my questions and cheer me on.

Despite all the generous help that I benefited from Wagner and Ledyard, this book, *Ch'aekkŏri Painting: A Korean Jigsaw Puzzle*, in its present format, is my sole responsibility. It has been a pioneer effort, and I hope it inspires others to pursue the subject and complete the puzzle. I would like to thank Nahmi Kim Wagner, who has kindly allowed me to proceed with the project using her husband's research. Although much of the research and preparation of the book occurred a number of years ago, a house fire and family matters prevented me from completing the manuscript sooner, and complications with the process of publication took additional time.

Rhi Juhyung, Professor of Art History and the former Dean of Humanities at Seoul National University, contributed to this project for over twenty years. During the time he was studying for his doctorate at the University of California, Berkeley, he lived with my husband and me, and we came to think of him as our Korean son. He learned about baseball and other features of American life, and I learned about Korea. He has translated and interpreted for me, made sure that I had the most recent relevant books, and opened many doors to Korean museums and their staff. He has worked tirelessly to help me prepare this book for the publisher at the final stage, and without his help, this book would not have taken shape. Through Juhyung, I met his teacher Ahn Hwi-joon, Professor Emeritus of Art History of Seoul National University and the pioneering giant in establishing the modern scholarship of traditional Korean painting who has never been too busy to help, but who also kindly wrote a foreword to this volume.

Martina Deuchler, Professor Emerita of Korean Studies at School of Oriental and African Studies, University of London, has read the manuscript, corrected mistakes and omissions, made valuable suggestions, and provided encouragement. I am indeed fortunate to have had her expertise. Daphne Lange Rosenzweig, Professor of Art History, Ringling College of Art and Design in Sarasota, Florida, read my entire manuscript at an early stage and made many superb editorial suggestions for its improvement, including some insights into Chinese art history that would have escaped me otherwise. Another friend, Frank Hoffmann, while as a researcher at Harvard, was very generous in sharing with me his expertise and sources on the Colonial period (1910–1945). Sarah M. Nelson, my East Asian Archaeology professor (emerita) at the University of Denver, encouraged me at the outset of this project.

The help I received from Kim Insook, Professor Emerita at Kookmin University has been also invaluable. Twice she took me to the Sŏnggyun'gwan, interpreting for me with Ko Ŭng-bae and Pak Ch'an-ho. It was her clear explanation of the *Doctrine of the Mean* that led to my understanding of the *ch'aekkŏri* artist's symbolism on the Hongik screen. The late Suk Joo-Sun and her grand-niece Park Sung Sil, the founding Director of the Suk Joo-Sun Memorial Museum of Korean Folk Art at Dankook University, have helped me to identify objects, and they also opened doors to other folklorists. The late William D. Y. Wu, independent scholar, provided the news and photographs of *ch'aekkŏri* at the Ling Yan temple (Lingyansi). Lothar von Falkenhausen, Professor of Chinese Archeology and Art History at the University of California, Los Angeles, gave me information about *ch'aekkŏri* at the Museum of Peking Opera.

I am especially grateful to He Li, Curator of Ceramics at the Asian Art Museum of San Francisco–Chong-Moon Lee Center for Asian Art and Culture (AAM), who has deciphered many written messages, helped interpret some of the seals, and led me to many Chinese sources. Her deep knowledge of classical Chinese proved invaluable to the project. Moore Wai Quan of the New Unique Co. has also contributed to deciphering the seals, and Chan Chu Ching Lin has provided help with Chinese calligraphy. As my development editor, I owe Michael Morrison many thanks for his patience and skills. I would also like to thank Erfert Fenton for her editing assistance. My thanks extend to Terese Bartholomew, the former Curator of Himalayan Art and Chinese Decorative Arts (AAM), and Kumja Paik Kim, the former Curator of Korean Art (AAM), for sharing their expertise. I am indebted to Leonid Konsevich of the Smith Kettewell Eye Research Institute for his help on perspective. Brian Minihan helped with an early version of the bibliography. Soobum Kim gets credit for providing Chinese characters in the preliminary work for the glossary and the bibliography. My gratitude also extends to Mikyung Kang, Korean Librarian at the Yenching Library, Harvard University, for checking my Korean romanizations. Fred Cline, Jr, former AAM librarian, and John Stucky, current AAM librarian, have both aided me. In particular, John Stucky has been a tremendous help over many years with the translations of the Asian books and with romanizing the titles in Pinyin. Evelyn B. McCune encouraged me early on. At the Royal Ontario Museum (ROM), thanks are due to Koh Won-Young, formerly Assistant Curator of Korean Art, Jack Howard of the ROM's Asian library, and the late Hugh Wylie, Curator of Japanese and Korean art. Kim Dong-cheol, formerly of the Seoul Central Library, found references and procured Yi To-yŏng's genealogy for Wagner and me. I am indebted to Okada Tomoyuki for the perspective diagrams. Finally, I thank Kaz Tsuruta and his assistant Jessica Kuhn for transforming different kinds of photographs into digital format.

I am indebted to the following museums, their directors and curators, and to private Korean and American collectors and dealers who graciously allowed me to study and photograph from their collections:

Museums and Libraries

- Asian Art Museum of San Francisco–Chong-Moon Lee Center for Asian Art and Culture
- The Trustees of the British Museum, Jane Portal, Curator of Asian Art
- Brooklyn Museum: Robert Moes, Amy Poster, and John Findley, former Curators
- Iris & B. Gerald Cantor Center for the Visual Arts, Stanford University: Patrick J. J. Maveety, former Curator, Asian Art; John Listopad, Curator
- Ch'angdŏk Palace Museum, Korean Cultural Heritage Administration: Koh Su-gil
- Chŏnnam National University Museum, Kwangju: Professor Im Young-jin, Director
- Harvard University: Elisabeth Blair MacDougall, former Landscape Architectural Historian, Dumbarton Oaks
- Hongik University Museum: Kim Lena, Professor Emerita of Art History
- Honolulu Museum of Art (formerly Honolulu Academy of Art): Julia M. White, former Curator at the Academy and current Director of Asian Art, Berkeley Art Museum; and Pauline Sugino of the Academy
- Institute of Koryŏ Art Museum, Kyoto: Kim Paman, former Curator; Mariko Katayama, Curator
- Leeum, Samsung Museum of Art: Hong Ra-hee, former Director; Kim Chae-yŏl (Jae Yeol), former Deputy Director; Cho In-soo, former Chief Curator and Professor of Art History, Korean National University for the Arts; Jo Jiyoon, current Curator
- National Museum of Natural History, Smithsonian Institution: Chang-su Houchins, Department of Anthropology
- National Museum of Chŏnju: Lee Wŏn-bok, former Director
- National Museum of Korea: Chung Yang-mo, former Director; Oh Joo-Seok, former Assistant Curator; Lee Su-mi, Head of the Fine Art Department
- Onyang Folk Art Museum
- Royal Ontario Museum
- C. V. Starr East Asian Library, Columbia University: Amy V. Heinrich, Librarian; Amy Lee, Librarian Emerita
- T'ongdosa Museum, Yangsan, Korea: Jung Ho Han, former Curator and Associate Professor of Art History, Dongguk University, Kyŏngju

Private Collectors

- Joo Kwan Joong and Rhee Boon Ran
- Kim Eun-Young
- Gerrit and Giselle Kuelps
- Lim Okki Min
- Robert E. and Sandra Mattielli
- Mr. and Mrs. Minn Pyong-Yoo
- Mr. and Mrs. James Morrissey

Dealers
- Ahn Paek Sun
- Joseph Carroll
- Julia Meech, formerly at Christie's
- Suzanne Mitchell, former Director, Asian Art, Sotheby's, New York and
 Suzanne Mitchell Fine Arts
- Robert Moore
- Lea Sneider
- Anthony Victoria, Frederick P. Victoria and Son

Earlier versions of some of the chapters were published as "Hundred Antiques," in the *Journal of The International Chinese Snuff Bottle Society*, vol. 20, vol. 4 (Winter 1988); "*Ch'aekkŏri* Paintings: A Korean Jigsaw Puzzle" in *Archives of Asian Art*, vol. 46 (1993); "Court Style *Ch'aekkŏri*" in *Hopes and Aspirations: Decorative Painting of Korea* (San Francisco: The Asian Art Museum of San Francisco, 1998).

I would like to thank my daughters, Deborah and Kate Black and Courtney Carpenter, for their support and assistance in the preparation of the manuscript. Kate helped the work for publication as a devoted assistant throughout, and Debby also read the manuscript repeatedly for improvement. However, it is to Andrews D. Black, my late husband, who encouraged and supported me all the way, that I owe my greatest thanks.

Kay E. Black
San Francisco
February 2020

List of Publications by the Author

Kay E. Black. 1981. "The Korean Ethnographical Collection of the Peabody Museum of Salem." *Korean Culture* 21, no. 2, pp. 12–21, 28–33.

Kay E. Black. 1987. "The Peabody's Korean Connection." *The Peabody Museum of Salem 1987 Antiques Show*, pp 19–27. Salem, MA: The Peabody Museum of Salem.

Kay E. Black. 1988. "Hundred Antiques." *Journal of the International Chinese Snuff Bottle Society* 20, no. 4, pp. 42–22.

Kay E. Black. 1993. "Korean Surprises in Denver." *Orientations* 25, no. 4, pp. 42–47.

Kay E. Black and Edward W. Wagner. 1993. "Ch'aekkŏri Paintings: A Korean Jigsaw Puzzle." *Archives of Asian Art* 46, pp. 63–75.

Kay E. Black. 1994. "The Puzzling Portrait." *Orientations* 25, no. 4, pp. 68–70.

Kay E. Black and Edward W. Wagner. "Court Style *Ch'aekkŏri*." In *Hopes and Aspirations: Decorative Paintings of Korea*, edited by Kumja Paik Kim, pp. 22–35. San Francisco: Asian Art Museum of San Francisco, 1998.

Kay E. Black and Eckart Dege. 1999/2000. "St. Ottilien's Six 'True View Landscapes' by Chŏng Sŏn (1676–1759)." *Oriental Art* 45, no. 4, pp. 38–51.

Contents

Editorial Notes ——————————————————————————————————

- Korean words have been romanized using the McCune-Reischauer system, except for the names of those who are known in publications in English or a small number of collectors with whom the author was closely acquainted and who are also known outside Korea with their own romanizations.
- Chinese words have been romanized using Pinyin, except in quotations from other authors who have used alternative systems of romanization.
- Korean and Chinese personal names have been written following the Asian system beginning with the surname, except for those who work mainly in the English-speaking world.
- Many of the private collectors of Korean *ch'aekkŏri* who are mentioned in this book are no longer alive, and the ownership of their collections has changed. However, because the ownership of the present moment cannot be easily looked into or confirmed, the ownership of the time when the collections were studied for this book is presented.
- Photographic images of paintings are numbered sequentially, with the chapter number first, followed by the image number, to make it easy to navigate to the correct image. For example, "Figure 13.7" refers to image number 7 in chapter 13, even if the reference to the image is mentioned in another chapter.
- Panel numbers in Korean screens are referred to from right to left.

CH'AEKKŎRI PAINTING
A Korean Jigsaw Puzzle

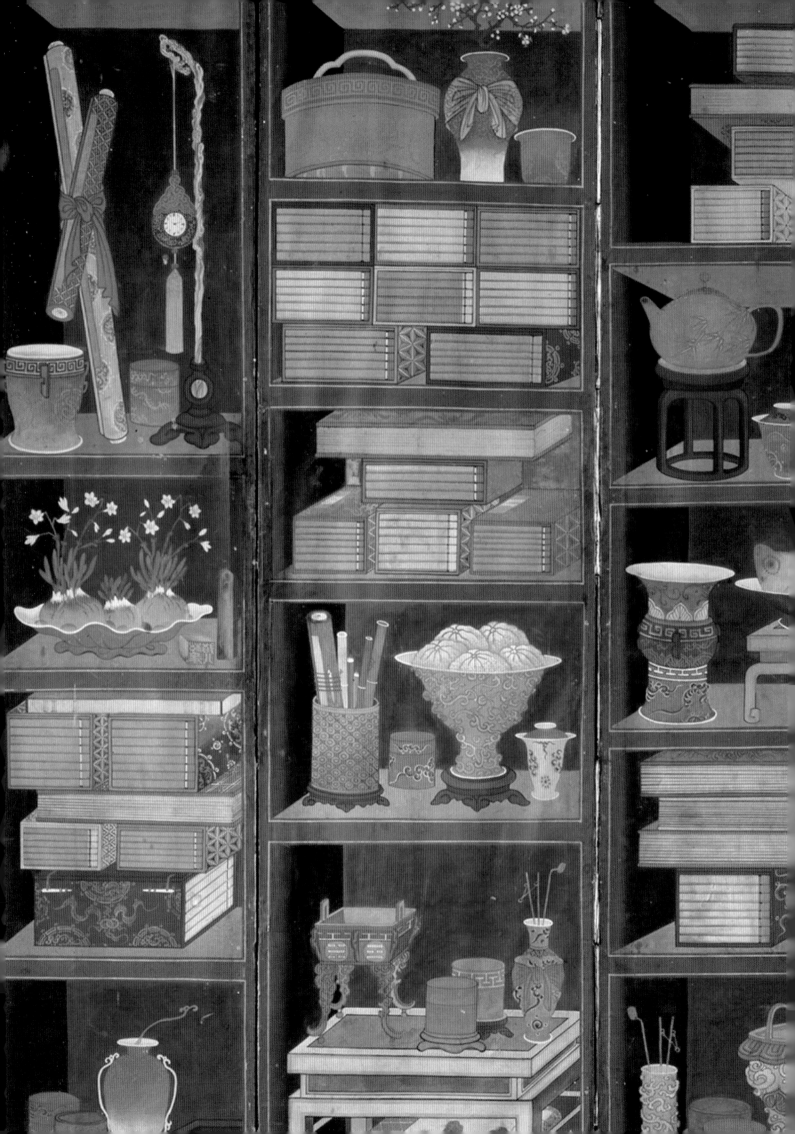

1

Korean *Ch'aekkŏri*: Introduction

Great scholars of the past said that if one occasionally entered one's study and touched one's desk, it satisfied one's mind, even though one was unable to read books regularly. Although I take pleasure in reading books, hard work keeps me from indulging in scholarly pursuits. I remember the words of the sages and look at this painting [*ch'aekkŏri*] and enjoy myself. Isn't this a wise thing to do?

— King Chŏngjo, 1798

In referring to *ch'aekkŏri*,[1] King Chŏngjo (r. 1776–1800) used a generic term for the genre, which includes many different kinds of still life painting. Korean *ch'aekkŏri* screens reflect a tradition of collecting and connoisseurship begun by Chinese scholar-officials in the Song dynasty (960–1279).[2] Many existing examples of Chinese figure painting depict one or more scholars surrounded by groups of antiquities, clearly indicating the delight that the owners took in viewing their own and each other's collections.[3] Inspired by Chinese prototypes, Korean artists took the *ch'aekkŏri* genre to a new artistic level with an indigenous style, as the illustrations will show. In Korea, beholding a *ch'aekkŏri* screen was seen as a substitute for pursuing the scholarly pleasures afforded by leisure, and because King Chŏngjo had one hanging behind his throne, owning such a *ch'aekkŏri* became a status symbol.[4] His enthusiasm for and patronage of *ch'aekkŏri* may well account for the popularity of the genre during the latter part of the Chosŏn period (1392–1910).[5]

At the time when Edward W. Wagner and I became interested in exploring the history and meaning of these remarkable screens, we found that little previous scholarship had been undertaken and that much of the available material was incomplete or inaccurate. I hope this study will serve to rectify some of these misunderstandings. Unraveling the iconography and social importance of these complex works proved to be an arduous challenge. Discovering the authorship of some of these accomplished screens presented an even more difficult task, an elusive mystery that, to date, we have only partially solved.

Ch'aekkŏri Characteristics

Ch'aekkŏri are Korean paintings, most often on folding screens, used for interior decoration during the latter part of the Chosŏn period.[6] The genesis of the word ch'aekkŏri is not clear. Ch'aek is the Korean pronunciation of the Chinese character meaning "book." Kŏri is a bound Korean word having the nuance of "the makings of" or "material for." The resulting combination of these word elements—ch'aek-kŏri—has been used for some time by art historians to describe these paintings and can be defined as "a painting of books and appurtenances," or more simply, "books and things."[7] Another interpretation is that kŏri comes from the verb kŏlda ("to hang"); therefore, the word could be defined as "to hang a book."[8]

The characteristic painting medium of ch'aekkŏri artists was Korean mineral and vegetable colors mixed with glue, sometimes with a touch of monochrome ink painted on silk, paper, and the finest quality of hemp. Sometimes it is very difficult to tell the difference between silk and hemp because the paint obscures the fabric's texture and sheen.[9] Paintings on silk or hemp were for the palace or wealthy aristocrats. Those on paper were for anyone who could afford them, since mineral pigments and fine quality paper were also expensive. Color was almost an indispensable element in ch'aekkŏri painting. The same pigments were used in Buddhist temple paintings.

The usual format for ch'aekkŏri painting was a two-, six-, eight-, or ten-panel framed, wooden folding screen of silk, hemp, or paper mounted on silk.[10] Its purpose was both utilitarian and aesthetic. Tall two-panel folding screens were used in the corners of rooms. Larger multi-paneled folding screens protected the floor-sitting Koreans from drafts, while at the same time decorating the interiors of their houses. Ch'aekkŏri were painted in other formats as well. For instance, wide horizontal single panels were possibly tailored to fit on doors to attic spaces (Figure 1.1),[11] or more probably on architraves in Buddhist temples (Figure 1.2); small folk-style ch'aekkŏri panels were used to decorate cupboard doors (Figures 1.3 and 1.4);[12] and a special single-panel ch'aekkŏri known as a "dressing screen" provided privacy in women's quarters (Figure 1.5).[13] They were used in children's rooms, sometimes on a child's first birthday, occasionally in village schools, and in reception rooms for guests.[14] The sheer number of extant ch'aekkŏri examples provides ample evidence that they were an integral part of household furnishings.

Though there are stylistically distinct types of ch'aekkŏri, they are thematically united by the depiction of scholarly paraphernalia—books, bronzes, ceramics, flower arrangements, bowls of fruit, and miniature landscapes. Many of the bronzes depicted in ch'aekkŏri may be found in the Song dynasty catalogue Bogu tulu.[15] Artists chose from a vast, well-established catalogue of these treasures, determining which and how many to include in a given painting. Always present are "The Four Friends of the Scholar's Room" (munbang sau)—paper, ink, brush, and inkstone. Inspiration for the two most popular styles of inkstones depicted by the artists might have come from Sancai tuhui (volume 3).[16] Inkstones are usually included in court style ch'aekkŏri, but not in the still life type. Among other objects depicted, listed in order of popularity, are: rolls of paper and vessels tied with wrapping cloths or rib-

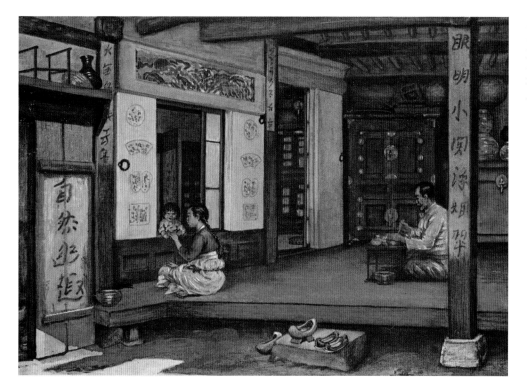

Figure 1.1
Interior scene showing a painting used to decorate a door to an attic space. Photo from Keith and Scott, *Old Korea: Land of the Morning Calm* (1946), p. 51.

bons; peacock feathers; coral branches; paper whites (narcissus), the Chinese New Year flower; small vases shaped like a half-open magnolia blossom; cut-open watermelons; vessels shaped like clubmoss (*selaginella involvens*); and carps on a stand.[17] As the combination of a peacock feather and/or a coral branch was the second most popular motif featured in all three types of *ch'aekkŏri* as a symbol of officialdom, it seems likely that the Koreans might have adopted its Chinese symbolism for their own. Because the Chinese language has a limited number of monosyllables, many words have the same pronunciation, although their written characters and their respective meanings differ. Given together the use of these homonyms and homophones, their symbols form a rebus. In China, a container of peacock feathers and/or coral was a rebus meaning, "May you achieve the highest official rank" (*lingding huihuang, hongding hualing*).[18] Its significance is derived from the red knob and peacock feather worn on their hats by officials of the first rank.

Generally, the subject matter is secular in nature, even though some *ch'aekkŏri* depict archaic and archaistic Chinese bronze types specifically associated with ancestor worship and Confucian temples during the Chosŏn period.[19] While some other items might seem to carry religious connotation because of their association with Buddhism, Daoism, or shamanism, their inclusion in late Chosŏn period *ch'aekkŏri* probably was meant to convey auspicious wishes. Iconographically, the theme is syncretic, but its message is propitious and Neo-Confucian.

The question about whether the nineteenth-century Koreans used the Chinese symbolism inherent in the rebuses and their imagery has to be left for future scholars. However, I think that the Koreans must have believed them, or the vase with peacock feathers with and without coral would not appear in so many *ch'aekkŏri* as

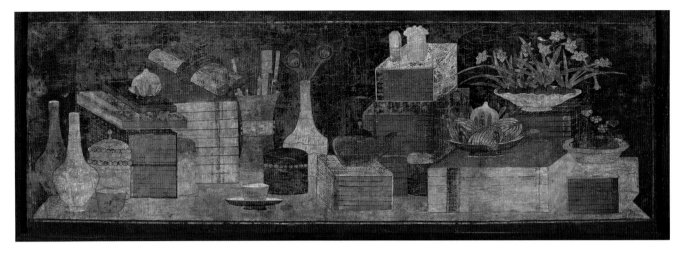

1.2

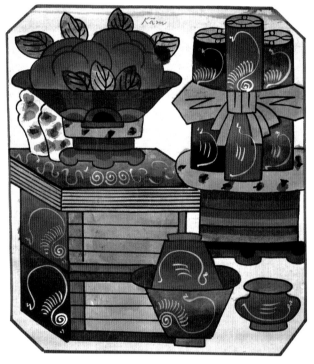

1.3

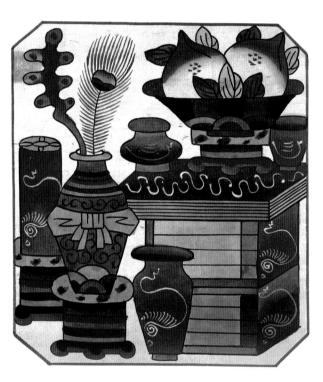

1.4

Figure 1.2
Single-panel trompe l'oeil *ch'aekkŏri* possibly
used to decorate doors to attic spaces or
architraves in Buddhist temples. Ink and
mineral pigments on paper. 51 × 157.5cm.
Arthur M. Sackler Museum, Harvard University
(acc. no. 1920.22, gift of Denman Ross). Photo
courtesy of the Arthur M. Sackler Museum.

Figures 1.3 and 1.4
Still life type *ch'aekkŏri*. National Museum of
Natural History, Smithsonian Institution (acc.
no. 77052-10 [right], 77052-7 [left]). Photos
courtesy of the Smithsonian Institution.

Figure 1.5
Single-panel "Dressing" screen used in
women's quarters. Ink, vegetable and mineral
pigments on paper. 57×34.4cm. Onyang Folk
Art Museum. Photo from the exhibition
catalogue *Han'guk minhwajŏn* (1981), p. 43.

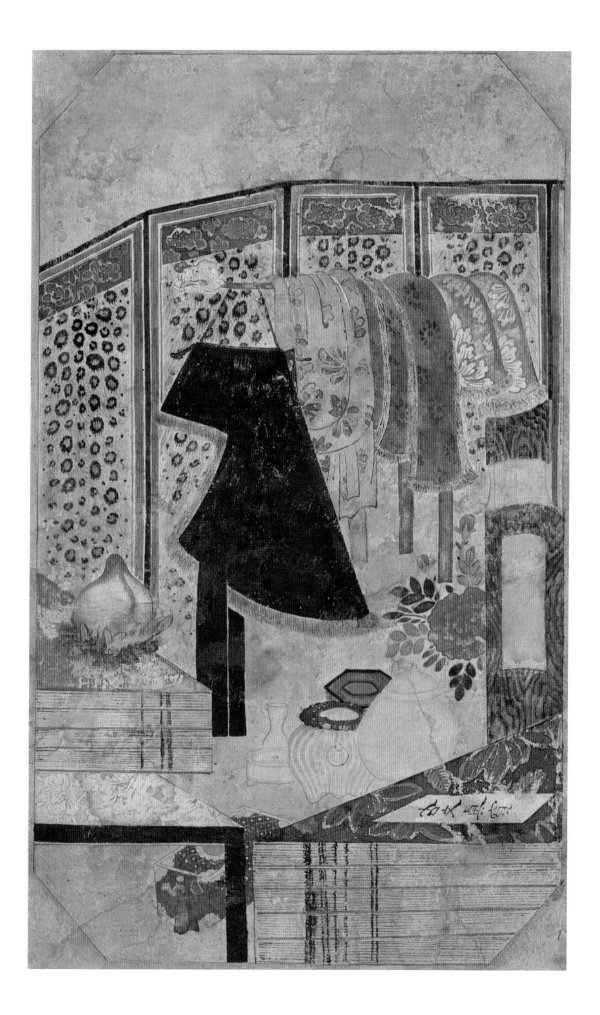

a symbol of achieving "officialdom."

Wagner and I found some 150 examples of *ch'aekkŏri* paintings during our twenty-year search, many in museum storage, others in private collections, auction houses, and at art dealers in Korea, Japan, China, Europe, and the United States. Though some of these works have been published—usually the same ones over and over again—many have not. In the course of our research, three distinct types of *ch'aekkŏri* screens have emerged. Wagner and I have labelled these the "isolated," "trompe l'oeil," and "still life" types.

Isolated Type *Ch'aekkŏri*

Isolated *ch'aekkŏri* screens are characterized by the rendering of each of their panels as a separate composition (Figure 1.6). The integrity of a panel does not depend on its adjacent panels. The subject matter is strewn somewhat randomly in vertical columns on each panel of a screen. Scholarly objects, such as books and "The Four Friends of the Scholar's Room," are not arranged on shelves, but rather are depicted singly and in small groups, appearing to float in space without any visible means of support or coherent ordering. Pictorial effect is achieved through the use of color, differences in scale, modeling of the objects, the device of overlapping books and items in some of the arrangements, and the empty spaces that surround the objects. The only visible influence of Western painting in isolated type *ch'aekkŏri* is the shading used to model the contours of the treasures portrayed.

Wagner's and my research supports the conclusion that the isolated type of *ch'aekkŏri* was the first of the three *ch'aekkŏri* types to be developed in Korea. Korean artists no doubt drew inspiration from screens by Chinese painters that depicted objects from the collections of Chinese emperors and other prominent collectors. These collectors commissioned artists to catalogue their treasured objects pictorially. The artists used a handscroll format, woodblock-printed books, and painted catalogues. Objects in isolated type *ch'aekkŏri* retain many of the qualities of these Chinese catalogues, as each item is presented in isolation, not as part of a large, unified composition. Although I believe the earliest Korean example might someday be traced to the late seventeenth century, as yet I have found no isolated type *ch'aekkŏri* examples earlier than the nineteenth century.

Trompe l'Oeil Type *Ch'aekkŏri*

The second *ch'aekkŏri* type, which Wagner and I have labelled the trompe l'oeil type (Figure 1.7), presents a three-dimensional bookcase with all of the scholarly treasures arranged on the shelves in an overall composition. Floral arrangements intrude into the ceiling spaces of the screen. The vessels are elaborately depicted, and many are tied with wrapping cloths or ribbons. Some stacks of two books show the Korean fashion of five-stitch binding. Two timepieces from Europe stand out: one is a clock with a bell on top (panel 3) whose Roman numerals are incorrectly depicted;

the other is a pocket watch (panel 6). One other "Baroque" trompe l'oeil type *ch'aek-kŏri* screen with similar vessels and objects bursting into the ceiling of the bookcase is an eight-panel anonymous *ch'aekkŏri* sold at Christie's, New York on March 23, 1999 (Lot 305) (Figure 1.8). The same screen was sold again at Christie's, New York, on September 22, 2005 (Lot 446). "Trompe l'oeil" comes from the French words meaning "trick-of-the-eye" and is a term used throughout the Western world to describe a realistically rendered three-dimensional scene on a two-dimensional surface. This bookcase format provided the perfect geometric framework for Korean artists to exploit the Renaissance system of linear perspective, which had been introduced to the Chinese court by Jesuits during the reign of the Kangxi emperor (1661–1722) or possibly even earlier.[20]

One observer describes his reaction upon encountering this phenomenon:

> Scroll books closed with ivory needles and jade pins fill the library. There is a magnificent cabinet containing "curios" that sparkle from top to bottom. To the north stands a table. And on that table stands a vase containing a bouquet of pheasants' feathers. A brilliant feather fan appears in the setting sun. In the rays of the sun the shadow of the fan, the shadow of the vase, the shadow of the table—all perfectly rendered…. You are tempted to enter…. You stretch out your hand and suddenly realize that you are facing a wall.[21]

Trompe l'oeil type *ch'aekkŏri* began to be produced much later than the isolated type, only after Korean artists had begun to see the possibilities offered by the use of linear perspective. This technique was well developed in the time of King Chŏngjo, perhaps as much as 150 years after the isolated type of *ch'aekkŏri* was produced, though this is only speculative. The technique allowed artists to render depth recession convincingly by drawing two lines that converge at infinity, whereas in the

Figure 1.6
Eight-panel *ch'aekkŏri* screen of the isolated type by Han Ŭng-suk, an artist of the first half of the 19ᵗʰ century. Ink and mineral pigments on silk. 133×32.5cm. Mrs. Minn Pyong-Yoo collection, Seoul. Photo by Norman Sibley.

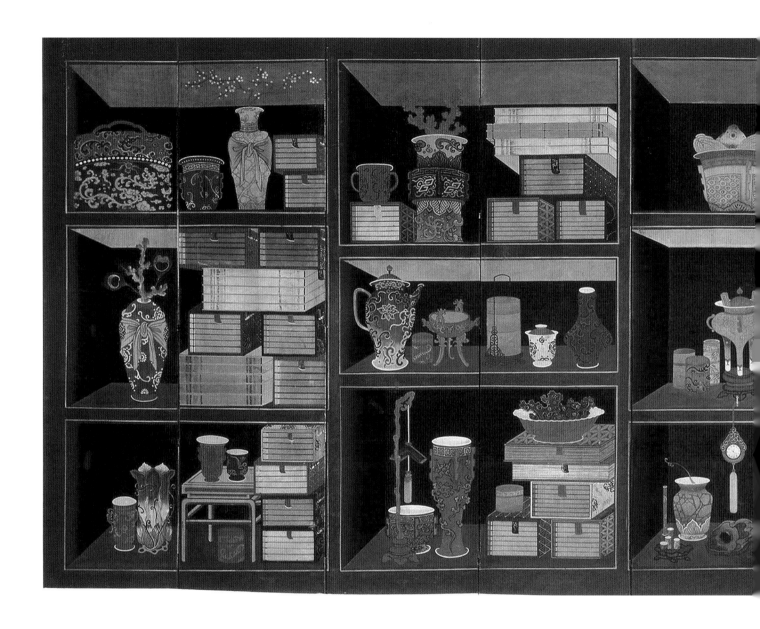

Figure 1.7
Ten-panel "Baroque" trompe l'oeil type *ch'aekkŏri*. Heavy mineral pigments on silk. 137.5 × 38 cm, end panels 35 cm. National Museum of Korea (acc. no. 3322). Photo by Norman Sibley. Symmetrical, balanced composition by an anonymous artist who understood linear perspective. Late 19th century. A floral arrangement, or an ornament, intrudes into the ceiling space in five sections of the screen, much as in Pang Han-ik's *ch'aekkŏri*. The vessels are elaborately depicted, and many are tied with wrapping cloths or ribbons. Four stacks of two books show the Korean fashion of five-stitch binding. Two timepieces from Europe stand out; one is a clock with a bell on top whose Roman numerals are incorrectly depicted; the other is a pocket watch.

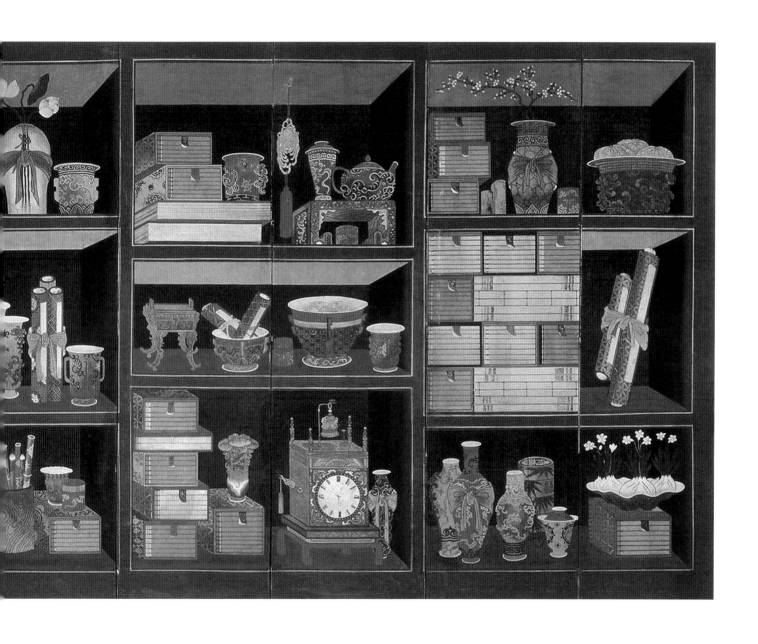

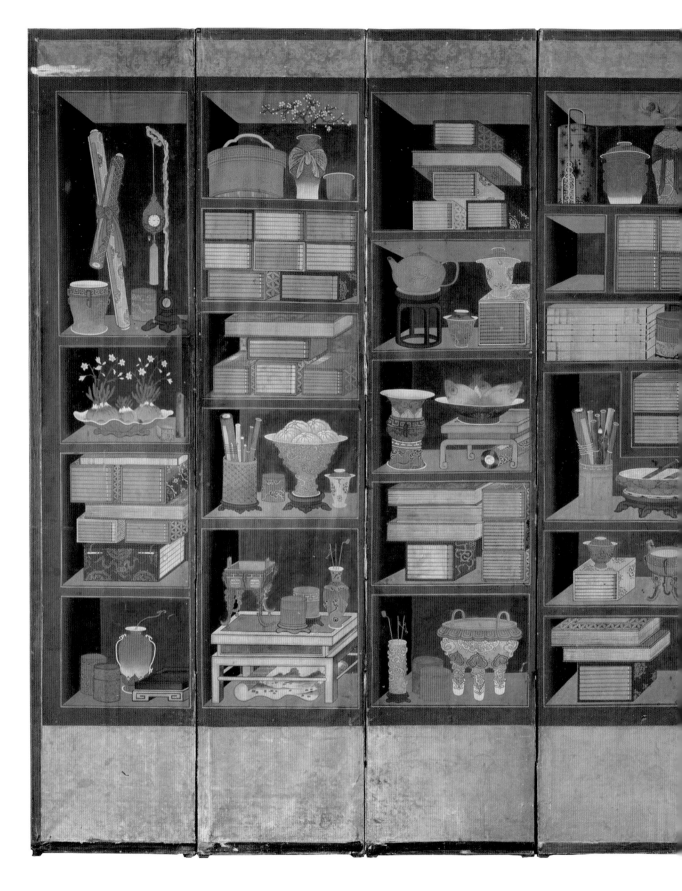

Figure 1.8
Eight-panel "Baroque" trompe l'oeil type *chʾaekkŏri* screen by an anonymous painter with similar
vessels and objects bursting into the ceiling of the bookcase. Ink and color on silk. 161.9 × 341
cm. Sold at Christie's, New York, March 23, 1999. Photo courtesy of Christie's. The same screen
was sold again at Christie's, New York, Japanese and Korean Art, September 22, 2005.

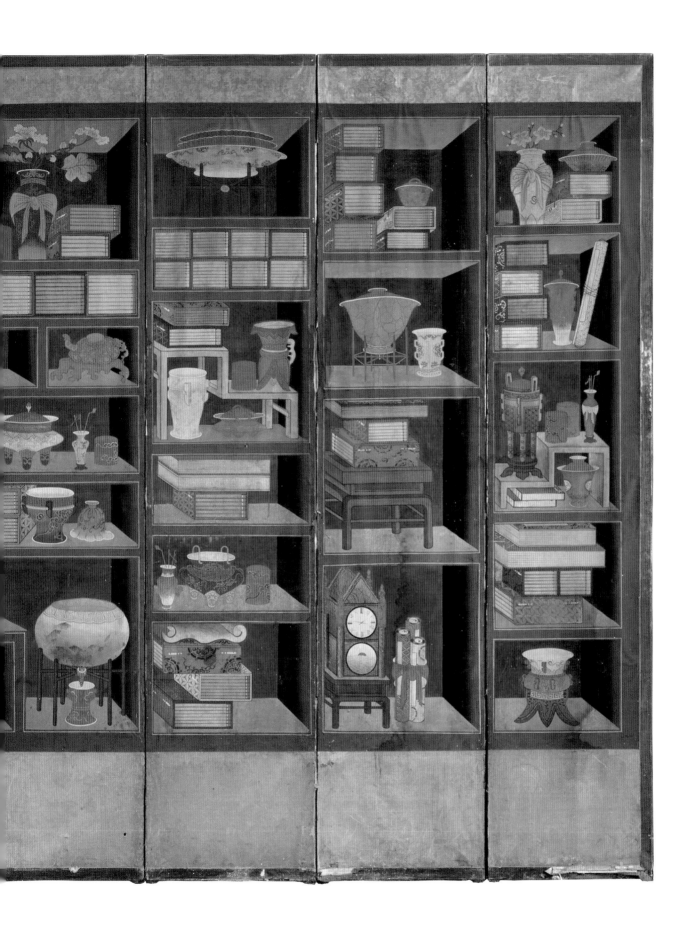

Korean <i>Ch'aekkŏri</i>: Introduction 11

Asian system of isometric perspective lines remain parallel, incapable of meeting.[22] For the first time, Korean artists were able to reveal five sides of an interior space as opposed to only the three sides permitted by the isometric Asian system. Strangely, painters of trompe l'oeil type *ch'aekkŏri* were the only Korean artists to exploit linear perspective in this manner. For instance, painters did not use it for depictions of architectural interiors or exteriors.

Through the combined use of linear perspective and a careful manipulation of color values and shading on a two-dimensional surface, a three-dimensional visual effect is achieved. A trompe l'oeil *ch'aekkŏri* creates an illusion. Make-believe bookcases were pictorially created to serve as displays for the make-believe treasures of the scholar in an overall composition across the many panels of a screen. The bookshelf designs, whose original source may have been Chinese, could have been based on actual contemporary Korean examples used in book storage rooms.[23] Bookcase designs in Korean *ch'aekkŏri* are symmetrical or balanced and lack decorative carved borders, unlike actual examples of the Qianlong period (1736–1796) bookshelves, which are generally asymmetrical and elaborately carved. No two identical bookcase designs depicted in *ch'aekkŏri* have thus far been found, an indication that the painters had no set pattern to follow.

Historically, two things had happened to inspire the creation of trompe l'oeil *ch'aekkŏri*. First, since the fourteenth and fifteenth centuries, Europeans had begun assembling treasure rooms with cases of exotic and valuable items such as armillary spheres, horoscope charts, seashells and elaborate glass and metal vases.[24] The European idea of displaying rarities in this manner must have made its way to China via cultural exchange, possibly in book illustrations brought to the Chinese court by Jesuit missionaries.

Two seventeenth-century Dutch still life paintings in the Rijksmuseum in Amsterdam provide a close conceptual and visual connection to the trompe l'oeil type of *ch'aekkŏri*. One anonymous Dutch artist focused on rarities from around the world in his still life painting: pepper from the Far East, olives from Italy, and a ceramic bowl from China are included in the composition. Jan Davidsz de Heem's *Still Life with Books* (c. 1628) shows a still life on a shelf. A picture of the type could easily have made its way to China or Japan, for it is known that the Dutch established direct trading links with Chinese merchants in 1608, and the next year they had established a trading post in Japan. As Korea sent tribute missions to China and trade missions to Japan—and a court artist was always along—it is easy to see how transmission was possible.

Second, Fillipo Brunelleschi (1377–1446) discovered linear perspective; it was codified by Leon Battista Alberti (1404–1472) in 1453 in his treatise *Della Pittura* (On Painting). This system of perspective allowed artists to show convincingly the third dimension on a two-dimensional plane. Two European influences—the curio cabinet and the new painting technique of linear perspective—reached the Chinese court. Trompe l'oeil paintings might well have been seen by a Korean emissary or by a court painter who took the idea, perhaps even a painting, home to Seoul.

Yi Ik (1681–1763), one of the most famous "Practical Learning" (*Sirhak*) scholars, wrote about linear perspective in his *Sŏngho sasŏl*. Yi Ik describes the system as based

on Euclidian geometry. In the eighteenth century, Korean court artists, particularly the "painters-in-waiting," were probably aware that the vantage point was mathematically calculated, but they chose to ignore it and focused, instead, on trompe l'oeil conventions. The reason for this preference, in the case of the *ch'aekkŏri*'s folding screen format, was an awareness of the distortion problems caused by the extreme width of the bookcases and their shallowness. Multiple vantage points were necessary. Otherwise, severe distortion would have resulted at the screen's ends, and there would have been no visible shelf space on the end shelves on which to depict the objects. Thus, although the artists understood the rational concept inherent in linear perspective, their application of it was intuitive, which suited the trick-of-the-eye bookcase on its folding screen format.

Korean *ch'aekkŏri* folding screens were usually without feet.[25] The strong ceiling and floor perspectives indicate that a trompe l'oeil screen was meant to be viewed close on, at eye level, by floor-sitting people at 65 to 70 cm, not from a chair's height.[26] That affected the composition of a bookcase, necessitating a central focus, which is why artists maintained more or less level vanishing points through the middle register of the screen. The objects above are seen from below, and those below the middle zone are viewed from above. This viewing perspective was important for trompe l'oeil *ch'aekkŏri*. The three *ch'aekkŏri* in their original mountings—Yi Ŭng-nok's screen in the National Museum (Figure 13.10), the Stanford screen (Figure 4.2), and the Shufeldt screen in the Smithsonian (Figure 4.1)—have a very shallow top mounting (a heaven), or just the frame, and a slightly deeper bottom mounting (an earth). Both embroidered *ch'aekkŏri* (the Smithsonian's and Stanford's) have top mountings one-half the depth of the bottom ones. The National Museum's screen by Yi Ŭng-nok has no top mounting, only a narrow silk strip covering the frame, and a shallow bottom one. In all three cases, the mountings are much abbreviated compared with most remounted Korean *ch'aekkŏri* and traditional East Asian hanging scrolls. Therefore, I suggest that these screens be used as models for remounting as they indicate Chosŏn period mounting proportions. The Korean artists accommodated the technical aspects of their screen compositions and formats to the *ch'aekkŏri* function as decorative draft protectors for their floor-sitting patrons.

Still Life Type *Ch'aekkŏri*

The third type of *ch'aekkŏri*, which Wagner and I have labelled the still life type, provides by far the most numerous examples for study and is often the most complicated. Shown in this introduction are two folk-style still lifes painted for cupboard doors (Figures 1.3 and 1.4). Also in the folk style are three panels painted in ink, diluted color (*tamch'ae*), and thick mineral color on the fan. The collectors Joo Kwan Joong (Chu Kwan-jung) and Rhee Boon Ran (Yi Pun-ran) refer to these panels as "Practicing Penmanship" *ch'aekkŏri* (Figures 1.9 and 1.10).[27] A single panel with a fantastic rock with entwined grapevine and a tiny squirrel, all but hidden in the foliage, is the focus of a third still life composition (Figure 1.11). Books both in Chinese-style slipcases and one in the center stacked flat in the Korean manner are seen on top of

Figure 1.9
Panel from a screen in the folk style (see also Figure 1.10). Ink and diluted color. 52 × 27 cm. Joo Kwan Joong and Rhee Boon Ran collection, Seoul. Photo by the author. In this panel, a densely colored fan draws viewers' attention.

Figure 1.10
Panel from a screen in the folk style (see also Figure 1.9). Ink and diluted color. 52 × 27 cm. Joo Kwan Joong and Rhee Boon Ran collection, Seoul. Photo by the author. This panel features a scholar's stationery brush.

Figure 1.11
Single panel with a fantastic rock, a grapevine with a tiny squirrel all but hidden by foliage, and a chest decorated with a brass tiger mask. Ink and color on paper. 55 × 30 cm. Joo Kwan Joong and Rhee Boon Ran collection, Seoul. Photo by the author.

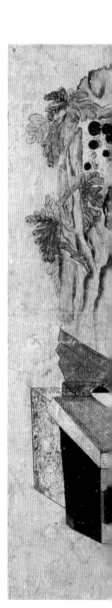

Figure 1.12
Panel from a still life type *chaekkŏri* screen (see also Figure 1.13). Ink and mineral pigments on paper. 72×41 cm. Leeum, Samsung Museum of Art. Photo by Norman Sibley. This is decidedly not in the folk style; rather, it is painted in the meticulous style of Pyŏn Sang-byŏk. Probably six panels—two now in Germany and four in Korea—were originally mounted together with another two to make an eight-panel folding screen. In this panel, a rabbit is depicted naturalistically.

Figure 1.13
Panel from a still life type *chaekkŏri* screen (see also Figure 1.12). Ink and mineral pigments on paper. Gerrit and Giselle Kuelps collection, Germany. Photo courtesy of Gerrit Kuelps. This panel includes a tiger skin.

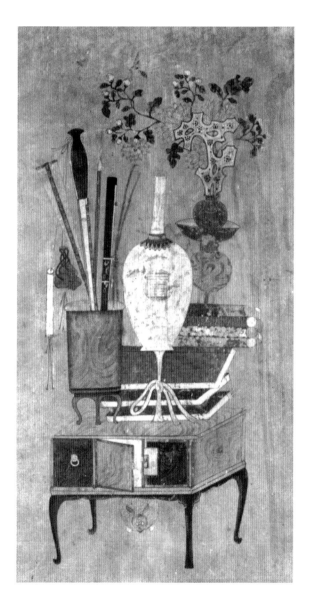
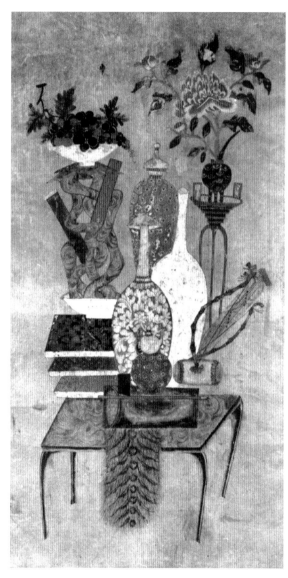

a small chest. The hardware consists of a tiger's masque with a butterfly for a nose. In this type, tables, chests, and pieces of small furniture are usually incorporated into the composition as places to put the scholarly objects. An exception is seen in the seal script (*chŏnsŏ*, C. *chuanshu*) style, which is totally lacking in furniture. Different kinds of perspective, both East Asian and European, are combined to create compositions of intermingled and integrated shapes on each panel. The resulting still life arrangements appear as unified architectonic constructions, owing to the alignment of compositional elements and to the transitions from one plane to another. Scholarly objects are still prominently displayed in still life type *chʼaekkŏri*, but a greater range of subject matter, including such items as clothing, scientific apparatus, spectacles, and animate objects, populate the panels of still life *chʼaekkŏri*.

In the Leeum, Samsung Museum of Art,[28] there are four *chʼaekkŏri* panels of the still life type which are definitely not in the folk style. The panels are painted in the meticulous style of Pyŏn Sang-byŏk (1730–1775), court painter of animals and fowl during the reign of King Yŏngjo (1724–1776), with objects depicted naturalistically. (One, featuring a rabbit, is shown in Figure 1.12.) In a German collection, there are two similar panels, also in the style of Pyŏn Sang-byŏk, which might easily have been painted by the same hand or at least from the same workshop, and might have been from the same set in a six- or eight-panel folding *chʼaekkŏri* screen. One of these panels, which includes a tiger skin, is shown in Figure 1.13. Objects are all finely detailed, including a pipe instrument played with a bow; many are not anchored securely to the furniture surfaces, but float on the picture frame. A delicate overall effect is achieved. It is conceivable that they might have been painted by Pyŏn Sang-byŏk, but none of his works are known to this author for comparison.

Court Style *Chʼaekkŏri*

Of the above types, isolated and trompe l'oeil *chʼaekkŏri* are considered to be "court style."[29] That is, they were created for royalty and aristocracy. The third type, still life, was commissioned by anyone with the means to purchase paintings made with expensive pigments. As to physical criteria for the court style, both trompe l'oeil and isolated *chʼaekkŏri* screens tend to be enormous in scale, which made them unsuitable for any but large palace rooms or big houses of the wealthy. Therefore, until the twentieth century, size was an important criterion in determining if the screens were created for the court, but it was not foolproof as a late nineteenth-century *chʼaekkŏri* painted to commemorate Kim Ki-hyŏn's seventieth birthday (see Chapter 17) will demonstrate. Other court style physical criteria are books displayed in slipcases in the Chinese manner and the inclusion of Chinese scholars' objects.

Chʼaekkŏri Artists

Often one of the most difficult first steps in academic research is to reject accepted assumptions. In the case at hand, there was the long-held belief that anonymous

folk artists produced all *ch'aekkŏri*. The artistic quality of several *ch'aekkŏri*, however, clearly suggested that many of these paintings could not have been executed by untrained folk painters. Learning about the artists of the *ch'aekkŏri* genre proved to be the most difficult aspect of putting together the pieces of this *ch'aekkŏri* puzzle. Eventually, Wagner and I discovered clues in the paintings themselves that enabled us to identify the names of specific government artists who had created certain *ch'aekkŏri*, thereby putting to rest the notion that many of these paintings were primarily the work of folk artists. Wagner and I have identified some painters, yet others I have not been able to find, and I hope that future scholarship will succeed where I have failed.

The sources for our study were the paintings themselves, Korean genealogies of the so-called "middle people" (*chungin*), other lineage documents, and lists of those who passed the various "miscellaneous examinations" (*chapkwa*), those taken predominantly by *chungin* class members.[30] Because only five published *chungin* genealogies are known, it has been difficult to determine who certain artists were, even though their name seals were depicted as objects in the subject matter. Wagner and I were extremely lucky when the genealogical record confirmed an artist's identification. Further complicating matters, although we found many artists' pen names disguised as seals, we could not match them with surnames. Puzzling over the interpretations of numerous clues found within the subject matter has not been easy, but it has been an irresistible challenge.

In addition to the seals of pen names, Wagner and I found several seals with surnames and given names. I have followed Wagner's preference for hyphenating the two given names, following the surname using the McCune-Reischauer system of romanization. We have accepted these names as being genuine because the *ch'aekkŏri* in our study are at least sixty to 175 years old, created before the vogue for Korean *ch'aekkŏri* led to forgeries painted for the commercial market.

At the onset, Wagner and I imagined our undertaking as a gigantic jigsaw puzzle, and here I present the pieces we have so far been able to put into place in the hope that future scholars will be able to complete what we have begun.

NOTES

1 O Chu-sŏk, "Hwasŏn Kim Hong-do: kŭ in'gan kwa yesul" (The painter immortal Kim Hong-do: the person and his Art), in *Tanwŏn Kim Hong-do: t'ansin 250 chunyŏn kinyŏm t'ŭkpyŏljŏn nonmunjip* (Tanwŏn Kim Hong-do: a collection of papers for the exhibition on the 250th anniversary of his birth), edited by National Museum of Korea (Seoul: Samsung Culture Foundation, 1995), pp. 82–84. I am indebted to Ahn Hwi-joon for drawing my attention to this paper.

2 Kay E. Black, "Hundred Antiques," *Journal of the International Chinese Snuff Bottle Society* 20, no 4 (Winter 1988), p. 4. The culturally linked chronological divisions within the Chosŏn period reflect information conveyed in a personal communication from Edward W. Wagner, August 30, 1996.

3 Two examples of Chinese painting showing scholars enjoying antiquities are: *Enjoying Antiquities* by Du Jin (active 1465–1509) shown in Wen C. Fong and James C. Y. Watt, eds., *Possessing the Past: Treasures from the National Palace Museum, Taipei* (New York: Metropolitan Museum of Art, 1996), pl. 183, p. 367; *A Literary Gathering in the Apricot Garden* by Xie Huan (active 1426–1452) in Richard Vinograd, *The Boundaries of Self: Chinese Portraits, 1600–1900* (Cambridge: Cambridge University Press, 1992), pl. 3.

4 See the account of Nam Kong-ch'ŏl's (1760–1840) *Kŭmnŭngjip* cited in O Chu-sŏk, p. 82.

5 *ibid.*

6 Two sources attest to the traditional use of folding screens. In *Hanjungnok*, a memoir by Crown Princess Hong (1735–1815) (Bruce K. Grant and Kim Chin-man, trans., *Han joong nok: Reminiscences in Retirement* [New York: Larchwood Publications, 1980], pp. 42–44), she describes her quarters as having been "appointed with furniture, room curtains, folding screens." The novel *Kuunmong* by Kim Man-jung (Richard Rutt and Kim Chong-un, trans., *Virtuous Women: Three Classic Korean Novels* [Seoul: Royal Asiatic Society, Korean Branch, 1979], p. 69) tells, "Then he struck the folding screen with a fly whisk and called out…. At once a girl came out from behind the screen smiling all over her face." For specific mention of the decorative use of *ch'aekkŏri* screens in nineteenth-century upper-class homes, see the account in Yu Chae-gŏn's *Ihyang kyŏnmun nok*: *Ihyang kyŏnmun nok* [and] *Hosan oegi* (Seoul: Asea Munhwasa, 1974), p. 411.

7 For a discussion of the term *ch'aekkŏri* see Yi Wŏn-bok, "Ch'aekkŏri sogo" (Note on *ch'aekkŏri*), in *Kŭndae han'guk misul nonch'ong: Yi Kuyŏl sŏnsaeng hoegap kinyŏm nonmunjip* (Papers on modern Korean art: festschrift in honor of Yi Ku-yŏl on his sixtieth Birthday) (Seoul: Hakkojae, 1992), p. 107. Taehan min'guk yesulwŏn (National Academy of Arts of Korea), ed., *Han'guk misul sajŏn* (Dictionary of fine arts of Korea) (Seoul: National Academy of Arts, 1985), p. 535 has a short entry on *ch'aekkŏri* under the alternate term *ch'aekkado*, in which mention is made of yet another name by which this genre is known, *munbangdo*. *Munbang* (scholar's room) was one of the eight genre subjects on which painters-in-waiting were tested. Since *munbang* comprised the *ch'aekkŏri* category on Kang Kwan-sik's lists from the Royal Library (Kyujanggak), it would appear to have been in use since the eighteenth century. Kang Kwan-sik, *Chosŏn hugi kungjung hwawŏn yŏn'gu* (Study of court painters of the late Chosŏn period) (Seoul: Tolbegae, 2001), vol. 2, pp. 115–186.

8 Personal communication with Hahn Changgi (Han Ch'ang-gi; former publisher of the Korean *Encyclopedia Britannica* and the Deep-Rooted Tree Publishing House), October 1983 and correspondence from Ahn Hwi-joon, June 4, 1998. A Chinese woodblock color-printed calendar dated to the tenth year (1745) of Qianlong's reign portrays a still life with books on science and mathematics published by the Board of Astronomy, which is stuck to a Buddhist rosary suspended from a hook. One wonders whether this could have inspired the word *ch'aekkŏri*. Higuchi Hiroshi, *Chūgoku hanga shūsei* (Collection of Chinese woodblock prints) (Tokyo: Hitō shoten, 1967), p. 10.

9 According to Suk Joo-Sun (Sŏk Chu-sŏn), only the finest quality of hemp was used for painting, and it was 34.5 cm wide. Personal communication with Suk Joo-Sun (the former founding director of the Suk Joo-Sun Memorial Museum of Korean Folk Art, Dankook University), October 1986.

10 The panel numbers are counted from right to left in the Asian manner.

11 Elizabeth Keith and Scott E. K. Robertson, *Old Korea: the Land of the Morning Calm* (New York: Philosophical Library, 1947), p. 50.

12 Ensign John B. Bernadou said of these still life type *ch'aekkŏri*, "decorated vases, pencil rest, dish of peaches on the table, coral and peacock feathers in tall vase decorated with wave patterns, and conventional dragon. The common people delight in these gaudy pictures and hang them up in their living rooms. Used for hanging on a closet door." Walter Hough, "The Bernadou, Allen, and Jouy Korean Collections in the US National Museum," in *Report of the United States National Museum for the year ending June 30, 1891* (Washington DC: GPO, 1893).

13 The objects in the screen describe a room in still life fashion, showing a screen within a screen.

14 Zo Za-yong and Lee U Fan, *Traditional Korean Painting: A Lost Art Rediscovered*, translated by John Bester (Tokyo and New York: Kodansha International, 1990), p. 155. A still life *ch'aekkŏri* appears in a photograph behind a child celebrating his first birthday. See Kungnip minsok pangmulgwan (National Folk Museum of Korea), ed., *Kŭndae paengnyŏn minsok p'ungmul* (Folk customs of 100 years in modern Korea) (Seoul: National Folk Museum of Korea, 1995), p. 55, fig. 79. See also Kim Ho-yŏn, ed. *Han'guk minhwa* (Korean folk painting) (Seoul: Kyŏngmi munhwasa, 1977), p. 204.

15 *Bogu tulu* (1752 edition).

16 *Sancai tuhui*, vol. 3 (Taipei: Chengwen chubanshe, 1970), p. 1335.

17 The motif of tying a ribbon or wrapping cloth around paper rolls and vessels was popularized during Qianlong's reign. See Hugh Moss, *By Imperial Command: An Introduction to Qing Imperial Painted Enamels* (Hong Kong: Hibiya, 1976), pl. 66 (enameled porcelain vase from Peking palace workshops, 1735–1796). The precedent for either depiction is the Chinese long ribbon (*shoudai*), a longevity symbol. See Terese Tse Bartholomew, *Hidden Meanings in Chinese Art* (San Francisco: Asian Art Museum of San Francisco, 2006), p. 214; Shen Congwen, ed., *Zhongguo gudai fushi yanjiu* (Studies of ancient Chinese clothing) (Hong Kong: Shangwu, 1981). The ribbon motif goes back to the Western

Han depicted on bronze mirrors (*ibid*, p. 126); on figurines of the Northern Wei and Southern Wei dynasties (p. 149); and on Tang ladies' sashes (p. 215).

18 Bartholomew, *Hidden Meanings in Chinese Art*, p. 123, section 5.25.4.

19 Kim Man-hŭi, *Minsok torok* (Illustrations of Korean folklore), vol. 3 (Seoul: Sangmisa, 1975), pp. 22–26.

20 The trompe l'oeil technique was brought to China during the reign of Emperor Kangxi (1661–1722) who gave the Jesuits a site within the walls of the Forbidden City to build their North Church (*Beit-ang*) as a reward for having cured him of smallpox. The opening took place in 1703. A trompe l'oeil painting by Brother Gheradini (resided in China 1698–1707) simulated a vista elongating the sanctuary that was much admired by the Chinese, and is the earliest painting of the type known to the author. See Cécile and Michel Beurdeley, *Giuseppe Castiglione (1688–1766): A Jesuit Painter at the Court of the Chinese Emperors*, translated by Michael Bullock (Rutland, VT and Tokyo: Charles E. Tuttle, 1971), p. 33.

21 Beurdeley and Beurdeley, pp. 93–94.

22 For a lucid explanation of the difference between Asian and Western perspectives, see Benjamin March, "A Note on Perspective in Chinese Painting," *China Journal of Science and Arts* 7, no. 2 (August 1927), pp. 69–72, fig. 2.

23 The late Ye Yong-hae, former *Han'guk ilbo* journalist and Korean folk art expert, remembered a large bookcase in his father's book storage room. He himself had one. Apparently, such huge bookcases were used for storage rather than for decorative purposes in a study, where the bookcase is found. Personal communication, 1990.

24 Julius von Schlosser, *Die Kunst-und Wunderkammern Der Spätrenaissance* (Braunschweig: Klinkhardt & Bermann, 1978), pls. 148, 149. A 1596 inventory describes a few Chinese wall hangings from Archduke Ferdinand von Tirol's (1520–1595) Castle Ambras near Innsbruck proving a cultural exchange from China to Europe in that period. Von Scholosser, pl. 71, pp. 45–46.

25 A *munjado* eight-panel screen in its original mountings from the Mission Varat, 1888, does have feet, but it is the only one of which I am aware. See Cambon, pl. 94.

26 Personal communication with Leonid Konstevich, 2006.

27 Personal communication with Joo Kwan Joong, October 1986.

28 The collection of the Leeum, Samsung Museum of Art, was formerly known as the Ho-Am Art Museum until 2004 when the new Museum opened in Seoul, and we referred to it by the earlier name in previous publications. Hereinafter, we will refer to it simply as the Leeum.

29 Much of the general information on *ch'aekkŏri* is from Kay E. Black and Edward W. Wagner, "Court Style *Ch'aekkŏri*," in *Hopes and Aspirations: Decorative Paintings of Korea,* edited by Kumja Paik Kim (San Francisco: Asian Art Museum of San Francisco, 1998), pp. 29–33. In this article, we refer to the trompe l'oeil and isolated types as court style because we established that both were created by artists in government employ. However, the term "court style" should not be misinterpreted as a reflection of European court life. In Korea, royal families celebrated engagements, marriages, and other social events in the palace. The court is merely a yard situated in front of the king's audience hall where formal rituals are enacted. Eighteen stones mark the area where officials are placed according to their ranks, and the *chungin* court painters stand at the very back. Personal communication with Ledyard, November 16, 2004. It is known that both trompe l'oeil and isolated type *ch'aekkŏri* were created for the palaces, large and small, by the court painters, who likely accepted private commissions, too. The "painters-in-waiting" worked in the royal library; the ordinary court artists worked outside the palace. Kang Kwan-sik, vol. 1, pp. 36, 39–40. Henceforth, palace *ch'aekkŏri* refers specifically to the works of Yi Hyŏng-nok (and Yi Ŭng-nok and Yi T'aek-kyun—his alternate names) because he is the only designated painter-in-waiting (*ch'abi taeryŏng hwawŏn*) in this study to our knowledge. The regular court painters (*hwawŏn*) are referred to by that term and by the term "government painter" in an effort to break away from the context of the European court.

30 Personal communication with Wagner, June 15, 1993. The examination rosters give the names of four ancestors: father, grandfather, great-grandfather, and maternal grandfather. Kay E. Black and Edward W. Wagner, "*Ch'aekkŏri* Paintings: A Korean Jigsaw Puzzle," *Archives of Asian Art* 46 (1993), pp. 63–75; Black and Wagner, "Court Style *Ch'aekkŏri*," pp. 23–35. There have been some changes in the current book: what we then called "table" *ch'aekkŏri* we now refer to as "still life" *ch'aekkŏri* because we have discovered examples of the type that do not include tables or other furniture in the composition.

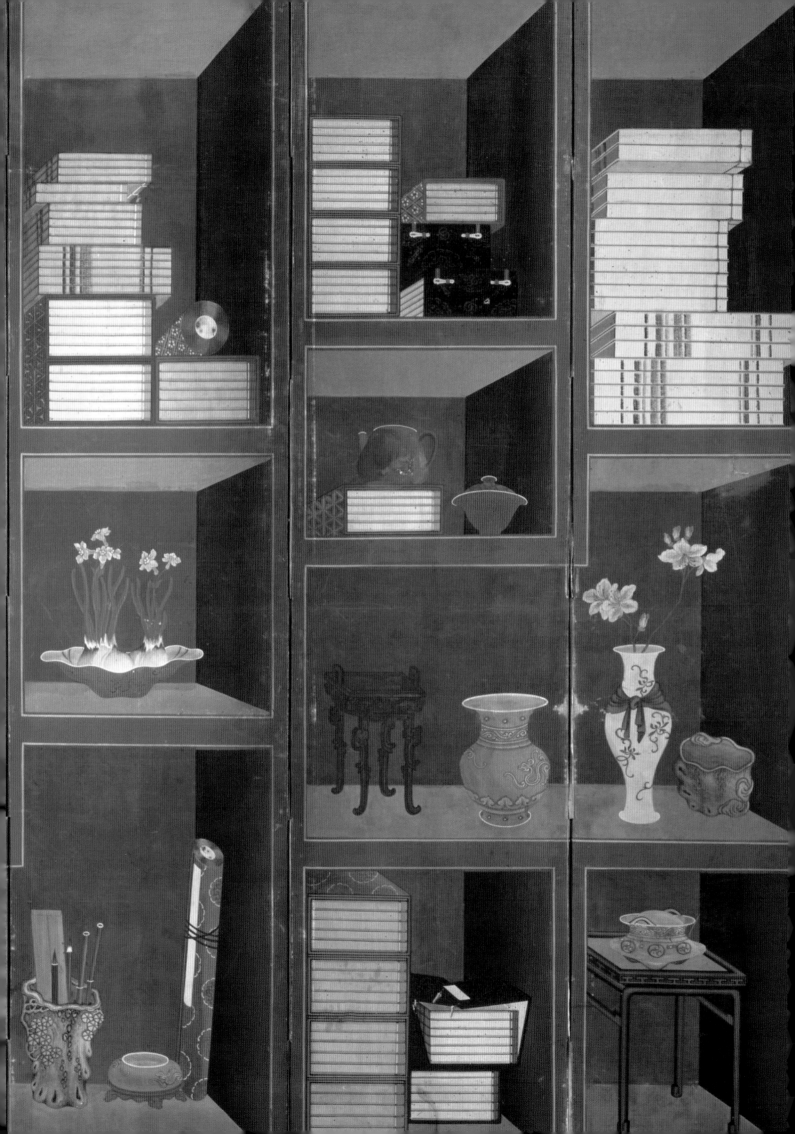

2

Ch'aekkŏri and the Korean Court

The fortuitous discovery of written records during the course of our *ch'aekkŏri* investigation clearly dispelled the notion that *ch'aekkŏri* were the products of anonymous folk artists. It has been well established that *ch'aekkŏri* painting enjoyed royal patronage under King Chŏngjo (r. 1776–1800).[1] Indeed, *ch'aekkŏri* painting was one of the eight essential subjects necessary for an artist to qualify for the Painting Bureau [*Tohwasŏ*] during King Chŏngjo's reign.[2] Yi Kyu-sang (1727–1799) states in the *Ilmonggo* (Essay on a Dream) that the European trompe l'oeil and *chiaroscuro* techniques in executing *ch'aekkŏri* were first adopted in the Painting Bureau during Chŏngjo's time.

At the time the painting technique of European countries was first adopted at the Painting Bureau, if one looked at a completed [*ch'aekkŏri*] painting with one eye closed, everything could be viewed in a coherent order. The people called this type of painting *ch'aekkŏri*. It was always painted with thick colors, and no one in the upper class failed to decorate his walls with one. Kim Hong-do was particularly good at this technique.[3]

Moreover, *ch'aekkŏri* painting proved to be highly regarded by the court, so much so that mastery of the genre was required for appointment to the position of court painter. Within the court during the Chosŏn period (1392–1910), *ch'aekkŏri* were executed by professional painters who were appointed to the Painting Bureau, apparently upon receiving the recommendation of a high government official, and perhaps also after passing one or more of the "miscellaneous examinations."[4]

The term *chungin* ("middle people") refers to the hereditary class of technical specialists—including court artists—in the capital. They enjoyed secondary status as an elite group below the aristocrats, but above the commoners.[5] According to Hwang Kyung Moon, the governing ideology that elevated Confucian ethics and philosophy over military or technical skills helped to relegate the *chungin* to this secondary status.[6] The main reason for their social stigma was their hereditary status, which precluded them from bureaucratic advancement beyond mid-level

appointment to county magistrate.[7] Furthermore, early sixteenth-century examination rosters list a scattering of names of illegitimate sons of the *yangban* who passed examinations normally taken by *chungin*.[8] This may have contributed to the social stigma attached to the *chungin* class that persisted throughout the Chosŏn period. *Chungin* lineages, because they were discriminated against (for whatever reasons), have not published their genealogies. Consequently, the paucity of genealogical materials has made the identification of palace and other government artists extremely difficult.

According to Kang Kwan-sik, in addition to the miscellaneous examinations for *chungin* required for professional painters, King Yŏngjo (r. 1724–1776), grandfather of the *ch'aekkŏri* patron King Chŏngjo, had already established an extremely competitive examination system (nokch'wijae) to select the five best members of the Painting Bureau to become "painters-in-waiting" (ch'abi taeryŏng: on duty as palace artists awaiting the King's command).[9] In 1783, King Chŏngjo increased the number of these painters-in-waiting from five to ten. More importantly, in the same year King Chŏngjo created the "extra bonus examination system" (*nokch'wijae*),[10] under which the ten painters who scored highest on the exam were given a promotion and special compensation.[11] The prizes were substantial. In addition to more salary, the painters were awarded some tangible goods: fish, fans, calendars, books, and firewood on traditional holidays.[12] With incentives such as these, the competition must have been fierce. Comprising twelve exams per year, this system continued until 1881.[13] These painters-in-waiting were attached to the Royal Library Kyujanggak, and worked at Ch'angdŏk Palace, and thus presumably enjoyed an advantageous proximity to the *yangban* at the court.[14] All the ordinary court painters who were members of the Painting Bureau worked outside the palace.[15] Painters-in-waiting had two duties: to paint whatever the king commanded and to write red lines in copy books for his records.[16] They were expected to be able to paint eight different subjects competently: figure, genre, landscape, architecture, birds and animals, grass and insects, prunus and bamboo, and scholar's objects. Significantly, *ch'aekkŏri* were included in the category of the "scholar's room painting" (*munbangdo*).

In 1788, Chŏngjo ordered his painters-in-waiting to paint middle-sized folding screens of a subject of their choosing. He apparently had expected that Yi Chonghyŏn (1748–1803), considered the founding father of this study's mainstream *ch'aekkŏri* tradition[17] and Sin Han-p'yŏng (1726–?) would paint *ch'aekkŏri* because they were both so good at it, and when they created pictures of different subjects he was so infuriated that he expelled them.[18] Evidently, Yi Chong-hyŏn was reinstated as a painter-in-waiting, because in 1796 his *munbangdo* style was evaluated. Although it was praised by high officials as being very elegant, the king did not agree, and subsequently Yi Chong-hyŏn failed to score in the *munbangdo* examination.[19] Even though there is no record of prizes for Yi Chong-hyŏn, his son, Yi Yun-min (1774–1841), scored first or second a total of eight times on the extra bonus examinations between 1808 to 1821.[20] More particularly, Yi Yun-min scored 100 percent in *munbangdo* in 1831, as did his brother Yi Su-min (1783–1839).[21] Yi Yun-min's son, Yi Hyŏng-nok, won first or second place twelve times in thirty years, and,

among the eight genres that made up the examination categories, he scored highest in the *munbangdo* genre at 66.7 percent.[22] Yi Hyŏng-nok was only twenty-six in 1833 when he received the first of his several first prizes.[23]

Astonishingly, eight members of Yi Hyŏng-nok's Chŏnju Yi *chungin* lineage served as painters-in-waiting at Ch'angdŏk Palace (Exhibit 13.1): Yi Chong-hyŏn (active 1783–1796); Yi Yun-min (active 1808–1832); Yi Hyŏng-nok (active 1833–1863); Yi Ch'ang-ok (active 1873–1879); Yi Chae-sŏn (active 1860–1869); Yi Kyŏng-nok (active 1873–1876); Yi T'aek-nok (active 1835–1843); and Yi Su-min (active 1811–1835).[24] Furthermore, Yi Hyŏng-nok and his son, Yi Chae-sŏn, were there for three years at the same time. Yi Chong-hyŏn's nephew, Yi Su-min and his son, Yi T'aek-nok, also were painting for brief periods during Yi Hyŏng-nok's time at Ch'angdŏk Palace. Clearly, there was a Yi Chong-hyŏn family presence of painters-in-waiting at Ch'angdŏk Palace from 1783 to 1876— almost 100 years.

Yi Hyŏng-nok reached the position of *chich'u*, an abbreviation for a high-ranking position in the Office of Ministers-Without-Portfolio (*chung-ch'uwŏn*). This position carried senior second rank and was apparently within the reach of many *chungin* painters, the class to which most court painters belonged.[25]

A concentration of professional painters can be found in other *chungin* genealogies, suggesting not only that painting was an inherited profession, but also that family workshops may have existed. Since most *chungin* painters are thought to have lived in Seoul, not a large city in the nineteenth century, no one was too isolated to have escaped an exchange of influences.

Around this time, King Chŏngjo had appointed illegitimate lineages to positions as editors-compilers in the Royal Library, an indication that the discrimination to which they had long been subjected was becoming less severe.[26] The privileged *chungin* who became painters-in-waiting demonstrated that they, too, were moving ahead socially to positions in Chosŏn society to which their skills, if not birth, entitled them.[27] These were subtle signs that times were changing in a class-conscious culture. Some *chungin* amassed substantial wealth, particularly the interpreters, medical officers, geomancers, and court painters who accompanied the tribute missions to China and the embassies to Japan. The emissaries were able to engage in trade for profit.[28] Their resulting affluent status would have enabled them to commission expensive *ch'aekkŏri* screens, perhaps reflecting their interests in science and technology. They possessed the skills necessary for a proper understanding and use of technical instruments such as the gnomons, clocks, and pocket watches pictured in the screens. *Ch'aekkŏri* no longer belonged exclusively to the royals and aristocracy. This might explain why the still life screens are not considered court style; they were created for wealthy *chungin* and commoners.

King Chŏngjo's influence on the *ch'aekkŏri* genre extended even to the subject matter of the screens. The record states that he personally chose the book titles depicted on *ch'aekkŏri* in order to change the literary tastes of those at court.[29] Since we have found no *ch'aekkŏri* thought to date from King Chŏngjo's time, it is impossible to know from extant visual evidence which particular books the king preferred. Presumably, they were predominantly Neo-Confucian and intended to improve character and elevate scholarship as an aid to good government.[30] None-

theless, King Chŏngjo's choice of literature might well have influenced the titles selected for depiction on later *ch'aekkŏri*, provided that their creators had seen eighteenth-century examples. In this study, only seven screens include depictions of books with legible titles written on their spines.[31] These appear in one two-paneled, trompe l'oeil type *ch'aekkŏri*, one atypical trompe l'oeil type, and five examples of the still life type. All are nineteenth-century paintings except for one twentieth-century screen. The titled books are predominantly Chinese and Neo-Confucian, although a few Daoist and Buddhist books are included, as well as some Korean titles.

Seven *ch'aekkŏri* screens include book titles written in Chinese on the spines of depicted books (see Appendix I). The list of books that make up the traditional Korean Confucian canon includes often, but not always, the Four Books (*Sasŏ*) and the Three Classics (*Samgyŏng*), not the Five Classics traditionally included in the Chinese canon.[32] Appropriately, a screen in a private collection, which will be discussed later in Chapter 25, excludes *The Book of Rites* and *The Spring and Autumn Annals*, texts from the Chinese canon that have been excluded from the Korean list, even though they were well known to Korean scholars.[33] Also missing is *The Book of Poetry*, one of the Three Classics that is included in the traditional Korean listing of the classics. The Four Books are all depicted on this *ch'aekkŏri*. The sixteen book titles depicted in the case, with three probable exceptions, were all Chinese in origin. The three probable exceptions were *Saryak, Un'go*, and *Haeun*. The titles are depicted vertically but traditionally, from right to left.

This inclusion of Neo-Confucian books is not at all surprising because during the Chosŏn period, the ethics of Neo-Confucianism dominated every aspect of Korean life. Neo-Confucianism was taken far more seriously in Korea than it was in China. However, Buddhism, Daoism, and shamanism co-existed. Buddhism was discouraged in the capital, although it persisted in the country-side, where the temples were frequented almost exclusively by women. Shamanism was condemned as a kind of superstition, although it, too, has persisted in Korean culture from early times to this day.

One consequence of the Korean adherence to Neo-Confucian philosophy was a strictly regulated social order. Neo-Confucian relationships were headed by the king, responsible for protecting his subjects, who in turn were expected to be completely loyal to him. Like Chinese emperors, Korean kings were thought to rule by the "Mandate of Heaven" for the welfare of the people, and if they failed in this, duty required them to resign. This relationship served as a model for all other social relationships. Parents should love their children, and children should show filial piety in return. Under the "Law of the Three Obediences" (*samjongjido*), a wife must obey her parents before marriage, obey her husband after marriage, and obey her eldest son in the event of her husband's death (or if she has no son, her late husband's nearest male relative). Younger brothers must defer to older brothers. A friend more than ten years older than oneself must be treated as if he were an older sibling. A friend more than twenty years older than oneself must be treated as if he were one's own parent.

In a society where morality meant more than legality, the "Five Moral Rules" (*oryun*) were formed as the fundamental ethical norms for Confucians to govern

human relations between father and son (respect), between king and subjects (righteousness), between husband and wife (distinction), between old and young (order), and between friends (fidelity). It governed both family and social morality.[34] Scholarship and self-cultivation were eagerly sought by the Chosŏn gentlemen of the Confucian state.

The iconography of *ch'aekkŏri* painting reflects the Neo-Confucian social order, particularly the reverence for scholarship, as shown by the vast number of books depicted on the screens. Many more books fill the Korean *ch'aekkŏri* panels than is the case in their Chinese counterparts. Bronzes, such as a wine vessel (*jue*), used in the Confucian rites for the ancestor worship ceremony are shown primarily among the subject matter of gnomon style *ch'aekkŏri*, which provides another visual manifestation of Confucian principles.[35]

NOTES

1 O Chu-sŏk, p. 82.

2 O Chu-sŏk, p. 82, n. 217 and its reference to Kang Kwan-sik, p. 66, n. 9.

3 O Chu-sŏk, p. 83. Regarding Yi Kyu-sang's comment that monocular vision allowed a painting to be seen in coherent fashion, Leonid Konsevich demonstrated how monocular vision flattened a picture, whereas binocular vision emphasized its three-dimensionality.

4 These were the "miscellaneous" examinations taken preponderantly by the *chungin* class, not the examinations that were reserved for the elitist *yangban* class. Passing the *chapkwa-chungin* examinations admitted the passer to a variety of professional positions, including medical officers, translators-interpreters, technicians in the astronomy and meteorology office, accountants, statute law clerks, and scribes, in addition to positions as court painters. Lee Ki-baek, *A New History of Korea*, translated by Edward W. Wagner with Edward J. Shultz (Cambridge, MA and London: Harvard-Yenching Institute, Harvard University Press, 1984), pp. 174–175.

5 Kyung Moon Hwang, *Beyond Birth: Social Status Emergence in Modern Korea* (Cambridge, MA: Harvard University Asia Center, Harvard University Press, 2004), p. 32.

6 Hwang, pp. 33–34.

7 Personal conversation with Ledyard, September 18, 2008. A graphic example of discrimination could be seen at the courtyard in front of the king's audience hall during formal rituals. Eighteen stones marked the area where the aristocratic elite were placed according to their rank, and *chungin* court painters stood at the very back.

8 Notes from Wagner contain an examination roster, which gives four names: father, grandfather, great-grandfather, and maternal grandfather.

9 Kang Kwan-sik, vol. 1, pp. 27–29.

10 Kang Kwan-sik, vol. 1, p. 27.

11 Kang Kwan-sik, vol. 1, pp. 27, 29.

12 Kang Kwan-sik, vol. 1, p. 52.

13 Kang Kwan-sik, vol. 1, p. 69.

14 Kang Kwan-sik, vol. 1, pp. 20, 39–40.

15 Kang Kwan-sik, vol. 1, p. 36.

16 Kang Kwan-sik, vol. 1, p. 39.

17 The term "mainstream artists" refers only to the Yi Chong-hyŏn line.

18 Kang Kwan-sik, vol. 1, p. 82.

19 Kang Kwan-sik, vol. 1, p. 93.

20 Kang Kwan-sik, vol. 1, pp. 83–84, Tables 3-3, 3-4; pp. 99–100.

21 Kang Kwan-sik, vol. 1, p. 98.

22 Kang Kwan-sik, vol. 1, pp. 83–85, 99. Hyŏng-nok also earned two military positions, Senior Six (first place) and Senior Seven (second place), under Five Military Commands (Headquarters).

23 Kang Kwan-sik, vol. 1, p. 75.

24 Kang Kwan-sik, vol. 1, pp. 60–63, 76.

25 The position perhaps most commonly enjoyed by *chungin* painters was in its abbreviated form, *tongji*, which was Junior Second Rank. See Black and Wagner, "Ch'aekkŏri Paintings: A Korean Jigsaw Puzzle."

26 For more information on *yangban* and *chungin* status during King Chŏngjo's reign, see Lee Ki-baek, pp. 250–251.

27 Lee Ki-baek, pp. 250–251.

28 Hwang, p. 117.

29 Kang Kwan-sik, vol. 1, pp. 591–593.

30 Peter H. Lee and William Theodore de Bary, ed., *Sources of Korean Tradition, vol. 1: From Early Times through the Sixteenth Century* (New York: Columbia University Press, 1997), p. 305.

31 See Gari Ledyard's list of "Books on Shelves and Tables: Introductory Notes" in Appendix II. See also Appendix I for book titles presented in each of eight *ch'aekkŏri* screens.

32 Richard Rutt, "The Chinese Learning and Pleasures of a Country Scholar," *Transactions of the Korea Branch of the Royal Asiatic Society* 36 (1960), pp. 28–29.

33 *ibid.*

34 Yi Hŭi-dŏk, "Formation of Confucian Ethics in Korea," *Korea Journal* 13, no. 2 (1973), pp. 10–11.

35 Kim Man-hŭi, *Minsok torok*, vol. 5 (Seoul: Sangmisa, 1976), p. 26; *Sancai tuhui* (Taipei: Chengwen chubanshe, 1970), vol. 3, p. 1076.

3

Overview of Isolated Type *Ch'aekkŏri*

Of the three broad types of *ch'aekkŏri* that Wagner and I have identified, it seems certain that the isolated type was the first to be developed. Isolated type *ch'aekkŏri* are seemingly rooted in China's Song dynasty. *The Imperial Catalogue* of Emperor Huizong (r. 1100–1126) (*Xuanhe bogutu*) grew out of the connoisseurship movement begun in the eleventh century by Ouyang Xiu (1007–1072). The *Imperial Catalogue* presented illustrations of the objects in the emperor's collection, and it was the first pictorial record of an imperial collection to appear. Specifically, Wagner and I conclude that isolated type *ch'aekkŏri* emerged from Ming (1368–1644) embroideries inspired by Huizong's collection, which was depicted in a series of thirty-two handscrolls. Their contents are found in the 1752 edition of the *Illustrated Catalogue of Antiquities in the Qianlong Period* (*Bogu tulu*). Included in the *Bogu tulu* are pictures and descriptions of ancient bronze ritual vessels of the Shang, Zhou, Han, Tang, and Song dynasties. Musical chimes and bells, lamps, bronze mirrors, horse trappings, axes, knife blades, crossbow mechanisms, and ancient coins were also shown. In addition, there were illustrations of various jade objects such as *bi* discs, garment hooks, amulets, seals, and scabbard slides and chapes. All objects are depicted in isolation, with no background and no means of support—that is, the objects float in space; they do not rest on a table or shelf.

In 1388, twenty years after the establishment of the Ming dynasty, Cao Zhao published the *Essential Criteria of Antiquities* (*Gegu yaolun*).[1] It was much more comprehensive than the previous catalogues had been, for it added illustrations of paintings, ink-slabs, zithers, ceramics, and lacquerware, as well as a few objects of foreign make. During the Ming, artists began to copy objects from the pages of the *Imperial Catalogue*, borrowing them to serve as the subject matter included in embroidered silk panel screens. The earliest Chinese example of the isolated type is one set of eight silk-on-silk embroidered panels from the Ming dynasty, made in Guangdong Province and now mounted as hanging scrolls, is preserved in the National Palace Museum in Taipei. Ten to twelve different kinds of antiquities are

depicted floating in space on each panel.[2] The prototypes for all of the bronzes shown in these panels can be seen illustrated in the pages of the *Bogu tulu* and the *Gegu yaolun*, a reflection of the imperial collecting habit and taste.

An imperial catalogue in the collection of the Percival David Foundation of Chinese Art in London, and now on loan to the British Museum, is most important to the historical background of the decorative theme *bogu*. A handscroll entitled *The Scroll of Antiquities* (*Guwantu*) is labeled number six from a series of unknown size. It was executed in color on paper by an anonymous court artist and is dated to the sixth year of Emperor Yongzheng of Qing (1728). Of particular interest is the throne shown in Figure 3.1. In this handscroll, 200 different objects— bronzes, jades, and porcelains— are depicted at their actual size, representing the emperor's collection of antiquities, many of which are shown complete with stands and covers made in the palace workshops. A pair of scepters (*ruyi*) illustrated on the handscroll can apparently be identified with extant ones still in the former imperial collection.

There is another similar scroll in the Victoria and Albert Museum.[3] It is labeled number eight and is dated to the year equivalent to 1729 AD. Again, the objects are depicted in such detail that extant physical examples match those in the handscroll.[4]

Antiquities from the *Bogu tulu* were not the only inspiration for these Ming dynasty embroiderers. In addition to these imperial catalogues, Chinese painters of the *bogu* theme also drew inspiration from catalogues of private Chinese collections. In Korea, however, unlike in China, I know of only one private art collector during the Chosŏn period, a salt merchant named An Chi (An Ki in Korean), who assembled a collection during the eighteenth century.[5] His collection has long since been dispersed, and none of it has remained in Korea. However, paintings of scholars surrounded by their treasures do exist and provide an idea of what some of the objects looked like. For example, Kim Hong-do's painting of "A Hermit" playing a *pip'a* with a *saeng* at his feet reveals a scholar seated among his treasures: a vase with coral, fungus of immortality, an incense burner, inkstone with ink stick, a vase decorated with cracked-ice pattern, paper rolls tied with a scarf, and a stack of four slipcases of books—all decorated and shaped as they appear in some *ch'aekkŏri*.[6]

The *bogu* theme's transmission from China to Korea most likely came with returning tribute emissaries sometime during the Ming. These tribute missions usually included an artist among the delegates, and it is reasonable to conclude that these artists might have seen Ming embroidered panels of the *bogu* theme while in China, transmitting the concept to Korea upon their return home, just as years later the young emissary Hong Tae-yong would record his exposure to trompe l'oeil painting in China (see Chapter 11). It seems a logical assumption that isolated type *ch'aekkŏri* in both the embroidery and painting media must have been produced in Korea prior to the trompe l'oeil type.

The objects depicted in examples of Korean isolated type screens themselves illustrate the connection between Chinese trompe l'oeil paintings of bookcases displaying scholars' treasures and Korean *ch'aekkŏri*. Although books were not included in the Chinese illustrated imperial catalogues, nor in the Ming embroidered panels, they are regularly included in both Chinese and Korean "scholar's room paintings."

Throne detail from the "Scroll of Antiquities,"
dated 1728, showing treasures from Emperor
Yongzheng's collection. Color on paper. Percival
David Foundation, on loan to the British
Museum. Photo courtesy of the British Museum.

Overview of Isolated Type *Ch'aekkŏri*　29

Exhibit 3.1 Table of Identified Artists of Isolated Type *Ch'aekkŏri*

Artist's Name	Pen Name	Courtesy Name	Date	Collection
	Sŏkch'ŏn			Formerly Ahn Paek Sun (Figure 5.7 in this book)
	Hyech'un or Ch'unhye			Formerly Minn Pyong-Yoo(Figure 5.3)
Han Ŭng-suk				Formerly Minn Pyong-Yoo(Figure 5.1)
	Sŏktang			1) Institute of Koryŏ Art Museum (Figure 10.4); 2) Minn Pyong Yoo (Figure 10.1)
	Sosŏk or Susŏk			Kim Eun-young (Figure 5.5)
Yi Hyŏng-nok (Yi Ŭng-nok)	Songsŏk	Yŏt'ong	*b* 1808-*d* c.1874; painted under the name Yi Hyŏng-nok (used 1833-1863)	Chosŏn Fine Arts Museum (Figure 5.11)
Yi T'aek-kyun	Songsŏk	Yŏt'ong	Painted under the name Yi T'eak-kyun (used 1873-1874)	T'ongdosa Museum (Figure 5.9)
Yi To-yŏng	Kwanjae (most frequently used); Pyŏkhŏja; Myŏnso. Inscription: "Kwanjae Yi To-yŏng"; Seal impression: "Seal of Yi To-yŏng"	Chungil	*b* 1884-*d* 1933	Formerly Minn Pyong-Yoo (Figure 7.1)

All of the other objects shown in screens from either country are derived from similar sources. Most items of scholarly paraphernalia painted in *ch'aekkŏri* by the Korean artists (with plenty of artistic license) are Chinese in origin. However, careful examination of the Chinese and Korean depictions of any given item readily reveals distinct stylistic differences between the artists of the two countries.

* A table of artists we have identified who painted Isolated type *ch'aekkŏri* screens is in Exhibit 3.1.

NOTES

1 See Chao Ts'ao, *Chinese Connoisseurship: The Ko Ku Yao Lun, the Essential Criteria of Antiquities*, edited and translated by Sir Percival David (New York and Washington DC: Praeger Publishers, 1971).

2 *Guoli gugong bowuyuan: kesi, cixiu* (Tapestry and embroidery in the collection of the National Palace Museum) (Tokyo: Gakken Co, Ltd., 1970), *Cixiu* volume, pls. 26, 27. Each one of the eight panels shows ten to twelve antique objects.

3 Communication with Jessica Harrison Hall, curator at the British Museum.

4 *ibid.*

5 Personal communication with Yi Wŏn-bok, October 1983. According to him, An Chi's collection is partially at the National Palace Museum in Taipei, and partially in private collections; none of it remains in Korea.

6 O Chu-sŏk, p. 148, fig. 187.

4

Isolated Type Embroidered *Ch'aekkŏri*

An isolated type embroidered *ch'aekkŏri* with documentation was acquired by Rear Admiral Robert W. Shufeldt in 1883 when he went to Korea as the negotiator of the Treaty of Amity and Commerce, opening Korea to the world. This ten-panel screen, still in its original blue silk palace mounting style, was deposited at the Smithsonian Institution, possibly as early as 1885 (Figure 4.1).[1] Assuming the *ch'aekkŏri* was new when acquired by Shufeldt, it would have an approximate date in the early 1880s. There is no reference in the Smithsonian sources as to how Admiral Shufeldt obtained this screen. It is known that King Kojong (r. 1863–1907) gave an embroidered screen to another American official during the 1880s, and it may be surmised that the king or queen honored Admiral Shufeldt in the same way.[2] The screen is important for three reasons: aesthetically, as a fine example of its type; historically, because of its famous collector; and comparatively, as a touchstone, for rarely does a Korean work of art have such a gilt-edged provenance.[3]

In order to create an embroidered screen, a court artist would have first drawn the *ch'aekkŏri* design in monochrome ink on the silk panels of the screen before turning it over to the court embroiderers, as was the practice at the royal palace.[4] The royal palace had its own embroidery office, with designated court embroiderers, all women from P'yŏngan Province.[5] The area was famous for the production of high-quality silk thread.[6]

Although embroidered screens originally were made for palace use, they were in popular use by rich scholars and *chungin* by the late nineteenth and early twentieth century.[7] The Shufeldt screen's artist who drew the design on the silk panels for the embroiderer to work was not concerned with perspective, only with depicting every piece of scholarly paraphernalia he could think of. The objects float on the surface, but they do not spill off the picture plane. The Shufeldt ten-panel *ch'aekkŏri* is reminiscent of the cluttered compositions that cascade down the picture plane in the isolated type *ch'aekkŏri* by Yi Hyŏng-nok/Yi T'aek-kyun (two names for the same painter) described earlier. It is even possible to suggest that Yi T'aek-kyun (the

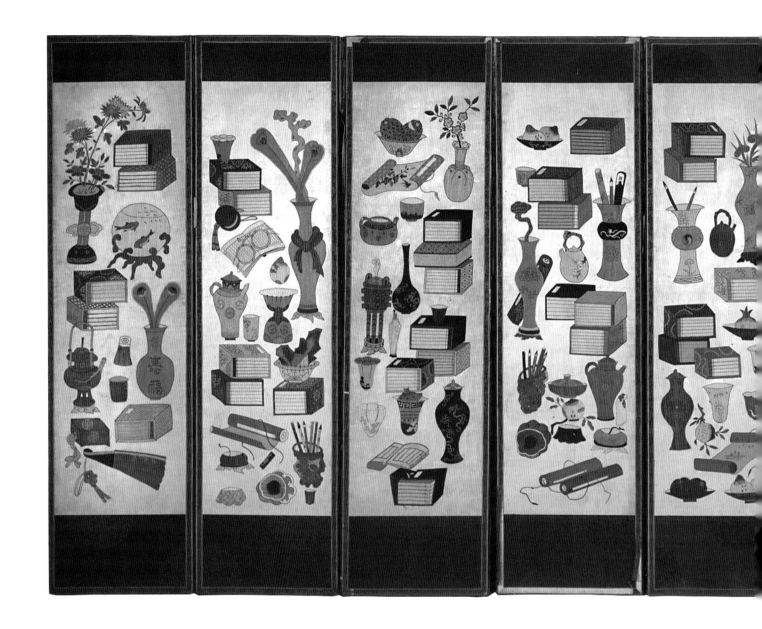

Figure 4.1
Ten-panel screen of the isolated type by anonymous palace embroiderers.
Late 19th century, known as the Shufeldt screen. Embroidered on silk.
152.5 × 510 cm. National Museum of Natural History, Smithsonian Institution
(acc. no. 211226). Photo courtesy of the Smithsonian Institution.

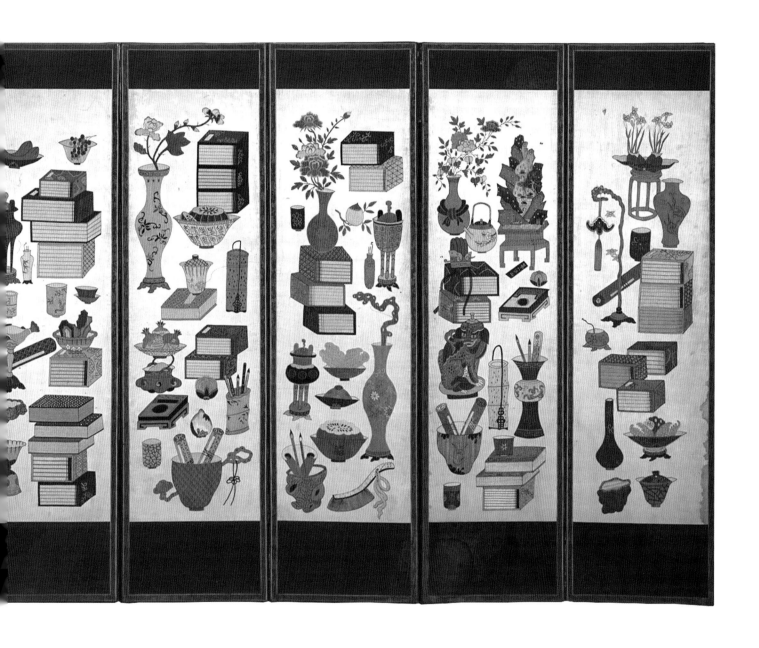

later name) himself might have drawn the designs on the silk for the embroiderer to work, for it is known that he was painting under that name in 1873 and 1874, and it could well have taken seven years for the embroiderers to finish the screen around 1883. Both the depiction of single objects at the bases of one or more compositions on each *ch'aekkŏri*, and the book stacks receding to the viewer's right are likely the result of Yi Hyŏng-nok's/Yi T'aek-kyun's influence. As a painter-in-waiting, he must have exerted tremendous influence on other court artists.

Admiral Shufeldt's daughter, Mary, provided this hand-written description of the embroidered isolated type *ch'aekkŏri* screen:

> The large screen is an unusually good example of Korean embroidery, which differs from any other [known or kind]. The whole background is first filled in, then the designs are superimposed, making when many colors are used a very much raised design. A very good specimen is the spectacle case & the spectacles, in which the glass is represented by [illegible] pale blue silk, through which the characters of a book are seen. This screen is known as the household screen. The objects being all those of household use.[8]

This statement directly contradicts the label written in Chinese characters on the back of the mounting, *su munbangdo*, which translates, "Embroidered Scholar's Room Painting." There are notable problems with Miss Shufeldt's written observations: no characters are visible on the pages of the book, which is located underneath the spectacles, only lined paper; and most of the objects were appropriate for a scholar's study, certainly not for general household use. On an ink stick in panel 2, there are four Chinese characters reading, "The Number One Scenery" (*cheil kangsan*). Otherwise, there are no Chinese characters visible on the screen. Elsewhere in her writing, Miss Shufeldt alludes to "mattresses and cushion given me by the Queen of Korea"[9]—an indication that she had been a visitor to the royal palace, where she may have seen some of the decorative objects depicted in the screen, and therefore her statement perhaps reflects a broad generalization and should be dismissed from further consideration.

Another ten-panel embroidered screen in the Stanford University Art Museum was donated to the university in 1896 by Timothy Hopkins (Figure 4.2).[10] Again, assuming it was fairly new when acquired by Hopkins, it would have an approximate date in the early 1890s. It seems more "streamlined" and is thought to be later by perhaps ten years than the Shufeldt screen that was acquired approximately thirteen years earlier. All the book stacks recede in the same direction, to the viewer's right. There are a third more books than objects, as opposed to the Shufeldt screen, which contains twice as many objects as books. The Stanford screen's artist played with perspective by depicting a given book stack from both two different perspectives (panel 6, top). Although frequently seen in *ch'aekkŏri* of the still life type, combined perspectives have not been encountered before in this study of isolated type *ch'aekkŏri*. There are three levels of depth recession created by the artist's use of overlap. Other stacks of books appear ready to topple, and are balanced haphazardly in panel 4. The whole is simplified by a reduced palette of pale colors, a more

realistic scale of objects, and the alignment of all the books in the same direction.

Of 136 objects found embroidered on the Shufeldt *ch'aekkŏri*, only two are typically Korean. The first is the mythical beast called a *haet'ae*, much revered by the Koreans as their fire protector (Figure 4.1, panel 2). This mythical beast figured as an emblem of officialdom in both Ming and Qing China and Chosŏn Korea as a symbol of justice because it knew the difference between right and wrong. The *haet'ae* is an example of specific Korean usage.[11] It came to Korea from the fantasy world of China where they were illustrated in the *Shanhaijing*.[12] These creatures combined physical attributes of more than one beast and were open to artistic license; thus, depictions of Korean *haet'ae* show great variety. In Korea, *haet'ae* appear in sculptural and pictorial representations as amulets against fire and are typical pieces of their folk art. Korean people's preoccupation with fetishes manifested itself in many ways. The hanging of *haet'ae* paintings was one, and the Smithsonian Institution has a fine nineteenth-century example of folk painting from the Ensign John B. Bernadou collection (Figure 4.3).[13] In 1881, following his graduation from the United States Naval Academy, Bernadou had gone to the Smithsonian to be trained in how to assemble a collection of ethnographic material.[14] In his 1885 report to the Smithsonian, Ensign Bernadou called the *haet'ae* "one of the four animals of watchfulness—hung outside a storeroom." Although folklore has often been considered a preoccupation only of the common people, the stone sculptural *haet'ae* guarding Kyŏngbok Palace suggests wider acceptance. Furthermore, there is a *haet'ae* embroidered on the Smithsonian *ch'aekkŏri* screen. Since these particular screens were made by Queen Myŏngsŏng's (1862–1895) ladies-in-waiting as gifts for foreign dignitaries, there is added support for the theory that a belief in *haet'ae* cut across class lines in Chosŏn society. Stone images of *haet'ae* are seen decorating palaces and private homes in Seoul even today.[15] A photograph taken before 1927 shows a boy standing on the head of a huge stone *haet'ae* in front of the gate of Kyŏngbok Palace, Kwanghwamun.[16]

The second Korean item on the Shufeldt *ch'aekkŏri* is a black silk courtier's hat with gold stripes denoting the owner's rank (Figure 4.2, panel 2), which would have been worn with his dress for palace ceremonies by civil and military officials. Called *kŭmgwan*, it was part of the adoption of the entire full formal court dress of Ming China. Korea's Koryŏ court accepted this in 1370, and it was formally adopted in the Chosŏn dynastic statutes in 1416. Only in Chosŏn Korea were Ming court costumes worn, because during the Qing dynasty the Chinese wore Manchu dress.[17]

The Schufeldt screen has moved less far from its prototypes, the Ming hanging scrolls, than any other of the isolated type. This suggests that the depiction of the *bogu* theme remained intact in the tapestry/embroidery medium in Korea, after its transmission from China. A common motif in both the Schufeldt and Stanford screens is the open slipcase of books. A water or wine pitcher in panel 9 of the Stanford screen is very similar to the one shown in the *Bogu tulu*.[18]

Although discussion of the Shufeldt and Stanford embroidered *ch'aekkŏri* is placed at the beginning of the section on the isolated type, they are very late examples. In Korea, the embroidery tradition is a very old one, and if the isolated type was the first of the *ch'aekkŏri* genre, then the type might have originated in

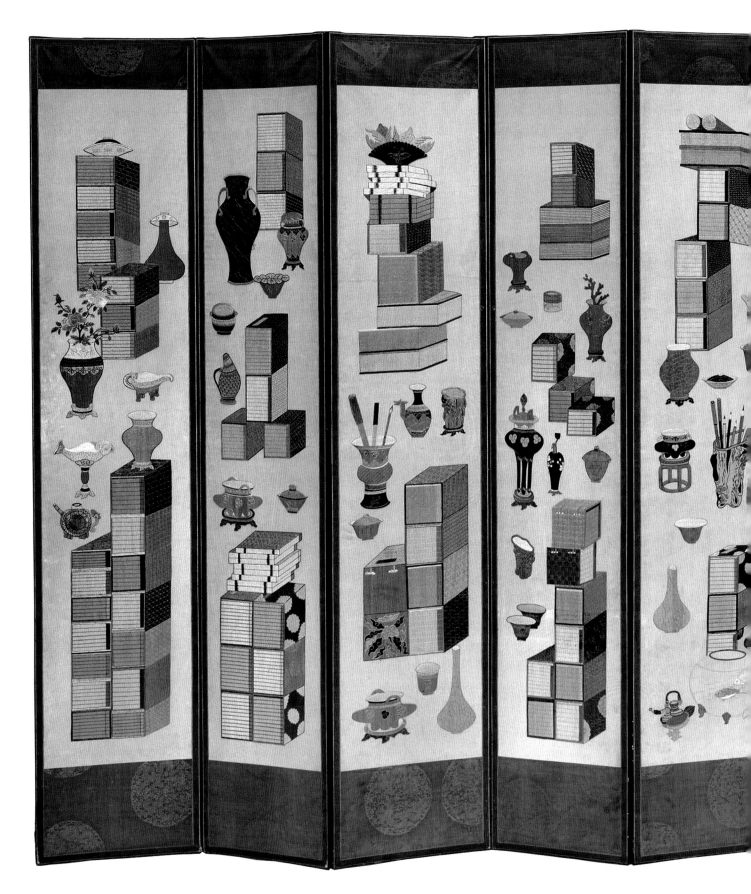

Figure 4.2
Ten-panel screen of the isolated type by anonymous palace embroiderers.
Embroidered on silk. 217.4 × 435 cm. The Iris and B. Gerald Cantor
Center for Visual Arts, Stanford University (acc. no. 9685, donated by
Timothy Hopkins in 1890). Photo courtesy of Stanford University.

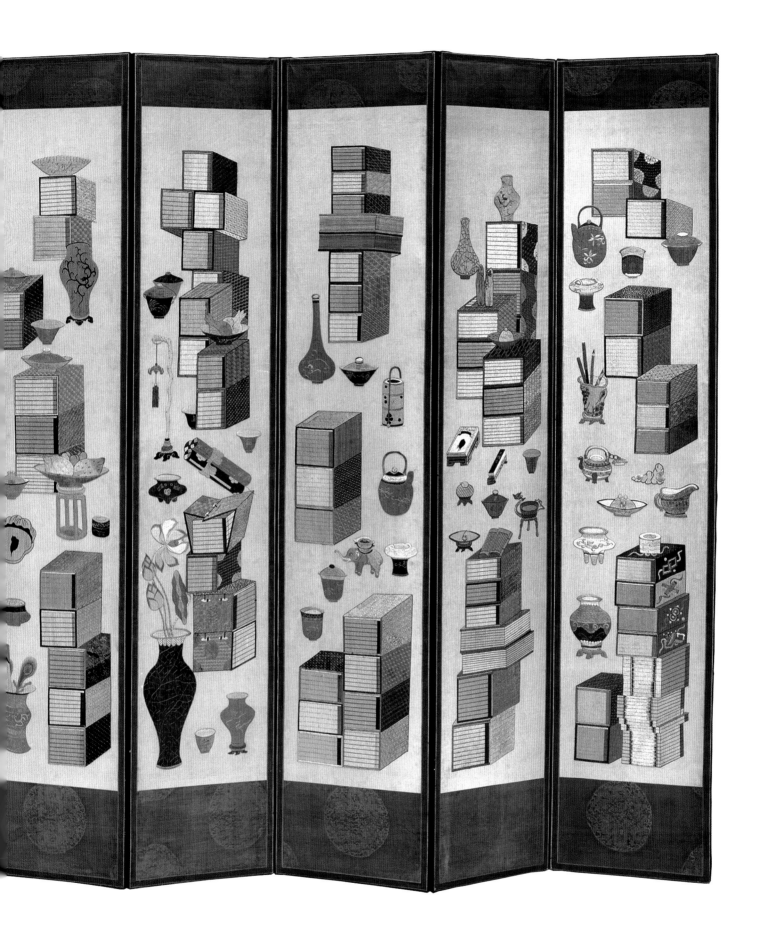

Figure 4.3
Folk painting of a *haet'ae*, "one of the four animals of watchfulness hung outside a storeroom." Late 19th century. Mineral colors on paper. Ensign John B. Bernadou collection, National Museum of Natural History, Smithsonian Institution (acc. no. 770752, no. 11). Photo courtesy of the Smithsonian Institution.

the embroidery medium and continued to be produced by the palace throughout the Chosŏn period. Although I have never seen an embroidered *ch'aekkŏri* older than from the last quarter of the nineteenth century, I believe that they existed and have simply disappeared over time. Perhaps someday one will come to light, or a descriptive document of an embroidered isolated type *ch'aekkŏri* will be found to vindicate my speculation.

NOTES

1 United States National Museum: Catalogue no. 211, 226; acc. no. 38,151; Registrar, 1834–1958 (Accretions to 1976): Accession Records. Office Memorandum from Robert A. Elder, Jr, Assistant Curator of Ethnology, "To Whom It May Concern, 21 Dec 1959."

2 United States National Museum: Registrar, 1834–1958 (Accretions to 1976): Accession Records. Hand written inventory of 118 Korean objects of H. N. Allen's collection on deposit Acc. 101058 from October 4, 1889: "1 Screen embroidered in the Palace. Presented by his Majesty." Of these, 116 objects were officially accessioned as a gift (acc. no. 22,405) on April 12, 1928.

3 The Smithsonian came close to losing this important embroidered *ch'aekkŏri*. In 1896 the admiral's daughter, Mary Abercrombie Shufeldt, expressed a desire to sell the objects that her father had on deposit at the Natural History Museum. According to her notebook, her intention was to use the proceeds to endow a hospital bed in her father's memory. It was to be called "'A Bed for Seafaring Men' in loving memory of my dear Father who was always the sailor's friend." It is not known to the

authors whether this memorial was established or not. In the same notebook entry, she mentions her fear that she would not have sufficient funds for the project. (In March of 1900, a court settlement of $115 was paid to her brother, George A. Shufeldt, who had sued her over their father's estate.) By 1901, straitened circumstances caused Miss Shufeldt to offer her father's collection to the Museum for sale. The negotiations between Miss Shufeldt and the Natural History Museum for the purchase of the Shufeldt collection began in March of 1901 when the Museum offered $300, which was refused. The parties finally agreed on a price of $400, and the matter was officially concluded in June of 1901. The price paid for the isolated *ch'aekkŏri* was $10. At today's auction prices, it would certainly bring many times that amount.

4 Huh Dong-hwa and Park Young-sook, *Crafts of the Inner Court* (Seoul: Museum of Korean Embroidery, 1988), p. 65.

5 Cultural Heritage Administration of Korea, ed., *The 1990 Exhibition of Works by Important Traditional Handicraft Holders* (Seoul: Cultural Heritage Administration of Korea, 1990), asset no. 80.

6 *ibid.*

7 Personal communication with Yi Wŏn-bok, November 4, 1998.

8 United States National Museum: Registrar, 1834–1958 (Accretions to 1976): Description V.

9 United States National Museum: Registrar, 1834–1958 (Accretions to 1976): Notebook of M. A. Shufeldt.

10 Many years ago Patrick J. J. Maveety showed me this *ch'aekkŏri*. Recently John Listopad, the Patrick J. J. Maveety Curator of Asian Art at the Stanford University Art Museum has helped me.

11 Shin Young-hoon et al., *Kyŏngbokkung Palace*, translated by Hahn Chul-mo, et al., *Korean Ancient Palaces* 1 (Seoul: Yŏlhwadang, 1986), pp. 19, 44. Two mythical beasts said "to engulf fire" and called *pulgasari* (starfish) are illustrated (p. 44). One resembles the *haet'ae*, the other an elephant. These stone sculptures decorated the railings of the Kyŏnghoeru, a pavilion on a pond at Kyŏngbok Palace, which was rebuilt in 1867 by King Kojong. The conflicting imagery is confusing, but there seems to be no doubt that Koreans considered the beast to be their fire protector. According to Suk Joo-Sun and her colleague Park Sung Sil, there was perhaps no distinction in Korean minds between the *xiezhai* (*haet'ae*) and *xiezi* (*saja*, lion). Furthermore, the Koreans had borrowed the significance of the marsh animal *baizi* (*paekt'aek*) and had attached to it all the representations of their *haet'ae* and saja. Chinese images of the *xiezhai* and *baizi* are very similar, causing confusion, which might have been why the Koreans applied the water connotation of the *paekt'aek* to the *haet'ae*—thus giving birth to the fire protector. Personal communication with Suk and Park, 23 May 1991. Allen D. Clark and Donald N. Clark, *Seoul Past and Present: A Guide to Yi T'aejo's Capital*, Royal Asiatic Society Korea Branch Guidebook Series, no. 1 (Seoul: Hollym Corporation, 1969), pp. 78–79. For more information about *haet'ae*, see: Kim Man-hŭi, *Minsok torok*, vol. 14 (Seoul: Sangmisa, 1979), p. 134; Onyang minsok pangmulgwan (Onyang Folk Museum), ed., *Tosŏl han'guk ŭi minsok* (Illustrated survey of Korean folklore) (Onyang: Onyang Folk Museum, 1980), p. 293.

12 For more on the sources of Chinese mythical animals see Richard E. Strassberg, trans., *A Chinese Bestiary: Strange Creatures from the Guideways through Mountains and Seas (Shanhaijing)* (Berkeley and Los Angeles: University of California Press, 2002).

13 Hough, p. 469, acc. no. 77052, collected by Ensign John B. Bernadou, US Navy in Seoul, Korea, 1885 (Smithsonian Institution National Archeological Archives, Rockhill, Allen, Shufeldt papers). See *Smithsonian Gift Catalogue of Spring 1979* (Washington, DC: Smithsonian Institution, 1979), p. 17, no. 5, which advertises a needlepoint kit of "our mythical unicorn-lion." This design is copied from the folk painting of the *haet'ae* in the Ensign Bernadou collection.

14 Personal communication with D. C. Allard, Department of the Navy, Naval Historical Center Washington Navy Yard, Washington, DC, June 26, 1981.

15 For instance, the collector Mrs. Minn Pyong-Yoo has always had a stone *haet'ae* facing south toward the mountain to safeguard her house from fire.

16 Cho P'ung-yŏn, *Sanjin ŭro ponŭn Chosŏn sidae: saenghwal kwa p'ungsŏk* (Daily life and custom in the Chosŏn period as seen in photographs) (Seoul: Sŏmundang, 1986), pp. 206–207.

17 Personal communication with Ledyard, April 19, 2005.

18 An example of a similar water or wine pitcher is found in the *Bogu tulu* (1752 edition), chapter 7, no. 12.

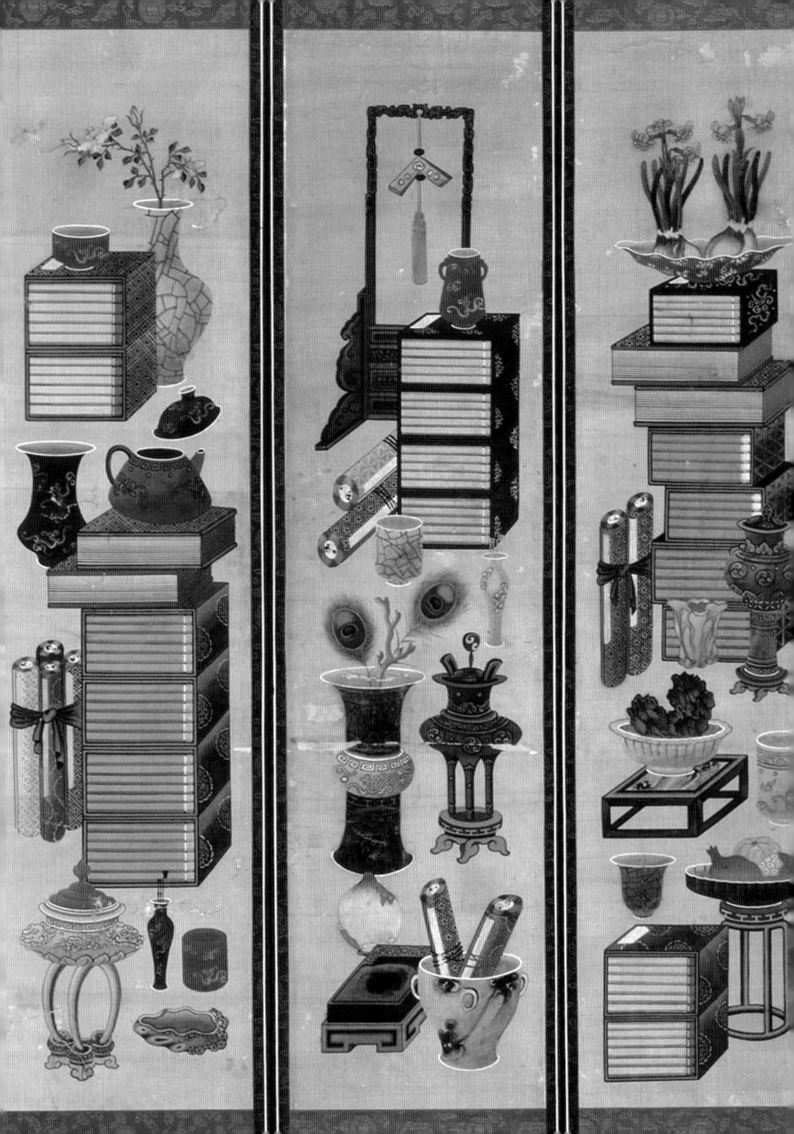

5

Identified Artists of Isolated Type *Ch'aekkŏri*

Determining the names of artists working in the isolated style has proven to be an elusive piece of the *ch'aekkŏri* jigsaw puzzle. The first *ch'aekkŏri* to which Wagner and I were able to assign specific painters by name were of the trompe l'oeil type (see Chapter 13). In those screens, we discovered that the painters often included a depiction of their seals as a way of signing the paintings. Of the twenty-four isolated type *ch'aekkŏri* screens that I have studied extensively, only ten can be assigned authorship based on seals that appear as part of the subject matter (Exhibit 3.1). Five of these seals include both surnames and given names: Yi Hyŏng-nok, Yi Ŭng-nok, Yi T'aek-kyun, Han Ŭng-suk, and Yi To-yŏng.

One of the painters, Han Ŭng-suk, in my opinion, painted one of the best isolated *ch'aekkŏri* paintings discussed in this study (Figures 5.1 and 5.2). Wagner believes him to be a member of the Ch'ŏngju Han family painters born between 1767 and 1834. There are thirty-four Han with Ŭng as one element in their given name listed on the genealogical list for the family, but there is not a single one named Han Ŭng-suk.[1] This suggests that Han Ŭng-suk, like Yi Hyŏng-nok, may have changed his name at least once during his career. Scholars speculate that during the late Chosŏn period, if a person suffered continued bad luck, he might have been inclined to change his name, hoping for better fortune, despite the fact that according to Yi Hun-sang it took a special decree from the king to do so. On the other hand, if a person experienced extremely good fortune, he might have changed his name to commemorate the event.[2] Perhaps future scholarship will establish Han Ŭng-suk's identity.

Other screens contain seals of pen names that we have so far been unable to assign to known artists. The pen names Hyech'un/Ch'unhye[3](Figures 5.3 and 5.4 from panel 1), Sosŏk/Susŏk (Figures 5.5 and 5.6 from panel 3), and Sŏkch'ŏn (Figures 5.7 and 5.8 from panel 10) are found cached as part of the subject matter on three other isolated type *ch'aekkŏri*, and the pen name Sŏktang appears on two different *ch'aekkŏri* screens, both considered to be by the same artist (see Chapter

 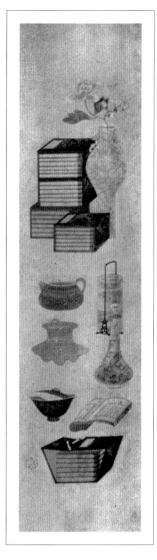

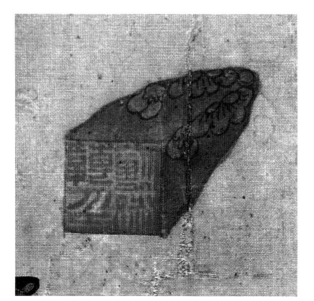

Figure 5.1
Eight-panel *ch'aekkŏri* screen of the isolated type by Han Ŭng-suk, an artist of the first half of the 19th century. Ink and mineral pigments on silk. 133 × 32.5 cm. Formerly Mrs. Minn Pyong-Yoo collection, Seoul. Photo by Norman Sibley.

Figure 5.2
Detail of Figure 5.1, panel 8. Seal of Han Ŭng-suk. Photo by Norman Sibley.

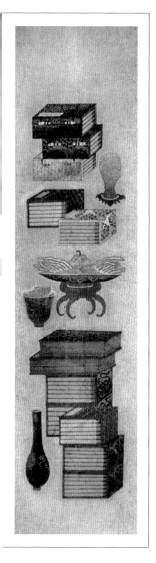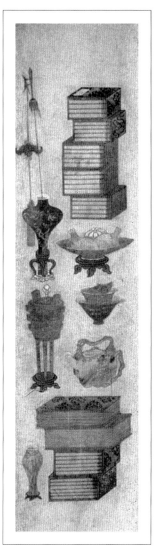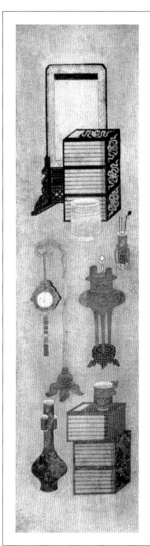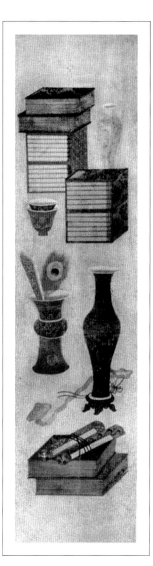

10).[4] Records that might suggest to whom these pen names belonged have not been found, and therefore, no dates or other background information is available.

Just as it is difficult to assign authorship to isolated type *ch'aekkŏri*, it is equally difficult to say when they were executed. Based on the examination of seven screens with some known information, however, I can posit a tentative chronology. Yi Hyŏng-nok created the first two under that name. A third isolated type *ch'aekkŏri* under the name Yi T'aek-kyun is in T'ongdosa (T'ongdo Monastery) Museum (Figure 5.9 and 5.10 from panel 9). It is known that Yi Hyŏng-nok was born in 1808 and was still painting in 1874. As mentioned before, in 1833, at the age of 26, he won his first special competitive painting examination award as a painter-in-waiting at the Painting Bureau.[5] Wagner and I also have conclusively determined that he was still painting under the name Yi Hyŏng-nok in 1863, but was using the name Yi Ŭng-nok in 1864 and 1866.[6] Thus, theoretically, the six-panel isolated screen in the Chosŏn Fine Arts Museum in P'yŏngyang must have been painted between 1833 and 1863,

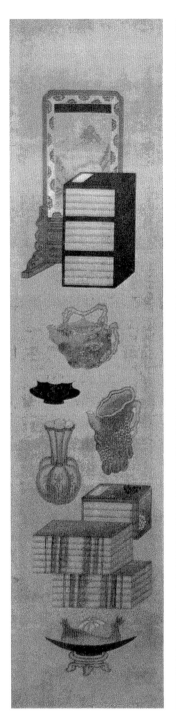
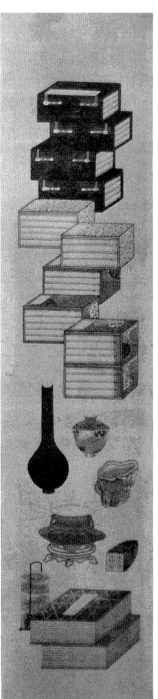

Figure 5.3
Two panels of a ten-panel screen
of the isolated type by Hyech'un or
Ch'unhye, the pen name of a painter
in the second half of the 19th century.
Ink and mineral pigments on silk.
138 × 32 cm. Formerly Minn
Pyong-Yoo collection, Seoul.
Photo by Norman Sibley.

Figure 5.4
Detail of Figure 5.3. Seal of Hyech'un
or Ch'unhye. Photo by Norman Sibley.

the years during which he was using the name Yi Hyŏng-nok (Figures 5.11 and 5.12 from panel 3).[7]

A cluttered composition cascades down each picture plane in Yi Hyŏng-nok's isolated type screen in P'yŏngyang. The viewer's eye moves down an imaginary waterfall comprising an equal number of objects and book stacks. These objects and books recede little on the picture plane, and overall, the effect is very lively. The picture plane cuts off the objects in each composition, thereby framing the panel like a window through which the viewer might reach out and touch the scholarly paraphernalia.

Yi Hyŏng-nok varied the styles of his seals. For example, in his P'yŏngyang screen he depicts an isolated seal, floating in space on the picture plane (Figures 5.11 and 5.12 from panel 3). As Yi T'aek-kyun, he showed his seal on top of a Chinese seal case (Figures 5.9 and 5.10 from panel 9). Chinese seal script characters are consistently used in these signatures.

The bright *ch'aekkŏri* in the T'ongdosa Museum (Figure 5.9) that Yi Hyŏng-nok painted as Yi T'aek-kyun, was likely created for King Kojong, made clear by his seal that reads "painted by little subject Yi T'aek-kyun" (Figure 5.10 from panel 9). This screen follows the same pattern as the P'yŏngyang screen he painted under the name Yi Hyŏng-nok (Figure 5.11). Most of the seventy books and ninety objects appear to be connected, as they are touching or overlapped. Even where they are not linked, very little space exists between the objects, forcing the eye to move back and forth, up and down the elongated compositions, a tendency that we can see beginning in Yi Hyŏng-nok's P'yŏngyang screen. In works produced under both names, Yi Hyŏng-nok has overlapped many objects to suggest visual depth on the picture plane, but it has not succeeded because he failed to anchor each composition with a book, thereby creating a top-heavy effect on the spectator.

The bottom registers in both Yi Hyŏng-nok's P'yŏngyang screen and Yi T'aek-kyun's T'ongdosa screen depict single objects and a few book stacks at the bases of their compositions; this results in a top-heavy overall appearance because most of the top, or background zones, have larger book stacks. All but one of the twenty-four artists of the isolated type in our study followed this same pattern. Sŏktang's screen in the Institute of Koryŏ Art Museum was the exception as he anchored each of his eight panels with book stacks in the lower shelves (Figure 10.4). The artists whose screens succeeded aesthetically were those who employed color and spatial relationships to advantage in each panel. Thus, they were able to achieve a balanced overall composition despite their having anchored some of their compositions with small items.

The only isolated *ch'aekkŏri* with a solid provenance is a ten-paneled screen painted in the literati monochrome tradition for Chŏn Kye-hun (1812–1890), who commissioned the screen (Figure 5.5). It has been in the same family for four generations—ever since it was painted around 1870. The only bright color on this isolated type *ch'aekkŏri* is the red of the two Chinese characters found on a seal depicted as subject matter (not impressed) on the screen in panel 3 (Figure 5.6). The seal characters can be read as Sosŏk, or, less likely, Susŏk, which presumably indicates an artist's pen name. Usually, *ch'aekkŏri* screens are painted in many different

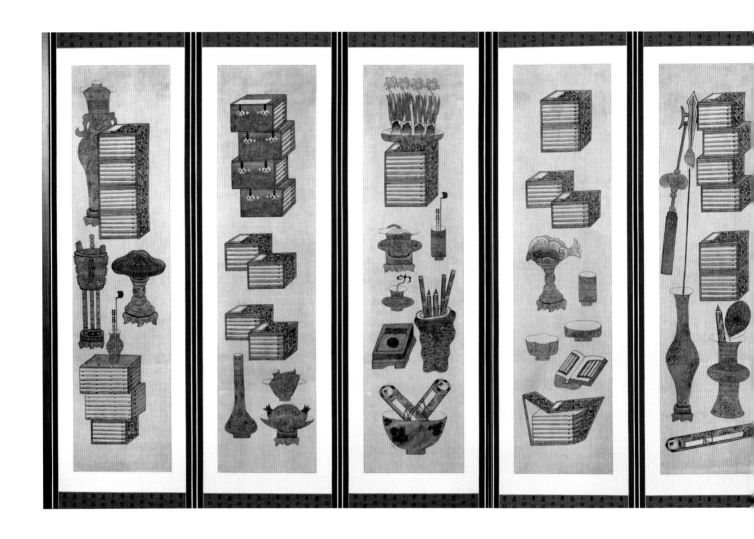

Figure 5.5
Ten-panel screen of the
isolated type by Sosŏk or
Susŏk. Monochrome ink
on silk. 108.5 × 27.4 cm.
Kim Eun-young collection,
Seoul. Photo by Lee Jung Ae.

colors, so finding one in monochrome ink is surprising and rare. Chŏn Kye-hun
was an official who enjoyed the company of artists and intellectuals, occasionally
inviting them to stay at his house. According to the Chŏn family, Sosŏk/Susŏk was
a houseguest when he was commissioned to paint this *ch'aekkŏri*.[8]

In the screen, the compositions of each panel appear neatly arranged into col-
umns, with the objects fairly evenly spaced. There is a well-ordered quality due to
the predominance of books with their rectilinear lines and a limited number of
other items placed onto the picture plane. Its effect on the viewer is one of under-
statement. One panel has a bowl of narcissus whose blossoms are depicted on a
horizontal line. Another panel reveals a tall vase protruding above and behind the
book stack. Both the flowers and the position of the vase are higher than the books
in the other eight panels causing the eye of the viewer to move up and down, all of
which follow the same height across the screen while adding a little variety to relieve
its static quality. Thus, Sosŏk/Susŏk has given his design unity and simplification.

Another *ch'aekkŏri* with some provenance is a twentieth-century screen by Yi
To-yŏng (1884–1933) (Figure 7.1) It is quite different from all of the nineteenth-cen-
tury examples. In this ten-panel folding screen, each object maintains its own
spatial integrity, although one or two are grouped together to form still life compo-

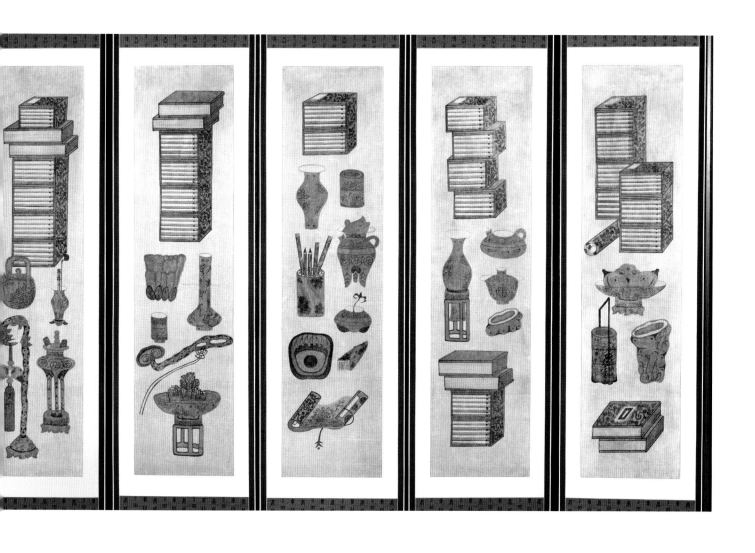

Figure 5.6
Detail of Figure 5.5. Seal of Sosŏk or Susŏk.
on panel 3. The seal's Chinese characters
depicted in red provide the only color
on the painting. Photo by Lee Jung Ae.

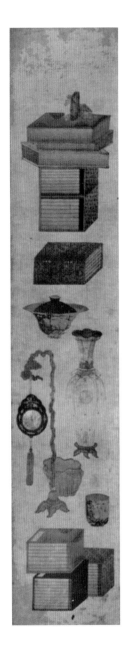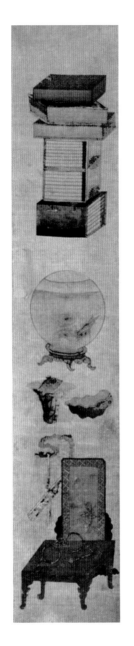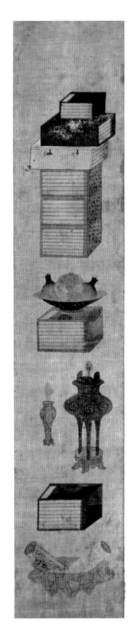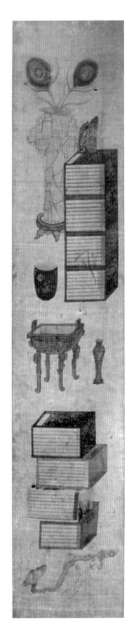

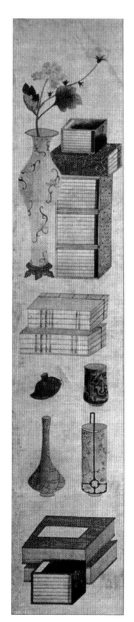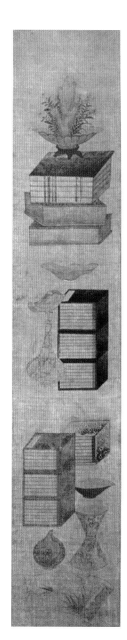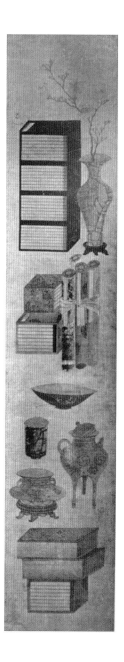

Figure 5.7
Ten-panel screen of the isolated type with the seal of Sŏkch'ŏn
(panel 10), pen name of an unidentified artist. Late 19th century.
Ink and mineral pigments on silk. 142 × 27 cm. Formerly
Ahn Paek Sun collection, Seoul. Photo by Norman Sibley.

Figure 5.8
Detail of Figure 5.7. Seal of Sŏkch'ŏn on
panel 10. Photo by Norman Sibley.

Identified Artists of Isolated Type *Ch'aekkŏri* 51

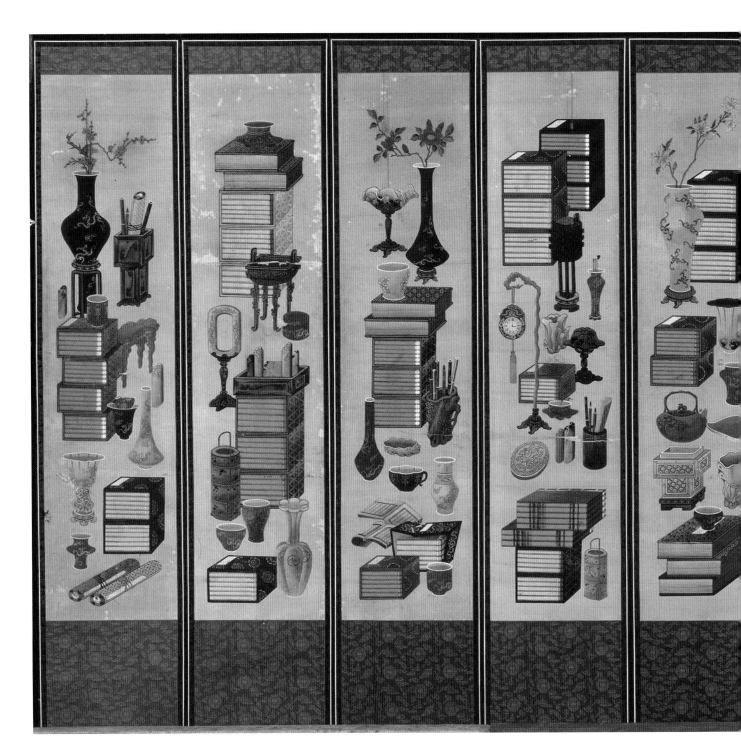

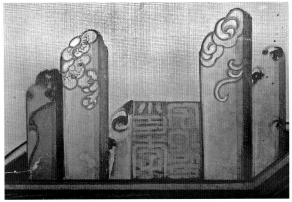

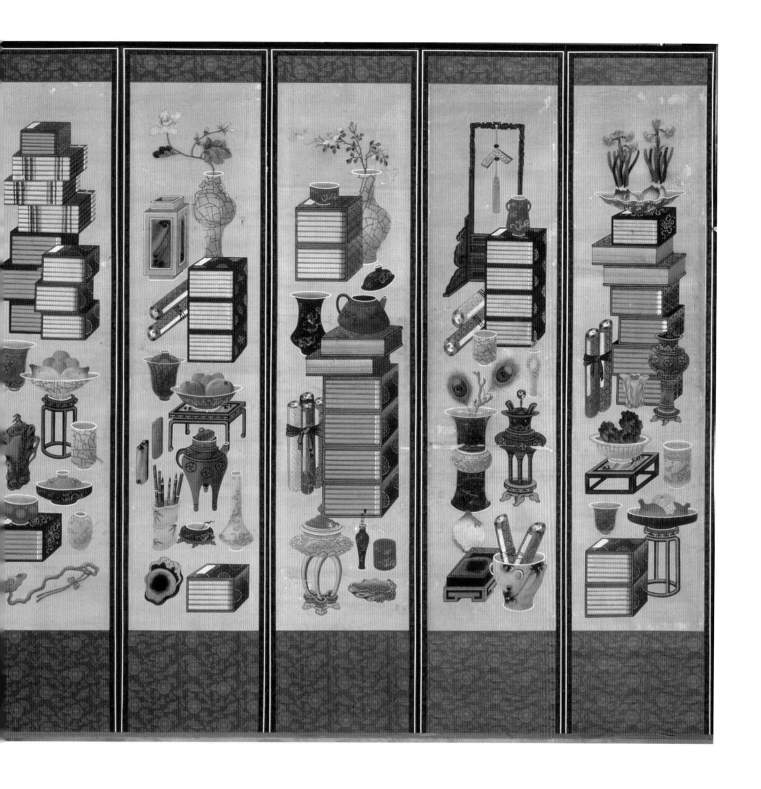

Figure 5.9
Ten-panel screen of the isolated type. Ink and mineral pigments on coarse silk gauze. 150.5 × 37 cm. T'ongdosa Museum, Yangsan. Photo by the author. The seal (panel 9) reads, "Painted by Little Subject Yi T'aek-kyun," which indicates that T'aek-kyun probably painted it for King Kojong (r. 1863-1907).

Figure 5.10
Detail of Figure 5.9. Seal on panel 9 reading "Painted by Little Subject Yi T'aek-kyun." Photo by the author.

Identified Artists of Isolated Type *Ch'aekkŏri* 53

sitions. Except in one instance, books anchor the foregrounds of the compositions, sparing them from appearing top heavy.

Indicating the potential pitfalls of this speculative chronology, the twentieth-century artist Yi To-yŏng works with alternate schemata. In his isolated type screen, books almost equal the objects in number, thirty-nine to forty. This represents a return during the Japanese colonial period (1910–1945) to the equal number depicted by Yi Hyŏng-nok in his P'yŏngyang screen eighty or ninety years earlier. In Yi To-yŏng's trompe l'oeil type *ch'aekkŏri*, however, he depicts twice as many books as objects. Thus, systematic chronological transitions from one schemata to another appear to exist within his oeuvre. However, except for Yi To-yŏng and the anonymous artist of the Shufeldt screen (Figure 4.1), books outnumbered the objects as the isolated tradition wore on.

Among Yi To-yŏng's rare items depicted is a fanciful version of a typically Korean Buddhist incense burner, probably from Koryŏ. Other examples are found in panel 1 of Yi Hyŏng-nok's P'yŏngyang screen (Figure 5.11), in panel 10 of Yi T'aek-kyun's *ch'aekkŏri* (Figure 5.9), in panel 5 of Sŏkch'on's work (Figure 5.7), in panel 9 of Hyech'un/Ch'unhye's screen (Figure 5.3), and in panel 9 the Shufeldt screen (Figure 4.1, panel 9), which is particularly Korean. Finally, still another Korean item is an incense burner shaped like a spiral cone, from which smoke issues forth as a defense against mosquitoes. This device is found only in Yi To-yŏng's isolated screen (Figure 7.1, panel 3) and in a *ch'aekkŏri* in the Onyang Folk Museum. Specific to Korean *ch'aekkŏri* depiction is a Chinese-style slipcase of books shown partially open. It appears in all but three screens of the isolated type in this study—almost as a signature.

The most obvious Korean detail used in the screens is the five-stitched bookbinding found among the subject matter on four court style *ch'aekkŏri* of the isolated type.[9] A *ch'aekkŏri* in the Ewha Womans University Museum has one (not shown).[10] Sŏkch'on's *ch'aekkŏri* (formerly in the Ahn Paek Sun [An Paek-sun] collection; Figure 5.7) has three instances of books with five-stitched bindings, although the red string bindings are visible at the rear of the book stacks and are hard to see (panels 3, 4, and 6). Similarly, Yi T'aek-kyun's screen (Figure 5.9) has books with white five-stitched binding at the rear of books in panels 5 and 7. Yi Hyŏng-nok (the name that Yi T'aek-kyun used earlier in his career) depicted five-stitched bookbinding only once—in the center of the trompe l'oeil type *ch'aekkŏri* in the Leeum (Figure 13.4, panel 5). (The Yi Hyŏng-nok *ch'aekkŏri* in a private collection is missing two panels; it, too, might have depicted a five-stitched bookbinding, but this cannot be determined.) Yi To-yŏng's painting has four examples (Figure 7.1, panels 5, 6, 7 and 8). There are no examples of five-stitched binding on two other trompe l'oeil screens of that type by Yi Ŭng-nok (Yi Hyŏng-nok's second name). Sosŏk/Susŏk's *ch'aekkŏri* (Figure 5.5, panel 10) shows visible Chinese four-stitched bookbinding in the isolated type, as do screens by two anonymous artists: the Ch'angdŏk Palace collection corner screens catalogue nos. 15 (Figure 8.1, panel 2) and 16 (Figure 8.2, panel 1).

A new object—a table screen—graces these isolated type *ch'aekkŏri*. Known in China since the late Tang (618–906), but more particularly the Song (960–1279)

dynasty, these table screens featured panels of decorative marble inserted in a wooden stand. They were used for contemplation by a scholar to inspire lofty thoughts.[11] Three kinds evolved: one was used as an ornament on a small table; the second, called a pillow screen, was placed on a couch or bed to protect the sleeper's head from drafts; and the third was an inkstone screen, placed on a scholar's desk to hide the servant grinding ink at the other end.[12] Small paintings could also be inserted in the frame of a table screen.[13] Four isolated type *ch'aekkŏri* included in this study have small screens in one of their panels, Han Ŭng-suk's (Figure 5.1, panel 2), Hyech'un/Ch'unhye's (Figure 5.3), Yi T'aek-kyun's (Figure 5.9, panel 2), and Sŏkch'ŏn's (Figure 5.7, panel 9). These objects are most likely absent from the shelves of trompe l'oeil type *ch'aekkŏri* because that type demanded that the objects included be rendered in realistic scale, and the bookshelves were insufficiently tall to accommodate the height of a table screen. There are several similarities in the screens of Han Ŭng-suk (Figure 5.1), and Hyech'un/Ch'unhye (Figure 5.3): the previously mentioned table screens, book stacks, and similar blue vases and seals pointing in the same direction, floating in the picture plane.

A goldfish bowl and spectacles, seemingly borrowed from the subject repertoire of still life type *ch'aekkŏri*, appear in some *ch'aekkŏri* of the isolated type, specifically in those by Sŏkch'ŏn and Sŏktang, and in the Shufeldt screen. Spectacles (a Western object) in the *ch'aekkŏri* context symbolized status during the Chosŏn period. The goldfish were a fertility symbol. More interesting is that in Korea, it is said that a goldfish never blinks and consequently sees things all the time.[14] In all probability, some of the different items of subject matter may turn out to have been introduced over time, but I think that certain of them, such as the table screen, were reserved for inclusion in isolated type screens all along.

Five artists broke away from the established pattern of depicting all the book stacks receding to the viewer's right by inserting a few single volumes and/or a few book stacks receding to the viewer's left. Examples are found in the anonymous artist's Shufeldt screen (Figure 4.1) and in panels 9 and 10 of Sŏkch'ŏn's (Figure 5.7).

In contrast, Han Ŭng-suk's isolated type *ch'aekkŏri* lacks this uneven display and only two of the eight panels are not anchored by books at the bottom of the panel (Figure 5.1, panels 6 and 7). It is surprising to discover that Han Ŭng-suk's *ch'aekkŏri*, which has the least number of overlapping objects (only half as many as seen in Yi Hyŏng-nok's or Yi T'aek-kyun's works) gives the impression of having the most depth recession. Theoretically, fewer overlaps on a *ch'aekkŏri* should create a shallower picture plane, but by filling the foreground with stacks of books, Han Ŭng-suk forces the viewer's eye to the groups of overlapped books in the background without the distraction of too many objects in between, thus creating the impression of recession. His objects are evenly spaced on each of the panels, and are more sharply defined. Based on Han Ŭng-suk's tighter organization and successful recession of his compositions, a tentative chronology is suggested that would position his *ch'aekkŏri* in the last quarter of the nineteenth century. Until at least one or two biographical dates are found for Han Ŭng-suk, Hyech'un/Ch'unhye, or Sŏkch'ŏn, any chronology remains speculative.

Han Ŭng-suk used the same palette of rosy red, malachite, yellow, and soft blue

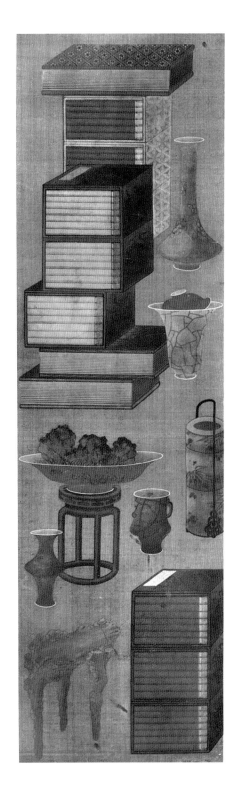 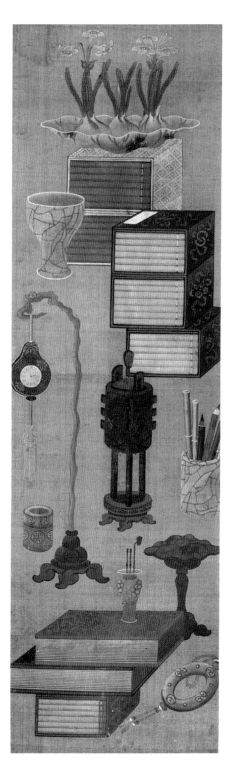 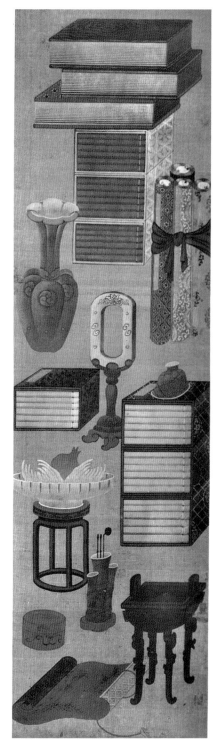

Figure 5.11
Six-panel isolated *ch'aekkŏri* by Yi Hyŏng-nok. Ink and mineral
pigments on silk. 121 × 36 cm each panel. Chosŏn Fine Arts Museum,
P'yŏngyang. Photo from the *Chōsen bijutsu hakubutsukan* (1980), p. 96.

Figure 5.12
Detail of Figure 5.11, panel 3. Seal of Yi Hyŏng-nok. Photo
from the *Chōsen bijutsu hakubutsukan* (1980), p. 96.

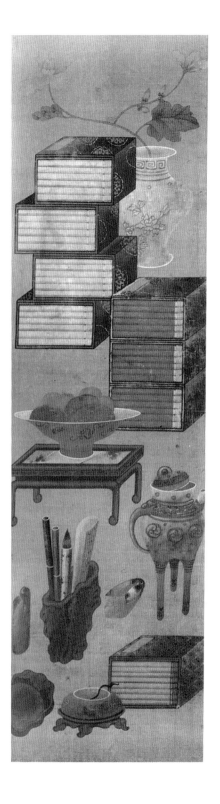
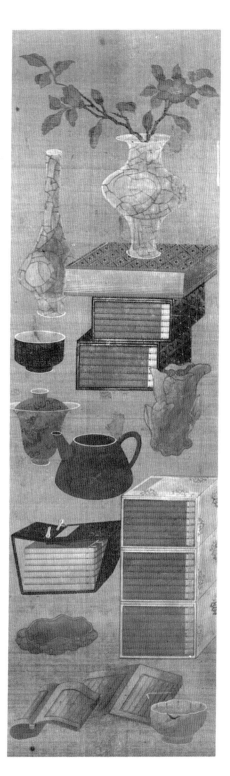
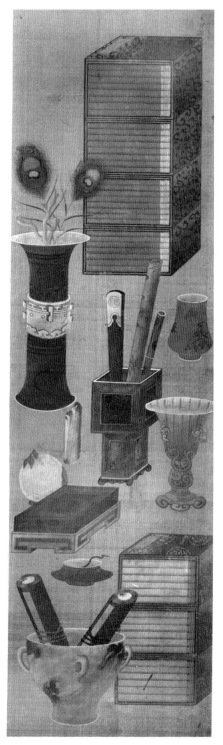

as Sŏkch'ŏn and Hyech'un/Ch'unhye. Perhaps all three artists were from the same family workshop, whereas Yi Hyŏng-nok/Yi T'aek-kyun favored much brighter colors. Patterns provide a further possible aid in developing a stylistic chronology. Book cover patterns and some vessels, similar to those found in Yi Hyŏng-nok's paintings and those of Kang Tal-su's trompe l'oeil screens, appear in Han Ŭng-suk's, Hyech'un/Ch'unhye, and Sŏkch'ŏn's isolated type examples. Because Sŏkch'ŏn's use of perspective is a little more adventurous, this painting could be later than the other two artists' works, perhaps around 1890 to 1910. The book stacks and other objects interspersed in the theme are nicely balanced and organized into columns throughout the panels of all three screens. Han Ŭng-suk's, Hyech'un/Ch'unhye's, and Sŏkch'ŏn's works are more tightly organized than other isolated type examples.

Curiously, an ink stick with Chinese characters that translate as "500 Catties of Oil" (obaekkŭn yu) appears in both Yi To-yŏng's (Figure 7.1, panel 1) and Sŏkch'ŏn's ch'aekkŏri (Figure 5.7, panel 4). (The ink stick's name is a reference to the quality of the ink stick.[15]) One other fact suggests the possibility that Sŏkch'ŏn's ch'aekkŏri might be approximately the same vintage as Yi To-yŏng's. Yi To-yŏng's has two instances of five-stitched bookbinding and Sŏkch'ŏn's screen has four, the most for the isolated type in this study, and one that represents a late development. For example, a trompe l'oeil ch'aekkŏri at Ch'angdŏk Palace (Figure 16.4) is decorated with a repetitious overall pattern composed of books, many with five-stitched bindings. Curiously, its artist shows half of the books stacked in the Korean fashion with five-stitched bindings, and the other half in Chinese-fashion slipcases. Since this Ch'angdŏk ch'aekkŏri is very late stylistically, it does seem that a plethora of five-stitched bindings on books might indicate a final stage for the type. It would be simply unreasonable to think that artists of the isolated and trompe l'oeil types worked in ignorance of a Koreanization trend in those styles. These chungin artists lived in the middle part of Seoul and were probably acquainted and aware of the current trends.

Slipcases of books anchor no more than half of Yi Hyŏng-nok's isolated panels on any one of his three screens (including one sealed Yi T'aek-kyun), which effectively limit the panels' spatial recession. For instance, when the composition is based on a few small items floating against the picture plane, the visual impression is one of instability. Seemingly, the whole composition might tumble toward the spectator. This characteristic of Yi Hyŏng-nok's was shared by other ch'aekkŏri painters of the isolated type with few exceptions. The exceptions are: Han Ŭng-suk's screen, which has six of eight panels anchored by books contributing to the ch'aekkŏri's overall success; the anonymous artists, almost assuredly court painters, of Ch'angdŏk's corner screens (Figures 8.1 and 8.2) have both panels anchored with slipcases; and Stanford's embroidered screen (Figure 4.2) has seven of ten panels supported by books. Other exceptions are by the twentieth-century artists Yi To-yŏng and Sŏktang. The former used alternate schemata in his two screens.

Two screens are similar in their compositions and palettes: Hyech'un/Ch'un-hye's ten-panel ch'aekkŏri (only two panels are shown in Figure 5.3) and Sŏkch'ŏn's ten-panel screen (Figure 5.7). Both resemble the monochromatic Sosŏk/Susŏk screen, which was executed around 1870 (Figure 5.5). Because of this likeness, it

would seem safe to suggest that all three were painted about the same time, and possibly by the same hand, and in the same workshop during the last quarter of the nineteenth century.

Until pen names are linked with surnames cum given names (or other background information emerges), the dates I have posited are completely speculative. Also, some artists were more skilled and talented than others, but Han Ŭng-suk, it should be kept in mind, is one of the best painters of the isolated type.

Without discovering when the artists lived, or some good provenance for these "isolated" *ch'aekkŏri* screens, I am unable to establish a solid chronology. I had hoped by studying the overlaps and proportions of books and objects that a pattern would emerge, but such is not the case. For example, Yi Hyŏng-nok painted an even number of books and objects in his P'yŏngyang work, but as Yi T'aek-kyun, he painted ninety objects and seventy books. These two screens could have been painted forty-three years apart, or as little as eleven years. As a "painter-in-waiting" Yi Hyŏng-nok must have exerted tremendous influence on other court painters.

NOTES

1 Wagner made an exhaustive search in both the *Sŏngwŏnnok* and the *chapkwa* passers in all the likely places but could not find Han Ŭng-suk.

2 Edward W. Wagner, *Chosŏn wangjo sahoe ŭi sŏngch'wi wa kwisok* (Achievement and ascription in the Chosŏn dynasty), translated by Yi Hun-sang and Son Suk-kyŏng (Seoul: Ilchogak Publishers, 2007). See especially Yi Hunsang's supplement no. 2: "Ch'aekkori kŭrim chakka ŭi munje wa chejak sigi e taehan chae koch'al" (Reexamining the problem of the renaming of the *ch'aekkŏri* artists and the dating of some works), pp. 477–492.

3 The name carved on a seal that appears in the screen of Figure 5.3 can be read as either Hyech'un or Ch'unhye. The imprint of the seal would read "Hyech'un" from right to left. However, because the reverse reading is also found in *ch'aekkŏri* screens as in the case of "Sosŏk," the possibility of the reading "Ch'unhye" cannot be ruled out.

4 The Sŏktang *ch'aekkŏri* are in the collections of the Koryŏ Museum of Art in Kyoto and Mrs. Minn Pyong-Yoo's daughter in Seoul.

5 Kang Kwan-sik, vol. 1, pp. 33–85, 99.

6 Pak Chŏng-hye (Park Jung-hye), "Ŭigwe rŭl t'onghaesŏ pon Chosŏn sidae ŭi hwawŏn" (Court painters of the Chosŏn dynasty examined through ceremonial records), *Misulsa yŏn'gu* 9 (1995), pp. 253–254.

7 *Chōsen bijutsu hakubutsukan* (Chosŏn Fine Arts Museum) (Tokyo: Chōsen kabosha, 1980), pl. 96.

8 The Chŏn (Chun) family has continued to be patrons of the arts, and they were, and are, artists themselves. It is thanks to Chŏn Hyŏng-p'il (1906–1962) that an important part of Korea's cultural heritage did not go to Japan during the colonial period. The art collection he assembled comprises the best Korean art in private hands in the country, and it is on view twice a year at the Kansong Museum in Seoul, located on the grounds of the Chŏn family estate. The current owner of Sosŏk/Susŏk's *ch'aekkŏri* in monochrome ink is Kim Ŭn-yŏng (Eun-young), holder of Seoul Important Cultural Property 13, *maedŭpchang* (ornamental knots). Based on e-mail communication with Keith Howard (SOAS), August 9, 2004. Kim Ŭn-yŏng received the screen from her mother-in-law Kim Chŏm-sun (1905–1987), who was Chŏn Hyŏng-p'il's wife. Kim Ŭn-yŏng is the wife of Chŏn Sŏng-u (Chun Sung Woo), the well-known contemporary painter. The line of descent of Sosŏk/Susŏk's *ch'aekkŏri* is as follows: Chŏn Kye-hun (1812–1890), Chŏn Ch'ang-yŏl] (1838–1917), Chŏn Yŏng-gi (1865–1929), and Chŏn Hyŏng-p'il (1906–1962).

9 On book bindings: in 1986, at T'ongmun'gwan, one of the primary old book stores in Seoul, the proprietor Yi Kyŏm-no told me that the Chinese used four-stringed bindings and covers for their books. Frequently, two volumes would share a cover, symbolizing the yin and yang; sometimes there were from two to ten books in one case. In Japan, four-stringed binding was favored, although occasionally six-stringed bindings did appear. Koreans used five-stringed bindings, and their books never had

hard covers during the Chosŏn period; therefore, when one sees slipcases, they are assumed to be Chinese. Another difference is that Korean books are bigger than either Chinese or Japanese ones.

10 For an illustration of the Ewha Womans University Museum *ch'aekkŏri*, see Evelyn B. McCune, *The Inner Art: Korean Screens* (Berkeley: Asia Humanities Press; Seoul: Po Chin Chai, 1983), pp. 26–27, fig. 25.

11 Shixiang Wang and Curtis Evarts, *Masterpieces from the Museum of Classical Chinese Furniture* (Chicago and San Francisco: Chinese Art Foundation, 1995), p. 158. According to Wang, Song dynasty literati like Ouyang Xiu, the founder of connoisseurship, Mi Fu, and Su Shi praised the veining of the marble and claimed that its abstract imagery rivaled the finest painting.

12 Sarah Handler, *Austere Luminosity of Chinese Classical Furniture* (Berkeley and Los Angeles: University of California Press, 2001), p. 280.

13 Artists could have been influenced by the depiction of a table screen with a landscape from the *Sancai tuhui*, vol. 3, p. 1343.

14 Personal conversation with Park Sung Sil, November 2002.

15 Yi Kyŏm-no, *Munbang sau* (Four friends of the scholar's room) (Seoul: Daewonsa, 1989), pp. 78–79; Kungnip chungang pangmulgwan (National Museum of Korea), ed., *Chosŏn sidae munbang chegu* (Diverse objects of the study in the Chosŏn period) (Seoul: National Museum of Korea, 1992), p. 38, pl. 82 lists 500 catties of oil (*obaekkŭn yu*) as being nineteenth century ink sticks.

6

Isolated Type *Ch'aekkŏri*
by Yi Hyŏng-nok/Yi T'aek-kyun

Wagner's and my attempts to put together the *ch'aekkŏri* puzzle began with an investigation into the authorship of screens of the trompe l'oeil type, and the first piece fell into place when we were able to attribute a *ch'aekkŏri* screen to the artist Yi Hyŏng-nok (see Chapter 13). Subsequent research revealed that this artist used two other names at different times during his career. Though early on Wagner and I were able to identify works by this artist working under the names Yi Hyŏng-nok and Yi Ŭng-nok, it would take fourteen years of research to finally uncover a *ch'aekkŏri* screen sealed with his third alternate name, Yi T'aek-kyun. In fact, although this name existed in the written records, no painting of any subject with Yi T'aek-kyun's seal had emerged, which was mystifying. Miraculously, in 1999 I was informed by Ahn Hwi-joon that a *ch'aekkŏri* screen with Yi T'aek-kyun's seal had been found at the T'ongdosa Museum (Figure 5.9). In August 1999, I visited the museum and confirmed that its ten-panel *ch'aekkŏri* screen in the isolated court style indeed bears Yi T'aek-kyun's seal (Figure 5.10). This is important because I now have two artists who painted in both the trompe l'oeil and isolated types: Yi To-yŏng (a *yangban*) and Yi Hyŏng-nok (a *chungin*). While I have located examples of both isolated and trompe l'oeil type *ch'aekkŏri* painted under the name Yi Hyŏng-nok, he apparently did not execute both types under his alternate names. At present, no examples of trompe l'oeil *ch'aekkŏri* under the name Yi T'aek-kyun, nor any of the isolated type under Yi Ŭng-nok's name, are known to exist. These gaps need to be filled in before there can be a more comprehensive study of Yi Hyŏng-nok's development.

On the ten-panel isolated type *ch'aekkŏri* screen at the T'ongdosa Museum the six-character painted seal, depicted as part of the subject matter, reads, "Painted by little subject Yi T'aek-kyun" (*sosin Yi T'aek-kyun in*), which proves for the first time that a *ch'aekkŏri* was executed for a king—King Kojong (r. 1863–1907) (Figure 5.10).[1] As for the screen's provenance, it is recorded that the monk Hyegak (1905–1998) donated the work to the temple, but how he came by it is unknown.[2] The list

of court painters verifies that Yi T'aek-kyun was alive and painting in 1873 and 1874.[3] Dimensions of the huge screen (each panel's painting measures 150.5 × 37 cm) suggest that it was created for a palace. Dating for the screen could be bracketed between 1864, 1865, or 1866, the last time the name Yi Ŭng-nok is listed, and 1873 or 1874, when Yi T'aek-kyun was recorded as a court painter.[4]

However, most importantly, Yi T'aek-kyun is the name that appears in the "Record of Applying for Positions" in 1864, the same year as the name Yi Ŭng-nok is given in a list of painters included in a royal record generally categorized as the "Record of Court Ceremonies"(ŭigwe).[5] Therefore, it is entirely possible that Yi Ŭng-nok and Yi T'aek-kyun were switching names back and forth at this time.

Yi T'aek-kyun might have painted the T'ongdosa Museum ch'aekkŏri for King Kojong in 1864, right after the latter acceded to the throne in the 12th lunar month of 1863 at the age of eleven and the artist was fifty-six years old. Although this is speculative, two factors suggest it. First, the year 1864 was a doubly auspicious one because it heralded both the beginning of a new sixty-year cycle in the lunar calendar (a kapcha year) and the virtual start of a new reign. Second, a ch'aekkŏri screen in the Royal Ontario Museum might also have been painted for King Kojong around his coronation year (see Chapter 24).[6]

The condition of Yi T'aek-kyun's screen has suffered a little through the years, for the silk has worn off in spots, especially around the edges. Its mounting of royal blue and claret red brocades (the same color scheme as several other late Chosŏn palace screens of differing subject matter, including ch'aekkŏri) is probably not the original one as there is no sign of wear. Eleven screens in palace collections, and one at the National Museum of Korea (formerly at the Tŏksu Palace Museum) are mounted in the same colors, which suggests that the palace had an official color scheme and mounting style during the waning years of the Chosŏn period.[7]

Yi Hyŏng-nok had painted an earlier six-panel isolated type ch'aekkŏri screen, now in the Chosŏn Fine Arts Museum in P'yŏngyang (Figure 5.11), which bears the seal of Yi Hyŏng-nok depicted as part of the subject matter (Figure 5.12).[8] In looking at Yi T'aek-kyun's/Yi Hyŏng-nok's isolated compositions, one notes that the scholar's objects in Yi T'aek-kyun's screen are linked together in well-ordered columns by overlap and recession. In contrast, in Yi Hyŏng-nok's less sophisticated screen, thought to be the earlier of the two ch'aekkŏri, each panel's composition appears more cluttered and disjointed because of fewer overlaps and less recession. Not more than half of Yi Hyŏng-nok's compositions were anchored by slipcases of books. This characteristic influenced subsequent followers of the isolated style.

As to the subject matter, some objects not seen in trompe l'oeil type screens are included in Yi T'aek-kyun's / Yi Hyŏng-nok's isolated ch'aekkŏri panels. One finds an hour-glass shaped incense burner reminiscent of twelfth- and thirteen-century Koryŏ bronze ones (although on Yi T'aek-kyun's screen they are flamboyantly depicted in swirls), a three-legged stand made from a tree root, open stationery books, a six-lobed vase, a tri-legged hu (K. ho) wine pitcher with tipped lid, a two-tiered square vessel with bosses, a curvilinear shaped inkstone, and an ornament, possibly a belt buckle on a stand. A roof tile, decorated with baby dragons, seen on Yi T'aek-kyun's painting, may be unique to the whole ch'aekkŏri genre (see Figure

5.9, panel 7). Seemingly, specific items were reserved for inclusion on the panels of isolated type *ch'aekkŏri* screens, and were not used in the trompe l'oeil or still life types. At issue is whether the depiction of these new objects was restricted to the isolated type, or whether it was chronological. Arguing for the restriction of new objects to the isolated type of *ch'aekkŏri* is the fact that they have turned up on other examples of the type, painted by three different artists. In all, from one to seven of these scholar's treasures can be found on fourteen isolated *ch'aekkŏri* paintings and on two embroidered screens. Most of these can be dated by style or provenance to a late date. Therefore, one might argue that the inclusion of these items in the subject matter was both restricted to the isolated type and was chronological.

Three innovations characterize Yi T'aek-kyun's painting style: a very bright palette, elaborately shaped and decorated curvilinear vessels, and prominent book stacks in isometric, or parallel, perspective, each group slanted in the same direction in every composition. That Yi T'aek-kyun's book stacks slanted in the same direction and his use of a lively palette are important portents of things to come as the isolated court style continued to develop. These surviving examples of court style *ch'aekkŏri*, reputed to have been started by Yi Chong-hyŏn in the last quarter of the eighteenth century (but known only to us through his grandson Yi Hyŏng-nok's/Yi T'aek-kyun's paintings), endured until the end of the Chosŏn period early in the twentieth century.

NOTES

1 This screen has been published in *T'ongdosa sŏngbo pangmulgwan* (T'ongdosa Sacred Treasure Museum), ed., *T'ongdosa: Han'guk ŭi myŏngch'al* (T'ongdosa, a great monastery in Korea) (Yangsan: T'ongdosa sŏngbo pangmulgwan, 1987), pp. 166–167. I am grateful to Han Chŏng-ho (Han Jung Ho), the former curator of the T'ongdosa Museum, for showing it to me. Also see T'ongdosa sŏngbo pangmulgwan, ed., *Hyegak sŏnsa kijŭng sŏhwa myŏngp'um* (Masterpieces of painting and calligraphy donated by Sŏn Master Hyegak) (Yangsan: T'ongdosa sŏngbo pangmulgwan, 1989).

2 Personal communication with Han Chŏng-ho, August 27, 1999.

3 Pak Chŏng-hye, p. 255.

4 In 2007 a few of Wagner's papers were published in Korean translation (*Chosŏn wangjo sahoe ŭi sŏngch'wi wa kwisok*) by Yi Hun-sang and Son Suk-kyŏng. I regret that I learned of them too late to include the information about *chungin* from the book in the final manuscript of this book, which has taken more than ten years to be published. See also Yi Hun-sang's supplement no. 2 in Wagner's book.

5 Wagner notes (November 10, 1995): "Yi T'aek-kyun was the name which appeared in the 'Record of Applying for Positions' in 1864; that same year the name Yi Ŭng-nok is recorded (Pak Chŏng-hye, p. 254)." He did not specify what the "Record of Applying for Positions" is, but it is most likely a list compiled in the *Daily Chronicle of Kyujanggak* (*Naegak illyŏk*).

6 See the Royal Ontario Museum's five-panel screen, Figure 24.1 in this book.

7 Numerous screens with royal blue and claret mountings exist on exhibit and in storage at two locations, Tŏksu Palace and Ch'angdŏk Palace, suggesting that there was a palace mounting style. The Tŏksu Palace has four (viewed September 1999): a four-panel longevity screen with octagonal cutouts; a two-panel corner screen painted by Kim Ch'ang-hwan in 1917; a two-panel screen decorated with longevity characters; and a "Five Peaks" screen. The Ch'angdŏk Palace has seven screens (viewed July 1987): two trompe l'oeil screens (catalogue nos. 66 and 67); two isolated type screens (catalogue nos. 65 and 125); a "Five Peaks" screen (catalogue no. 90); a screen by Chŏng Hak-kyo (catalogue no. 85); a palace scene screen (catalogue no. 72).

8 A six-panel *ch'aekkŏri* is most unusual. The screen may be missing two of its original panels. Because the painting is in North Korea at the Chosŏn Fine Arts Museum, I have not had the opportunity to investigate the matter. See *Chōsen bijutsu hakubutsukan*, pl. 96.

貫帛
齋道榮

7

An Isolated Type *Ch'aekkŏri* by Yi To-yŏng

One identified artist of isolated type *ch'aekkŏri*, Yi To-yŏng (1884–1933), was surprisingly a *yangban*, that is, a member of the aristocratic elite, not a *chungin*.[1] Yi Hyŏng-nok, a *chungin*, the first *ch'aekkŏri* artist Wagner and I were able to identify, was a court painter and a member of the Painting Bureau. Subsequent artists that we identified were also *chungin*, and it was their function to paint what was ordered—portraits and ceremonial and battle scenes—in addition to *ch'aekkŏri* and other subjects. In contrast, because they were amateur-gentlemen scholars, *yangban* painters considered it beneath them to paint on command. One *yangban*, Cho U-yŏng (1685–1759), is said to have been insulted when asked repeatedly by King Sukchong (r. 1674–1720) to paint his portrait and refused the commission, thereby receiving severe punishment.[2] It is to this class that Yi To-yŏng belonged.

Yi To-yŏng was a twelfth-generation descendant of famous sixteenth-century scholar Wŏlsa-gong (pen name of Yi Chŏng-gwi, 1564–1635).[3] Yi To-yŏng's father was a county magistrate; his grandfather was Minister of the Board of Rites, and upon reaching the age of seventy, was inducted into *Kisa* (the Old Gentlemen's Club).[4] It is surprising that Yi To-yŏng, a member of the Yŏnan Yi, one of the most powerful *yangban* families in Chosŏn Korea, became engaged in *ch'aekkŏri* painting—the province of *chungin* artists. At the age of eighteen, Yi To-yŏng, whose courtesy name (*cha*) was Chungil, and whose pen names were Kwanjae, Myŏnso, and Pyŏkhŏja, began his study of calligraphy and painting with the great figures of the day who were both court painters: An Chung-sik (1861–1919, pen name Simjŏn) and Cho Sŏk-chin (1853–1920, pen name Sorim).[5]

Headlines from Yi To-yŏng's obituary called him a "giant figure in the painting world." The painter An Chong-wŏn (1874–1951, pen name Sŏkchŏng), a close friend of Yi To-yŏng, spoke at his funeral and expressed his shock and sorrow.[6] Yi To-yŏng is praised in the article for continuing to paint in the old traditional ways in the face of the rapid changes in painting style.[7] During the Japanese colonial period (1910–1945), there were three societies for the arts, and Yi To-yŏng was a member

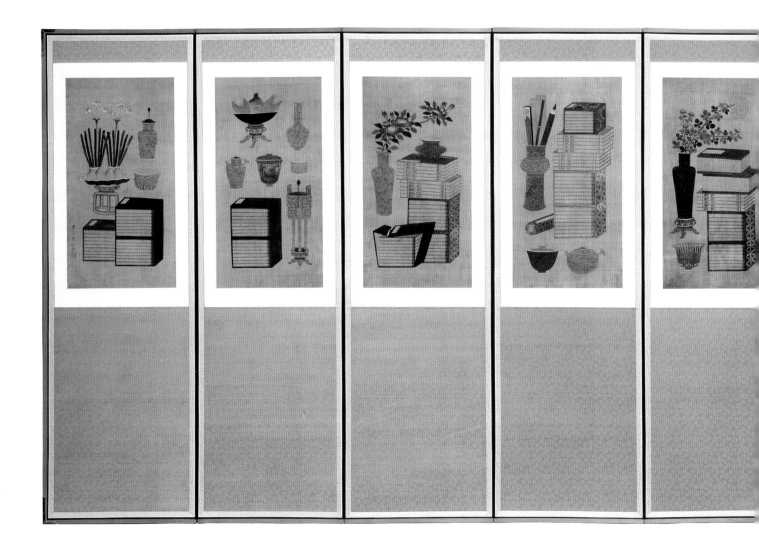

Figure 7.1
Ten-panel isolated type
chʾaekkŏri by Yi To-yŏng.
Ink, mineral, and vegetable
colors on silk. 65×35 cm.
Formerly Mrs. Minn Pyong-Yoo
collection, Seoul.
Photo by Lee Jung Ae.

of all three. The first began in 1911 as the pro-Japanese Sŏhwa misulhoe (Society for the Arts of Calligraphy and Painting) headed by the infamous Korean traitor Yi Wan-yong. Yi To-yŏng was a professor at this society.[8] The second, founded in 1915, was Sŏhwa yŏn'guhoe (Society for the Study of Calligraphy and Painting). The third, established in 1918, was the Sŏhwa hyŏphoe (Association of Calligraphers and Painters); it held its first art exhibition, Sŏhwa hyŏphoe chŏllamhoe (better known as Hyŏpchŏn) in 1921. The Chōsen Fine Arts Exhibition (*Chosŏn misul chŏllamhoe*; better known by its abbreviation, Sŏnjŏn), the most important annual art exhibition in colonial Korea, was organized by the Japanese colonial government. Its first exhibition was held in 1922.

Judging by extant *chʾaekkŏri* known to us, Yi To-yŏng is one of only two known painters to have worked in both the isolated and trompe l'oeil styles (the other being Yi Hyŏng-nok). One of each type is found in the former Minn Pyong-Yoo (Min Pyŏng-yu) collection in Seoul. The known Yi To-yŏng isolated type *chʾaekkŏri* has ten panels and is executed in mineral and vegetable colors and ink on silk in a palette of green, yellow, blue, red, brown, and tan (Figure 7.1). An inscription reading "Kwanjae Yi To-yŏng" (panel 10) and a seal impression that reads "Seal of

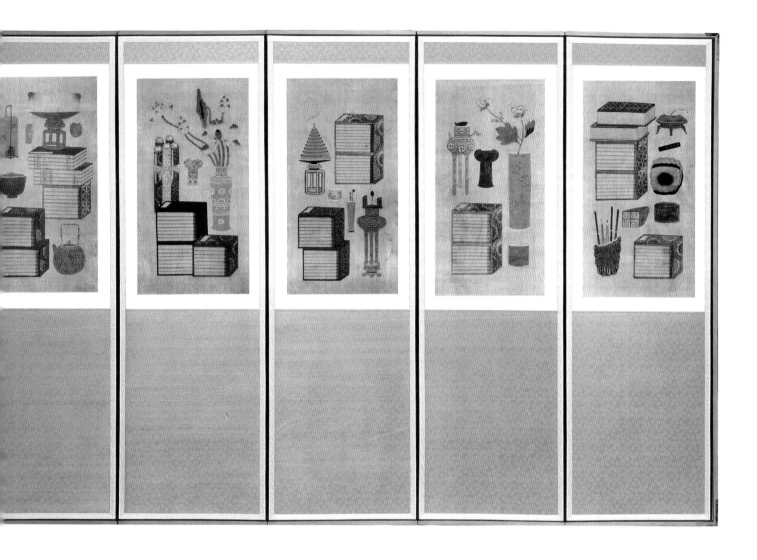

Yi To-yŏng" (also on panel 10) confirm that he was in fact the artist of this painting (Figure 7.2). There is another seal cached as part of the subject matter, a four-character seal—a blocky contemporaneous one that reads *"kiyŏngch'angin"* (Figure 7.3). This is an auspicious wish meaning: "Seal of praying for prosperity forever."

Although Yi T'aek-kyun depicted his name seal on the same style seal box that he used as Yi Hyŏng-nok/Yi Ŭng-nok in his trompe l'oeil type *ch'aekkŏri* paintings, Yi To-yŏng followed the more familiar practice of isolated type *ch'aekkŏri* painters, including the seal as a lone object without a seal box. His seal and the auspicious one presented as part of the subject matter are in keeping with traditional *ch'aekkŏri* painting, but finding Yi To-yŏng's signature on the painting is new to the genre.

Interesting objects among the subject matter include an ink stick with Chinese characters that translate as "500 Catties of Oil" (*obaekkŭn yu*) inscribed on its surface (Figure 7.1, panel 1). Apparently, this was a brand name of ink stick.[9] Still another object has been identified by Minn Pyong-Yoo as an incense burner used to keep mosquitoes away.[10] The mosquito trap is the only new object that Yi To-yŏng introduces in his screen (panel 3), and it appears in at least one other *ch'aekkŏri*,[11] but heretofore has been unidentified. The inclusion of such items reveals a little

Figure 7.2
Detail of Figure 7.1, panel
10. Inscription "Kwanjae
Yi To-yŏng" and impressed
Yi To-yŏng's seal. Photo
by Lee Jung Ae.

Figure 7.3
Detail of Figure 7.1, panel 1.
Block seal "Pray for prosperity
forever" (*kiyŏngch'angin*).
Any connection to Yi
To-yŏng is unknown.
Photo by Lee Jung Ae.

about the products that people used during the late Chosŏn and Japanese colonial periods.

In the Minn screen, Yi To-yŏng has reduced his isolated type *ch'aekkŏri* compositions to half the size as those in Yi T'aek-kyun's T'ongdosa screen, and he has depicted only half as many objects overall, possibly because of the smaller scale. Perhaps the commissioner requested a smaller format. The objects appear more abstract, stiff, and lack naturalism and grace. For example, the stems of narcissus resemble thick sticks. The blocky stands for the bowls of fruit and scholar's rocks are all shorter and squarer in shape than those in Yi T'aek-kyun's rendering, but their style is similar. His isolated *ch'aekkŏri* is somewhat lacking in aesthetic quality, which also could suggest an earlier date. Since the Minn isolated *ch'aekkŏri* does not bear Yi To-yŏng's "judge" seal (which presumably he was entitled to use only from 1922 through 1927, when he is known to have been a judge of the Chōsen Fine Arts Exhibition), it could have been painted before or after that period.[12]

Yi To-yŏng's obituary in the newspaper *Tonga ilbo* gives the names of the co-founders of the painting and calligraphy organizations Sŏhwa yŏn'guhoe and Sŏhwa hyŏphoe as Cho Sŏk-chin and An Chung-sik, who had been Yi To-yŏng's teachers and court painters during the Chosŏn period, as well as Chŏng Tae-yu (1852–1927), Kim Ton-hŭi (1871–1937), Kim Ŭng-wŏn (1855–1921), O Se-ch'ang (1864–1953), Ko Hŭi-dong (1886–1965), Kang Chin-hŭi (1851–1919), and Kim Kyu-

Exhibit 7.1 List of Yi To-yŏng's Paintings and Letters Given to Friends Recorded in Publications

Three Fan Paintings and a Letter

- 1908: *Pleasure on the River*, inscribed to Yŏnhyang (pen name of Yi Ch'ang-hyŏn), who is referred to as the "third brother" or the "third elder," and signed Kwanjae Yi To-yŏng. Yi Ch'ang-hyŏn, a *chungin* and court painter, was related to O Se-ch'ang, who was also a *chungin* and court painter. *Kansong munhwa* 12 (1977), pl. 22.
- No date: T*he Sound of the Wind in the Wutong Tree and Bamboo in Autumn*, inscribed to Wich'ang (pen name of O Se-ch'ang) from *Kwanjae Yi To-yŏng. Kansong munhwa* 12 (1977), pl. 31.
- 1918 (7ᵗʰ month): *Crows Flying in Search of a Roost as Night Approaches*, inscribed to Uhyang (pen name of Chŏng Tae-yu) asking for correction (*ajŏng*) and signed by Myŏnso (pen name of Yi To-yŏng). Chŏng Tae-yu, also a *chungin* and court painter, was a son of the painter Chŏng Hak-kyo. *Kansong munhwa* 12 (1977), pl. 8.
- 1921: A letter Yi To-yŏng wrote from a village near Sŏgwang Monastery on the Seoul-Wŏnsan line in present-day North Korea to O Se-ch'ang tells his friend about the house he just bought in North Korea. This letter provides further evidence of their friendship and also illustrates an example of his calligraphy. O Se-ch'ang, *Kŭnmuk* (2ⁿᵈ ed., Seoul: Ch'ŏngmunsa, 1981), pl. 1136.

Four Hanging Scrolls

- 1912 (10ᵗʰ month): *Pine Tree and Crane* signed by Kwanjae Yi To-yŏng. *Kansong munhwa* 43 (1992), pl. 17.
- No date: *Moon, Reeds, Flying Wild Geese* by Kwanjae Yi To-yŏng. *Kansong munhwa* 43 (1992), pl. 18.
- 1916 (4ᵗʰ month): *Willow, Chrysanthemum, and Longevity*, inscribed to Ŭnp'a (pen name of an unidentified person) by Kwanjae Yi To-yŏng. *Kansong munhwa* 11 (1976), pl. 31.
- 1928 (1ˢᵗ month): *Drinking Wine and Looking at the Oriole*, by Kwanjae Yi To-yŏng. *Kansong munhwa* 43 (1992), pl. 16.

Hand Scroll

- No date: *Fragrance of the Flowers of the Four Seasons*, by Yi To-yŏng. Kungnip chungang pangmulgwan (National Museum of Korea), ed., *Han'guk kŭndae hoehwa paengnyŏn 1850–1950*, pl. 71.

Double Album Leaf

- 1925: *Spring at Segŏm Pavilion*, near Sorim Monastery. *Han'guk kŭndae hoehwa paengnyŏn*, pl. 70.

Three Still Lifes

- 1910 (12ᵗʰ month): *Refreshing Things for the Office*, by Yi To-yŏng and Kim Ŭng-wŏn (status unknown, but probably *chungin* according to Wagner) in collaboration. Inscribed to Udang (pen name of Kwŏn Tong-jin) by Kwanjae Yi To-yŏng. *Kansong munhwa* 43 (1992), pl. 14.
- 1915 (1ˢᵗ month): *Refreshing Things for a Place in the House*, by Myŏnso Yi To-yŏng. *Kansong munhwa* 43 (1992), pl. 15.
- No date: *Looking Through the Window at the Snow on a Clear Day*, by Myônso Yi To-yŏng. *Kansong munhwa* 43 (1992), pl. 1.

Of the thirteen paintings listed above, six are inscribed to individuals by Yi To-yŏng. Of the six, four are *chungin* court painters, including two of three inscribed to O Se-ch'ang. Published paintings of Yi To-yŏng also include an autumn landscape of geese dated 1922 and inscribed to Sŏkchŏng (pen name of his good friend An Chong-wŏn), who spoke at his funeral. *Arts of Korea* (P'yŏngyang: Editions en Langues Etrangers, 1978), pl. 46.

jin (1868–1933). With the possible exceptions of Kim Ŭng-wŏn and Kim Kyu-jin, whose clan seats and statuses are unknown, the other members of the painting and calligraphy organizations were all *chungin*.[13] One wonders how Yi To-yŏng could have learned painting from *chungin*. As a descendent of the illustrious Yŏnan family, Yi To-yŏng's close association with artists from the *chungin* class seems strange unless it is interpreted as a sign that times were indeed changing. Fortunately, many of Yi To-yŏng's paintings have been previously published. The inscriptions on the paintings Yi To-yŏng gave to his co-founders, however, provide irrefutable proof of the camaraderie that existed between Yi To-yŏng, a *yangban*, and the *chungin* artistic circle of his day (Exhibit 7.1).

Yi To-yŏng served as a judge for the Chōsen Fine Arts Exhibition (*Sŏnjŏn*) in the category of traditional East Asian painting from 1922 to 1926.[14] Another Korean, Sŏ Pyŏng-o (1862–1935), and a Japanese judge also served with him for the first three years of the *Sŏnjŏn*.[15] But from 1925 to 1927, Yi To-yŏng was the only Korean artist to officiate in the *Sŏnjŏn*, along with one Japanese judge.[16] Because of Yi To-yŏng's involvement as a judge for the prestigious *Sŏnjŏn*, it would be difficult to overlook the possibility that he collaborated politically with the Japanese. However, it is said that during the 1920s, everyone collaborated with the Japanese as that was their only access to Korean culture.[17] Apparently, it was not until later in the 1930s, when the Japanese began jailing Koreans, that some Koreans did become political collaborators.[18] Therefore, since Yi To-yŏng died in 1933, it seems unlikely that he had collaborated with the colonial government.

There were no Korean judges in the *Sŏnjŏn*'s category of traditional East Asian painting from 1932 to 1938, and there were no Korean judges officiating at the exhibition.[19] Although 1938 saw the return of Korean judges, they were judges in name only, and were allowed to show their paintings but not to officiate. This makes sense, because 1932 marked the beginning of the third period of Japanese colonial rule when the cultural freedoms won by the Koreans as a result of the 1919 March First Movement ended. There were no more Korean language newspapers, magazines, or organizations, and the Koreans were henceforth subjected to very repressive conditions.

NOTES

1 An earlier name is also "To-yŏng" but written with different characters. Yi To-yŏng's "clan-uncle" was Yi Kyŏng-sŏng (*b*. ca. 1856/57), pen name Idang, known for his renderings of butterflies. Kim Yŏng-yun, *Han'guk sŏhwa inmyŏng sasŏ* (Biographical dictionary of Korean painters and calligraphers) (3ʳᵈ ed., Seoul: Yesul ch'unch'usa, 1978), pp. 471–472.

2 Korea National Commission for UNESCO, ed., *Traditional Korean Painting*. Korean Art 2 (Seoul: Si-sa-yong-o-sa, 1983), p. 46.

3 Personal communication with Wagner, November 1990.

4 Yi To-yŏng's obituary published in *Tonga ilbo*, October 23, 1933.

5 *ibid*.

6 Yi To-yŏng's obituary published in *Tonga ilbo*, October 23, 1933; *Hang'uk misul yŏngam* (1979 edition), p. 646.

7 *Hang'uk misul yŏngam* (1979 edition), p. 646.

8 *ibid*.

9 Yi Kyŏm-no, p. 78.

10 Personal communication with Minn Pyong-Yoo, November 1998.

11 See, for example, the *ch'aekkŏri* in the Onyang Folk Museum.

12 I am grateful to Frank Hoffmann for providing the source materials and sharing his expertise of this period. Personal communication, November and December 2003. Also see *Chosŏn ilbo*, May 11, 1927; Ch'oe Sŏk-t'ae, "Yi To-yŏng yŏnbo" (Chronology of Yi To-yŏng's life), *Han'guk kŭndae misulsahak* 1 (1994), pp. 116–119.

13 Personal communication with Wagner, June 10, 1996. Also see *Tonga ilbo*, September 23, 1933.

14 Ch'oe Sŏk-t'ae, pp. 116–119.

15 *ibid.*

16 Chōsen sŏtokufu, ed., *Chōsen bijutsu tenrankai zuroku* (Catalogue of a special exhibition of Chosŏn art) (1922–1940; reprint, Seoul: Kyŏngin munhwasa, 1982). Personal communication with Frank Hoffmann, November and December 2003.

17 Personal communication with Ledyard, December 3, 2003.

18 *ibid.*

19 Chōsen sŏtokufu, ed., *Chōsen bijutsu tenrankai*. Personal communication with Frank Hoffmann, November and December 2003.

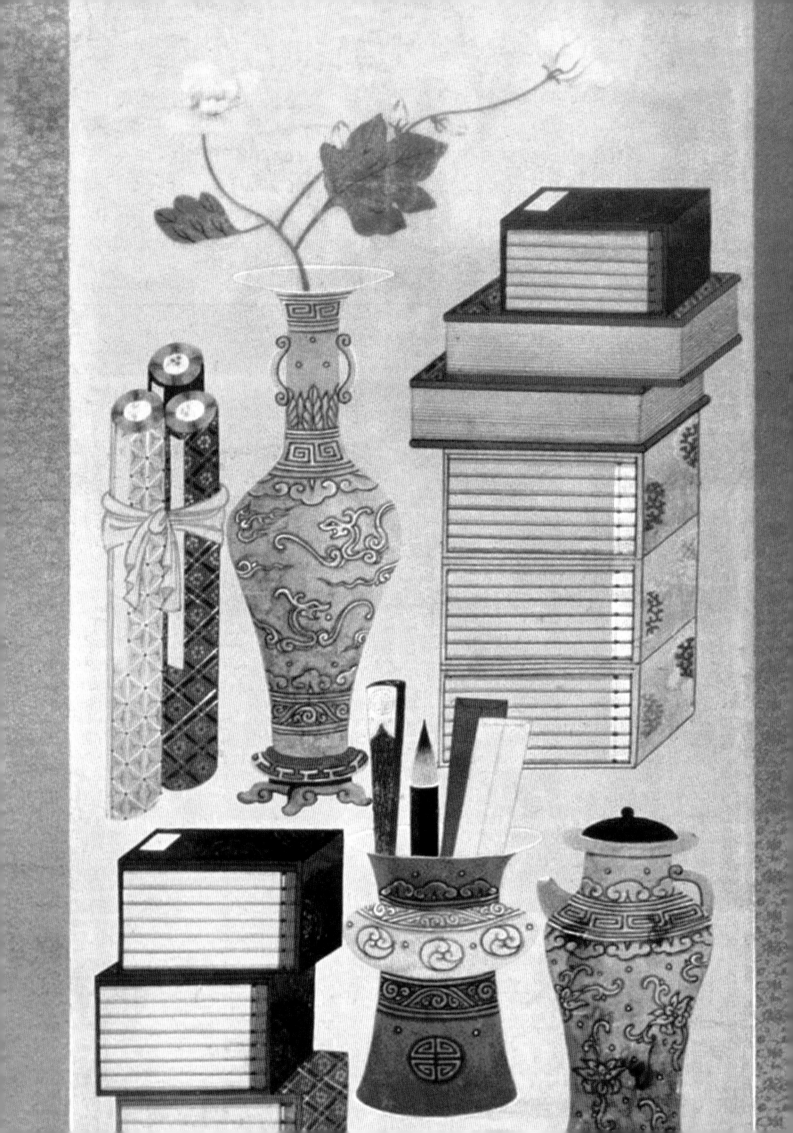

8

Three Isolated Type Corner *Ch'aekkŏri* Screens

Two-panel screens were used to decorate the corners of rooms and cut down on drafts. Two very similar corner screens of the isolated type are in the Ch'angdŏk Palace collection (catalogue nos. 15 and 16) (Figures 8.1 and 8.2). However, after studying them, I realized that some of the items varied. Most important is their different compositional organizations.

Both Ch'angdŏk Palace screens (Figures 8.1 and 8.2) show an affinity with several other isolated type screens. A bronze *fangding* used in ancestor worship rituals, a partially opened book cover, and a collection of seals also appear in Sŏkch'ŏn's ten-panel screen (Figure 5.7 panels 5, 7, 10), Han Ŭng-suk's eight-panel screen (Figure 5.1, panels 5, 7, 8), and Yi T'aek-kyun's ten-panel screen at the T'ongdosa Museum (Figure 5.9, panels 8, 9). Among these objects only a partially open book cover appears in Sosŏk/Susŏk's monochromatic ten-panel *ch'aekkŏri* (Figure 5.5) executed around 1870.

In the Ch'angdŏk Palace screen, catalogue no. 16 (Figure 8.2), the artist has staggered the books in the right-hand pile in the upper left panel to create a peephole indicating a little recession. It appears to be the earlier of the two corner screens, based on its lack of overlapping objects to indicate depth, the ratio of books to objects, and the older appearance of the silk on which it is painted. Most objects in these screens are Chinese in style, including two books bound in Chinese fashion with four stitches (panel 1). One exception stands out. The partially opened book cover is depicted in a characteristic Korean fashion. A handscroll is open to reveal a landscape in a palette of pale aqua and a peachy tan that is reminiscent of the fifteenth − or early sixteenth − century Chinese Wu school colors; these were used in Korea particularly during the eighteenth and nineteenth centuries in landscape painting.

The anonymous artist of Ch'angdŏk catalogue no. 16 has organized his two panels exactly the way Yi Hyŏng-nok did; furthermore, it is reminiscent of Yi Hyŏng-nok's work in all respects. The Chinese-style bronze vase holding peacock feathers

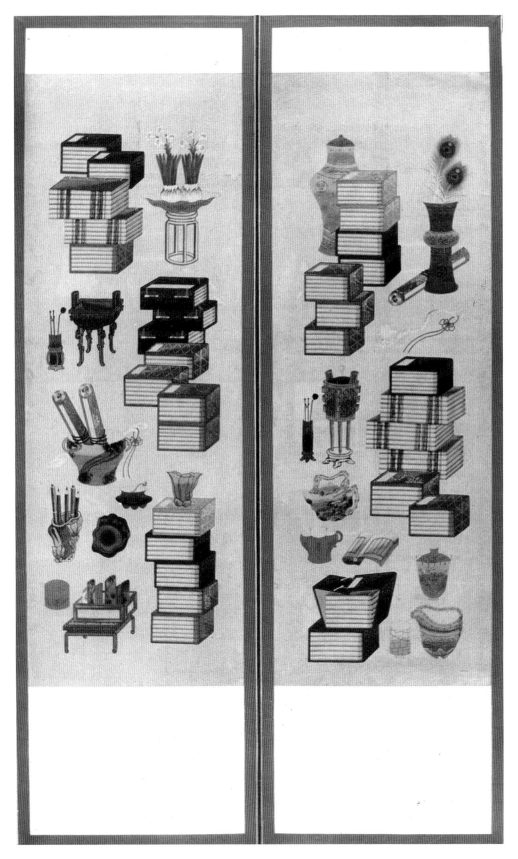

Figure 8.1
Two-panel isolated type corner screen by an anonymous court painter. Second half of the 19th century. Ink and mineral pigments on pale silk. 159×56.5 cm. Ch'angdŏk Palace Museum (catalogue no. 15). Photo by Norman Sibley.

Figure 8.2
Two-panel isolated type corner screen by an anonymous court painter. Second half of the 19th century. Ink and mineral pigments on gold silk showing age. 145.5 × 47 cm. Ch'angdŏk Palace Museum (catalogue no. 16). Photo by Norman Sibley.

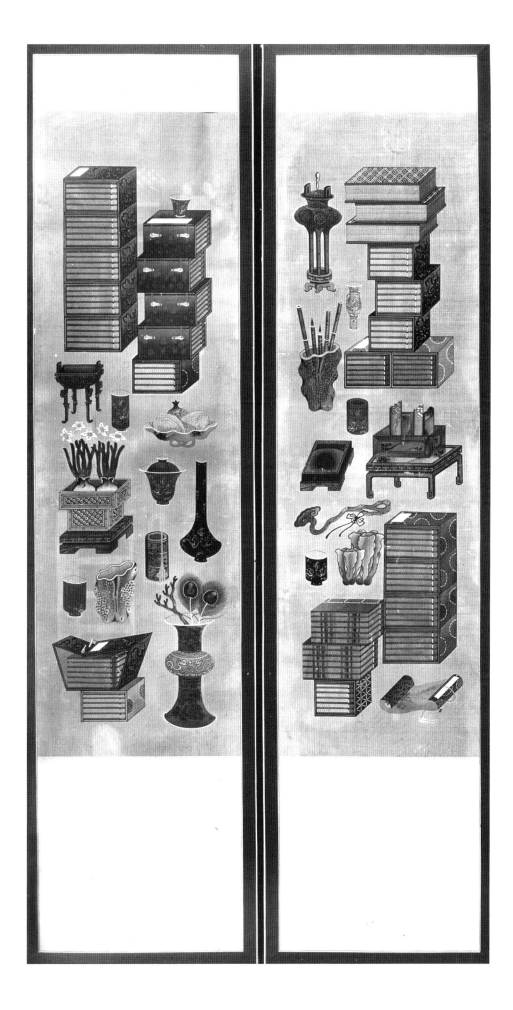

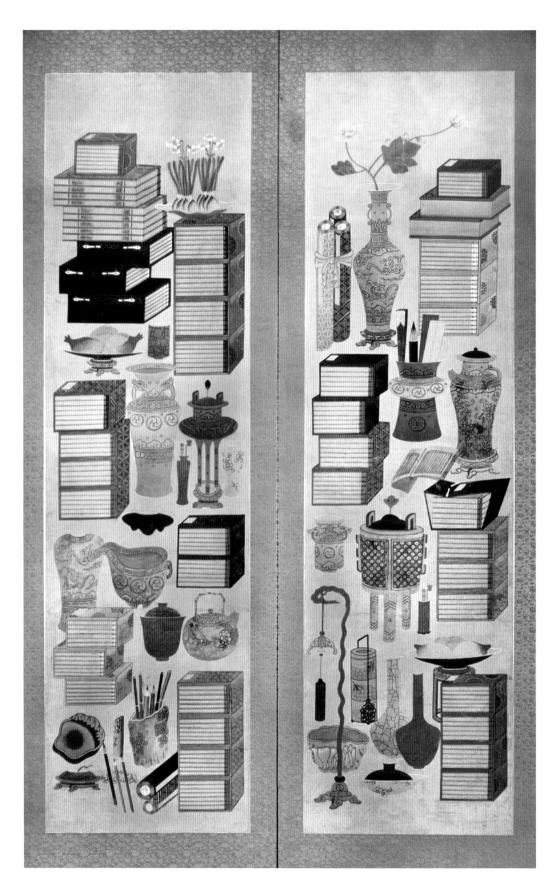

Figure 8.3
Two-panel isolated type corner screen by an anonymous court painter.
Early 20th century. Ink and mineral pigments on silk. 176 × 48 cm.
Leeum, Samsung Museum of Art. Photo by Norman Sibley.

and coral is exactly the same as the one depicted in the screen by Yi Ŭng-nok in the Asian Art Museum of San Francisco. The two-tiered bronze container with bosses is identical to the one depicted by Yi T'aek-kyun. Everything about this corner screen, including palette, book patterns, and scholarly paraphernalia, suggests that it might well have been painted by Yi Hyŏng-nok himself—even though it does not have his seal amongst its objects. The silk of the Ch'angdŏk *ch'aekkŏri* no. 16 shows age. Perhaps Yi Hyŏng-nok might have painted it during the years he is thought to have used that name—1833–1863—its compositions certainly recall those of his P'yŏngyang six-panel *ch'aekkŏri*.[1]

A third corner screen at the Leeum (Figure 8.3) is quite different from all the works mentioned above due to the huge scale of the objects. The bottom register of each panel is based on a single stack of slipcases plus five other assorted scholarly items. Taken together with the slipcases, the items fill the picture plane with little space left between. The screen's anonymous court artist depicted three levels of recession. However, the eye moves laterally, instead of going vertically up and back, because several of the objects are depicted in the same scale as their adjacent stacks of books. That the painting contains twenty-five percent more books than objects, and the unusually large scale of some of the items, suggest that the Leeum screen might be the latest of the trio and could date to the twentieth century. The objects are painstakingly detailed, and among the books, there is the same half-opened book cover in the Korean style that appears in both of the Ch'angdŏk Palace corner screens. All three of these two-panel isolated type screens share the same Korean palette of bright colors.

NOTES

1 Wagner, *Chosŏn wangjo sahoe ŭi sŏngch'wi wa kwisok* and Yi Hunsang's supplement no. 2.

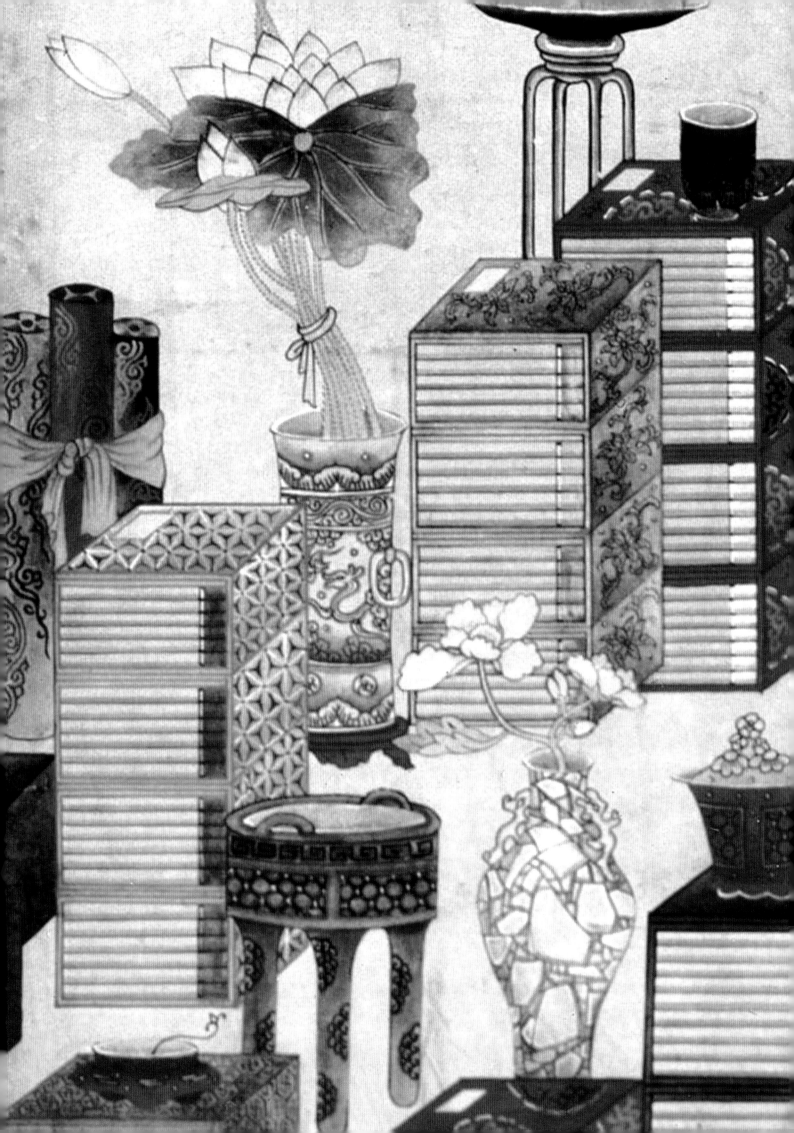

9

An Isolated Type Theatrical *Chʾaekkŏri*

This theatrical *chʾaekkŏri* (one of only two in our study) shows a raised curtain revealing a stage set with scholar's paraphernalia (Figure 9.1), flower arrangements, small tables and stands, vessels of every description, and books; several of the book stacks spill over from one panel to another. These are overlapped in every panel all the way to the top, creating a successful illusion of spatial recession to form a stage. The stage's silk curtain framing the *chʾaekkŏri* is rolled up in tent fashion. The artist has used the Western technique of chiaroscuro advantageously in showing the folds and drapery of the curtain. Its corners are caught by tie-backs decorated with prunus blossoms and dangling silk knotted tassels. The gold-colored silk curtain, facing the implied audience, is decorated with red longevity medallions. Six floral arrangements grace three of the four panels on this stage set, more than are usually found on screens of this type. A stack of books is bound in the Chinese four-stitched way (panel 4), while another pile is bound with a two-stitch binding (panel 2). The vessels and small table with seals depicted on top of a *faux marbre* seal box are Chinese in style. One of the seals (panel 4), an oval-shaped one, has propitious characters meaning "wealth" (*pu*) and "longevity" (*su*), not a name or pen name. The characters' horizontal depiction, end-to-end (*pusu*), doubles its auspicious meaning.

A very Korean addition to the genre's subject matter is the stags' antlers protruding from the bronze vessel in panel one. Stags' antlers have been infrequently found in the Chŏnnam-style of still life *chʾaekkŏri* (see Chapter 23), but finding them in an isolated type example is a surprise. Another Western influence is the presence of a pocket watch, seen dangling from a staff decorated in prunus blossoms (panel 4). Its artist did not depict the Roman numerals correctly—an apparent failing of all the Korean painters who illustrated the pocket watch. This item was apparently reserved for inclusion in late nineteenth-century court style *chʾaekkŏri* only, as it has not been found in earlier examples of the still life type.

This screen was hung in the fourth room at Chʾangdŏk Palace in the late 1980s,

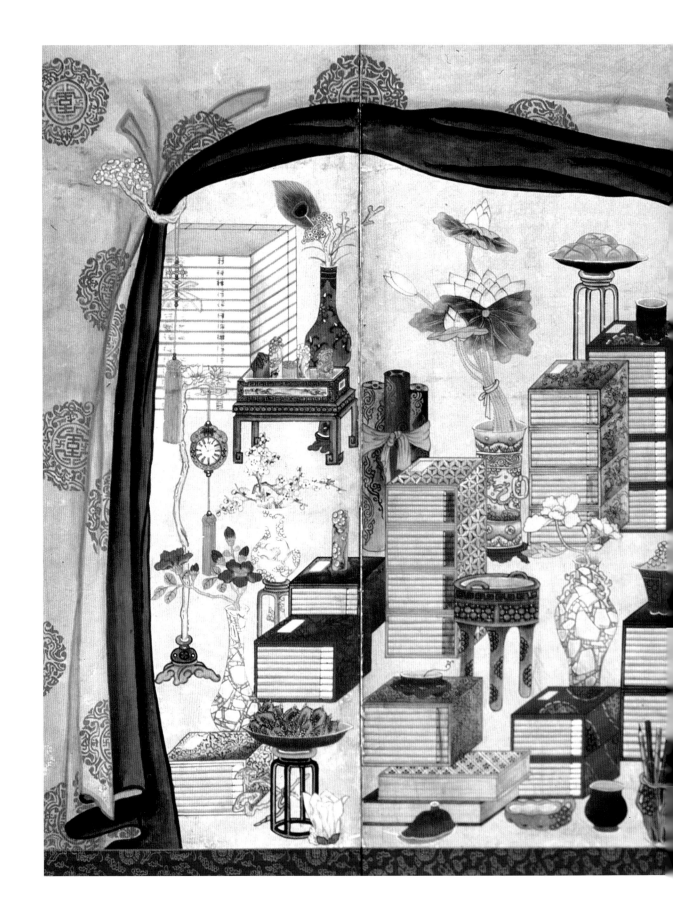

Figure 9.1
Four-panel isolated *ch'aekkŏri* of a theatrical setting by an anonymous court
artist. Late 19th or 20th century. Ink and mineral pigments on paper. 143 × 57.5 cm.
Ch'angdŏk Palace Museum (catalogue no. 65). Photo by Norman Sibley.

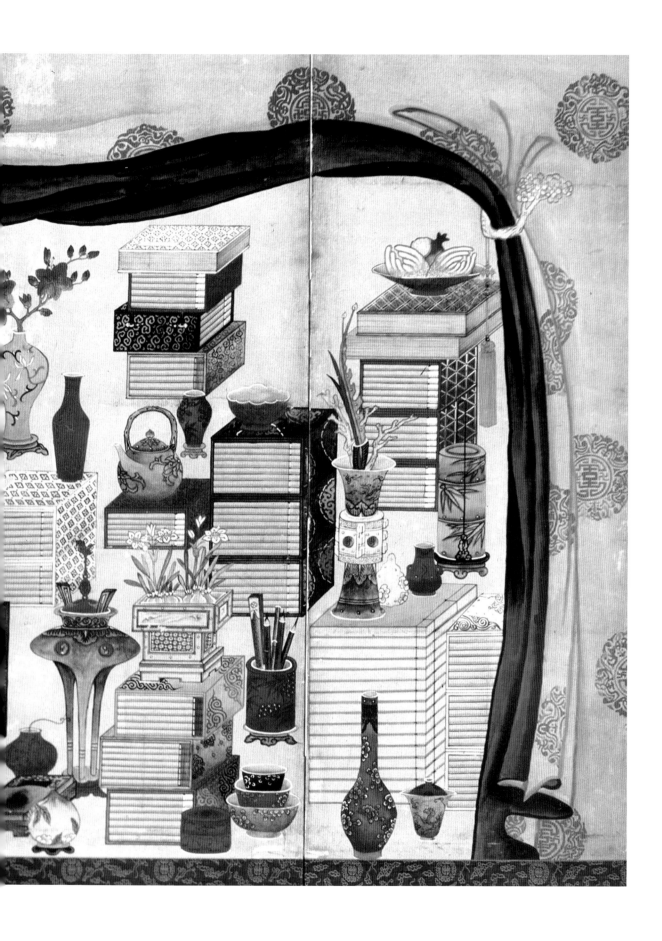

and before that it was seen in the art storehouse, so I am confident that it was created by a court painter for palace use and has continued *in situ* ever since.[1] The mounting of royal blue and claret red brocade is a perfect example of what I believe was the official palace mounting style at the end of the Chosŏn period.

NOTES
1 I visited Ch'angdŏk Palace for the purpose of viewing paintings in storage in June 1985, then again in October 1986, when Norman Sibley photographed them.

10

Two Twentieth-Century Isolated Type
Ch'aekkŏri by Sŏktang

One sees at a glance that these two screens, one in the former Minn Pyong-Yoo collection in Seoul and the other in the Institute of Koryŏ Art Museum in Kyoto, are by the same artist (Figures 10.1 and 10.4). The pen name Sŏktang appears on seals in both screens (Figure 10.2 from panel 3 of Figure 10.1 and Figure 10.5 from panel 7 of Figure 10.4). Although the seal in the Institute of Koryŏ Art Museum's screen is meant to be read straight on, not as an imprint, the seal on the Minn Pyong-Yoo screen must be flipped over to make a readable impression. The two characters on both seals, Sŏktang, are believed to refer to the artist. However, to date I have been unable to link the pen name to any twentieth-century artist. Other similarities are the colors, the style of Chinese characters carved in regular script, the adjacent vessels, and the patterns of the book covers upon which the seals rest. All the book cover patterns and the vessels are identical. Even the four Chinese characters written on the ink sticks are the same: "Gentle wind sweet rain" (*hwap'ung kamu*).

On both screens, Sŏktang created an innovative composition by alternating the direction in which the two piles of single volumes and slipcases are presented. The compositions on the Institute of Koryŏ Art Museum's screen are compact and straightforward. Each composition has two stacks of books with two objects surmounting them. The upper pile is smaller than the lower one, creating a logical and balanced construction. By contrast, the Minn Pyong-Yoo *ch'aekkŏri* reveals a third group of objects, thereby embellishing the picture, as well as elongating each panel. However, only a few of the panels are anchored with books, reflecting Yi Hyŏng-nok's isolated style. Sŏktang created a lacy outline along the top of the Institute of Koryŏ Art Museum's screen, and as a result that *ch'aekkŏri* does not suffer from being top-heavy. Shorter stacks of books also help in this regard. However, Yi Hyŏng-nok's pattern of anchoring some panels with small items was followed by Sŏktang in the Minn Pyong-Yoo screen. Sŏktang's two screens show that both compositional styles were produced during the Japanese colonial period.[1]

Appearing in the isolated type for the first time in the Minn Pyong-Yoo *ch'aek-*

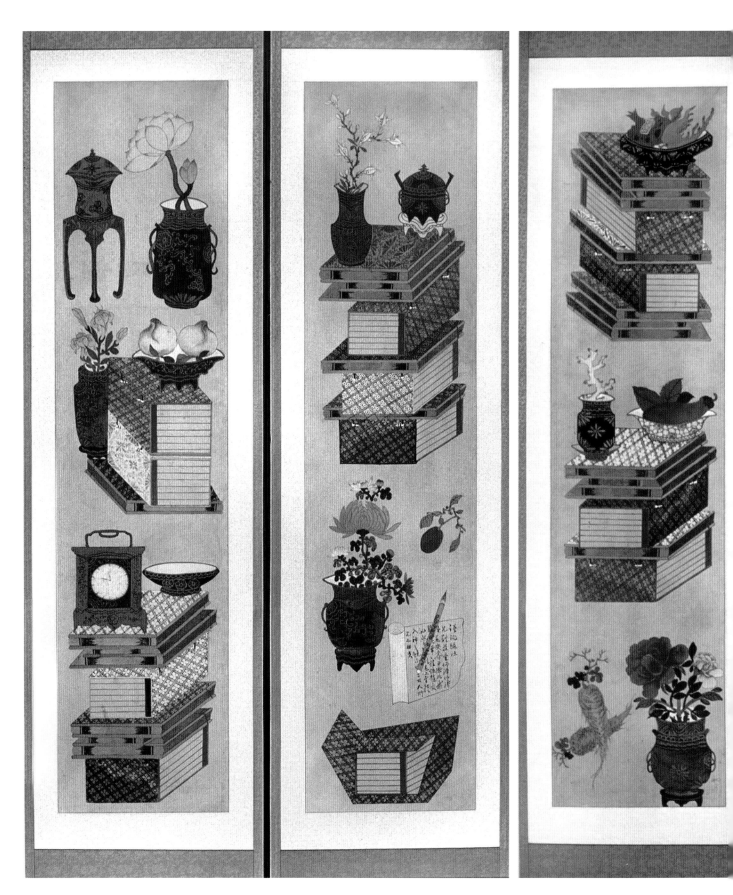

Figure 10.1
Ten-panel *ch'aekkŏri* by Sŏktang (only six panels are shown). Ink and mineral pigments on silk. 114×28 cm. Formerly Minn Pyong-Yoo collection, Seoul. Photo by Norman Sibley. To date we have not been able to link Sŏktang with any artist in the 20th century.

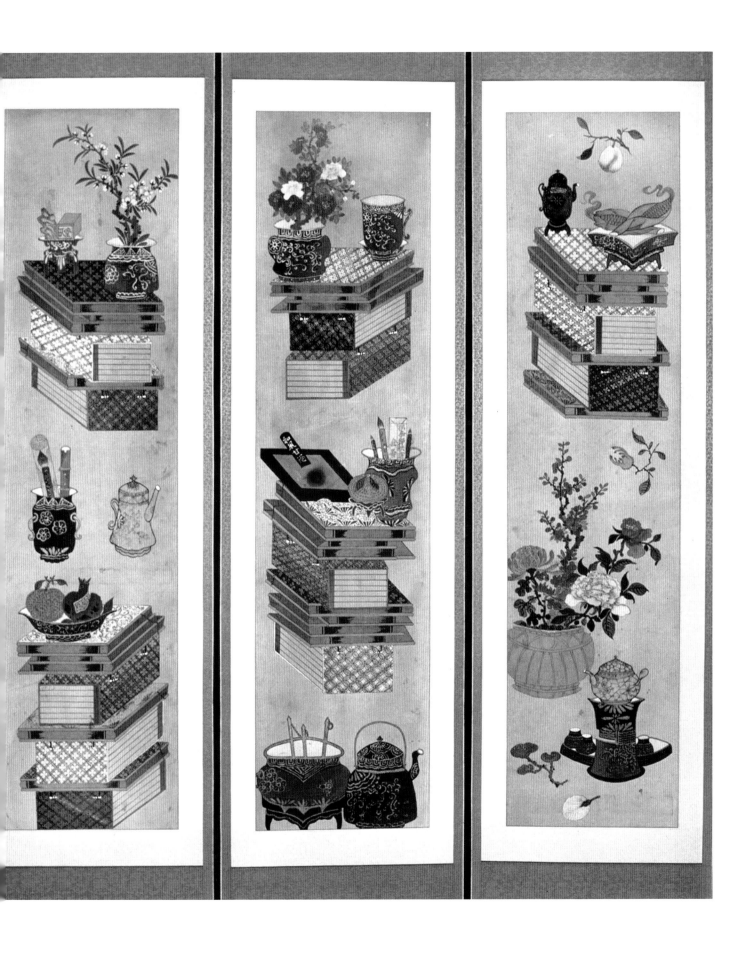

Figure 10.2
Detail of Figure 10.1, panel 3
(third panel from right).
Inscribed seal of Sŏktang.
Photo by Norman Sibley.

Figure 10.3
Detail of Figure 10.1, panel 5
(fifth panel from right).
Inscribed letter below
a lychee nut. Photo
by Norman Sibley.

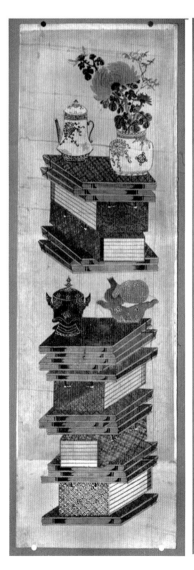
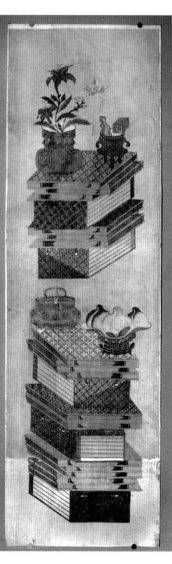
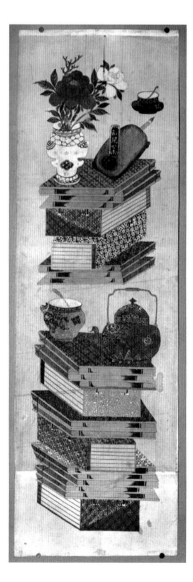
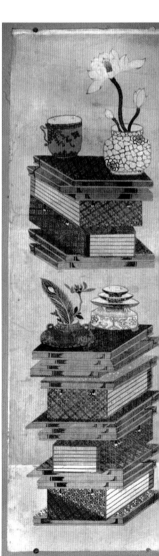

Figure 10.5
Detail of Figure 10.4, panel
7. Seal of Sŏktang. Photo
courtesy of the Institute
of Koryŏ Art Museum.

Figure 10.4
Eight-panel isolated type
ch'aekkŏri by Sŏktang. Ink
and mineral pigments on silk.
103.5 × 32 cm. The Institute of
Koryŏ Art Museum, Kyoto.
Photo courtesy of the Institute
of Koryŏ Art Museum.

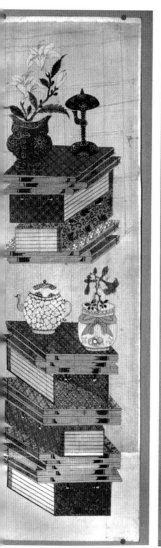
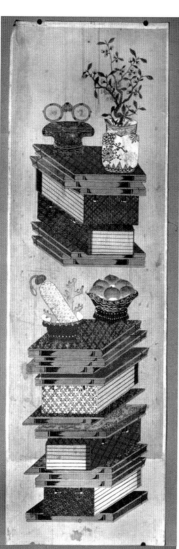
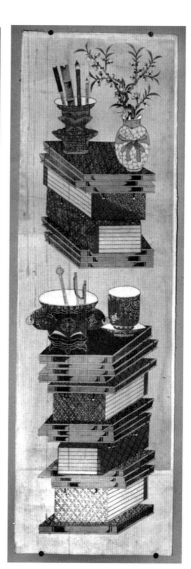
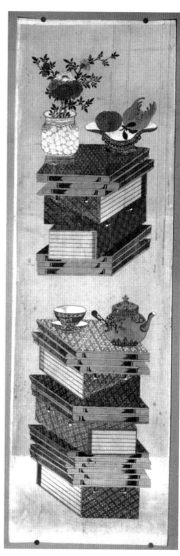

kŏri are two corn cobs (Figure 10.1, panel 1) and two ginseng roots (panel 4). There are other innovative touches seen in the Minn Pyong-Yoo screen—a peach, a Buddha's Hand citron, a carriage clock, and a lychee nut seemingly in free-fall on the panels. Spectacles appear here—one of just two known instances in the isolated type.

Below the lychee nut is an inscribed handscroll (Figure 10.3). However, the inscription is incomplete because the artist depicted the writing brush crossing over the rows of characters, rendering some of them illegible. One sees the beginning of a family letter. Its format is different from normal Chinese script, which reads in vertical columns from right to left, as Sŏktang's is written the other way around—from left to right.

> Sincere greetings,
> [I trust that] brother you are in good health; brothers Chukchan and Chukkye are also doing well; relatives from the Northern prefecture must be struggling to survive under tough circumstances. Cho U-yŏng's skills do not follow the ancient rules of masters but are intended to work out a spiritual mood. Brother and mother …[2]

Cho U-yŏng (1685–1759) is mentioned in Chapter 7 as a *yangban* who was insulted when the king asked him to paint his portrait. However, it seems unlikely that he would have had any connection to the letter in Sŏktang's painting.

Perhaps the most unusual feature of Sŏktang's screens is the depiction of many Qing dynasty high-fired, black-glazed vessels. Their surfaces are hard, shiny, mirror-like, and are embellished with gilt traceries.

NOTES

1 A pair of Sŏktang style *ch'aekkŏri* panels were advertised in CIRCLINE: Brouse Art, 2000. Perhaps created as cupboard door decorations, their dimensions (61 × 39 cm) are much smaller than those of the screens by Sŏktang.
2 I am grateful to He Li for the translation.

11

Overview of Trompe l'Oeil Type *Ch'aekkŏri*

Until the last quarter of the nineteenth century, Korea was generally isolated from direct contact with the Western world. Therefore, it is probable that the European painting techniques of linear perspective and chiaroscuro, the use of shading to give an object three-dimensionality, filtered into Korea from China, either in art works or texts brought home by returning emissaries or by visiting Chinese. These techniques were known in both China and Japan by the second half of the seventeenth century; however, Chinese and Japanese artists used them in different ways for different purposes.

The earliest dated Japanese picture known to employ the techniques of linear perspective and chiaroscuro is a woodblock print by Okumura Masanobu (1686–1764) of the interior of the Nakamura Theater. Dated to 1740, it shows great depth recession, in the manner of the seventeenth-century Dutch school.[1] Other eighteenth-century Japanese prints of interiors show similar recession, unlike the shallow perspective typical of Korean *ch'aekkŏri* screens. Two Japanese artists, Maruyama Ōkyo (1733–1795) and Shiba Kōkan (1747–1818), were fascinated with Dutch glasses, an optical gadget built on the principle of the camera obscura through which one could view a three-dimensional effect.[2] Their paintings, using linear perspective and chiaroscuro to produce deep recession and illusionistic effects, reflect this influence. However, their works are documentary in nature, descriptions of specific scenes and events, unlike Korean trompe l'oeil ch'aekkŏri, which present an imaginary thing—the illusion of an actual bookcase.

By contrast to Japanese examples, eighteenth-century Chinese paintings using linear perspective and chiaroscuro, although illusionistic, are "fool-the-eye" paintings of imaginary scenes. Trompe l'oeil paintings on the walls of the South Church in Beijing (Peking) by the Italian missionary Father Giuseppe Castiglione (Lang Shining, 1688–1766), court painter to the Chinese emperor, attest to the success of his work as "fool-the-eye" painting.

Korea sent many tribute missions to China, perhaps two or more a year, and

each included a court artist in the group.[3] The transmission of linear perspective from China to Korea was undoubtedly facilitated by such missions, though its exact path of penetration remains unknown.

In the winter of 1765–1766, Hong Tae-yong (1731–1783), a brilliant thirty-five-year-old Korean astronomer and mathematician, arrived in Beijing as a junior emissary,[4] accompanying his uncle, Hong Ŏk (1722–1809), secretary of the Winter Solstice Embassy. Hong Tae-yong was endowed with an inquiring mind and unusual perseverance. His keen powers of observation and skill as a raconteur emerge from the pages of his *Peking Memoir* (*Tamhŏn yŏngi*) and provide a colorful and descriptive picture of Beijing at the height of its prosperity in the Qianlong period (1736–1796).[5]

Bundled against the cold, Hong Tae-yong proceeded to the South Church (*Nantang*) where, having inveigled an interview, he presented himself to the Jesuit mathematicians and astronomers August von Hallerstein (Liu Songling, 1703–1774) and Anton Gogeisl (Bao Youguan, 1701–1771).[6] Upon entering the church, he made an amazing discovery:

> As you go in the gate, there is a brick wall on the eastern side, perhaps two *chang* (4 m) high. A hole had been knocked in this wall, making a gate; through this half-open gate could be seen some multi-storied buildings on the yonder side, rising up several stories high. I thought this a most unusual sight, and called Sep'al over to ask him about it. But Sep'al laughed, and said, "It's all a painting!" I went forward a few steps and inspected it closely, and indeed, it was a painting.

> We went through another gate on the west side and then saw, on the north, the reception hall. Its door, which opened to the south, was provided with a brocade curtain. We went in the door, and found a room about six kan in size, with a brick floor. On the east wall was a painting of the heavens, with all the stars and constellations; on the west was a political map of the world (*tianxia yudi tu*). Some chairs had been placed in the middle of the room, three each on the east and the west; all were of carved pomegranate and sandalwood and had brocaded cushions on them. After we had sat awhile, the gate man came in again and invited us through the door on the north side of the room. It led out to a raised porch, opening on a wide courtyard and showing a much taller building to the north. The ornamentation was not overly dazzling, but the workmanship and finish were as if done by the gods. We went in the door, even though neither of the men had yet made his appearance.

> Here too there were paintings on two of the walls. Both the buildings and people in these paintings are done with their true colors. In the interior parts of the buildings, the various spaces all complement each other, and the people move about as if alive. The perspective of things near and far is especially expert. In some places the rivers and valleys stand out, in others they are obscured; here the mists and clouds may be bright, there they will be damped

out. Everything is given just the right color, even to the farthest point in the sky; there is no sense that it is not real. I have heard that the marvel of Western painting is not just in its superhuman skill and conception, but in its method of organizing perspective, which is exclusively mathematical in origin.

The people in the paintings all have hair hanging down their backs and wear gowns with large sleeves. Their eyes are bright. The buildings and furnishings are of a type never seen in China; they must all represent Western styles. On the north side of the room was a single folding screen with a Chinese ink-wash landscape. The brushwork very highly refined.[7]

In this passage, Hong Tae-yong's reaction makes clear that this was his initial exposure to "fool-the-eye" painting, providing the dramatic, first-known description of trompe l'oeil painting by a Korean. The Jesuits themselves referred to trompe l'oeil decorations as "perspectives that deceive."[8] Since they had been in China for a long time, it is not unlikely that Korean emissaries before Hong had encountered the style. For instance, in 1703, some sixty years prior to Hong Tae-yong's encounter, it is known that Brother Gherardini had executed a trompe l'oeil painting on the dome of the North Church in Beijing,[9] where it could have undoubtedly been seen by visiting Koreans.[10]

It is not surprising to find in China a prototype for Korean trompe l'oeil type *ch'aekkŏri*, a painting that has been attributed to Giuseppe Castiglione on the basis of its seal and signature (Figures 11.1 and 11.2).[11] One would expect an Italian-trained artist to be familiar with European perspective and with trompe l'oeil painting. Because the Chinese characters of the signature are broader than in other Castiglione works, the painting's authenticity has been questioned. Based on the optical tricks visible in the glass bowls, an expert in eighteenth-century court painting determined that this *ch'aekkŏri* might indeed be an early work of Castiglione; or perhaps the painting of one of his best students; or more likely, a copy of a genuine Castiglione painted by a later artist.[12] Unlike Korean *ch'aekkŏri*, the probable Castiglione bookcase painting on a single panel employs linear perspective convincingly, with shadows more masterfully rendered, objects pictured larger, and with far fewer books included in the composition (Figure 11.1). However, the perspective lines drawn from all the orthogonals do not convene in the center of the painting. Instead, they fall into the central compartment, revealing that Castiglione did not paint from a mathematically defined single vantage point as required in artificial perspective, but nonetheless created a successful trompe l'oeil painting.[13]

Both Castiglione's single panel bookcase work and Korean *ch'aekkŏri* could have been inspired by a Kangxi era painting of a Qing dynasty interior, *A Scene from the Romance of the Western Chamber*.[14] Here a bookcase with scholarly treasures is expertly rendered in detail and might have served as a model for the Chinese artists' trompe l'oeil flat panel paintings and their Korean counterparts—folding *ch'aekkŏri* screens. As the Yuan dynasty (1280–1368) drama *Romance of the Western Chamber* (*Xixiangji*) was published in woodblock illustrations, its transmission to

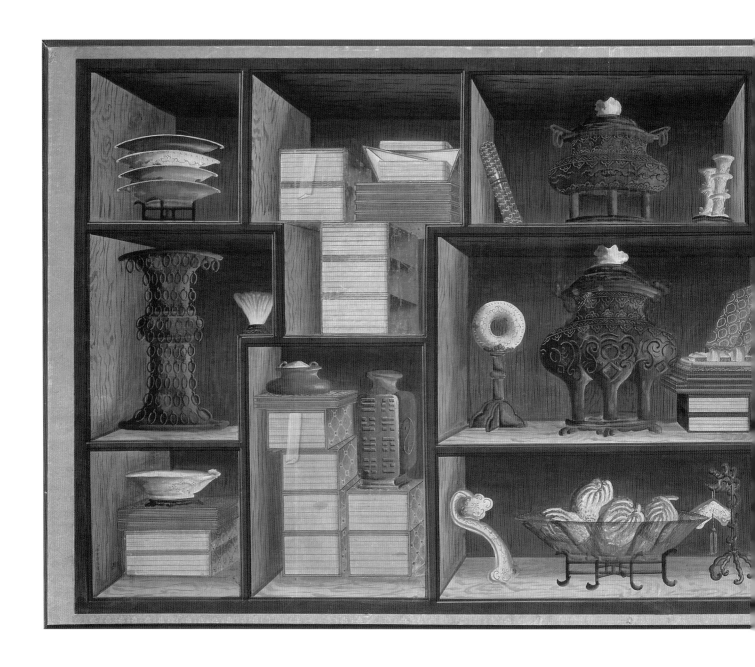

Korea is easily imagined. The fact that it was known in Korea is proven because *Romance of the Western Chamber* is one of the book titles depicted in both the *chʻaekkŏri* screens in the Brooklyn Museum (Figure 15.1) and the Sneider collection (Figure 20.1).

Other Chinese examples of trompe l'oeil type "scholar's room painting" have been discussed. Six skillfully executed parts, or fragments of what is thought to have once been a large painting, now in the Anthony Victoria collection in New York City, reveal a mastery of painting technique (Figures 11.3–11.6).[15] For example, the Western quill pen in its inkwell, flower arrangement, and box with a vase all have perfectly rendered shadows, unlike their Korean counterparts (Figure 11.3). The titled books are perhaps the most revealing aspect of the Victoria fragments. Twelve

Figure 11.1
Attributed to Father Giuseppe Castiglione (Lang Shining). Qing dynasty. Ink and mineral pigments on paper. 125 × 245.1 cm. Mr. and Mrs. James Morrissey collection, Palm Beach, Florida. Photo by Lucien Capehart.

Figure 11.2
Detail of Figure 11.1, bottom left panel. Castiglione's inscription, which reads, "I am privileged to address the emperor thusly, painted with respect by Lang Shining." This was a customary way for a government official to address an emperor. Photo by Lucien Capehart.

volumes of *Ancient Writings (Guwen)* are found in Figure 11.4. Eight volumes of the *Spring and Autumn Annals (Chunqiu)*, and two volumes of *Tang Poetry (Tangshi)* are depicted in Figure 11.5. This Chinese trompe l'oeil "scholar's room painting" shows that the practice of including specific book titles existed in China as well as in Korea. Documentary evidence indicates that King Chŏngjo (r. 1776–1800) instructed his court artists to include book titles in their *ch'aekkŏri* in order to elevate the literary taste of his palace circle. Since there are no known surviving *ch'aekkŏri* paintings from Chŏngjo's reign, and it is unknown when the Victoria fragments were painted in China, we cannot conclude in which country the practice began.

Other objects are also labeled in the Victoria fragments. A large tea canister has the name of a famous brand, "Wuyi Spring Tea," and a smaller one is captioned,

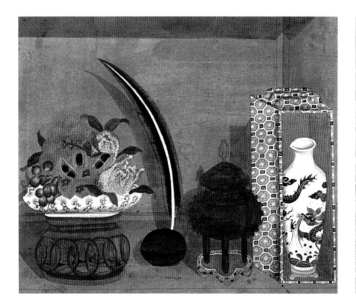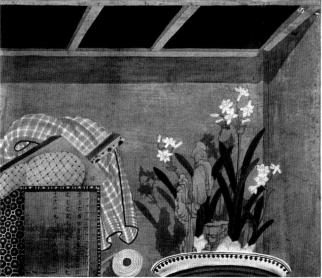

Figure 11.3
Detail of Chinese trompe
l'oeil *ch'aekkŏri* fragments
thought to have once been
part of a larger Qing-dynasty
painting in the Anthony G.
Victoria collection, New York
City. It illustrates a feather
quill pen in its ink well, a
dragon-decorated vase, and
flower and fruit arrangements.
Photo by the author.

Figure 11.4
Detail of a Chinese Qing-
dynasty trompe l'oeil *ch'aekkŏri*
fragment in the Anthony
G. Victoria collection, New
York City. It illustrates eight
volumes of the *Spring and
Autumn Annals*, two volumes
of the *Tang Poetry*, and the
Chinese New Year flower, the
narcissus. Photo by the author.

"Transcendent—one who has become immortal by eliminating desire" (Figure 11.6). In Figure 11.5, there are two handscrolls rolled up next to each other; one says, "Wen Zhengming's painting," the other reads, "Dong Beiyuan's [Dong Yuan's] landscape." Both Wen Zhengming (1470–1559) and Dong Yuan (c. 934–c. 962) were elite artists of the Southern School whose works served as correct models for literati to observe and copy. A third handscroll, found in a brush holder on the same fragment, is labeled, "A genuine work by Lanting," which refers to Wang Xizhi's (303–361) famous calligraphy entitled *Lantingji xu*.[16] Lanting is the name of a celebrated pavilion in Shaoxing, Zhijiang Province. The painting's imagery and inscriptions convey the eremitic ideal of a simple life in nature, which was popular with Chinese scholar officials. A painting on this theme, when presented to an official, showed appreciation for the recipient's personal qualities and his inner harmony and purity of spirit, thus illustrating this ideal.[17]

A set of twelve hanging scrolls from the Kangxi period (1661–1722) entitled *Twelve Beauties of the Yangmingyuan* reveals built-in bookcase shelves with a display of precious objects like the ones seen in Korean *ch'aekkŏri* screens. However, the style of the Chinese bookcases is very different from that of the Chosŏn ones. The Qing bookcases are asymmetrical, and elaborate openwork embellishes their frames.[18] While the Chinese and Korean display cases are related in concept, the Korean choice of simplicity and elegance of line for their bookcase design is indebted to Ming furniture, not Qing.

Other examples of Chinese "scholar's room painting" have been found in Buddhist settings. A group of trompe l'oeil paintings decorates the interior architraves of the Monastery of the Magic Cliff (Lingyansi) in Jinan, Shandong Province (Figure 11.7: only five of twenty-five shown).[19] Another trompe l'oeil type painting, entitled *Still Life of Offerings, Wat Sutat, Bangkok, Reign II* (1809–1824) is in a Buddhist temple in Thailand.[20]

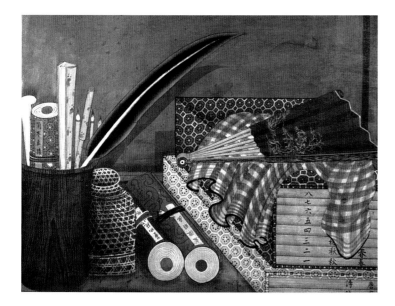
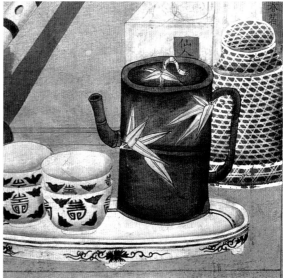

The Buddhist connection to *chaekkŏri* painting is far from clear.[21] It is thought that monks and perhaps lay people as well painted the temple *chaekkŏri* in China and Korea. According to the monks at the temple in Thailand, their *chaekkŏri* was painted by Chinese artists hired to decorate the columns and beams.

Chinese trompe l'oeil *chaekkŏri* exist in other media. For example, the bookcase theme is carved in marble in the three-dimensional friezes at White Pagoda Park, Lanzhou, Gansu Province. Curio cabinets replete with twenty-five scholars' and Buddhists' objects, but only one book, are deeply carved in another marble frieze decorating Dragon Mountain Temple (Longshansi) on Mount Wutai in Shanxi Province.[22] The friezes' ornate style suggests an early nineteenth-century date.

An unusual pair of late Qing reverse glass "scholar's room paintings" were auctioned at Sotheby's, London in 2006.[23] Their anonymous artist intended them to be hung as a pair facing each other, but without the focal center panel. The objects are very large, leaving little empty space in the compartments of the bookcase.

The aforementioned textual references and the extant examples of Chinese trompe l'oeil type *chaekkŏri* firmly establish the point of departure that Korean painters might have used as they further developed the genre. Korean artists did a curious thing when they produced trompe l'oeil paintings on folding screens. They combined elements of both Western and East Asian perspective into one style of screen, by revealing five surfaces of an interior space, in the Western style, and by using multiple vanishing points and isometric perspective to depict book stacks, in the East Asian tradition.[24] In East Asian perspective, there were multiple vantage or station points, in contrast to the single one characteristic of the European method. In painting trompe l'oeil *chaekkŏri*, Korean artists were attracted to the pictorial innovation of showing the five interior surfaces of a bookcase or curio cabinet—floor, ceiling, back, and two sides—in the Western manner, instead of depicting only three of its interior surfaces as was possible in the East Asian tradi-

Figure 11.5
Detail of a Chinese Qing-dynasty trompe l'oeil *chaekkŏri* fragment in the Anthony G. Victoria collection, New York City. It illustrates two hand scrolls: one is labeled, "Wen Zhengming's painting," the other, "Dong Beiyuan's landscape." The label on the third hand scroll translates, "A genuine work by Lanting." Photo by the author.

Figure 11.6
Two tea canisters shown in a Chinese Qing-dynasty trompe l'oeil *chaekkŏri*. One is labeled "Wuyi Spring Tea," the other, "Immortal or Fairy who has become immortal by eliminating desire." Anthony G. Victoria collection, New York City. Photo by the author.

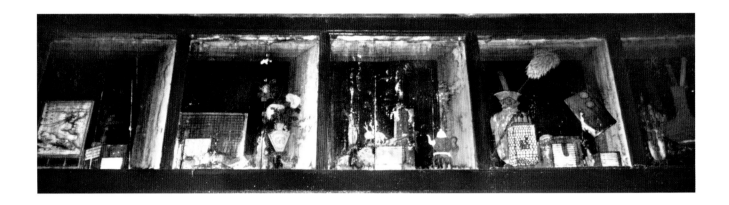

Figure 11.7
Five trompe l'oeil panels
decorating architraves of the
Monastery of the Magic Cliff
in Jinan, Shandong Province.
Photo by William D. Y. Wu.

tion. Strangely enough, these *chaekkŏri* painters were the only Korean artists who exploited the perspective system in this manner.

The stylistic chronology of trompe l'oeil *chaekkŏri* has revealed an experimental phase, a middle one, and an apogee. Clearly, a long period must have elapsed as the Korean *chaekkŏri* artists overcame the difficulties presented by the European system of perspective, and moved from isometric, with its equidistant parallel lines representing recession, to linear, with its convergent receding lines. *Chaekkŏri* artists maintained the central section as their focal point. The strong ceiling and floor perspectives indicate that the screens were meant to be viewed close on at eye level from a seated position on the floor. Thus, the Korean tradition of trompe l'oeil *chaekkŏri* painting developed independently from that of China. Once the high point had been reached by artists using an intuitive versus mathematical approach, and paintings of make-believe bookcases with scholar's treasures succeeded in tricking the eye, there was a shift in focus. As the later examples demonstrate, their artists were no longer interested in the use of linear perspective and trompe l'oeil techniques to create an illusion. Instead, they began experimenting in a new direction. Subject matter was abstracted, simplified, and the emphasis was on color and form. No longer did the trompe l'oeil *chaekkŏri* fool the eye, causing the beholder to think he was looking at a real bookcase filled with scholar's treasures. The metaphor for the scholar's world remains, but the illusion is gone.

* A table of artists we have identified who painted trompe l'oeil type *chaekkŏri* screens is in Exhibit 11.1.

Exhibit 11.1 Table of Identified Artists of Trompe l'Oeil *Ch'aekkŏri*

Artist's Name	Pen Name	Courtesy Name	Date	Collection
Trompe l'oeil/ isolated type combination	Sŏkch'ŏn or Ch'ŏnsŏk		*sangwŏn kapcha:* 1864, or 1924	Brooklyn Museum (Figure 15.1)
Yi Hyŏng-nok (two examples)	Songsŏk	Yŏt'ong	*b*1808–*c*1874; painted under the name Yi Hyŏng- nok (used 1833–1863)	1) Leeum, Samsung Museum Art (Figure 13.4) 2) Private collection in Seoul (missing two panels) (Figure 13.1)
Yi Ŭng-nok (two examples)	Songsŏk	Yŏt'ong	Painted under the name Yi Ŭng-nok (used 1864 and 1866)	1) Asian Art Museum of San Francisco (Figure 13.7) 2) National Museum of Korea (Figure 13.10)
Kang Tal-su		Chasam	*b*1856; Passed Medical Examination in 1876	Joseph Carroll (Figure 16.1)
Yi To-yŏng (with two seals impressed)	Kwanjae (most frequently used); Pyŏkhŏja; Myŏnso	Chungil	*b*1884–*d*1933	Formerly Minn Pyong-Yoo (Figure 21.1)
Attributed to Pang Han-ik; painted in honor of Kim Ki-hyŏn	Chisan, possibly Kosong	Pongnae	*b*1833; passed Translator's Examination, 1850	Leeum, Samsung Museum of Art (Figure 17.1) * Date posited for screen: 1895

NOTES

1 Cal French, *Through Closed Doors: Western Influence on Japanese Art 1639–1853* (Rochester, MI: Meadow Brook Art Gallery, Oakland University, 1977), p. 99.

2 Michael Sullivan, *The Meeting of Eastern and Western in Art* (revised and expanded ed., Berkeley and Los Angeles: University of California Press, 1989), p. 16; French, pp. 103–104. These peep boxes, calledDutch glasses, were imported into Nagasaki from Suzhou, China, in 1718.

3 Lee Ki-baek, p. 189.

4 Gari Ledyard, "Hong Taeyong and His Peking Memoir," *Korean Studies* 6 (1982), pp. 63, 71, 91, 97, n. 8.

5 Ledyard, p. 91.

6 Ledyard, pp. 71, 97, n. 8.

7 Translation by Gari Ledyard. I am grateful for Ledyard's contribution of this unpublished material.

8 Beurdeley and Beurdeley, p. 56.

9 Beurdeley and Beurdeley, p. 33.

10 Because Hong Tae-yong was sophisticated in his knowledge of mathematics, he could well have understood the principles of Euclidian congruent triangles inherent in linear perspective and transmitted the concept back to Korea, although there is no evidence that he did.

11 During the reign of Yongzheng (1722–1735), Castiglione, the Jesuit priest who was at the Chinese court for thirty years, is said to have helped Nian Xiyao, Superintendent of Customs, to adapt Pozzo's treatise *Perspective Pictorum et Architectorum* into Chinese. This Chinese publication appeared in 1729 and was reissued in 1735. Beurdeley and Beurdeley, p. 37.

12 Personal communication with Daphne Lange Rosenzweig, November 23, 1994, after she examined the painting when it was in the collection of Anthony Victoria in New York City. This painting was published in Black and Wagner, "Court Style *Ch'aekkŏri*," fig. 1.

13 The following criteria are used to describe the registers within trompe l'oeil *ch'aekkŏri*:
 - Upper: Anything bordered by the top frame of the bookshelf.
 - Lower: Anything bordered by the bottom frame of the bookshelf.
 - Middle: One or two shelves through the middle ground of the bookshelf, bordered by neither the top nor the bottom frame of the bookshelf.

14 Thomas Lawton, *Chinese Figure Painting* (Washington DC: Smithsonian Institution, 1973), pl. 15.

15 I am indebted to Anthony Victoria for allowing me to photograph his paintings.

16 Personal communication with He Li, July 29, 2005.

17 Julia K Murray, *The Last of the Mandarins: Chinese Calligraphy and Painting from the F. Y. Chang Collection* (Cambridge, MA: Arthur M. Sackler Museum, Harvard University, 1987), p. 60.

18 Tian Jiaqing, "Early Qing Furniture in a Set of Qing Dynasty Court Paintings," *Orientations* 24, no. 1 (January 1993), pp. 36–37, figs. 12, 12A; Wan Yi et al., *Qingdai gongting shenghuo (Life in the court of the Qing dynasty)* (Hong Kong: The Commercial Press, Hong Kong Branch, 1985), pl. 164.

19 I am grateful to William D. Y. Wu for sharing his knowledge and photographs of these *ch'aekkŏri*.

20 Elizabeth Lyons, *Thai Traditional Painting* (Bangkok: Fine Arts Department, 1963), fig. 6 and p. 5. According to Forrest McGill, paintings such as this are seen all over Thailand. They may, or may not, date to the Bangkok, Reign II (1809–1824). Personal communication with McGill, September 13, 2004. In China, Korea, and Thailand, it was the practice to repaint the paintings in Buddhist temples whenever they wore out. Therefore, it seems impossible to date them precisely without documentation or other corroborating evidence.

21 It is unknown whether a monk or a layperson painted the temple *ch'aekkŏri* in China or Korea. The Sackler's one-panel trompe l'oeil *ch'aekkŏri* most probably did come from a Buddhist temple, but proof is lacking. However, according to Minn Pyong-Yoo and his wife, the temples had many paintings sent as presents to the royal family and aristocrats to help their prayers be answered. In addition to paintings, small bags of gold were suspended from the temple's beams to curry favor. The beams were decorated in black calligraphy with the names of the donors. Personal communication with Mr. and Mrs. Minn Pyong-Yoo, October 1983.

22 I am indebted to Patrick Maveety for a photograph of the frieze at White Pagoda Park and to Patricia Berger for her opinion that the frieze lacked great age. She thought perhaps it was a modern replacement for an old one destroyed during the Cultural Revolution. I am grateful to John S. Edwards for photographs of the two friezes at Dragon Mountain Temple.

23 Sotheby's, London, *Chinese Ceramics and Works of Art* (auction catalogue), November 8, 2006, Lot 416. A pair of reverse glass *ch'aekkŏri* paintings from the late Qing dynasty were recently sold at auction. These solid panels were intended to be hung together; painted from opposite vantage points, creating a central focus. The Chinese artist had reverted to isometric perspective, as only three interior sides of the bookcase are visible. The objects are large, and the only shading visible is on the incense burner.

24 For a lucid explication of the difference between Asian and Western perspective, see March, pp. 69–72, fig. 2.

12

Peep Box Trompe l'Oeil Type *Ch'aekkŏri*

The two-panel *ch'aekkŏri* in the Joo Kwan Joong and Rhee Boon Ran collection in Seoul is called the "Peep Box'" screen because it embodies the camera obscura principle (Figure 12.1). The camera obscura, from the Latin meaning "dark room," is the ancestor of the photographic process. The instrument was a darkened enclosure having an aperture usually provided with a lens through which light from external objects entered to form an image on the opposite surface. Instruments of this sort were popular in Europe for drawing and viewing perspective scenes during the seventeenth and eighteenth centuries.[2] By the end of the seventeenth century, peep boxes had found their way to China where they were manufactured in Suzhou.[3]

The Peep Box screen differs from others of the trompe l'oeil type by depicting deep compartments instead of shallow shelves to hold the books and vessels. This depth reflects the principle of the camera obscura, and is reminiscent of Maruyama Ōkyo's and Shiba Kōkan's fascination with it in the late eighteenth and early nineteenth centuries in Japan. Note the upper left compartment of the right panel. Here the artist shows the compartment straight on using linear perspective, but he pivots the books to the right while leaving their spines aligned with the shelf—a position impossible to duplicate in reality. However, it is typical for the spines and edges of book stacks and slipcases to remain parallel to the leading edges of the shelves in trompe l'oeil *ch'aekkŏri*.

A new compositional element is the depiction of drawers that cut the panels in half, separating the upper and lower compartments. The artist uses European linear perspective to create compartments on his screen, while he renders the book stacks in East Asian isometric perspective, yet another *ch'aekkŏri* characteristic. One compartment best represents the juxtaposition of East Asian perspective, where the lines remain parallel as they recede, and European perspective, where the receding lines converge. In this respect, the screen seems earlier because of the deep recession, particularly visible in the upper right compartment.

Three vessels of exceptional shapes and proportions, thirty books, framing, and

Figure 12.1
Two-panel "Peep Box" trompe l'oeil type screen. Mineral
pigments on paper. 75.3 × 42.6 cm. Joo Kwan Joong and Lee
Boon Ran collection, Seoul. Photo by Norman Sibley.

drawers take up most of the picture plane, creating an overall geometric design of elegant simplicity. The colors are soft and muted. The vessels are delicately articulated with their arrangements of Buddha's Hand citrons and peaches, but without the usual flowers. The graceful bottle with a cracked-ice patterned glaze is overlaid with a foliate design. Another unusual detail is the presence of the nine books bound in the Korean fashion with five stitches, not the Chinese nor Japanese bookbinding style of four stitches.[4]

NOTES

1 The right-hand panel is published in Kim Chŏl-sun, ed., *Minwha* (Folk painting), Han'guk ŭi mi, vol. 8(Seoul: Chungang ilbosa, 1978), pl. 160.

2 For an example of a Japanese version of this instrument, see French, catalogue nos. 42, 43.

3 French, p. 103.

4 An Ch'un-gŭn, *Och'im anjŏngbŏp* (Method of five-stitched bookbinding) (Seoul: Chŏnt'ong munhwa, 1983), p. 17.

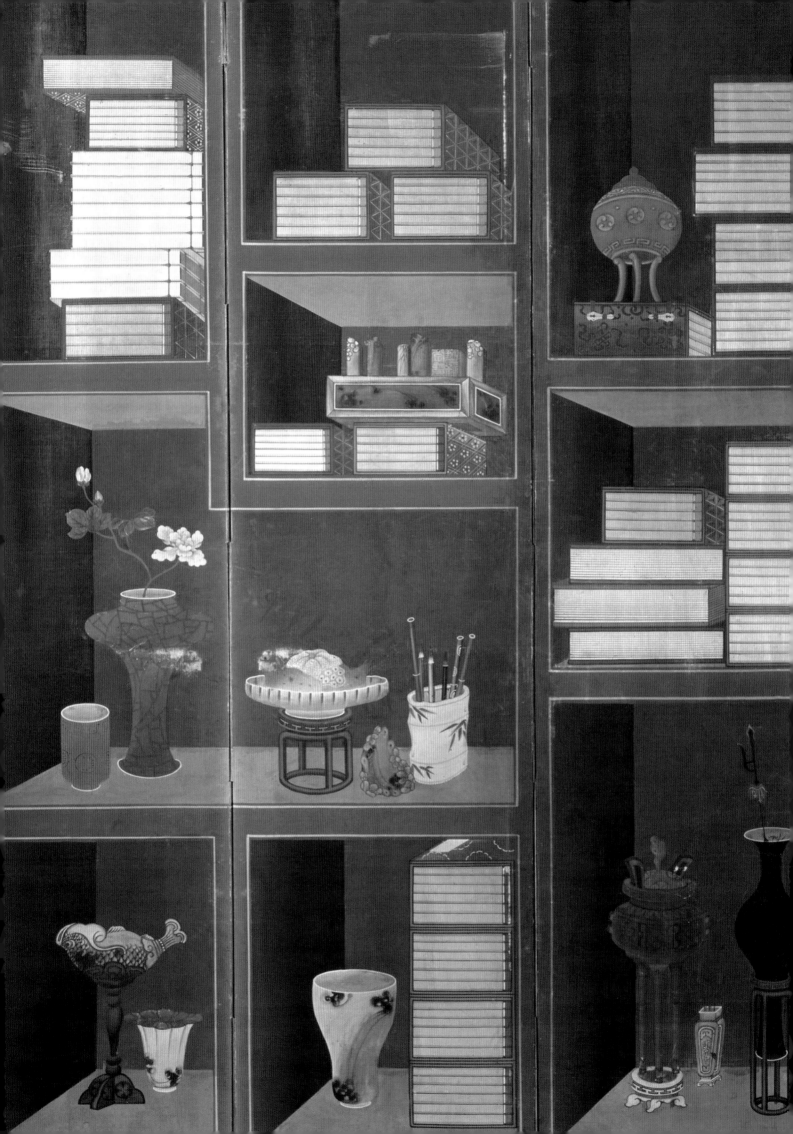

13

Trompe l'Oeil *Ch'aekkŏri* at the Chosŏn Court:
A Late Chosŏn Period Artist with Three Different Names

Having identified artists who painted in the trompe l'oeil style (Exhibit 11.1) and having determined that *ch'aekkŏri* painters were indeed patronized by the court, our investigation was encouraged by the high artistic quality of several *ch'aekkŏri*, which continued to contradict the notion that the screens had all been produced by folk painters. Our desire to identify more specific *ch'aekkŏri* painters inaugurated a search that would prove more complicated and mysterious than Wagner and I would ever have imagined, as we tried to unravel the case of one artist who painted under three different names.

In 1986 Wagner and I discovered that the artists of four trompe l'oeil *ch'aekkŏri* paintings could be identified—two by an Yi Hyŏng-nok (Figures 13.1 and 13.4) and two by an Yi Ŭng-nok (Figures 13.7 and 13.10).[1] (See Chapters 2 and 5 for earlier discussions concerning Yi Hyŏng-nok). Wagner and I discovered that the artists' name seals were cleverly depicted as elements of the composition, not stamped onto the surface as a signature in the traditional manner of East Asian painters.[2] *Ch'aekkŏri* artists were innovative. They painted into their works one or more seals by which they could be identified. Indeed, the *ch'aekkŏri*'s theme provided the perfect context for an artist to cleverly reveal his name in this way. Furthermore, not only could Yi Hyŏng-nok be identified by name, he also proved to be a painter-in-waiting (*ch'abi taeryŏng hwawŏn*).[3] However, for years, there were no available records that identified Yi Ŭng-nok. Were the four *ch'aekkŏri* by two separate hands? Or, as their shared surname Yi might suggest, were the artists related to each other because of the same second element in their personal names—or were they even the same person? Wagner and I puzzled over this quandary for four long years.

Since Kim Hong-do (1745–before 1818) was Korea's most famous and versatile painter of the period and held the distinction of becoming the county magistrate of Yŏnp'ung, his connection to the *ch'aekkŏri* genre elevates its importance. It has been suggested that Kim Hong-do might have painted King Chŏngjo's *ch'aekkŏri*.[4] Furthermore, it is thought that the earliest *ch'aekkŏri* painter to have been identified

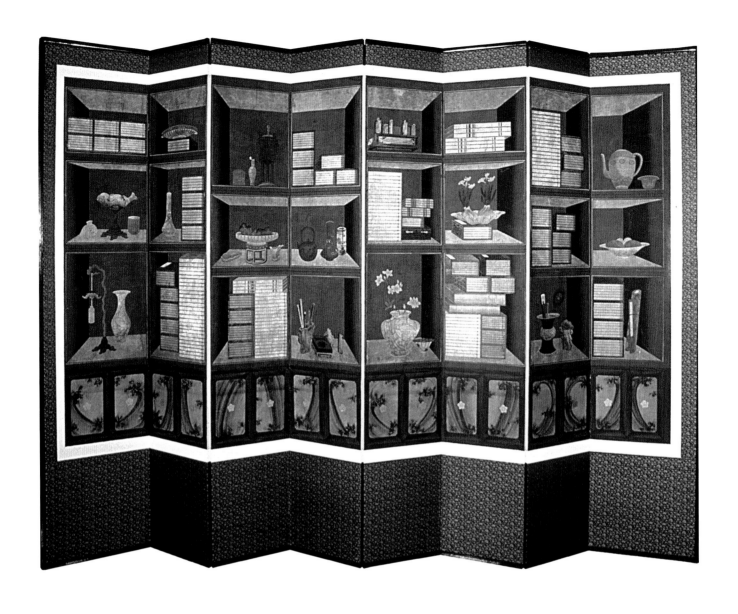

Figure 13.1
Ten-panel trompe l'oeil type screen, (mounted without two panels at the left end currently missing) by Yi Hyŏng-nok between 1827–1863. Ink and mineral colors on paper. 163 × 320 cm. Private collection, Seoul. Photo by the author.

Figure 13.2
Detail of Figure 13.1, panel 4 top. Seals of "Man of Wansan" (right) and Yi Hyŏng-nok. Photo by the author.

104

Figure 13.3
Perspective overlay of the
private collector's screen
(Figure 13.1) showing five
vanishing points used by
Yi Hyŏng-nok. A sixth
vanishing point is presumed
to have existed on the
missing two panels.

to date, Yi Chong-hyŏn (1718–1777), may have been influenced by Kim Hong-do
because they were known to have collaborated for a year at Kang Hŭi-ŏn's house.[5]
Because the family of Kim Hong-do did not leave a legacy of *ch'aekkŏri* painters
behind (as far as is now known), Yi Chong-hyŏn must be considered the founder of
the Korean mainstream of trompe l'oeil type *ch'aekkŏri,* even though his style might
have been influenced by Kim Hong-do. This mainstream passed to Yi Chong-hyŏn's
son, Yi Yun-min (1774–1841), who in turn passed it down to his son, Yi Hyŏng-nok
(1808, or after 1874).[6] Literary documentation attests to the quality of Yi Yun-min's
ch'aekkŏri. Recorded in the *Ihyang kyŏnmun nok* (Village Observations) by Yu
Chae-gŏn (1793–1880) is the following:

> Painting master Yi Yun-min (1774–?), courtesy name Chaehwa, was skilled at
> painting the various appurtenances of a scholar's study, and among the screens
> and paper sliding doors in upper-class houses many are from his hand. In his
> time he was praised as having no peer, he was so outstanding. His son Hyŏng-
> nok also continued the family tradition, and he achieved an extremely refined
> artistry. I had one set of his multi-paneled "study screens" (*munbangdo*), and
> whenever I set it up in my [study] room, visitors who might see it [at first]
> had the mistaken impression of books filling their cases full. But then, when
> they came close for a better look, they would smile. Such was the exquisite
> lifelikeness of his painting.[7]

Unfortunately, no extant works by Yi Chong-hyŏn or his son, Yi Yun-min,
are known. Therefore, the mainstream style must be judged by the paintings of Yi
Hyŏng-nok. When Wagner and I began our study of *ch'aekkŏri*, reference materials
on the subject were scant. The standard reference works divulged that there was an
Yi Hyŏng-nok born in 1808, but no death date was given. Records further indicated

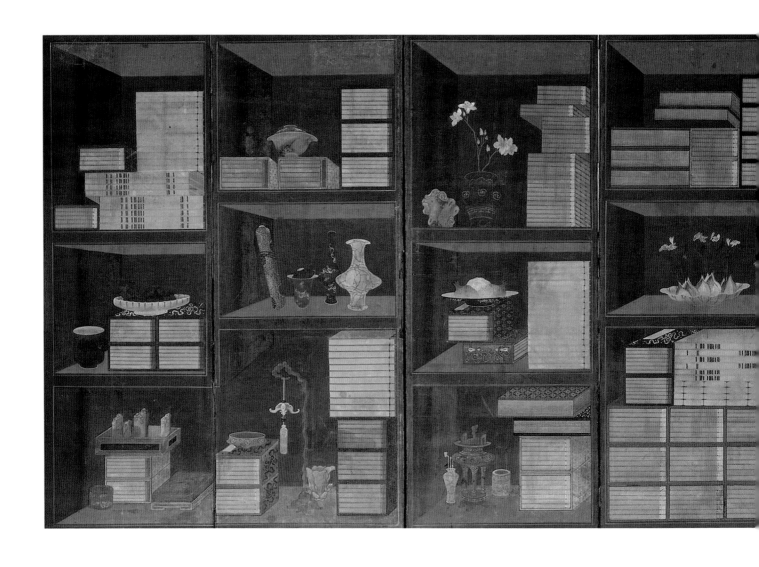

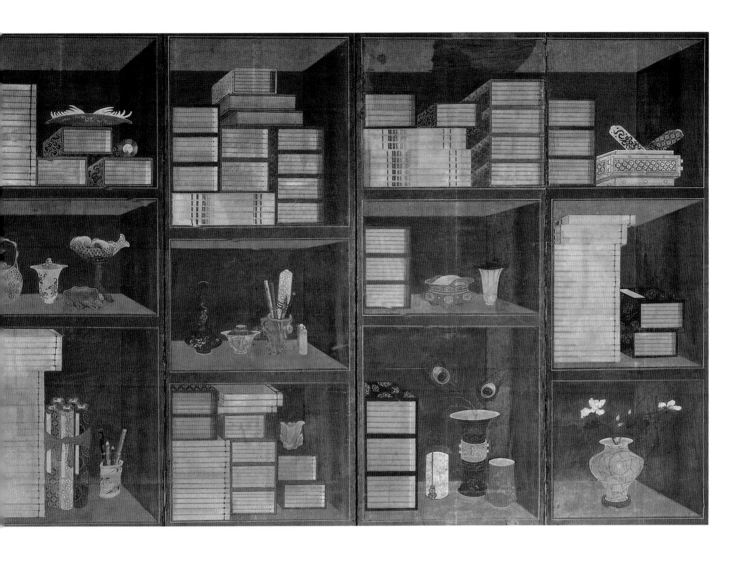

Figure 13.4
Eight-panel *chaekkŏri* screen, trompe l'oeil type by Yi Hyŏng-nok between 1827–1863. Ink and mineral colors on paper. 140.2 × 468 cm. Leeum, Samsung Museum of Art. Photo courtesy of the Leeum.

Figure 13.5
Detail of Figure 13.4, panel 8. Seal of Yi Hyŏng-nok. Photo courtesy of the Leeum.

Exhibit 13.1 Yi Hyŏng-nok's Chŏnju Yi *Chungin* Genealogy

Explanatory Notes:

Relationships and dates are from the clan genealogy: *Chŏnju Yi-ssi chokpo* 全州李氏族譜. Seoul?: 1858. 7-40a ff.. except that Tŏk-yŏng 悳泳's year of birth is found in *Taehan min'guk kwanwŏn iryŏksŏ* 大韓民國 官員 履歷書. Seoul: National History Compilation Committee. 1972. p. 32c. The genealogy, however, makes no mention whatsoever of the artistic activities of those in the lineage who served as Court Painters (those marked with a "Court Painters"), nor does it record a pen name for any of them. Identification as Court Painters has been taken from sources recording *chungin* lineage data and from the several *chapkwa pangmok* 雜科榜目, the rosters for the various "miscellaneous" government service examinations.

that, at some point, he changed his name to Yi T'aek-kyun.[8] His courtesy name (*cha*), Yŏt'ong, and his pen name (*ho*), Songsŏk, are also recorded.[9]

"Man of Wansan," that is, Chŏnju and a second one, Yi Hyŏng-nok's seal, both seen resting on a Chinese-style seal box (Figure 13.2), were the vital clues in a *ch'aekkŏri* screen in a private collection in the U. S. (hereafter "private collector's *ch'aekkŏri* [or screen]") because they linked this painter to one of the very few *chungin* genealogies known to have been published, that of an important *chungin* sublineage of the royal Chŏnju Yi clan.[10] This is fortuitous indeed, because it is to this particular Chŏnju Yi sublineage that Yi Hyŏng-nok belongs. One recent source notes that the Chŏnju Yi lineage to which he belonged included six close kinsmen

Figure 13.6
Perspective diagram for Yi Hyŏng-nok's Leeum screen (Figure 13.4) showing eight vanishing points on two different levels. Image by Okada Tomoyuki.

who also were court painters.[11] As can be seen in Exhibit 13.1, there were six successive father-to-son generations of court painters in Yi Hyŏng-nok's direct line of descent from an early eighteenth-century apex figure. There were twenty-one descendants and one son-in-law altogether in these six generations who were painters—a truly remarkable concentration of professional painters in one family. However, where would Wagner find written information about Yi Ŭng-nok, the other *ch'aekkŏri* painter identified by the presence of a name seal within the composition of the screen? Whose "extra" son might he have been? Was he already listed in the family genealogy, but under a different name? Otherwise, was it possible that the four *ch'aekkŏri* screens under study here were executed by one hand, not two? At the outset of Wagner's and my research, a case could have been made either way. The practice of name changing that was prevalent during this period made it necessary to consider the possibility that Yi Hyŏng-nok and Yi Ŭng-nok were one and the same person. Furthermore, the four screens are stylistically similar, yet enough differences exist between the paintings that include Yi Hyŏng-nok's seals and those that include Yi Ŭng-nok's seals to suggest that the screens represent either two distinct phases within the work of one artist, or the work of two artists—perhaps two with a close working relationship. To this end, I undertook a full stylistic analysis of the four paintings as a way to determine whether or not Yi Hyŏng-nok and Yi Ŭng-nok were in fact a single painter.

Because Yi Ŭng-nok's *ch'aekkŏri* (Figures 13.7 and 13.8)[12] in the Asian Art Museum of San Francisco (AAM) had been remounted in Japan as eight separate hanging scrolls, it was necessary to reassemble the paintings in the probable sequence of the screen that the artist originally planned before a comparison between it and the other three *ch'aekkŏri* could be made. Since the National Museum of Korea screen (Figures 13.10 and 13.11) that also bears the Yi Ŭng-nok seal is still in its original mounting, it led me to use the composition's symmetry as a model for reconstruction of the AAM screen (Figure 13.7).[13] After ruling out the possibility that two panels were missing in the AAM screen, the panels were then placed in their probable order. The key to determining the proper order of

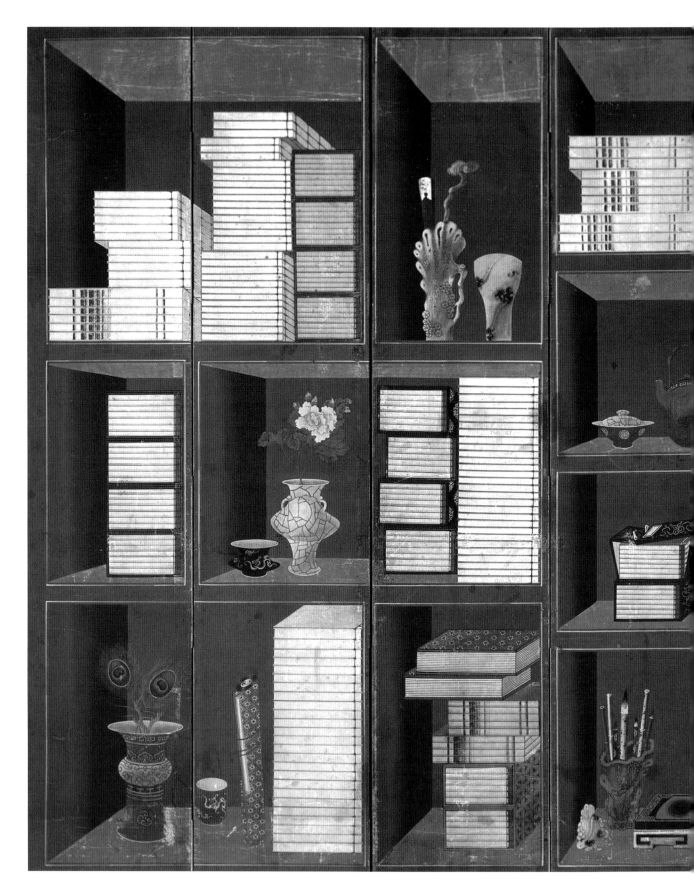

Figure 13.7
Eight-panel trompe l'oeil type *ch'aekkŏri* screen by Yi Ŭng-nok, between 1864–1866.
Ink and mineral pigments on paper. 163 × 276 cm. Asian Art Museum of San Francisco
(acc. no. 1998.11). Photo courtesy of the Asian Art Museum of San Francisco.

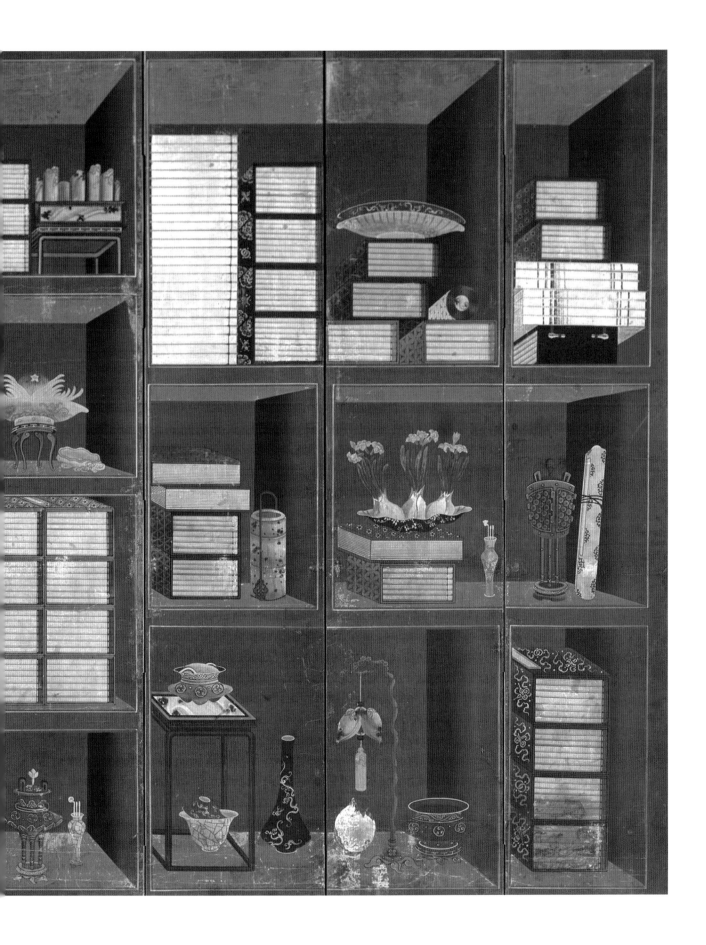

the panels lay in determining the angles at which the shelves are depicted. Here an orthogonal is perceived as an apparent acute angle, when it actually is a right angle, or third plane, which runs perpendicular to the vertical and horizontal planes of the bookcase shelves. I determined that the innermost panels were the ones in which the third dimension of the bookcase is delineated with the most acute angles. Proceeding outward from the center, the angles become less and less acute in successive panels.[14]

The accompanying diagrams attempt to show how the Korean artists used linear perspective to create their trompe l'oeil screens (Figures 13.3, 13.6, 13.9 and 13.12). It seems probable that the artists painted these five screens from the center outward because the center compartment is the only one where all five sides are visible: bottom, top, two sides, and back. (Isometric perspective allowed only three sides of an interior space to be seen.) The diagonal lines of the orthogonals form two sides of the triangles; the vertical sides create the bases. Theoretically, these opposing triangles should meet in the center. However, the artists were not slaves to linear perspective; they took artistic license to avoid the distortions that strict adherence to linear perspective dictates. In other words, they were not painted using a mathematically defined immutable vantage point, they were painted by eye. As the painters moved outward to either side from the center, their vantage points changed and new triangles emerged. Otherwise, severe distortion would have resulted at the screens' ends and there would have been no visible shelf space in which to depict the objects. Thus, the artist needed to include multiple vanishing points to keep the orthogonal angles acute. Once these angles became oblique, the shelves' contents would have been eclipsed by the sides of the shelves themselves.

Yi Ŭng-nok created the most congruent (same shape and scale) triangles in his National Museum symmetrical *ch'aekkŏri* in keeping with Euclidian geometry (Figure 13.12). This screen and Castiglione's Chinese one (Figure 11.1) are very similar in their use of perspective. Although the other three *ch'aekkŏri* have a few

congruent triangles, most are similar triangles.

The perspective of the "Baroque" *ch'aekkŏri* is the most successful of the trompe l'oeil examples in this study (Figure 1.8). Its anonymous artist has kept all six vanishing points almost level across the width of the screen's entire middle ground.

The four Yi Hyŏng-nok/Yi Ŭng-nok paintings are certainly connected by their inclusion of similar objects, including the narcissus, a brush holder fashioned from a tree root, bronze incense burners and tools, a clubmoss–shaped brush holder, a magnolia blossom specimen vase, the same style of inkstone, and peacock feathers in a bronze vase. Book covers are depicted in the same patterns, including the "seven treasures pattern" (*ch'ilbomun*), which *by* the late Chosŏn meant long life and happiness.[15] These "jewel symbols" from the Indian *saptna ratna* go back to the fourteenth-century Koryŏ period.

A Chinese bronze vase with a peacock feather and a coral branch conveys a wish for the highest official rank in China. The same meaning extends to either the feather or coral alone depicted in a vase. Terese Tse Bartholomew, in her *Hidden Meanings in Chinese Art*, used a detail taken from the AAM Yi Ŭng-nok *ch'aekkŏri* screen to illustrate the wish.[16]

There are also differences among the objects in the screens. For example, Yi Ŭng-nok's details, such as book cover patterns, are emphasized and are delineated by the "iron wire" line, a show of calligraphic skill. In his AAM screen, a blue brocade book cover with white roundels is cut off at the edge, just where the natural fold-under point occurs. This kind of detail represents a very logical approach, and differs from that seen in Yi Hyŏng-nok's works. A *taotie* mask, which is originally seen on Chinese bronzes from the Anyang period (c. thirteenth century–c. 1027 BC) of the Shang dynasty, is found depicted on the waist of a Qing dynasty version of an archaic bronze vase in Yi Ŭng-nok's painting.[17] If such a design appears in either of Yi Hyŏng-nok's screens, the lines depicting it are too abstract to be recognizable as such. By comparison, the relative reduction of detail makes Yi Hyŏng-nok's *ch'aekkŏri* appear farther away from the original.

This trend away from realism can be seen in the shadows cast on the interior sides of the bookcases in Yi Hyŏng-nok's works, which are unnatural and unconvincing. Instead of shading the colors gradually, one to another, there are four lines of demarcation. This is somewhat true in Yi Ŭng-nok's two screens, but the shading is softer, and while the shadow is unnatural, it is more believable because of the hazy effect. Everything about the Yi Hyŏng-nok *ch'aekkŏri* in the Leeum is looser and more schematized.

Since Wagner and I recognized that the four trompe l'oeil type *ch'aekkŏri* were similar in their formal aspects and had seals carved in the same style of ancient seal script, it seemed likely that there was an important connection between Yi Hyŏng-nok and Yi Ŭng-nok. Naturally it was necessary to discover if they were related, but the evidence was at first inconclusive. Since the second character of their given names (the generation specifier) was identical, it was possible—perhaps even likely—that the two men were brothers or first cousins belonging to the same sublineage. Unfortunately, no record could be found of a painter named Yi Ŭng-nok, the two trompe l'oeil type *ch'aekkŏri* screens being his only known link to the

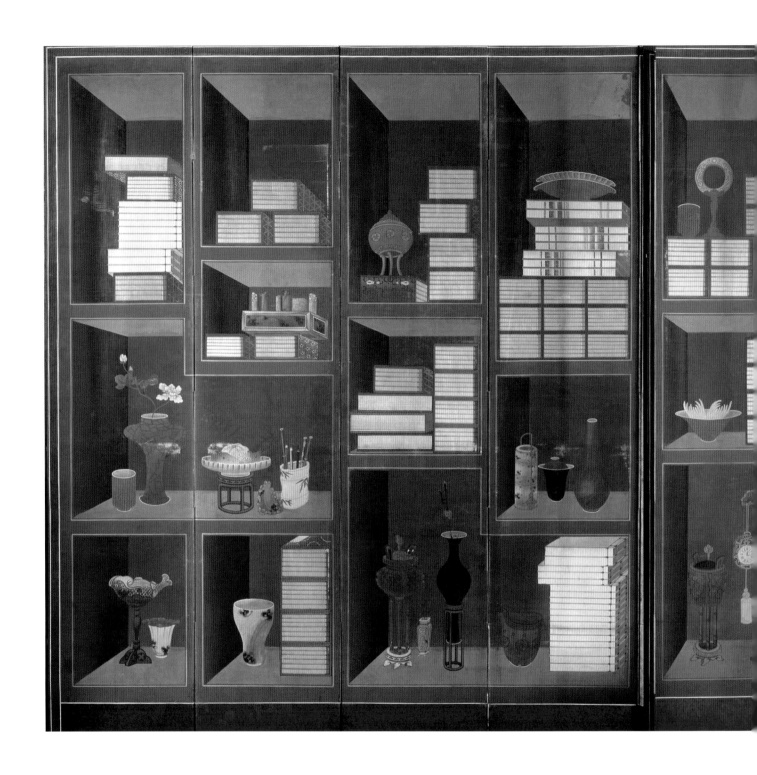

Figure 13.10
Ten-panel trompe l'oeil type *ch'aekkŏri* screen by Yi Ŭng-nok,
probably between 1864–1866. Ink and mineral pigments on silk
or hemp. 152.7 × 351.8 cm. National Museum of Korea (Tŏksu
Palace 6004). Photo courtesy of the National Museum of Korea.

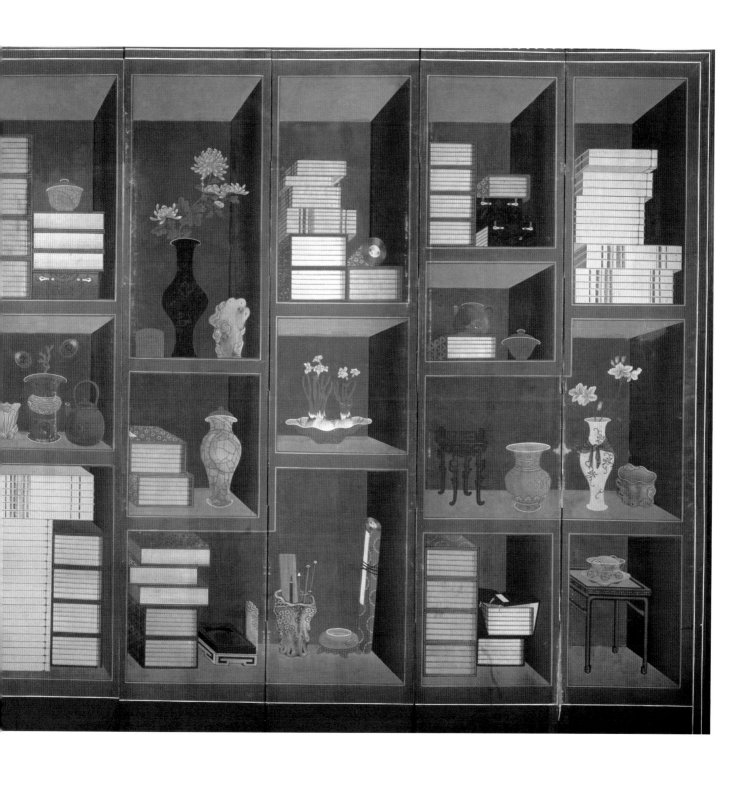

Exhibit 13.2 Yi Hyŏng-nok's Marriage in the Chŏnju Yi and Hanyang Yu *Chungin* Genealogies

Chŏnju Yi genealogy, 7-41b-42a:

Commander of Ten Thousand 萬戶	[Yi] Yun-min 〔李〕潤民	son Hyŏng-nok 子 亨綠	married a 配	Hanyang Yu family 漢陽劉氏	f. (rank 2b mil. post) 父 同樞	Un-p'ung 運豐	gf. Chun-gi 祖 濬基	ggf. Ik-kyŏm 曾 益謙

Hanyang Yu genealogy, 4-29b-31a:

Commander of Ten Thousand 萬戶	[Yi] Yun-min 〔李〕潤民	son Ŭng-nok 〔子〕李膺*祿	[is the husband of a]	Hanyang Yu dau. 〔漢陽 劉〕女	f. (rank 2b title) 〔父〕嘉善	Un-p'ung 運豐	gf. Chun-gi 〔祖〕濬基	ggf. Ik-kyŏm 〔曾〕益謙

Chŏnju Yi genealogy, 7-41b-42a:

〔children of this marriage:〕	son Chae-gi 子 在基	son Chae-sŏn 子 在善	son Chae-gyŏng 子 在慶	dau. 〔m.〕Paek Yŏng-bae 女 白英培	dau. 〔m.〕Pak Hŭng-yun 女 朴興胤

Hanyang Yu genealogy, 4-29b-31a:

〔children of this marriage:〕	son Yi Chae-gi 子 李在基	son Yi Chae-sŏn 子 李在善	son Yi Chae-gyŏng 子 李在慶	dau. 〔m.〕Paek Yŏng-bae 女 白英培	dau. 〔m.〕Pak Hŭng-yun 女 朴興胤

* This *"ŭng 膺"* character is not the one（應）found on the *ch'aekkori* screen seals. Perhaps the best explanation for this difference is to note that similar variation is found not infrequently in traditional Korean records and that, specifically, other cases of the switching of these two characters, which share at least one meaning in common, are known.

f.: father
gf.: grandfather
ggf.: great grandfather
dau.: daughter
m.: married to

painting world.

For years, Wagner and I puzzled over the mystery of Yi Ŭng-nok's identity. As far as was known at the time, the name did not appear anywhere except on two *ch'aekkŏri*. Wagner had in his possession Yi Hyŏng-nok's Chŏnju Yi genealogy (Exhibit 13.1), but it alone was not sufficient to allow positive identification of specific individuals. At last, another *chungin* genealogy came into Wagner's hands (Exhibit 13.2)[18] that resolved the mystery of Yi Ŭng-nok's identity. This genealogy, in recording Yi Hyŏng-nok's marriage to a daughter of Hanyang Yu Un-p'ung, wrote the husband's name as Yi Ŭng-nok, recording at the same time the names for his father, his three sons, and his two daughters' husbands with Chinese characters which were identical to those used in the Chŏnju Yi genealogy. Since the birth date of Yi Hyŏng-nok's Hanyang Yu wife (the 18 day of the 6th lunar month, 1805) is found in the foreword to the Chŏnju Yi genealogy dated 1858, it is certain that she was his first (if not only) wife and the mother of the five children named identically in both genealogies. Thus, the mystery of Yi Ŭng-nok's identity was unraveled: one artist created the screens that included both the Yi Hyŏng-nok and Yi Ŭng-nok name seals.

Even though Yi Ŭng-nok is recorded as a court painter on the 10th day of the 1st lunar month of 1864 when he substituted as a painter-in-waiting for Cho Chŏ-dŏk,[19] it is not recorded that he ever took the extra bonus examination under that name, nor apparently under the name Yi T'aek-kyun.[20] This seems odd in light of

Figure 13.11
Detail of Figure 13.10, panel
9. Seal of Yi Ŭng-nok.
Photo courtesy of the
National Museum of Korea.

his having painted for the king twice in 1873 and once in 1874.[21] It is also odd that Yi Hyŏng-nok was recorded as a court painter under three different names, but that he only took the extra bonus examination as Yi Hyŏng-nok. Perhaps by the time he had changed his name to Yi Ŭng-nok, and then to Yi T'aek-kyun, he was enjoying a semi-retirement.

Once the problem of Yi Ŭng-nok's identity was solved, the next question to be answered was which name he used first: Yi Hyŏng-nok or Yi Ŭng-nok? In response to this question, there are two conflicting records. The genealogy of the Hanyang Yu family states that Yi Ŭng-nok was the name under which Yi was married (Exhibit 13.2). Men traditionally married very young in Korea, which suggests that Yi Ŭng-nok was the name first used. Furthermore, stylistic analysis also suggested that the Yi Ŭng-nok screens came first. Since Yi Ŭng-nok's works are somewhat more realistic than Yi Hyŏng-nok's, and realism generally precedes abstraction in painting, Wagner and I decided that the style of Yi Ŭng-nok's *ch'aekkŏri* seemed earlier than Yi Hyŏng-nok's, thus corroborating the Hanyang Yu genealogy and the conclusion that Yi Ŭng-nok must have been the name first used.

Since Wagner and I co-published this conclusion in 1993, the *"Record of Court Ceremonies"* was brought to our attention.[22] There it is recorded that Yi used the name Yi Hyŏng-nok from 1827 through 1863—from the age of nineteen until he was fifty-five.[23] The name Yi Ŭng-nok was not used until 1864 and once more in 1866,[24] before the artist changed it to another name, Yi T'aek-kyun, in 1873 and 1874.[25]

Wagner had a strong suspicion that Yi might have been switching back and forth between his names, Yi Ŭng-nok and Yi T'aek-kyun, at this time. His notes state that T'aek-kyun is the name which appears in the "Records of Applying for Positions" in 1864; the same year that the name Yi Ŭng-nok is given in a list of

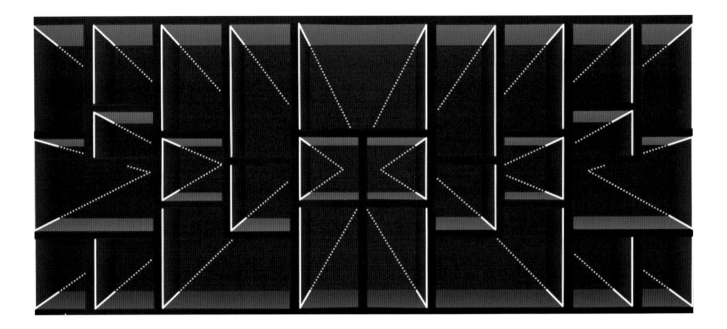

Figure 13.12
Perspective diagram for Yi Ŭng-nok's National Museum of Korea screen (Figure 13.10). Image by Okada Tomoyuki.

painters included in the "Record of Court Ceremonies."[26] Yi Ŭng-nok is also the name listed in the same record for 1866.

One might speculate further that the name his own lineage genealogy uses, Hyŏng-nok, represents that name by which he was known around the time the genealogy was being compiled in the late 1850s, when he was close to fifty years of age and presumably widely known in Seoul society as a painter. The reason why his name was changed, and indeed subsequently changed again, to Yi T'aek-kyun, probably lies in the area of popular superstitious beliefs, but cannot be known. It is easily demonstrated, however, that such name changes occurred with great frequency, indeed with even greater frequency, in nineteenth-century Korea. However, a name change did require a royal decree. The statute does not apply to the male population in general, where name changing was widely practiced, but only to those who served for the king or the palace.[27] The fact that Yu Chae-gŏn (1793–1880) referred to the painter as Yi Hyŏng-nok in the *Ihyang kyŏnmun nok* (Village Observations) at some point before Yi Yun-min died in 1841 further corroborates that Yi Hyŏng-nok, not Yi Ŭng-nok, was the first name Yi used. Hence, there must have been a delay between the time of Yi's marriage to the Hanyang Yu daughter and the time when the event was entered in the Hanyang Yu genealogy.

In light of this, it seemed important to rethink Yi Hyŏng-nok's stylistic development.[28] Stylistically, the trompe l'oeil *ch'aekkŏri* executed under the name of Yi Ŭng-nok appear to be more realistically rendered than do those painted under the name of Yi Hyŏng-nok, which are slightly more schematized and abstract. Since depicting a bookcase of scholarly treasures was meant to create the impression of a real bookcase, and the whole point was to fool the eye, it seemed logical to think that the schematized versions came later.

With the newly acquired knowledge that Yi Hyŏng-nok was the first name used by the painter, I reevaluated the development of the artist's style. A comparison

of Yi Hyŏng-nok's widest *ch'aekkŏri* (over fifteen feet long) at the Leeum (Figure 13.4)[29] and Yi Ŭng-nok's narrower one at the AAM (Figure 13.7) suggests that the painter used the name Yi Ŭng-nok in his later, more sophisticated work. Yi Hyŏng-nok's composition has a horizontal "flow," and the objects seem to be arranged in waves across the painting's surface. Various objects are scattered along laterally, and piles of books are grouped in zones. The percentage of books to objects is greater here than in Yi Ŭng-nok's *ch'aekkŏri*. This has the effect of simplifying the whole. A slight asymmetry is seen in the bookcase's structure on the end panels.

By contrast, Yi Ŭng-nok's AAM *ch'aekkŏri* depicts a narrower and taller bookcase structure that is quite asymmetrical in its two center panels, which are flanked by symmetrical wings, balancing the composition. In the AAM *ch'aekkŏri* the bottom half of the two center sections comprises four compartments, with the left side an upside-down version of the right. The eye of the viewer is thus drawn to the screen's central area. The wings depicted on his National Museum screen are mirror images of each other. There are complicated frontal planes because of Yi Ŭng-nok's use of four tiers of shelves, whereas Yi Hyŏng-nok's *ch'aekkŏri* has only three tiers of shelves throughout, resulting in simplified frontal planes. All four *ch'aekkŏri* have a central focus caused by the frontal planes guiding the eye to the middle. How Yi Hyŏng-nok and Yi Ŭng-nok created the illusion of space is important, and it is clear that in structure the bookshelves in Yi Ŭng-nok's paintings are more complex than those in Yi Hyŏng-nok's. Yi Ŭng-nok's palette is rich, and his handling of color contrasts is skillful and dramatic, whereas Yi Hyŏng-nok's colors seem bland and the forms flat.

The images are crisper and more plastic in both of Yi Ŭng-nok's *ch'aekkŏri*. For example, both the peach and the flower arrangement in the AAM screen attract the eye of the spectator by the way in which they glow against their muted backgrounds. The still life compositions in Yi Ŭng-nok's *ch'aekkŏri* are more tightly organized and less mannered than those in Yi Hyŏng-nok's screens. The palette became deeper and richer as his work evolved under Yi Ŭng-nok's name; gone were the light colors of shelves and ceilings of the bookcases from his years as Yi Hyŏng-nok.

The major difference between the screens painted under the names Yi Hyŏng-nok and Yi Ŭng-nok and the isolated type *ch'aekkŏri* painted under the name Yi T'aek-kyun at T'ongdosa Museum (Figure 5.9) is immediately visible in the palettes of the seven screens attributed to this artist. Yi Hyŏng-nok used somber grey and aubergine to form the background of his trompe l'oeil screens in the Leeum and in a private collection in Seoul, whereas Yi Ŭng-nok adds a grey-blue to the somber background of the AAM screen, and a rich green to enhance the National Museum of Korea screen's palette. In stark contrast to these somber palettes are the bright colors of Yi Hyŏng-nok's isolated type screens in P'yŏngyang and the National Museum of Korea. In Yi T'aek-kyun's T'ongdosa screen, the color scheme is even brighter—malachite green, cobalt blue, and cinnabar red all juxtaposed against a background of golden hued silk, which indeed make a lively *ch'aekkŏri* palette. The small sampling of Yi's *ch'aekkŏri* paintings available for study suggests that he reserved a brighter palette for his isolated type screens than for his trompe l'oeil *ch'aekkŏri*. However, at the same time, his trompe l'oeil palette became richer as that

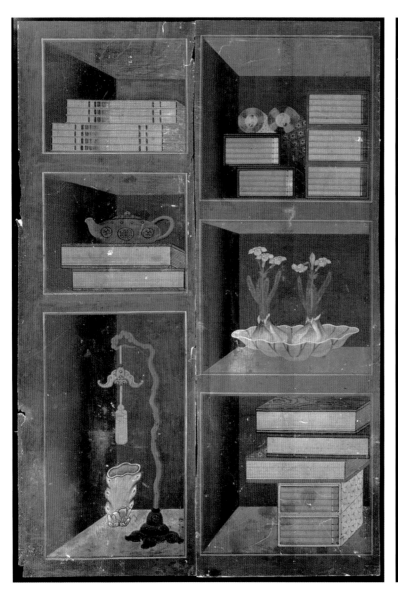
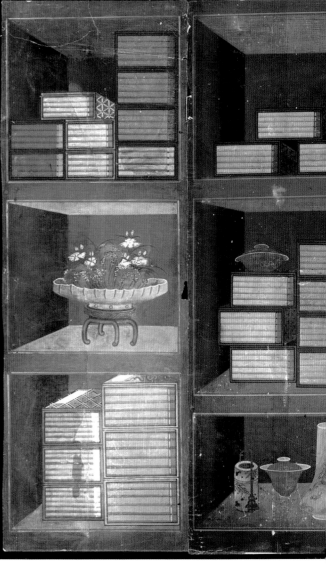

Figure 13.13
Eight-panel screen by an anonymous follower of Yi Hyŏng-nok.
Ink and mineral colors on paper. 102.6 × 280 cm. Sold at Christie's,
New York, March 23, 1999. This shows the same palette as the
Leeum screen of Figure 13.4. Photo courtesy of Christie's.

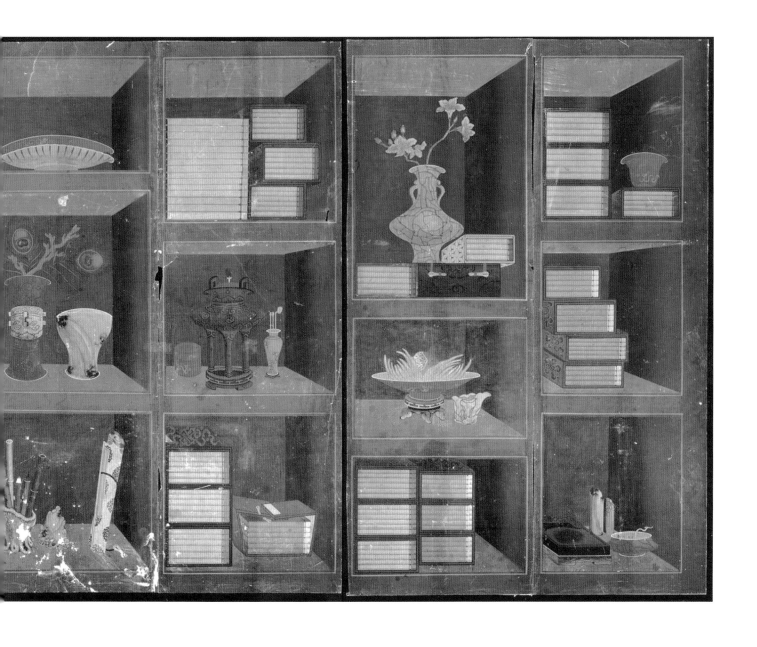

style evolved under Yi Ŭng-nok's name.

Four other versions similar to Yi Hyŏng-nok's *ch'aekkŏri* exist. Two are eight-panel screens lacking in seals. One was sold at auction in New York (Figure 13.13).[30] The other is in the Kurashiki Museum of Folk Craft in Japan.[31] The third is a four-panel *ch'aekkŏri* without a seal whose other half is now lost. It is in the Robert Mattielli collection in Portland, Oregon.[32] The fourth is a six-panel screen at the Musée Guimet (missing two of its first three panels on the right side, but it does have a pair of illegible seals shaped like those in the Anonymous Collector's *ch'aekkŏri* in Seoul.[33] They are so similar in palette and style to the two trompe l'oeil *ch'aekkŏri* painted by Yi Hyŏng-nok under that name that they raise the question: Were they painted by the famous *ch'aekkŏri* artist himself, or by a relative, or by another hand?

At present, neither examples of trompe l'oeil type *ch'aekkŏri* by Yi T'aek-kyun, nor any of the isolated type by Yi Ŭng-nok are known to exist. These gaps in the record need to be filled in before a more comprehensive study of Yi Hyŏng-nok's development—under each of his three names—can be established.

NOTES

1 I am indebted to Yi Wŏn-bok for his help in discovering Yi Ŭng-nok's name seal on the National Museum of Korea's *ch'aekkŏri* in 1983.

2 Black and Wagner, "*Ch'aekkŏri* Paintings: A Korean Jigsaw Puzzle," p. 74. It is certainly not unusual in Western trompe l'oeil painting to find the signature of an artist hidden or concealed in the subject matter. See Miriam Milman, *Trompe l'Oeil Painting* (New York: Skira and Rizzoli, 1983), pp. 89, 111 for examples. Both Giovanni Bellini (c. 1430–1516) and Vittore Carpaccio (1460/65–ca1526) signed nearly all their pictures on *cartellini*. In a similar fashion, Louis Leopold Boilly (1761–1845) inscribed his name on a piece of paper depicted on a tabletop. In China, moreover, the practice of hiding a seal imprint harks back to the Song period (960–1279), when artists' seals were first used on paintings and were sometimes concealed in a facet of a rock or the foliage of a tree. R. H. van Gulik, *Chinese Pictorial Art: As Viewed by the Connoisseur*, Serie Orientale Roma 19 (Rome: Istituto italiano per il Medio ed Estremo Orientale, 1958), p. 424.

3 Kang Kwan-sik, vol. 1, pp. 99–100.

4 O Chu-sŏk, p. 83.

5 *ibid*.

6 The last known date that Yi Hyŏng-nok/Yi Ung-nok/Yi T'aek-kyun was alive is the 17th day of the 10th month in 1883 (*Sŏngyŏng ilgi*). The passage notes that Yi T'aek-kyun, a regular salaried person in the Painting Bureau, had been promoted as a military officer.

7 Black and Wagner, "*Ch'aekkŏri* Paintings: A Korean Jigsaw Puzzle," p. 72; *Ihyang kyŏnmun nok* [and] *Hosan oegi*, p. 411.

8 This name change is noted in all the standard references. See Kim Yŏng-yun, p. 421; O Se-ch'ang, *Kŭnyŏk sŏhwajing* (Illumination on painters and calligraphers of Kŭnyŏk [Korea]) (reprint, Seoul: Hyŏptong yŏn'gusa, 1975), p. 235.

9 There remains some question as to Yi Hyŏng-nok's pen name, Songsŏk, which is not given in O Se-ch'ang's *Kŭnyŏk sŏhwajing*. In Kim Yŏng-yun's *Han'guk sŏhwa inmyŏng sasŏ*, exactly the same pen name, as well as the same birth year, is assigned to the entry immediately following Yi Hyŏng-nok, that of the much more widely known painter Yi Han-ch'ŏl.

10 The second seal, "Man of Wansan," is found on an eight-panel screen, originally a ten-panel *ch'aekkŏri*, now missing two panels. It is in a private collection in Seoul and to date is only one of two of Yi's screens to have a second seal included as part of its subject matter. This screen is published in Kim Chŏl-sun, pl. 164. Again, no mention is made of the artist's seals visible in the painting. Subsequently, it was reproduced, in black and white, in Kungnip chungang pangmulgwan, *Han'gukkŭndae hoehwa paengnyŏn 1850–1950*, p. 199.

11 *Han'guk misul sajŏn*, p. 461. These family members were: Yi Yun-min (father), Yi Su-min and Yi Sun-min (uncles), Yi T'aek-nok and Yi Ŭi-rok (cousins), and Kim Che-do (brother-in-law).

12 The AAM *ch'aekkŏri* (acc. no. 1998.11) was formerly owned by the C. V. Starr East Asian Library of Columbia University and is cited as the "Columbia screen" in our two former publications: Black and Wagner, "*Ch'aekkŏri* Paintings: A Korean Jigsaw Puzzle," fig. 5; "Court Style *ch'aekkŏri*," fig. 2.

13 Black and Wagner, "*Ch'aekkŏri* Paintings: A Korean Jigsaw Puzzle," fig. 9.

14 Since a significant number of trompe l'oeil type *ch'aekkŏri* we studied have been remounted in the wrong order, this method is suggested as a system for putting together screens that are currently misaligned.

15 Both of Yi Hyŏg-nok's *ch'aekkŏri* under consideration here have a bronze vase holding a coral branch and two peacock feathers. This particular combination of objects forms a Chinese rebus meaning, "May you achieve the highest official rank." While it is possible that the Chinese symbolism inherent in rebuses was shared by nineteenth-century Koreans, I have no confirming documentation other than the imagery on the *ch'aekkŏri* suggesting that it might have been.

16 Personal communication with Suk Joo-Sun, October 6, 1990. Also see Bartholomew, *Hidden Meanings in Chinese Art*, p. 121, section 5.25.4.

17 For more about this motif, see Keith Wilson, "Powerful Form and Potent Symbol: The Dragon in Asia," *The Bulletin of the Cleveland Museum of Art 77*, no. 8 (1990), pp. 286–291.

18 I am greatly indebted to Mun-sik Yu of Toronto for permitting his clan genealogy to be photocopied.

19 Kumja Paik Kim, "New Acquisitions in Korean Painting," *Orientations* (January 2000), p. 68.

20 Kang Kwan-sik, vol. 2, p. 417.

21 Pak Chŏng-hye, p. 255.

22 Yi Hun-sang, pp. 480–481

23 Pak Chŏng-hye, pp. 244–253, 283, entries for the years 1827a, 1830b, 1834a, 1835ab, 1836a, 1843a, 1848a, 1853bc, 1855bd, 1856a, 1857a, 1858b, 1859b, 1863c. Wagner's and my initial conclusion that Yi Ŭng-nok was the first name used by Yi Hyŏng-nok was reversed by the information provided in Pak Chŏng-hye's article.

24 Pak Chŏng-hye, 1864 a, 1866 acd, p. 281. Two different characters were used interchangeably for Ŭng. It is recorded that Yi Ŭng-nok substituted as a painter-in-waiting for Cho Chŏ-dŏk in 1864.

25 Pak Chŏng-hye, p. 255. Yi Hyŏng-nok is recorded, under that name, as a participant in the painting of an official portrait of the reigning monarch, King Ch'ŏlchong (r. 1849–1863), in 1861. Cho Sŏn-mi, *Han'guk ch'osanghwa yŏn'gu* (Study of portrait paintings in Korea) (Seoul: Yŏlhwadang, 1983), p. 181. Yi Hyŏng-nok is the name consistently used in attributions of paintings to him.

26 See chapter 6, n. 5 above.

27 Wagner, *Chosŏn wangjo sahoe ui songch'wi wa kwisok* and Yi Hun-sang's supplement no. 2.

28 For our original chronological sequencing of the names Hyŏng-nok and Ŭng-nok, see Black and Wagner, "Ch'aekkŏri Paintings: A Korean Jigsaw Puzzle," pp. 66–71.

29 The Leeum screen is published in Kim Ho-yŏn, pl. 148. Another eight-panel trompe l'oeil screen by Yi Hyŏng-nok in a private collection in Seoul is also known to us but will not be discussed here because it is missing two panels.

30 A fourth *ch'aekkŏri* with eight panels could also have come from the Yi Hyŏng-nok family workshop. Christie's, New York, auction catalogue, March 23, 1990, Lot 305; auction catalogue, March 29 and 30, 1990, Lot 148.

31 Kurashiki mingeikan, ed., *Kurashiki mingeikan zuroku* (Catalogue of Kurashiki Museum of Folk Craft), vol. 3 (Okayama: *Kurashiki mingeikan*, 1988), pl. 19.

32 A third *ch'aekkŏri* with only four panels (the other four now lost) also closely resembles Yi Hyŏng-nok's style. This screen is in the Robert Mattielli collection, Portland, Oregon.

33 A six-panel screen, at the Musée Guimet in Paris, is possibly missing two of its panels, but it does have two illegible seals shaped like those on the "Anonymous Collector's" screen in Seoul. Pierre Cambon, *L'Art Coréen au Musée Guimet* (Paris: Réunion des musée nationaux, 2001), p. 48.

14

The Antiquarian Spirit in Trompe l'Oeil Type
Ch'aekkŏri

Only details from the "Antiquarian Spirit" trompe l'oeil *ch'aekkŏri* are available from an unmounted eight-panel screen at the Leeum (Figures 14.1–14.5). Many of the vessels depicted are huge, like those in Castiglione's painting (see Figure 11.1). The artist painted his bookcase in the style of Yi Hyŏng-nok, but he employed a different palette of grey, charcoal, tan, and dark blue for the insides of the shelves. Soft reds, corals, off-white, green, and brown are used for the books and other items. The large expanse of blue in the background dates this *ch'aekkŏri* to the second half of the nineteenth century.

An unusual characteristic of the Leeum screen is the prevalence of clerical script (*yesŏ*, C. *lishu*) inscriptions written on five different vessels. One wonders whether these are merely platitudes conveying the antiquarian spirit, or rather clues to the painter's intentions. The inscriptions read:

"Long do not forget one another" (*changmusangmang*)
found on a box on the top shelf in panel 3 (Figure 14.1).

"A thousand autumns" (*ch'ŏnch'u*)
inscribed on an ancient bronze bell on the middle shelf in panel 6 (Figure 14.2).

While it is possible that *ch'ŏnch'u* could be a pen name, no link between it and someone's surname with given name has been found to date, and therefore a connection to a specific artist or to an honoree cannot be posited.

The third inscription proved difficult to translate. What, at first glance, appears to be three Chinese characters inscribed vertically on the bottle turns out to be six (Figure 14.3). Singly, the top and bottom characters take up the same amount of space on the vessel as do the middle four. The top and bottom ones have been taken from the first and last characters found on the red bowl (Figure 14.4): *man* (ten-thousand) and *kang/gang* (boundary, bound). The central character may be

Figure 14.1
The inscription "Long do not forget one another" found on a box on the top shelf in panel 3 of an unmounted eight-panel screen. Leeum, Samsung Museum of Art. Photo by Norman Sibley.

Figure 14.2
The inscription "A thousand autumns" on an ancient bronze bell on the middle shelf in panel 6 of an unmounted eight-panel screen. Leeum, Samsung Museum of Art. Photo by Norman Sibley.

broken down into four by combining the long "wood" radical on the left with the top, central element to form *song* (pine tree). Repeat this with the "wood" radical and the second element to form *paek* (cypress). Combine the character on the right side of the composite with the "wood" radical to form *sam* (fir). The last character in the central column is *se* (year).

Translate together all the characters on the bottle and it becomes "May you live as long as all the pine trees, cypresses, and firs [evergreens]" (*mansong paeksam segang*)—a longevity wish (Figure 14.3). The "Antiquarian Spirit" screen's anonymous artist was focused on the bottle's design of Chinese characters. Seemingly, his purpose was to be puzzling to subsequent viewers by designing such a mysterious middle character. "Ten-thousand years of longevity without bounds" (*mansu mugang*) is painted on a red fruit bowl on the middle shelf in panel 4—yet another wish for long life (Figure 14.4). "Happiness never ends" (*changnakmiang*) is written across a box, possibly an inkstone case, on the top shelf in panel 8. This four-char-

Figure 14.3
The inscription "May you live as long as all the evergreens," a longevity wish, on a ceramic bottle in panel 6 of an unmounted eight-panel screen. Leeum, Samsung Museum of Art. Photo by Norman Sibley.

Figure 14.4
The inscription "Ten-thousand years of longevity without bounds" on a fruit bowl in panel 6 of an unmounted eight-panel screen. Leeum, Samsung Museum of Art. Photo by Norman Sibley.

Figure 14.5
The inscription of a Han dynasty saying, "Happiness never ends," in panel 8 of an unmounted eight-panel screen. Leeum, Samsung Museum of Art. Photo by Norman Sibley.

acter phrase goes back to the Han dynasty and became a popular ink stick design in the Chosŏn period (Figure 14.5). In China, the character *chang* is associated with Hwangdi. Therefore, *mansu mugang* might be interpreted as birthday wishes for the emperor.

The inscriptions are all auspicious in their meaning. Moreover, China enjoyed a revival of the greater seal script (*chuanshu*) in the eighteenth century, and it became fashionable in the nineteenth century to collect archeological material, known in China as the *Beixue* movement, which was the practice of modeling calligraphy on epigraphical examples, not rubbings.[1] The same practice was in vogue also in Korea, and one wonders whether the Leeum screen with its archaic objects and their ancient inscriptions is a reflection of Northern Learning (*Pukhak*).

NOTES

1 Lothar Ledderose, "Some Observations on the Imperial Art Collection in China," *Transactions of the Oriental Ceramic Society* 43 (1978–79), p. 248.

15

An Atypical *Ch'aekkŏri* and Its Anonymous Painter

The artist who painted the *ch'aekkŏri* in the Brooklyn Museum presents an abstract version of the bookcase theme (Figure 15.1). While this screen is discussed here in the context of trompe l'oeil type *ch'aekkŏri* because it uses the bookcase structure, the painting does not fool the eye. This was a departure from the Yi family workshop tradition of trompe l'oeil type *ch'aekkŏri*. Instead of a continuous composition across the six panels of a folding screen designed to resemble a real bookcase, the artist presents six individual, fragmented still lifes, only hinting at a three-dimensional bookcase. A whimsical abstraction of flat patterns meets the eye. Many of the scholarly objects defy gravity as they are seen floating in space, unsupported by a shelf or resting upon another object. The artist was experimenting with perspective and patterns in an innovative way. Wagner and I discovered significant and tantalizing clues hidden in the subject matter indicating why this screen was commissioned and who the artist may have been.

The Chinese characters *sangwŏn kapcha*, written on an ink stick in panel 1, reveal a cyclical date of either 1744, 1804, 1864, or 1924: the beginning of a new sixty-year cycle in the lunar calendar.[1] Because the screen's abstract style suggests a late date, it seems logical to conclude that the screen was commissioned either to celebrate the New Year of 1864 and the accession of King Kojong to the throne, or 1924, fourteen years after the Chosŏn period ended. If one accepts the slipcase titled *Ch'uch'ŏp* (Figure 15.2, panel 2, center shelf) as a work by Kim Chŏng-hŭi (1786–1856; pen name Ch'usa), either the 1864 or 1924 date is possible for the Brooklyn Museum screen. Kim Chŏng-hŭi had not been born in 1744, and he still would have been too young in 1804 to have acquired fame as a calligrapher and a scholar of epigraphy.

Kim Chŏng-hŭi was a renowned literati artist of an abstract style of painting based on calligraphy and epigraphy. Perhaps the Brooklyn Museum *ch'aekkŏri* represents a parallel painting executed in emulation of Kim Chŏng-hŭi's abstract approach.[2] However tempting it is to assign the screen around the year of King

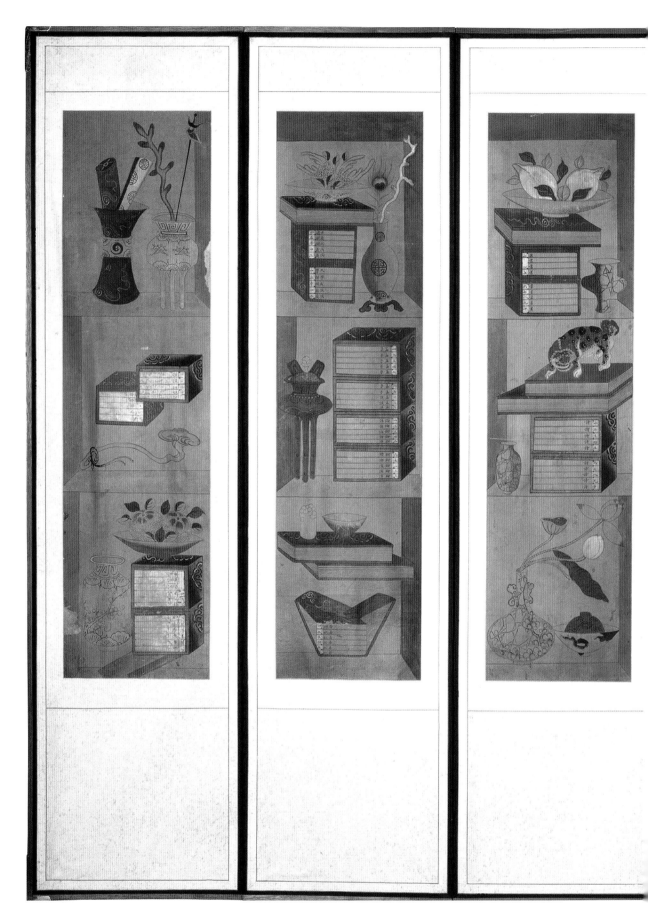

Figure 15.1
Six-panel atypical trompe l'oeil *ch'aekkŏri* with an artist's pen name depicted on a seal (panel 3), Sŏkch'ŏn or Chŏnsŏk. Cyclical date corresponding to 1864 or 1924 and so forth is depicted on the ink stick (panel 1). Ink and mineral pigments on paper. 153 × 39.4 cm each panel. Brooklyn Museum (acc. no. 74.5, gift of James Freeman). Photo courtesy of the Brooklyn Museum.

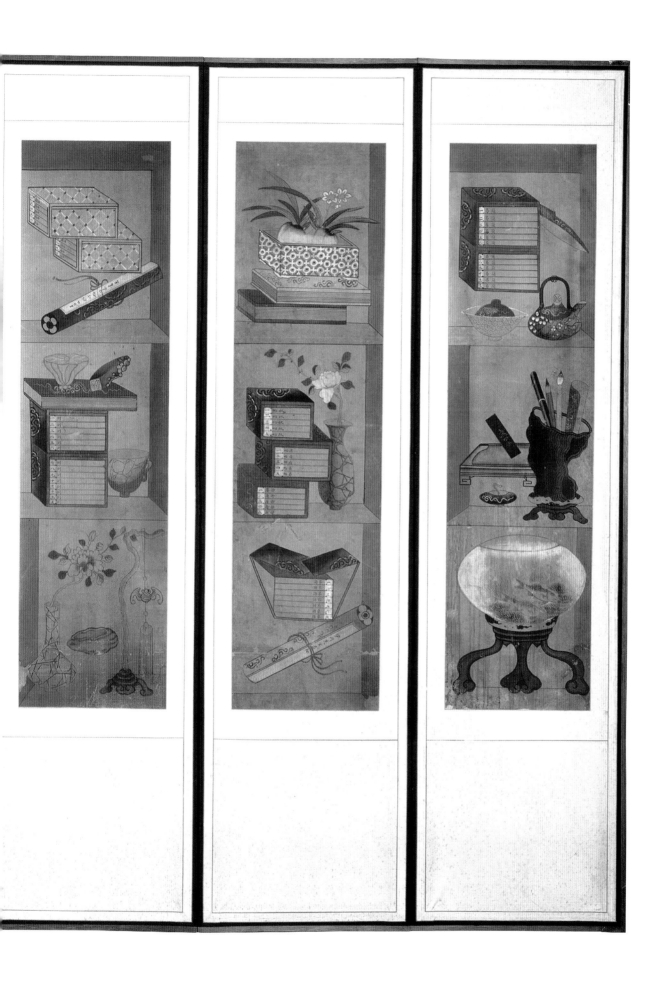

Kojong's accession to the throne, its abstract style suggests the later date of 1924, during the Japanese colonial period.[3]

The Brooklyn Museum screen is currently one of only two trompe l'oeil type *ch'aekkŏri* that we have studied that depicts books with legible titles on their spines, and one of only seven *ch'aekkŏri* in any style to show books with specific titles. The writing of book titles was a characteristic of the gnomon style of still life type *ch'aekkŏri* (see Chapter 25), but rarely appears in trompe l'oeil screens. What prompted the selection of the specific list of book titles? Was the painting's patron or artist responsible for specifying the titles to be included, and could this be traced back to King Chŏngjo's desire to elevate the literary taste of his palace circle?

In this screen there are nine different Chinese book titles, two Korean ones, and only one with a title that we have been unable to match with any actual book of the same name. There are three slipcases, two marked as "albums" with Korean titles—*Michŏp, Ch'uchŏp*, and one with the pen name Chŏngam. All are found on panel 2 and on the same shelf (Figure 15.2, center shelf). Seen floating in air, also in panel 2, is a rolled-up painting titled "A Hanging Scroll by Master Ichŏn" (*Ichŏn sŏnsaeng hwachŏp*) (Figure 15.3, bottom shelf), better known as Cheng Yi (1033–1107). Master Ichŏn (C. Yichuan), better known as Cheng Yi, was one of the revered pioneers of Song Neo-Confucianism. The artist was showing his respect for the Song philosopher and for Neo-Confucianism in this manner.

Angled on the shelf directly above Sŏkchŏn's (or Chŏnsŏk's) seal in panel 3 is another rolled-up painting titled "Wang Sŏkkok's Album of River Bamboo and Calligraphy" (*Wang Sŏkkok sujukchŏp kŭp naesŏan*) (Figure 15.4).[4] Wang Sŏkkok (C. Shigu) is Wang Hui's (1632–1717) courtesy name. He was one of the Four Wangs—famous Qing dynasty painters for whom the *ch'aekkŏri* artist was showing respect.

What, if anything, did the authors of the identified Korean albums have in common? Chŏngam is the pen name of Cho Kwang-jo (1482–1519), one of the first martyrs to Neo-Confucian ideology. *Michŏp* is the album of Hŏ Mok (1595–1682), pen name Misu, who was another important literatus. Kim Chŏng-hŭi was also exiled twice for political reasons, as well as for malice directed at him personally, and he barely escaped capital punishment.[5] Many statesmen were exiled for similar political reasons during this time. All three were statesmen who had political troubles and were purged because of their support of what they perceived as righteous causes. It seems clear that the artist was making a strong political statement by depicting the works of these three famous Korean statesmen.

The Chinese books named in panels 4 and 5 of the screen include all Four Books. Of the Five Classics, only *The Book of Rites* is missing. What this omission means and why it might be significant has yet to be determined. Nevertheless, it seems clear from the clues presented that this screen had some didactic purpose. Perhaps the screen's subject matter reflects either its patron's (more likely) or its artist's political views in some way. One thing is certain, the screen conveys multiple messages intended to instruct.

Interestingly, virtually all of the objects depicted in the screen are of Chinese derivation. The book patterns are more like those seen in two Chinese *ch'aekkŏri*

Figure 15.2
Detail of Figure 15.1, panel 2. Three
Korean albums on middle shelf on panel
2. Inscribed with "Chŏngam" (pen name
of Cho Kwang-jo), "Ch'u's (probably
Ch'usa's, Kim Chŏng-hŭi) album," and
"Mi's (probably Misu's, Hŏ Mok) album."
Photo courtesy of the Brooklyn Museum.

Figure 15.3
Detail of Figure 15.1, panel 2. Rolled-up scroll
entitled "A hanging scroll by Master Ich'ŏn."
Photo courtesy of the Brooklyn Museum.

Figure 15.4
Detail of Figure 15.1, panel 3. Rolled-up
scroll entitled "Wang Sŏkkok's painting
of river bamboo and calligraphy". Photo
courtesy of the Brooklyn Museum.

than those seen in the four trompe l'oeil type paintings by Yi Hyŏng-nok. For instance, when Yi Hyŏng-nok depicted a brocade book cover decorated with foliate roundels, he interspersed symbols of Buddhist origin from the set known as the seven treasures pattern.

As with many of the other *ch'aekkŏri* we have discussed, the presence of a name seal within the composition of the screen presents a tantalizing clue as to the identity of the painter. In this case, a stone seal atop a stack of books on the middle shelf of panel 3 of Figure 15.1 displays the Chinese characters *Sŏkch'ŏn* (or *Chŏnsŏk*). One of these is presumed to be the artist's pen name, but the point is moot as currently we are unaware of an artist with either name whose lifespan fits the first quarter of the twentieth century when this stylistically unusual screen was probably created.

NOTES

1 A cycle is formed by combining the ten stems and twelve branches of Chinese characters and in regular order, beginning with the first of each; the same combination comes up every sixty years. Other Chinese characters on the ink stick read, "Top quality sixty flowers," believed to be a brand name for the ink.

2 Lee Ki-baek, p. 260.

3 For overview, see Kim Yongna, *20th Century Korean Art* (London: Laurence King Publisher, 2005).

4 The pen name on the seal is ambiguous in the way it is depicted as an imprint, not as carved intaglio on the seal. It could be logical to read the name as Sŏkch'ŏn because the same name, unambiguously readable, appears on a seal in another screen discussed above (Figures 5.7 and 5.8), but the latter is apparently not by the same hand. Usually, but not always, the characters imprinted with the seals are read from right to left; therefore, I leave open both possibilities.

5 Lee Ki-baek, pp. 205–206.

16

The Identification of Kang Tal-su:
A New Piece in the *Ch'aekkŏri* Jigsaw Puzzle

Having discovered in the Yi Hyŏng-nok/Yi Ŭng-nok screens that the depiction of seals in *ch'aekkŏri* were clues to the identity of their artists, Wagner and I searched other screens to see what secrets they would reveal. In 1992, we identified a third *ch'aekkŏri* painter by name.

The existence of Kang Tal-su (1856–?) as a painter is substantiated solely through a ten-panel trompe l'oeil type *ch'aekkŏri* screen in the Joseph Carroll collection in New York, formerly in Ambassador Pierre Landy's collection in Paris (Figure 16.1).[1] In this screen, Kang Tal-su's seal is found depicted on top of a Chinese seal box (Figure 16.2) in the same way that seals appear in the screens by Yi Hyŏng-nok/Yi Ŭng-nok (Figures 13.2, 13.5, 13.8, and 13.11). Evidence of Kang Tal-su's connection to the Chinju Kang lineage is found in the *Sŏngwŏnnok* (Records of [*Chapkwa-Chungin*] Lineage Origins) (see Exhibit 16.1 for Kang Tal-su's genealogy).[2] There it is established that he passed the medical examination in 1876.[3] Born in 1856, Kang Tal-su's courtesy name was Chasam. Kang Tal-su and Yi Hyŏng-nok were relatively closely connected, as one can see from the Kang Tal-su family tree created by Ledyard (Exhibit 16.2). He is Yi Hyŏng-nok's second cousin once removed, a seven-inch cousin (*ch'ilch'on*). They are, respectively, grandson and great grandson of the brothers Yi Chong-hyŏn (founder of the mainstream of *ch'aekkŏri*) (see Exhibit 13.1) and Yi Chong-gyu, both court painters themselves.[4] Kang Tal-su's Chinju Kang genealogy reveals a most unusual practice of "adopting out" three first born sons to near relatives who had no sons (Exhibit 16.1).[5] Perhaps if more *chungin* genealogies are ever published, Kang Tal-su's family tree may not seem so odd.

The many visible similarities between Kang Tal-su's screen and those by Yi Ŭng-nok suggest that Kang Tal-su's might have come from the Yi workshop or family studio. Given the manner in which Chosŏn period families lived in close proximity in clusters of houses and courtyards, a formal art workshop as is found in the West need not have existed for ideas and styles to have been freely shared.

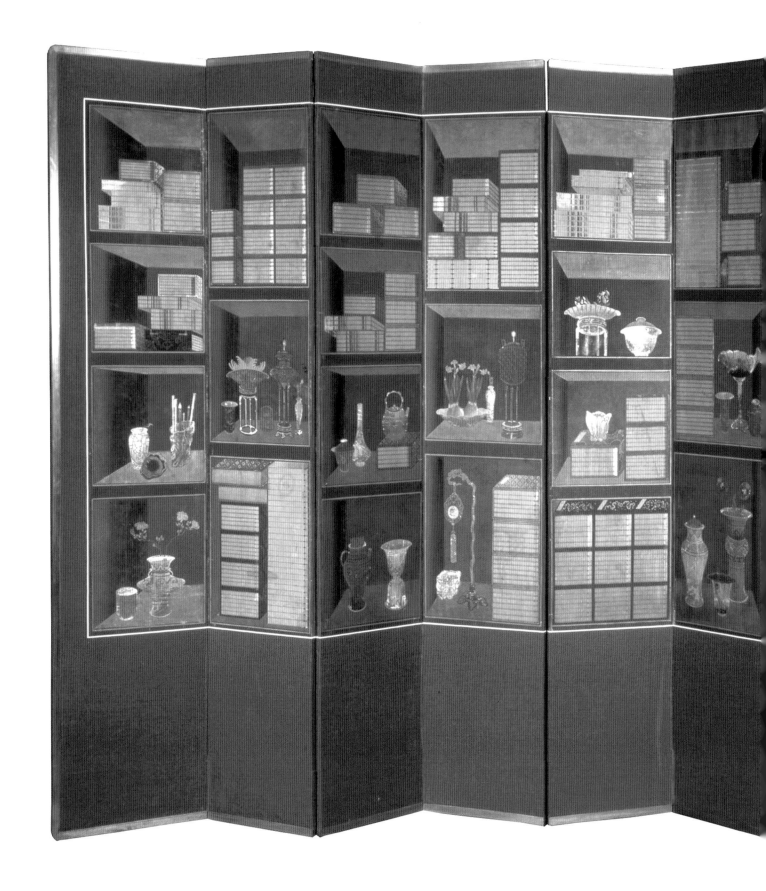

Figure 16.1
Ten-panel trompe l'oeil type *ch'aekkŏri* screen by Kang Tal-su in the last quarter 19th century. Ink and mineral pigments on silk or hemp. 144 × 382 cm. Joseph Carroll collection. Photo by the author.

Figure 16.2
Detail of Figure 16.1. Seal of Kang Tal-su, panel 2. Photo by the author.

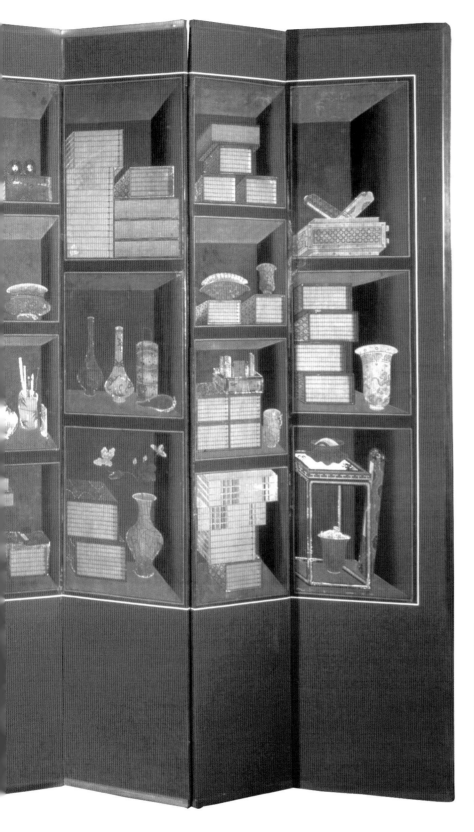

Kang also apparently abandoned the established prototypical design with the screen's central focus, and instead experimented with new *ch'aekkŏri* compositional devices. His screen presents an innovative shelving construction, in which he alternates panels of four-tiered and three-tiered shelves across the screen in a zigzag pattern, thus flattening the three-dimensional effect. The viewer's eye is induced to move vertically as well as horizontally across the screen. At present, this is the earliest known *ch'aekkŏri* composition which is neither symmetrical nor balanced and in which the impact is diffused, conveying the impression that the screen lacks formal boundaries. Stylistically, Kang's work belongs to the last quarter of the nineteenth century, long after the problems presented by linear perspective had been solved for the purpose of creating trompe l'oeil screens, and marks the beginning of a new trend in trompe l'oeil *ch'aekkŏri* painting.

Thematically, Kang Tal-su's *ch'aekkŏri* reveals enough similarities to Yi Ŭng-nok's to suggest that Kang was following his style. The striking difference between Kang Tal-su's work and Yi Ŭng-nok's is the rich blue background color of Kang Tal-su's panels. The background palette is somber on Yi's trompe l'oeil screens (executed under two of his names, Hyŏng-nok and Ŭng-nok). Kang's lavish use of cobalt blue appears fresh, if not radical, in the *ch'aekkŏri* genre (even though it is prevalent in folk paintings and Buddhist paintings of the late Chosŏn period).

In other ways, though, Kang uses elements in a manner similar to Yi Ŭng-nok. The Chinese characters on the seal (Figures 16.1 and 16.2 from panel 2, lower middle) are carved in the same great seal script (*taejŏn*, C. *dachuan*) that is associated with Yi Ŭng-nok. Certain objects in the screen also are reminiscent of objects used in Yi Ŭng-nok's compositions. A Chinese-style table with the bronze bowl resting on its marble top, a European pocket watch suspended from a coral stand, a peach-shaped water dropper with a red top and green leaves, a stacked pair of red and white bowls, a bronze vase holding a pair of peacock feathers and a coral branch, a bronze incense burner in the shape of an elongated *ding*, book patterns, and vessel shapes—all are presented in the Yi Ŭng-nok manner. In the two screens he painted under the name Yi Ŭng-nok, the pots are more attenuated than they are in earlier screens painted under the name Yi Hyŏng-nok. Yi Ŭng-nok's vessels conform to his narrower shelves; Kang Tal-su further exaggerates this attenuation of shapes in his painting.

Other features of Kang Tal-su's screen suggest his familiarity with the isolated type *ch'aekkŏri* of Yi Hyŏng-nok/Yi T'aek-kyun. Some of the same scholarly treasures appear on Yi Hyŏng-nok's/Yi T'aek-kyun's isolated type *ch'aekkŏri* screens. For example, the Koryŏ Buddhist hour-glass shaped incense burner appears in both Yi T'aek-kyun's isolated *ch'aekkŏri* (Figure 5.9, panel 10) and Kang Tal-su's trompe l'oeil screen (Figure 16.1, panel 8). This particular style of incense burner did not appear in any of Yi Hyŏng-nok's nor Yi Ŭng-nok's known trompe l'oeil screens.

An unusual object, a square box with bosses, first appears in a one-tiered version in Yi Hyŏng-nok's trompe l'oeil *ch'aekkŏri* in the Leeum (Figure 13.4, panel 1), and it is seen again in Kang Tal-su's screen (Figure 16.1, panel 1), while Yi T'aek-kyun painted a two-tiered version in his isolated type *ch'aekkŏri* at T'ongdosa Museum (Figure 5.9, panel 6). Another unusual object, an enlarged rectangular

Figure 16.3
Six-panel anonymous
courtpainter's *ch'aekkŏri* screen
in the living room at Naksŏn-jae,
home of the late Prince Yi Ku
and his former wife Julia Lee, in
1975–1977. Photo by the author.

ornament (possibly a belt buckle), is found in both Yi Hyŏng-nok's P'yŏngyang screen (Figure 5.11, panel 4) and Yi T'aek-kyun's work (Figure 5.9, panel 9). A scholar's green brush washer in the form of half a peach is depicted Kangxi style in Kang Tal-su's trompe l'oeil screen, and also in Yi T'aek-kyun's isolated *ch'aekkŏri*, and in the National Museum's isolated screen, which is not illustrated here because it is unmounted. Curvilinear incense burners, micro landscapes reminiscent of the Tang dynasty blue-green school of Chinese painting, and red-tipped peach-shaped water droppers are depicted almost identically in both Yi T'aek-kyun's painting and Yi Hyŏng-nok's isolated screen in the National Museum of Korea.

From 1975 to 1977, a six-panel trompe l'oeil type *ch'aekkŏri* screen was displayed in the living room at Naksŏn-jae, the home of Prince Yi Ku and his former wife Julia Lee, on the grounds of Ch'angdŏk Palace (Figure 16.3). This screen was later seen in art storage at Ch'angdŏk Palace catalogue no. 67 (Figure 16.4).[6] Its brilliant palette of cobalt, malachite, and red, earlier and somewhat more subtly used by Kang Tal-su, was now pronounced and striking, suggesting a twentieth-century date. Kang Tal-su's *ch'aekkŏri* with its four tiers of undu-lating shelving construc-tions has many objects breaking up its cobalt-blue background. Some of Kang Tal-su's scholars' items are individually delineated against the background, not just consolidated into one, two, or three compound shapes as they are in the Naksŏn-jae *ch'aekkŏri*.

More important, the Naksŏn-jae screen has only two tiers of shelves that appear

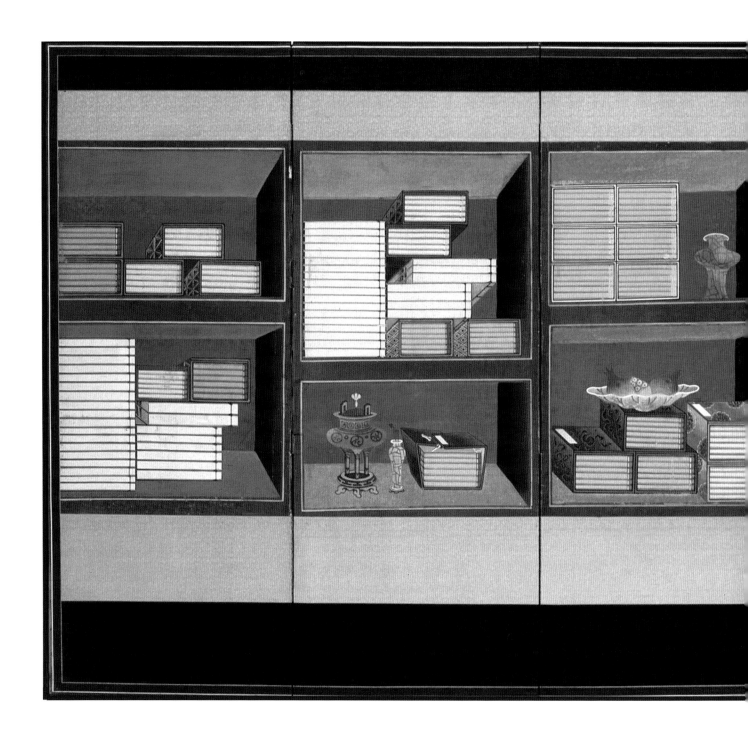

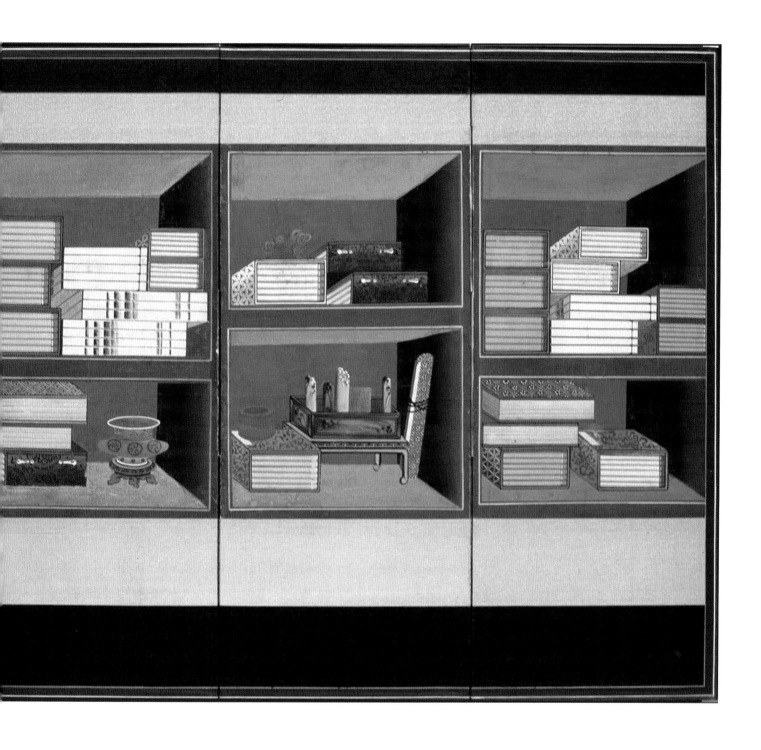

Figure 16.4
Six-panel screen formerly at Naksŏn-jae (viewed in
1975–1977), now in Ch'angdŏk Palace Museum (catalogue
no. 67, viewed in 1986). Mineral pigments on coarse
silk. 70.5 × 278 cm. Photo by Norman Sibley.

Figure 16.5
Detail of Figure 16.4. Auspicious seal "Best wishes
for longevity, happiness, health, and peacefulness,"
panel 2. Photo by Norman Sibley.

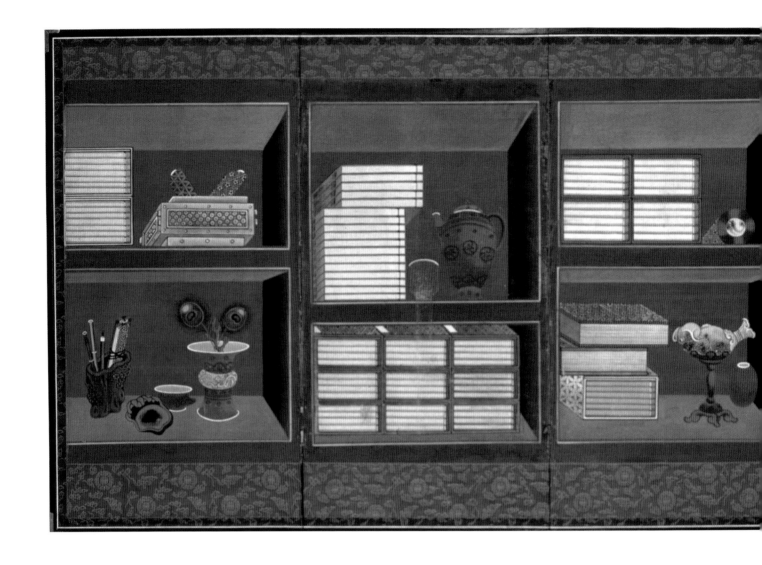

Figure 16.6
Six-panel trompe l'oeil type *ch'aekkŏri* by an anonymous painter.
20ᵗʰ century. Coarse silk gauze. 74.5 × 285 cm. Ch'angdŏk Palace
Museum (catalogue no. 66). Photo by Norman Sibley. Inspired
by Yi Hyŏng-nok and similar to the screen of Figure 16.4.
Both have orthogonals all drawn in the same direction with
no central focus and revealing only four sides of the bookcase
indicating an early 20ᵗʰ century date. Note stack of books
bound in the Korean fashion with five strings in panel 2. Both
screens have the same bright palette of mineral pigments.

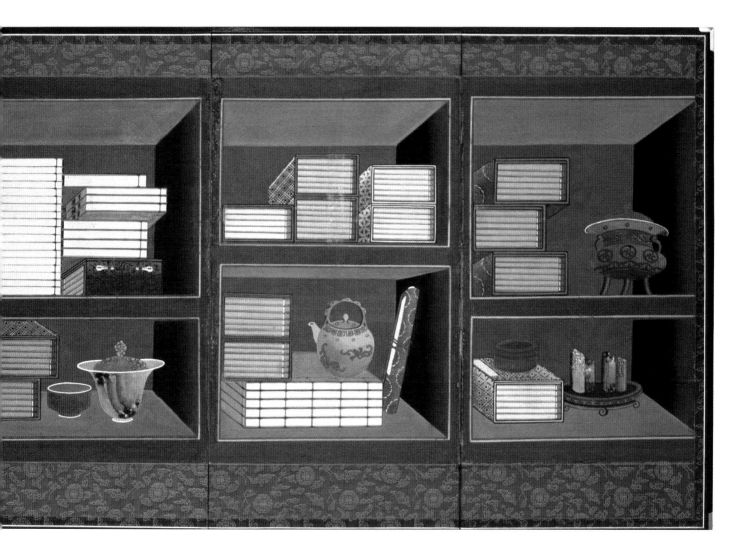

to undulate. There are far fewer objects depicted on them. Kang Tal-su's screen is approximately twice the height and one-fourth greater in width than the Nakson-jae work. The reduction of detail in the Nakson-jae screen makes its palette more prominent. Although the latter painting's style has been greatly simplified, and its bookcase construction is viewed from one angle only, evidence of Yi Hyŏng-nok's painting characteristics is unmistakable. One sees swelling pot bodies decorated with three interlocking comma-shaped motifs (similar to the pair used on the South Korean flag), vessels shaped like little clubmoss (*selaginella involvens*), marbleized seal boxes containing a seal painted with Chinese characters, and, finally, the same patterns decorating book covers used by Yi Hyŏng-nok and his follower Kang Tal-su. Disappointingly, the seal (Figure 16.5) is not a name seal, but a four-character seal conveying auspicious wishes. The characters read "longevity" (*su*), "happiness" (*pok*), "health" (*kang*), and "peace" (*nyŏng*). This represents a break with the mainstream *ch'aekkŏri* custom of painting name seals in the subject matter. Very similar to the Nakson-jae screen is the Ch'angdŏk Palace catalogue no.

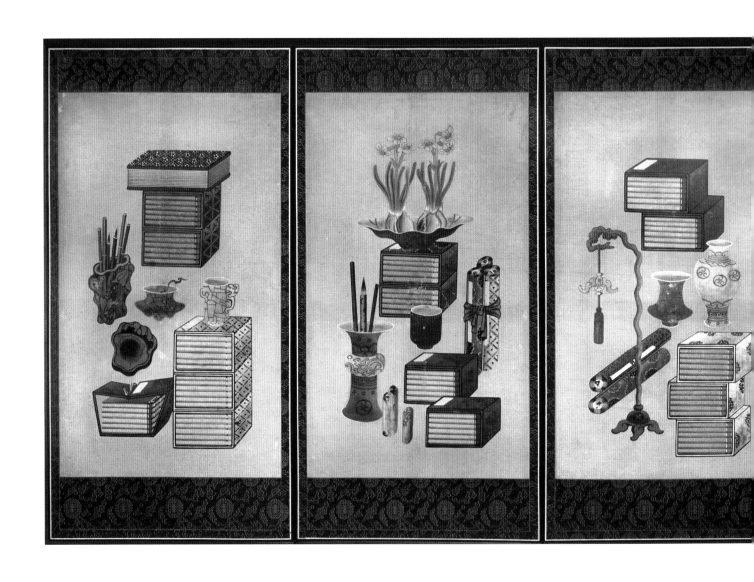

Figure 16.7
Six-panel isolated type *ch'aekkŏri*.
Ch'angdŏk Palace Museum (catalogue
no. 125). Photo by the author.

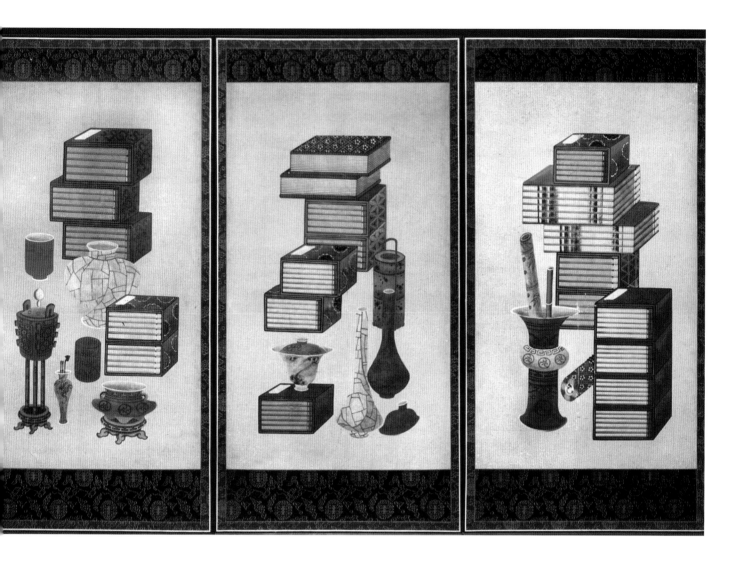

66 *ch'aekkŏri* (Figure 16.6). Both of these six-panel anonymous trompe l'oeil screens and the isolated Ch'angdŏk Palace catalogue no. 125 six-panel screen by followers of Yi Hyŏng-nok show that both types of court style painting continued into the twentieth century (Figure 16.7). Only the anonymous artist of Ch'angdŏk Palace catalogue no. 125 has compositions in which objects are linked, and when they are not, they are either touching or have very little space surrounding them. Little variance in the styles of objects and book cover patterns suggests that there might have been a formula. Certainly, our discovery of two similar trompe l'oeil ones in the Ch'angdŏk Palace collection suggests something of the sort.

Judging by surviving examples, the mainstream of the trompe l'oeil type *ch'aekkŏri*, begun by Yi Chong-hyŏn in the last quarter of the eighteenth century (but known to us only through the paintings of his grandson, Yi Hyŏng-nok, his follower Kang Tal-su, and the anonymous artist of the Naksŏn-jae *ch'aekkŏri*), endured until the end of the Chosŏn period.

Exhibit 16.1 Known Lineage Relatives of Kang Tal-su, of the Chinju Kang *Chungin* Lineage

(Compiled by Gari Ledyard from notes and sources in Edward W. Wagner's papers.)

adpt = adopted; b = birth year; numeral + a or b = highest rank achieved; I = Interpreter degree; /Jpn = Japanese, /Mng = Mongolian M = Medical degree * = Expanded degree List

Gari Ledyard Notes on the Family Chart of Kang Tal-su
Compiled from Notes and Sources in Edward W. Wagner's Papers

1. This chart is based on extensive notes left by my good friend and colleague, the late Prof. Edward W. Wagner, confirmed and in a few cases adjusted according to the entries on Kang Tal-su and his relatives on pp. 378-381 of *Chosŏn sidae chapkwas hapkyŏkcha ch'ongnam* (hereafter *CCHC*), a digitized processing and display of surviving rosters for the professional examinations (the so-called *chapkwa*) taken by members of Korea's former *chungin* class; and also by the *chungin* genealogies in the *Sŏngwŏnnok* (abbr. *SWR* in the Wagner notes) compiled by Yi Ch'ang-hyŏn (1850-1921) and several associates on the basis of family records collected in the late

nineteenth and early twentieth centuries. Prof. Wagner also had a photocopy of a collection of *p'alsebo* (eight-generation genealogical statements, submitted by candidates for professional examinations or compiled as a part of their personal dossiers), held by the Tenri University Library in Tenri (Nara prefecture), Japan. Using data on Kang Tal-su and his immediate relatives in one of these statements (Wagner's short-hand reference was "*TUP* 110", standing presumably for *Tenri University p'alsebo*, p. 110), he was able to substantially expand the coverage in *SWR*, p. 964, which had detailed the ancestors and descendants of Kang Chik-sun (b. 1794), with whom Kang Tal-su had some ancestors in common.

2. It is not clear just how to link *TUP's* data on the Tal-su group with the *SWR's* table. Wagner had arranged the details in a rudimentary genealogical diagram and placed it to the right of the Chik-sun group on a photocopy of *SWR's* p. 964. At first glance, this arrangement implies that Chik-sun's second-cousins In-sun (Tal-su's father) and Hwa-sun (his uncle and adoptive-father), for both of whom birth years are unknown, were born earlier than Chik-sun, or before 1794. However, a careful examination of all the birth-year data from *CCHC* makes it clear that Chik-sun's side of the family was older than that of the brothers In-sun and Hwa-sun. This is best seen in the ages of the grandchildren, but only 11 and 13 for In-sun's and Hwa-sun's (all ages here and below are reckoned Korean style). I am confident that if Prof. Wagner had had the opportunity to review his notes in preparing a finished table, he would have come to the same conclusion. Unfortunately, he does not seem to have returned to the problem before his illness had advanced to a state that made further study impossible. While the table given here is my view, the most plausible version, I present it with the reservation that it is subject to further revision by those with access to more complete source materials than those presently available to me, if such indeed exist.

3. *SWR*, supplemented by *TUP's* data as transferred by Wagner, presents a somewhat different picture than that indicated by *CCHC's* collected examination rosters. The oldest ancestor reflected by the latter is Kang Hŭi-myŏng, the great-grandfather of Chik-sun, In-sun, and Hwa-sun. *SWR* extends that back another five generations to a founding ancestor Kang Su-un, who would probably have lived in the late fifteenth century. While some data exists for Hŭi-myŏng's sons and grandsons, the picture becomes problematic only with the –sun and su- generations, which may be summed up as follows (name>> = adopted out; >>name = adopted in):

SWR	+	*TUP*		*CCHC*		
Chick-sun		In-sun	Hwa-sun	Chik-sun	In-sun	Hwa-sun
Hae-su		Tal-su»	»Tal-su	Hae-su	Tal-su»	»Tal-su
		Chin-su	Kal-su	Han-su		Man-su
						Chin-su

Two of the differences in the two schemes can be quickly resolved. 1) Prof. Wagner marked the first syllable of "Kal-su" with a question mark: 葛?, indicating that the character in his copy of TUP was not fully legible. One can see by the *CCHC* printout that the intended character was "Man-" (萬). 2) The absence of Han-su in the *SWR/TUP* scheme probably means that the source of the SWR data was Hae-su (or his descendant) and that he was older than Han-su. Even in *CCHC* there is no indication that he was a professional examination passer, although he didhold a rank 7b title, which was commonly held by professionals. Perhaps these qualifications were still in the future when Hae-su assembled his ancestral information.

The more difficult problem is the disparity in the affiliation of the sons of In-sun and Hwa-sun. In the *SWR/TUP* scheme, Tal-su is adopted out while Chin-su remains in In-sun's household. In the

CCHC scheme, Tal-su's adoption is as in *SWR/TUP*, but In-sun has no other son and is left with no heir at all. Hwa-sun ends up with three sons including the adopted Tal-su. So who is Chin-su's father? Why would Hwa-sun adopt a son when he already had two? Why would In-sun adopt out a son if he were left with none? Some perspective on adoption is necessary before considering these questions.

4. The general rationale for adoption in Korea's traditional Confucian society was to assure a male heir and a ritual line of first-son mourners in each succeeding generation. Secondarily, it had the effect of also keeping the deceased's property in the family, ensuring the support of the widow and younger siblings and thus maintaining the status and standing of the family within the lineage. Typically, a man with no sons would adopt a younger son of one of his brothers or cousins. For Confucian ritual purposes, this procedure had several advantages: 1) the sonless man and his ancestors would be properly mourned; 2) the adoptee, being usually a brother's or cousin's son, would himself already be a genetic descendant of the apical ancestor; and 3) would already be a member of the generation lacking to the adopter. Among sadaebu (ruling class) and yangban families (otherwise privileged or seen to be so by virtue of their Confucian education and known observance of mourning rules), the maintenance of a line of first-son ritual heirs (the so-called chongson) over the generations was socially and ritually a very powerful imperative.

It is very clear, at least in this group of Chinju Kang chungin, that no ritual ethos prevailed. Not only were three first-son heirs adopted out, but in In-sun's case—in the scenario evidenced by *CCHC*—it was a father's only son. It is more likely that economic factors were the chief motivation behind the adoptions. The chungin were a marginalized class, the vast majority of whom lived in Seoul and did not own agricultural land in the countryside. There were more of them than the government really needed to perform the professional duties for which they were trained. They had to struggle and plan ahead to maintain the family livelihood. For this reason they had a high degree of class solidarity and an ethic of mutual support within the family and among their relatives in the lineage. Passing the professional examinations was crucial to maintaining their status, and this involved special educational expense. We should consider In-sun and Hwa-sun against this background. Prof. Wagner's sketch had In-sun as the older of the two, which I can only assume was based in some way on *TUP*, but in fact I know of no data anywhere that would tell us which one was the older. There are hints that In-sun had not done well. There is no record that he ever passed a professional examination or held an official title. On the other hand, Hwa-sun probably had a military degree, was a rank 2b general, and later in life held a position of equal rank in the Office of Ministers-without-Portfolio (Chungch'ubu). He was in a position to provide a good professional education to his children. Conceivably, In-sun's son Tal-su was seen to be an intelligent lad who would have better opportunities in Hwa-sun's household, and was adopted out in order to give him a better chance in life. Later on, Tal-su, who had two sons, adopted out his first-born to his sonless brother Man-su; and his third cousin Hae-su, who had three sons, adopted his eldest to his sonless brother Han-su. The fact that Hae-su and Tal-su had to go back to their great-great-grandfather to have a common ancestor suggests that the custom of adopting out the first-son may have been a widespread custom in the Chinju Kang *chungin* lineage.

5. We now have to consider the conflict between *TUP* and *CCHC* as to who was the father of Tal-su's younger brother, Chin-su. There is no indication anywhere that he was ever the object of an adoption. Then was the father In-sun or Hwa-sun? Thanks to the Korean genealogical habit of identifying an individual's maternal grandfather, we know from *CCHC* that Tal-su and Chin-su had different mothers. But Chin-su's mother was different from the known wives of either In-sun or Hwa-sun. Given the huge gap in age between Chin-su and Tal-su, it is very possible that his mother was a second wife, but since no second wife appears in the records of either In-sun or

Hwa-sun, there is still no way to know which one was her husband. So we are still left in the dark. In the chart I have followed *CCHC*, which supplies most of the information, and made Chin-su the third son of Hwa-sun (after Man-su and the adopted Tal-su) and shown his mother as Hwa-sun's second wife. But with dotted lines I have indicated that it is also possible that he was In-sun's son, and if that were true the second wife would have to be In-sun's. It's probable that contemporaries simply regarded Chin-su as Tal-su's younger brother, but since Tal-su had both a birth father and an adoptive one, there could well have been genuine confusion about Chin-su, who was 17 years younger than Tal-su. Whoever his father was he would have been quite advanced in age when Chin-su was born. In the scenario of In-sun-as-father, it is also very possible that he would have died while Chin-su was still a young child. In such circumstances the child is often raised in the household of a brother or close cousin.

For Tal-su, two maternal grandfathers are indicated: his birth mother's father, Kaesŏng Kim Tong-gŏn; and his adoptive mother's father, Chŏnju Yi Taek-mu (see diagram). This reflects the circumstance that as a ritual mourner, Tal-su is responsible for his step-mother (Hwa-sun's wife), and that for legitimation purposes his birth mother must also be identified even if he has no formal mourning responsibilities for her. For In-sun, only the birth mother's father, Andong Kim Pyŏng-un, is identified. Such a circumstance would not necessarily have stopped contemporaries from calling them brothers. But Chin-su was seventeen years younger than Tal-su, and different mothers for the two brothers is not an implausible circumstance. So the issue of who was the father of Chin-su remains open, since either In-sun or Hwa-sun could have had a second wife. The overall weight of the totality of *CCHC*'s data has led me to assign Chin-su's paternity to Hwa-sun on the chart. But given the possibility that In-sun was the father, I have indicated that with a dotted line. This would also involve the reassigning of the second wife of Hwa-sun to In-sun.

6. A final observation is that 1885 was a big year for this branch of the Kang lineage. In addition to Chin-su, who passed his medical examination in that year, five of his nephews (Kyŏng-hŭi and Yŏng-hŭi), and their fourth-cousins in the same generation (Ch'an-hŭi, Wŏn-hŭi, and Chin-hŭi), all passed examinations in 1885, three in medicine and two as interpreters. One wonders if some of the adoption vagueries explored above might be explained as an effort to distribute the successful graduates as evenly around the family as possible. Prof. Wagner's notes on other aspects of the *ch'aekkŏri* project contain indications of at least three professional (*chungin*) families who had five passers in the same generation in the same year. In each of those cases, all five were grandchildren of a single grandfather, whereas with the Kangs the passers descended from three grandfathers (taking adoptions into account): In-sun, Hwa-sun, and Chik-sun. That all of these examination successes were in the same year would seem too unusual to be coincidental. While Chik-sun's grandson-passers Ch'an-hŭi, Wŏn-hŭi, and Chin-hŭi are at normal passing ages (23, 20, and 35 respectively), the grandson-passers of In-sun and/or Hwa-sun, i.e. Yŏng-hŭi and Kyŏng-hŭi, are 15 and 11. Some planning and strategy must have gone into this affair, especially since their uncle Chin-su—only 13!—joined them in their *coup d'éclat*.

Exhibit 16.2 The Relationship of Yi Hyŏng-nok to Kang Tal-su

(Chŏnju) Yi Sŏng-nin (1718-1777) (全州) 李聖麟		(Chinju) Kang Hŭi-myŏng (晉州) 姜熙明

Chong-hyŏn (1748-1803) 宗賢	Chong-gyu (1760-1793) 宗圭	Sŏng-gi 聖基
Yun-min (1774-1841) 潤民	Chong-gyu's = (Kaesŏng) Kim Tong-gŏn daughter 宗圭女 (開城) 金東健	Yun-jin 允鎭
Yi Hyŏng-nok (1808- ?) 亨祿	Kim Tong-gŏn's = (Chinju) Kang In-sun daughter 金東健女 (晉州) 姜仁淳	Hwa-sun 和淳
	Kang Tal-su adopted out to uncle, Kang Hwa-sun 姜達秀	Tal-su 達秀

The *Chosŏn sidae chapkwa hapkyŏkcha ch'ongnam*, digitized and compiled by Yi Sŏng-mu, Ch'oe Chin-ok, and Kim Hŭi-bok (Sŏngnam: Han'guk chŏngsin munhwa yŏn'guwŏn, 1990), pp. 378-379, provides the following information about Kang Tal-su:

Born 1856, Physician's degree (醫科), 1876
Served as Instructor (*kyosu* 教授, rank 6b); commended for Long Service (*ku'im* 久任)
Father: Kang Hwa-sun 姜和淳, General (*chang* 將, rank 2b)
Grandfather: Yun-jin 允鎭, a Recorder (*chubu* 注簿, rank 6b)
Great-grandfather: Sŏng-gi 聖基
Maternal grandfather: (Chŏnju) Yi T'aek-mu (全州 李宅懋, adoptive father Hwa-sun's father-in-law)
Birth father: Kang In-sun 姜仁淳 (*see note below)
Birth mother's father (Kaesŏng) Kim Tong-gŏn (開城) 金東健
Wife's father: (Kyŏngju) Kim Tong-gyu (慶州) 金東奎, b. 1833, Interpreter's degree, Chinese, 1852;
 Diplomatic document studies officer (*imun hakkwan* 吏文學官)
Wife's grandfather: (Kyŏngju) Kim Hak-su 金學洙, Group leader (*chikchang* 直長, rank 7b)

* Note: Kang In-sun adopted his son, Tal-su, out to his younger brother Kang Hwa-sun. Thus, Tal-su has a genetic link with the
 daughter of Yi Chong-gyu as indicated in the diagram. In the formal Confucian practice, Kang Hwa-sun is formally the legal
 and ritual father of Tal-su, eventhough In-sun and his wife are fully acknowledged as his birth parents.

■ **Known styles (*cha*) for Kang 姜 lineage members**

Name (名)	Style (字)
Chik-sun 直淳	Yuch'ŏng 惟清
Tal-su 達秀	Chasam 子三
Chin-su 進秀	Cha'ik 子益
Ch'an-hŭi 璨熙	Ch'anok 粲玉
Wŏn-hŭi 瑗熙	Wŏnok 爰玉
Chin-hŭi 璡熙	Chinok 進玉
Kyŏng-hŭi 璟熙	Kyŏngok 景玉
Yŏng-hŭi 瑛熙	Yŏngok 英玉

■ **Known Kang In-laws** (f-i-l = father-in-law, mg = maternal grandfather, other data if available)

(Puan 扶安) Im Sŏng-je 林聖濟, f-i-l of Se-jin, mg of Chik-sun

(Suwŏn 水原) Yi Wŏn-gi 李元基 , f-i-l of Chik-sun, mg of Hae-su

(Ch'ŏnnyŏng 川寧) Hyŏn Kwang-il 玄光一, f-i-l of Hae-su, mg of Chin-hŭi, Ch'an-hŭi, and Wŏnhŭi

(Susŏng 隨城) Ch'oe Yŏng-sik 崔永植, f-i-l of Chin-hŭi
 cha Kunsŏk 君錫, b 1835, Astr. Degree 1852

(Kyŏngju 慶州) Chŏng Chwa-gon 鄭左坤, f-i-l of Ch'an-hŭi

(Kaesŏng 開城) Kim Tong-gŏn 金東健, f-i-l of In-sun, birth mg of Tal-su

(Chŏnju 全州) Yi T'aek-mu 李宅懋, 1ˢᵗ f-i-l of Hwa-sun, adoptive mg of Tal-su

(Andong 安東) Kim Pyŏng-un 金炳運, 2nd f-i-l of Hwa-sun, birth mg of Chin-su

(Kyŏngju 慶州) Kim Tong-gyu 金東奎, f-i-l of Tal-su, mg of Yŏng-hŭi and Kyŏng-hŭi
 cha Kyŏngo 景五, b 1833, I/Chinese degree 1852, Chinese Language Officer, *pongsa* (8b)

(Kimhae 金海) Kim In-sik 金仁植, f-i-l of Man-su, adoptive mg of Yŏng-hŭi
 cha Chŏngbaek 正伯, b 1821, I/Chinese degree 1837, *kaŭi taebu* 嘉義大夫 (Sr. 2b)

(Kyŏngju 慶州) Chŏng Ŭi-bok 鄭宜復, f-i-l of Chin-su
 cha Wŏnch'il 元七, b 1809, Med. Degree 1828

(Onyang 溫陽) Pang Han-gyu 方漢奎, f-i-l of Yŏng-hŭi

NOTES

1 See Hôtel Drouot Auction Catalogue, *Succession Pierre Landy* (Paris, June 24, 1987), pl. 186. I am indebted to Anthony Victoria for sending me this catalogue.

2 Yi Ch'ang-hyŏn, comp., *Sŏngwŏnnok* (Records of [*chapkwa-chungin*] lineage origins), Koryŏ University Central Library reprint series 13 (Seoul: Osŏngsa, 1985), p. 964.

3 Moreover, it is significant to learn that this Kang Tal-su belongs to the same Chinju Kang *chapkwa-chungin* sublineage as the well-known modern painter Kang Chin-hŭi (1851–1919), the common ancestor being Kang Tal-su's great-great-grandfather. Also see Yi Sŏng-mu, Ch'oe Chin-ok, Kim Hŭi-bok, ed., *Chosŏn sidae chapkwa hapkyŏkcha ch'ongnam* (Complete record of successful candidates of the chapkwa examinations in the Chosŏn period) (Sŏngnam: Academy of Korean Studies, 1990).

4 Black and Wagner, "Court Style *Ch'aekkŏri*," p. 22.

5 Compiled by Ledyard from notes and sources in Wagner's papers.

6 I saw this screen again and Norman Sibley photographed it in the art storehouse at Ch'angdŏk Palace in 1987, where it was listed as catalogue no. 67.

17

A *Ch'aekkŏri* in Honor of Kim Ki-hyŏn's Seventieth Birthday

A trompe l'oeil type *ch'aekkŏri* at the Leeum presented Wagner and me with a problem: reorganizing the panels into what we considered their original order. Figure 17.1 shows how the panels are currently mounted. Figure 17.2 shows how we believe the panels were intended to be arranged. The seals' locations and panel references are based on our new sequencing. The key to determining the proper order of the panels lay in determining the angles at which the shelves are depicted. Wagner and I determined that the innermost panels were the ones in which the third dimension of the bookcase is delineated with the most acute angles. Proceeding outward from the center, the angles become less and less acute in successive panels.

This screen is of special interest because of its high artistic merit and its abundance of tantalizing but often difficult-to-unravel imagery. A veritable treasure trove of symbols and signs is dispersed across the ten panels of this impressive *ch'aekkŏri* screen. It displays one name seal, many pen name seals, inscriptions, and auspicious symbols. After extensive study, Wagner and I concluded that nothing is randomly placed. In particular, all fifteen seals, one inscription, and one object have been positioned purposely to provide autobiographical and geographical clues to the screen's creator, whose identity has yet to be resolved conclusively. In the case of this screen, deciphering the many seals reveals not just the name of the painter, but the person for whom the screen was created. An analysis of the seals and inscriptions and of the symbolism of the objects included in the composition strongly suggests that this screen was painted to commemorate the seventieth birthday of Kim Ki-hyŏn. Other details indicate that the artist was almost certainly Pang Han-ik.[1]

The one legible name seal (Figures 17.2 and 17.3, from panel 10, top) on the *ch'aekkŏri* has been traced to Kim Ki-hyŏn, a member of the Nagan Kim *chapkwa-chungin* lineage (see Exhibit 17.1), who was born in 1825 and passed the astronomy-geography examination in 1844.[2] At first glance, certain of the screen's details

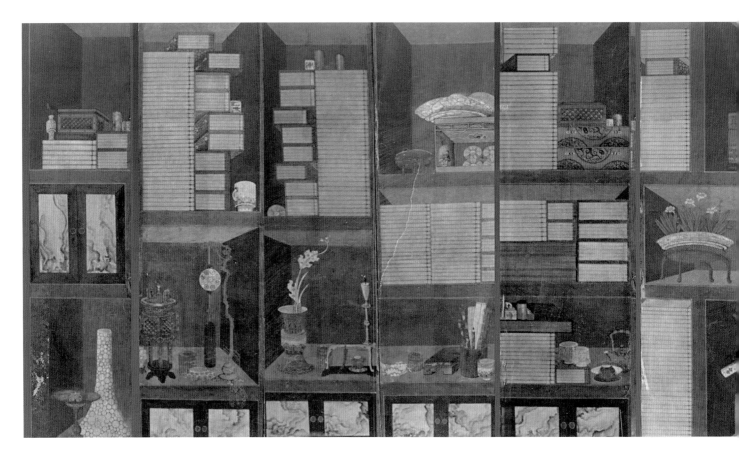

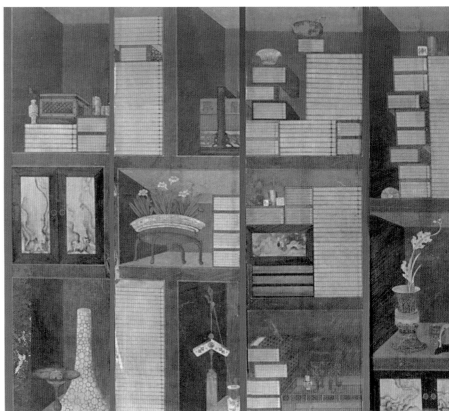

Figure 17.2
Author's resequencing of the panels of the Leeum screen of Figure 17.1 in the original order that might have been. Panel numbers where seals are located are referenced according to this sequence.

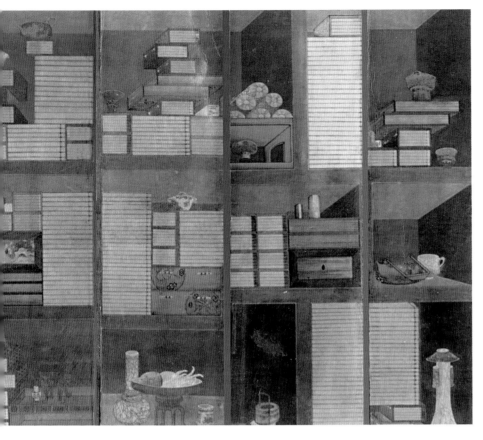

Figure 17.1
Ten-panel trompe l'oeil
ch'aekkŏri attributed to
Pang Han-ik. Probably
painted in 1895 in honor of
Kim Ki-hyŏn's seventieth
birthday. Ink and mineral
colors on silk or hemp.
144 × 333 cm. Leeum,
Samsung Museum of Art.
Photo by Norman Sibley.

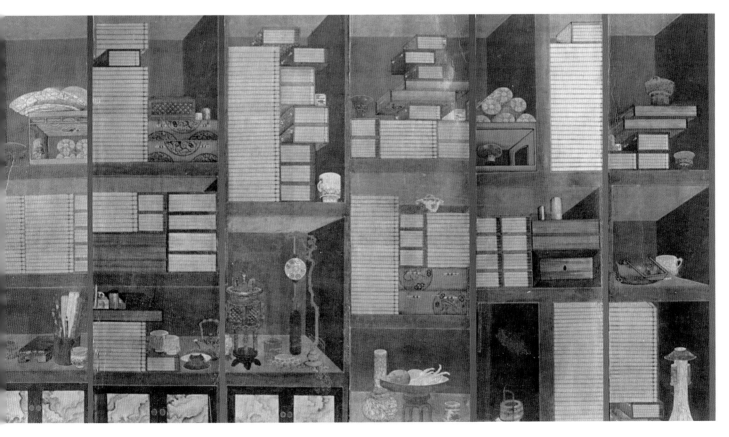

Exhibit 17.1 Family of Kim Ki-hyŏn 金基顯

Compiled by Gari Ledyard from notes and sources in Edward W. Wagner's papers: Kim Ki-hyŏn's Nagan Kim *Chapkwa-Chungin* Lineage from *Sŏngwŏnnok* (Records of [*Chapkwa-Chungin*] Lineage Origins) (Seoul, 1985), p. 378.

Note: The Kim Kihyŏn believed to be the focus of the *ch'aekkŏri* screen is written 箕顯 on the screen, but 基顯 in the *Sŏngwŏnnok* table. Circumstances compel us to equate the two spellings for one person, but the difference should be noted. Prof. Wagner evidently found that 箕顯 was the form on the *chapkwa* examination rosters. Note also that all dates and indications including the professional specialties of some of these individuals were found in Prof. Wagner's notes for this project, and are copied here as he left them.

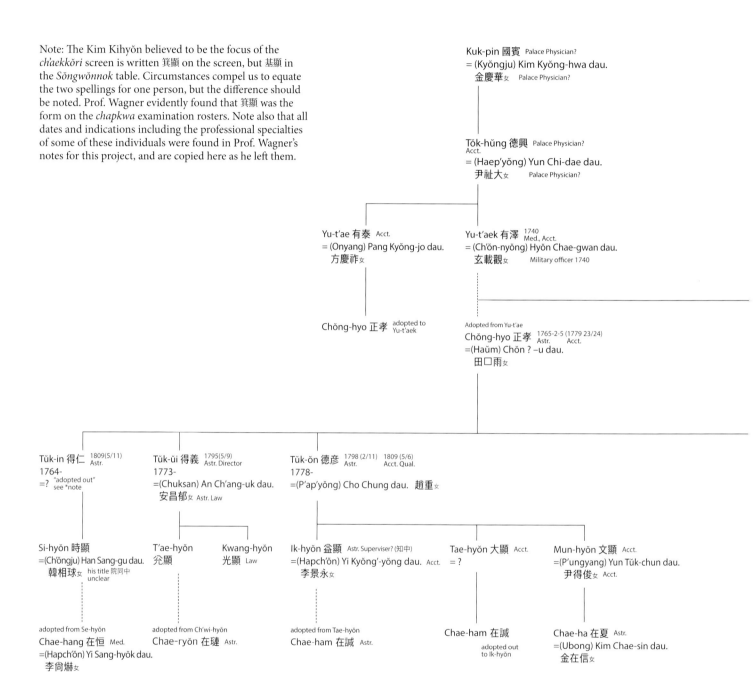

dau.: daughter
Med.: medical degree
Astr.: astronomy/geography degree
Acct.: accountant degree

* It will be noticed that there are two individuals named (Kim) Tŭk-in in the 5th generation below; the first (at far left) in the son of (Kim) Chŏng-hyo, the second (at far right) the son of (Kim) Kyŏng-hyo. It is clearly indicated that the first Tŭk-in was adopted out. It is also appropriate in such a case that no marriage is indicated for him (that would be the responsibility of the adoptive parents). The seemed Tŭk-in is clearly marked as adopted in (although—contrary to my indication—there is no mention of Chŏng-hyo as the natural father), and his marriage is duly indicated, what is highly irregular is that a son, Si-hyŏn, and a grandson, the adopted-in Chae-hang, are indicated under the first Tŭk-in. Either they should be placed under the seemed Tŭk-in or they have some other unknown parent. This situation could impact the propriety of taking the Nagan Kim situation as a case of one man having 5 sons who passed the examination. It would rather be 3 sons, one son in-law, and one nephew-albeit a nephew who was a natural son.

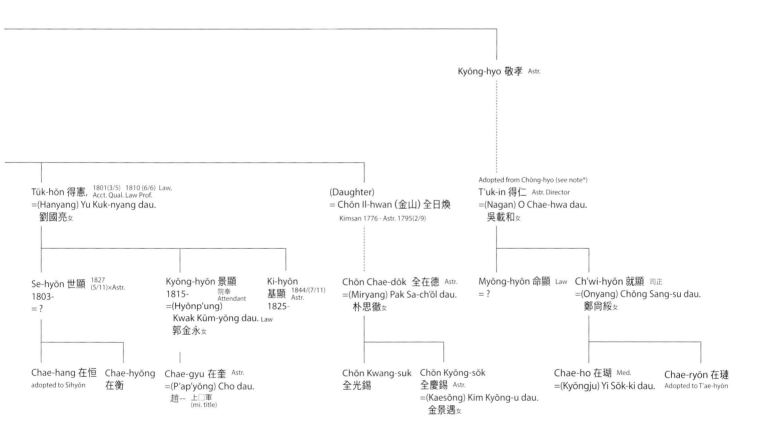

Note : The descendents of Chŏn Il-hwan are entered from the Kimsan Chŏn family table on p. 582 of *Sŏngwŏnnok*.

appear to be the work of Yi Hyŏng-nok. For example, its subdued colors and its *faux marbre* cupboard panels recall the *faux bois* panels on a known Yi Hyŏng-nok *ch'aekkŏri* screen in a private collection.[3] Further investigation disproved this supposition. First, the exceptionally large number of seals depicted is not typical of Yi Hyŏng-nok's *ch'aekkŏri*. Second, with one exception, all of the fifteen seals in the Leeum screen, including the one with Kim's name, were written in *p'albun* (C. *bafen*) script, a subtype of clerical script. In contrast, Yi Hyŏng-nok consistently used the great seal script (*chŏnsŏ*) to represent the seals in his four known trompe l'oeil type *ch'aekkŏri* paintings (with the exception of a seal translated as "man of Wansan," written in the small seal script (*sojŏn*, C. *shaochuan*). Third, the abruptly painted demarcation lines on the interior sides of the bookcase, which Yi Hyŏng-nok used to suggest shading, are absent.

Further innovations in the Leeum screen's composition catch the viewer's attention. Along the top register of the painting, the artist seems to have been preoccupied with balancing haphazardly stacked piles of books and other items, which press the limits of stability. For instance, the teapot whose shape penetrates the ceiling space in panel 8 teeters precariously because of the steeply tilted ceiling planes. In six of the panels the outlines of objects and books all are thrust into the ceiling space.[4] The resulting ragged, eye-catching line detracts from the appearance of the accordion folds of the screen along its top outline, making this *ch'aekkŏri* appear more like a real bookcase than in previous screens. The eye is indeed fooled.

Perhaps to relieve the viewer's anxiety caused by the precariously arranged book piles depicted along the top zone, the artist of the Leeum *ch'aekkŏri* cleverly draws the eye to the bottom third of the screen by introducing an undulating, sculptural alignment of shapes. He does this by overlapping the contours of the objects to show recession so that the scholar's treasures are no longer set out on a line parallel to the leading edge of the bookcase. Of the mainstream artists of trompe l'oeil type *ch'aekkŏri* so far identified, only Kang Tal-su employed a similar use of overlapping contours to show recession. The space which holds the overlapped objects is itself composed of a pair of opposing L shapes with steeply tilted ground planes embracing two central panels that depict shelves containing nothing but books.[5] These books appear ready to topple toward the viewer for lack of proper support and, clearly, the artist has employed an inconsistent use of perspective. He used three vanishing points on two different levels rather than a single one in the center section of the screen. The artist does not rely on Western-style perspective as consistently as did Yi Hyŏng-nok—yet another reason to dismiss Yi Hyŏng-nok as the screen's painter.

Bold patterns, broad curves, and right angles juxtaposed against a back-ground of flat planes in the Leeum screen result in a masterpiece of design. The bookcase's colors are limited to three: grey, pale aubergine, and deep aubergine, which effectively simplify the composition. The artist painted the interior sides of the bookshelves a single color overall. The objects themselves, with their overlapping contours, unite the many into one, creating further simplification of the whole geometric bookcase design of parallelograms and rectangles. Other formal elements of the painting—a restrained use of color, the repetition and exaggeration of pat-

terns such as the simulated crackle-ware glaze on several of the Chinese court style ceramics—unify the screen's composition.[6] Thus, by a reduction of formal elements, the artist has created an overall abstract effect. This abstract quality, together with the artist's use of overlapping objects to suggest recession and his innovative use of a ragged ceiling line to heighten the visual deception, are sophisticated developments in the *ch'aekkŏri* genre, suggesting a later date for the screen than for all four of the known trompe l'oeil type screens attributed to Yi Hyŏng-nok or Yi Ŭng-nok.

Each compartment with its still life of scholars' treasures is integrated in the most complex and tightly structured ordering of any trompe l'oeil *ch'aekkŏri* composition Wagner and I have studied to date. Astonishingly, one courtesy name and nine different pen names are depicted on seals. Four seals are shown individually, four in pairs, and three in one grouping. Only Kim Ki-hyŏn's courtesy name is depicted in isolation; with one exception at the top of Figure 17.2, panel 4, all other seals are grouped together with one or more vertical, striated, ivory cylindrical blank seals. Clearly, the artist attached special signi-ficance to Kim's courtesy name, Pŏmgyŏng (Figure 17.4). In four pairs of seals, depicted with characters facing the viewer and aligned with cylindrical blanks, there are two pairs with characters shown in the same color scheme. The first pair (Figure 17.5 from panel 8, middle) combines the characters for the pen name Chisan (meaning "Mushroom Mountain") and a seal with obliterated or illegible characters. Both are red on ivory, and both are positive, meaning that the raised part of the seal leaves a red character imprint on the paper; the ink picks up the character's outline.[7] The other six seals are negative, meaning that the raised part is the background, which picks up the red ink and outlines the recessed characters of the grey or gold paper color.[8] It stands to reason that Chisan, someone's pen name, had an association with the obliterated or illegible seal because of the close proximity of these two seals on the painting. What that association might have been cannot be determined today (unless sophisticated X-ray techniques might detect the elusive characters).[9]

In the second pair of seals (Figure 17.6 from panel 2, middle), one seal has two characters which translate as "a cave or shady dwelling" (*kŏsu*) and the other seal

Figure 17.3
Detail of Figure 17.2, top of panel 10. Seals of Kim Ki-hyŏn (right) and Kosong (pen name of the illustrious court painter Yi In-mun, 1745–1821). Photo by Norman Sibley.

Figure 17.4
Detail of Figure 17.2, top of panel 4. Seal of Pŏmgyŏng (courtesy name of Kim Ki-hyŏn). Photo by Norman Sibley.

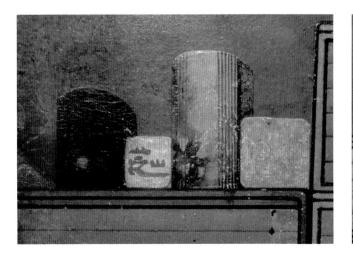

of four characters translates as "a small piece of land south of the river" (*kangnam ilp'yŏn*). Both inscriptions probably identify an individual; perhaps *kŏsu* is the studio or dwelling associated with either the artist or the honoree, and that small piece of land south of the [Han?] river is a reference to the studio's location. The artist further links each pair of seals by using a consistent color scheme; in this case, both seals are presented in grey on a red background. Seemingly, one pair of seals qualifies the other's meaning.

Kim's name seal is carved in positive fashion in panel 10, top (Figure 17.3, right), and the seal on which the pen name Kosong (Old Pine Tree) appears (within the same group) is carved in negative fashion (Figure 17.3, left). Since they are shown together—and artists frequently used their own positive and negative seals in pairs for the sake of harmony—it seems possible that Kosong may have been one of Kim's pen names. In another group of seals, the name Yusu is delineated in negative characters facing the viewer (Figure 17.7 from panel 5, bottom right), and is meant to be read straight on, not flipped over, while the seal reading Sohŏn is painted in positive and reversed characters, so that the name would be printed correctly as an imprint (Figure 17.7, panel 5, bottom left). The same pattern holds true for the group of three seals reading Chukhŏn, Ilsŏk, and Sohŏn (depicted with an ivory seal separating the latter pair; Figure 17.8 from panel 7, top), but not for Kim's name seal and for the pen name seal reading Kosong. The significance of this discrepancy is not clear.

The grouping of Chukhŏn, Ilsŏk, and Sohŏn is of particular interest in terms of hierarchy. Ilsŏk's gold and red seal is much the smallest, perhaps indicating that the artist intended to convey a grandparent-parent-child relationship. In China, nesting seals were referred to as "mother-and-child" sets, and perhaps the *ch'aekkŏri* artist was following this idea.[10] The trio was depicted in graduated sizes and three different color schemes, perhaps a symbolic reference to three generations of one family's association with the *ch'aekkŏri* project—possibly Kim Ki-hyŏn, his father, and his grandfather. Because Chukhŏn is the largest seal, it might have been the pen name of Kim's grandfather. It would then follow that Sohŏn was a pen name

that belonged to Kim's father, and that Ilsŏk was one of Kim's own pen names. The pen name Sohŏn seems especially significant since it is depicted twice on the screen, once with the Yusu seal (Figure 17.7 from panel 5, bottom), and again in the trio, along with the smaller Ilsŏk and larger Chukhŏn seals (Figure 17.8 from panel 7, top). Perhaps repetition of the name indicates that Sohŏn had a specific relation to Yusu as well as to Ilsŏk and Chukhŏn. Alternately, it could mean that two people involved with the *chʾaekkŏri* had the same pen name. The graduated sizes, various color schemes, and occasional repetition of the seals are apparent clues to the relative importance of the pen names. A final seal reads "Zither Strings" (*kŭmsŏn*) (Figure 17.9, panel 3, top). Even though several aspects of this screen's many seals are not yet clearly understood, future scholarship may someday properly interpret them and solve the riddle of this *chʾaekkŏri*.

In addition to the seal characters, other inscriptions appear, not on seals, but on other objects in the composition. The first inscription, seen on an inkstone slab (Figure 17.10 from panel 6, bottom) reads *Nampʾo cheil*, which means "Nampʾo number one," or "the best of Nampʾo." The former inscription ordinarily would seem likely to have no particular significance, since the superiority of inkstones produced in Nampʾo in Chŏlla Province has long been recognized. However, since Nampʾo is located only half a day's donkey ride from the Nagan Kim's clan seat, it becomes a reference marker. Indeed, it may be the *"Nampʾo Cheil"* was only a brand name for the highest quality inkstone. This inscription probably had a particular significance to those whose seals grace the painting, but to this author it represents a place name only.

The second inscription is of great significance because it helps to date the painting and identify its subject. The phrase *oja tŭnggwa yŏnjung samwŏn* appears very faintly, as would an engraving, on the rim of a bronze bowl containing fruit (Figure 17.11 from panel 3, bottom). The artist has made it easy for the viewer to read it (once located) by delineating the inscription in the only easy-to-read script on the entire painting, a version of running script (*haengsŏ*). The inscription on the bowl, which might be translated as "Five sons passed the examinations, among

Figure 17.7
Detail of Figure 17.2, bottom of panel 5. Seals of Yusu (right) and Sohŏn (left). Yusu is a pen name whose owner has not been identified. Photo by Norman Sibley.

Figure 17.8
Detail of Figure 17.2, top of panel 7. Three seals of Chukhŏn, Ilsŏk, and Sohŏn (from the left). They likely refer to three pen names. Photo by Norman Sibley.

Figure 17.9
Detail of Figure 17.2, top of panel 3. Seal of Kŭmsŏn, "Zither Strings." Kŭmsŏn may be a pen name. Photo by Norman Sibley.

Figure 17.10
Detail of Figure 17.2, bottom of panel 6. The inscription "*Namp'o cheil*" (Namp'o number one or the best of Namp'o) on an inkstone. Photo by Norman Sibley.

Figure 17.11
Detail of Figure 17.2, bottom of panel 3. The inscription "Five sons passed the examinations, among them three taking successive firsts" on a bronze bowl. Photo by Norman Sibley.

them three taking successive firsts,"[11] must refer to the honoree whose name or pen name appears on one of the fifteen seals found on the screen. To discover which distinguished Korean matched the description found on the bronze bowl, Wagner turned to the examination rosters and the genealogical records.[12]

Five brothers passing miscellaneous examinations (*chapkwa*) would be an unusual occurrence. In fact, the Chosŏn's National Code prescribed that the state would award substantial annual gifts of rice, as well as titular honors, to the fortunate father of five sons who passed either the higher civil service or the military service examination, or a combination thereof.[13] There appears to have been no similar provision applying to the *chapkwa* examinations taken by members of the *chungin* class, but there can be no doubt that, in *chapkwa-chungin* circles, this same achievement was regarded as a matter deserving of the highest expression of admiration and felicitation. Furthermore, if three of the five brothers took first honors in their examinations, then the celebration surely would call for even more elaborate festivities.

It is not easy to identify instances of five (or more) brothers passing either the *chapkwa* examination or the military examination (which indisputably was open to *chungin* aspirants on a fully equal footing with candidates from the *yangban* class).[14] Since Wagner did not find a notation in an examination roster or in a *chungin* lineage document reporting the achievement of having five or more sons pass the accountants' qualifying examination, he could disregard the examination, thereby reducing the number of recorded instances in which "five sons passed the examinations" to just nine possibilities from the *chapkwa* examinations. These divide chronologically into four cases of brothers born in the seventeenth century, three in the eighteenth century, and only two in the nineteenth century. If, indeed, the inscribed fruit bowl in the painting appears to honor a man then still living who sired five such sons, as we strongly believe, then it follows that the honoree is the father in one of the two nineteenth-century cases.

Of the two nineteenth-century families, the slightly earlier case, that of five Haeju O brothers who all passed the translator-interpreter examination, can be dismissed because neither the courtesy name nor any of the O family's pen names match those in the painting. In addition, only one of the five Haeju O brothers took a first on his examination, not three as described in the inscription.

The other nineteenth-century case, that of the Haeju Kim family, seemed promising because limited, but valuable, genealogical records reveal that among seven sons of a man named Kim Chae-gi (1819–1893: Astronomy-Geography 1848), four are known to be *chapkwa* passers, three having passed the astronomy-geography examination and one the medical examination. The coverage of this lineage in the *Records of [chapkwa-chungin] Lineage Origins (Sŏngwŏnnok)*[15] carries the notation *oja tŭnggwa*, meaning "five sons passed the examinations" beside Kim Chae-gi's name. A fifth son is listed with the succinct notation "[passed the] military examination."[16] This seems most likely to refer to the second of the seven brothers, who is reported in the genealogy to have held a military post that appears to have been given normally, if not exclusively, to men who had passed the military examination. Also, there is the encouraging fact that two of the brothers took firsts in their *chapkwa* examinations, leaving the third such achievement described in the inscription to be imputed to the military examination passer. This can only be imputed because the extant records for the military examinations held in the reign of King Kojong (1863–1907) are incomplete.

Furthermore, despite the availability of genealogical records, neither these nor other sources that might contain such information have yielded a single pen name for any of these seven Kim brothers or for their father. This is not particularly surprising, however, given the manifest reluctance of *chungin* genealogies to record pen names, even of distinguished artists or literary figures. Unhappily, a clear or indisputable connection between Kim Ki-hyŏn and the Haeju Kim clan cannot be established.

Wagner then undertook an examination of the eighteenth-century cases. There he discovered that Kim Chŏng-hyo (1745–?), a member of the Nagan Kim *chapkwa-chungin* lineage, does indeed qualify for the distinction of having five sons who passed the examinations when a rather loose definition of sons is ap-

plied (see Exhibit 17.1). The inscription does not state that all five sons passed the same examination. Kim Ki-hyŏn's father passed the law exam, his father's younger brother, two older brothers, and brother-in-law passed the astronomy-geography examination.[17] Two of the uncles took first place in the astronomy-geography examination, and the one who passed the military examination might possibly have scored first place (even though we have yet to uncover any records to document this).[18] If Kim Chŏng-hyo's son-in-law is included in the count, then this case closely matches the details of the inscription. Based on this evidence Wagner theorized that Kim Chŏng-hyo's grandson, Kim Ki-hyŏn, might be the painting's honoree.

If Kim Ki-hyŏn is indeed the honoree for whom the screen was painted, then logically the pen names must be related to him in some way. Five pen names found on the screen belonged to four well-known nineteenth-century artists and one calligrapher. Was this merely a coincidence, or did the artist intend the seals as specific references to these famous people? Both the pen names Yusu and Kosong that appear on the screen belonged to the illustrious *chungin* court painter Yi In-mun (1745–?) (Figures 17.3 and 17.7).[19] Oksan is the pen name of another court painter Chang Han-jong (1768–1815) (Figure 17.12). Okchŏn is the pen name of the painter Chang Tŏk-chu, (*b.* 18th century) (Figure 17.13),[20] who was associated with his Indong clansman Chang Han-jong.[21] Importantly, Chisan is the pen name of the calligrapher and painter named Pang Han-ik (*b.* 1833; passed translator's exam 1850).[22] That the names Chisan and Pang Han-ik belong to the same person is of great significance because it corroborates what the pair of seals, the one reading Chisan and the other with an obliterated or illegible inscription, depicted in a shared color scheme and in close proximity to each other, were possibly trying to

indicate (Figure 17.5 from panel 8, middle). Evidently, *chapkwa-chungin* lineages, constituting a relatively small percentage of the Chosŏn period population, were intricately interconnected one with the other, and it is perhaps unwise to assign too much importance to these relationships. However, Kim Ki-hyŏn was distantly related through marriage to both Pang and the Chang painters. Since Chang Han-jong died ten years before and Yi In-mun died four years before Kim Ki-hyŏn's birth, a connection other than veneration for these gentlemen, possibly friends of Kim Ki-hyŏn's grandfather, seems tenuous at best. By a process of elimination, then, only Pang Han-ik, eight years younger than Kim, might have had a direct connection as a friend.

This supposition is supported by another seemingly random feature of the screen: a zodiac clock suspended from a stand and painted to resemble a branch of coral (Figure 17.14, panel 4, bottom). The shelf directly above the clock is the one in which Kim's courtesy name appears. One suspects a link between the clock and the name seal because of their close proximity on the screen. The clock's hour hand points to the Chinese character *yu* (chicken) and the minute hand points to *mi* (sheep). Significantly, Kim Ki-hyŏn was born in the year of the chicken (1825), and he celebrated his seventieth birthday in the year of the sheep (1895). The zodiac clock is a curiosity, for the artist painted its hands in the style of a Western clock, but instead of Arabic or Roman numerals the zodiac animals from Chinese cosmology are depicted on the dial, perhaps emphasizing the date of 1895 and confirming that Kim Ki-hyŏn was the painting's honoree. Thematically, it seems entirely logical that a *ch'aekkŏri* painter would use an object to suggest not only the occasion for which this screen was commissioned, but also the date when it was painted. Two horological traditions have been inventively combined in a way to provide information to viewers who can unravel the imagery.

Further corroboration that this screen is, indeed, a birthday painting, is found in the many auspicious symbols depicted. For instance, the clock stand itself, made of a coral branch, is a longevity symbol, as are the character *su* (longevity) repeatedly decorating the clock's circumference and the green jade or glass bowl (Figure 17.2, panel 10, bottom). The Chinese characters depicted on the top tray of the brightly colored lunch box read "peaceful" (*nyŏng*) and "happiness" (*pok*) (Figure 17.15 from panel 9, top). When combined, they express a generalized wish for an undisturbed life. Below the characters are two more trays, each with two symbols decorating the box's front. Three of these, the interlocking rectangles and circles, and the crossed pair of rhinoceros horns, are from the "seven treasures pattern." By the nineteenth century, they had become a popular decorative motif and were used by artists and artisans in painting, ceramics, book-cover patterns, textiles, lacquer ware, and furniture hardware said to express longevity and happiness.[23] More mysterious is the cross drawn like an X, delineated in silver, on the bottom left corner of the lunch box. Five encircled swastikas, whose arms point left as in Lamaist articles of Chinese make, decorate the arms and center of the cross, a piece of mediaeval jewelry called a Nestorian cross.[24] The swastika is an ancient sun symbol, but in a Buddhist context the swastika is a mystical emblem with all good fortune and virtue inherent. Surely, the combination of these symbols expresses the wish that

Figure 17.13
Detail of Figure 17.2, top of panel 1. The seal of Okchŏn. Okchŏn is the pen name of the court painter Chang Tŏk-chu (born 18th century). Photo by Norman Sibley.

Figure 17.14
Detail of Figure 17.2, bottom of panel 4. Clock interpreted to read the time as the year 1895. Photo by Norman Sibley.

Figure 17.15
Detail of Figure 17.2, panel 9, top. Lunch box with auspicious symbols with the characters "peaceful and happiness," a Nestorian cross, and three symbols from the "seven treasures pattern." Photo by Norman Sibley.

Kim Ki-hyŏn will enjoy many more happy birthdays.

If Kim Ki-hyŏn is the painting's honoree, however, it is very unlikely that he was also its artist. (It was first thought that he was the artist as his was the only name seal legible. It was not until the research was done on the bowl's inscription, *oja tŭnggwa yŏnjung samwŏn*, that Wagner and I realized Kim Ki-hyŏn must be the honoree, not the painter.) If the clock is accepted as the clue which supplied both

the birth year and date of someone's seventieth birthday, the Chosŏn period artists whose pen names appear on the *ch'aekkŏri*—Yi In-mun, Chang Han-jong, and Pang Han-ik—do not qualify as the painting's honoree. None of these men was born, nor had seventieth or eightieth birthdays, in either the year of the chicken or the sheep.

Wagner's and my suggestion that the Leeum screen might have been painted for Kim Ki-hyŏn's seventieth birthday rests on four facts: first, his seal is the only legible one on the screen having a surname *cum* given name; second, a seal located elsewhere on the screen bears the characters of his courtesy name; third, the clock's hands point to the years of his birth and seventieth-birthday; and, fourth, his grandfather did have five sons (including a son-in-law) who passed the examinations, at least two of whom placed first.[25] The match between the only *cha* seal and the only surname seal appears decisive in naming the honoree.

Lacking resolution of the problems presented by characters on the illegible seal, and with three pen names that currently have no discernable links to any known person, Wagner and I can only speculatively assert that the artist was Pang Han-ik (known as a calligrapher and painter), who would have been sixty-two years old in 1895 and capable of creating this *ch'aekkŏri* masterpiece. His pen name appears in the same red on ivory color scheme as the obliterated or illegible seal, and in close proximity on the same shelf. Pang Han-ik could have created the *ch'aekkŏri* in a spirit of veneration for Kim Ki-hyŏn's grand-father and his coterie on the occasion of Kim Ki-hyŏn's seventieth birthday.

NOTES

1 Seal and object locations are given according to Figure 17.2, the probable original sequencing of the panels.

2 Personal communication with Ledyard, June 14, 2005. Nagan is just to the west of Sunch'ŏn in South Chŏlla Province (*Sinjŭng tongguk yŏji sŭngnam*, pp. 708–709). From Wagner's notes to me comes the following: "Kim Ki-hyŏn, our painting's honoree, may be linked with the broader world of the court painter and with the narrower confines of the *ch'aekkŏri* world. An elaborate link with the great master Kim Hong-do might be proposed. The great-great-grandfather of Kim Ki-hyŏn's mother (Yu Ch'ang-han of the Hanyang Yu family) and the grandfather of the husband of Kim Hong-do's sister (Yu Kye-han) were brothers. And on the level of the *ch'aekkŏri*'s honoree, it can be demonstrated that Kim Ki-hyŏn's sister-in-law and Yi Hyŏng-nok's daughter-in-law were third cousins (they had a common great-great grandfather)."

3 Black and Wagner, "Ch'aekkŏri Paintings: A Korean Jigsaw Puzzle," fig. 8. I first introduced the screen with the *faux bois* panels at the AKSE conference in Paris in 1991.

4 The same holds true for the "baroque" style *ch'aekkŏri* (Figure 1.8), suggesting that objects thrust into the ceiling spaces of their bookcases might indicate a later nineteenth century date.

5 These L-shaped spaces reflect the influence of eighteenth-century Chinese furniture style. See Michel Beurdeley, *Chinese Furniture*, translated by Katherine Watson (Tokyo and New York: Kodansha International, 1979), pl. 75, pp. 54–55; Gugong bowuyuan gujianzhu guanlibu, ed., *Zijincheng gongdian jianzhu zhuangshi neiyan zhuangxiu tudian* (Illustrated catalogue of the architectural decoration and interior design of the Imperial Palace) (Beijing: Zijincheng chubanshe, 1995), no. 268-2.

6 Crackle glazes emulating the Song style became very popular in late eighteenth-century China. Chinese potters were creating all sorts of trompe l'oeil glazes with which to delight Emperor Qianlong: marble, bamboo, cloisonné, shell, silver, and gold. The Royal Ontario Museum has a good collection of trompe l'oeil ceramics. Korean *ch'aekkŏri* artists borrowed the Chinese fool-the-eye finishes in their paintings. In fact, "the imitation of alien materials was a specialty of the Qianlong potters." R. L. Hobson, *A Catalogue of Chinese Pottery and Porcelain in the Collection of Sir Percival David* (London: The

Stourton Press, 1934), p. 179.

7 Na Chih-liang, *The Panoramic View of Chinese Seal Development* (Taipei: China Cultural Enterprises, 1972), p. 7.

8 *ibid.*

9 Unfortunately, what it might have been may now never be known, unless neutron auto-radiography, or some forensic photographic method, is used on the painting to decipher the characters. (This is a very sensitive technique that uses thermal neutrons to illuminate an image. Subsequently the neutrons activate, and later, when they deactivate, they radiate, exposing the film to its elemental composition—iron radiography. I am indebted to James Walker, Amparo Corp. of Santa Fe, New Mexico for this information.) Various other high-tech photographic methods have been tried and have failed.

10 C. T. Lai, *Chinese Seals* (Seattle: University of Washington Press, 1976), p. xiii. Nesting seals existed in Korea as evidenced by the two sets in the Robert and Sandra Mattielli collection in Portland, Oregon.

11 There can be no problem with the translation of the first four characters, but the rendering of the final four characters is highly tentative. For one thing, the character, instead of the expected "to pass (an examination)," is puzzling, and moreover, the term has several possible meanings, none of which seem satisfactory in this context. Taking it to mean "three firsts," as I have, leaves the function in grammatical limbo and its meaning doubtful.

12 *Sŏngwŏnnok*, pp. 378–379.

13 Han'guk chŏngsin munhwa yŏn'guwŏn (Academy of Korean Studies), *Yŏkchu Kyŏngguk taejŏn* (Annotated translation of *Kyŏngguk taejŏn*), vol. 1 (Sŏngnam: Academy of Korean Studies, 1985), p. 477.

14 If we define the search broadly to include passing the accountants qualifying examination (which properly is not accounted to be one of the *chapkwa*, then we can identify as many as twenty cases of five (or more) successful siblings.

15 *Sŏngwŏnnok*, pp. 350–352.

16 A fifth son of Kim Chae-gi is listed with the succinct notation "[passed the] military examination" with only the generation name character, thus lacking the second given-name character.

17 *Sŏngwŏnnok*, pp. 378–379.

18 *ibid.*

19 Yi In-mun's pen names are Kosongyusugwan Toin, and Yuch'un. Kim Yŏng-yun, p. 364.

20 Chang Tŏk-chu's pen name is Okchŏn; Kim Yŏng-yun, p. 390.

21 Chang Han-jong's pen name is Oksan; Kim Yŏng-yun, p. 386.

22 Pang Han-ik painted orchids and rocks: Kim Yŏng-yun, p. 445. He was known as a calligrapher who was from Onyang and whose courtesy name was Pongnae.

23 Personal communication with Suk Joo-Sun, October 1990.

24 Personal communication with Schuyler V. R. Cammann, February 25, 1990: "When I first looked at the picture, viewing it from across the lower left corner, the symbol formed a cross, I immediately thought of the so-called "Nestorian crosses," found in some quantity in the territory once ruled by the Khitan Tartars, the Jurchens, and the Mongols of the Yuan dynasty, in Inner Mongolia and Southern Manchuria, west of the Yalu River. These pieces of medieval jewelry, serving also as a kind of seal and as protective amulets, were generally made in the shape of crosses [or birds]. Because of this, they were avidly bought up by missionaries, who were convinced that they had belonged to Nestorian Christians living in that region before and during the Mongol dynasty. These amulets/seals/ ornaments were often marked with swastikas—an ancient sun symbol—and some of them might well have been Manichean: not Christian at all. (For some fifty years, European and American scholars wrangled over whether or not they were actually Christian, without making a final decision.) What an exciting example of an antique "jewel"—even though its meaning was forgotten!" For another picture of a Nestorian cross, see the Musée Guimet example inscribed on a stele: Jean Paul Desroches, "Beijing-Versailles: Relations between Qing Dynasty China and France," Oriental Art 43, no. 2 (1997), pp. 32–33, fig. 2. The swastika with its arms pointing left appeared on Lamaist articles made by the Chinese, but not by the Tibetans. Eleanor Olson, Catalogue of the Tibetan and Other Lamaist Articles in the Newark Museum, vol. 1 (Newark, NJ: Newark Museum, 1950), pp. 36–38.

25 Another Western influence is seen in a chocolate cup with handle on the middle shelf in panel 1, providing a *terminus post quem* for the painting. In other words, the *ch'aekkŏri* postdates 1750. Before the mid-eighteenth century, chocolate cups, both with and without handles, were used in Europe, but after 1750 Europeans preferred those with handles. Colin Sheaf and Richard Kilburn, *The Hatcher Porcelain Cargoes: The Complete Record* (Oxford: Phaidon, 1988), p. 108.

18

A Trompe l'Oeil Theatrical *Ch'aekkŏri*

Framed by a tiger skin, the curtain goes up on the Leeum four-panel trompe l'oeil *ch'aekkŏri* (the second theatrical one) to reveal a three-dimensional scene (Figure 18.1).[1] Its artist has combined elements of both the still life and the trompe l'oeil varieties to portray a three-dimensional theatrical stage. The right side shows a bookcase (only three interior sides are visible) depicted in parallel perspective as seen from above, while the left side displays a scholar's study. All the lines of the angular objects in the study, furniture, and inkstones are drawn parallel to those of the bookcase. The scene is successful as a trompe l'oeil painting because its artist has overlapped the furniture and other objects so that the audience sees them recede on the stage. Book stacks line the right side of the stage's back wall bringing the total number of books depicted to six stacks, while the composition is crammed with approximately fifty other objects. A few unusual items are illustrated: a blue garment, a musical chime, and three ceramic Chinese-style spoons.[2] Korean spoons such as these were rare during the Chosŏn period and have not been illustrated before in *ch'aekkŏri* to my knowledge. A bronze bell (also seen in the Leeum "Antiquarian Spirit" screen; Figure 14.2), and a nineteenth-century brass candlestick with shield are not usually depicted in court style *ch'aekkŏri*. Subject matter borrowed from the still life category includes spectacles lying upon a passage of an open book, a long-stemmed pipe, and a Chinese ritual wine vessel known as a jue used in Korea for the ancestor worship ceremony. This vessel is usually restricted to the gnomon style of still life *ch'aekkŏri*.

The tiger skin theatrical *ch'aekkŏri*'s artist was most skilled. The artist's brushstrokes were very fluid, as is demonstrated by the brush holder in Figure 18.1, panel 3, the prevalent wood graining, and particularly the manner in which the curtain folds appear to have been caught by a breeze. One can see by the demarcation lines visible that the outer part of the screen's tiger skin has been replaced and repainted. Perhaps the most important information this theatrical four-panel *ch'aekkŏri* provides is that it dispels the myth that a four-panel screen would not have been

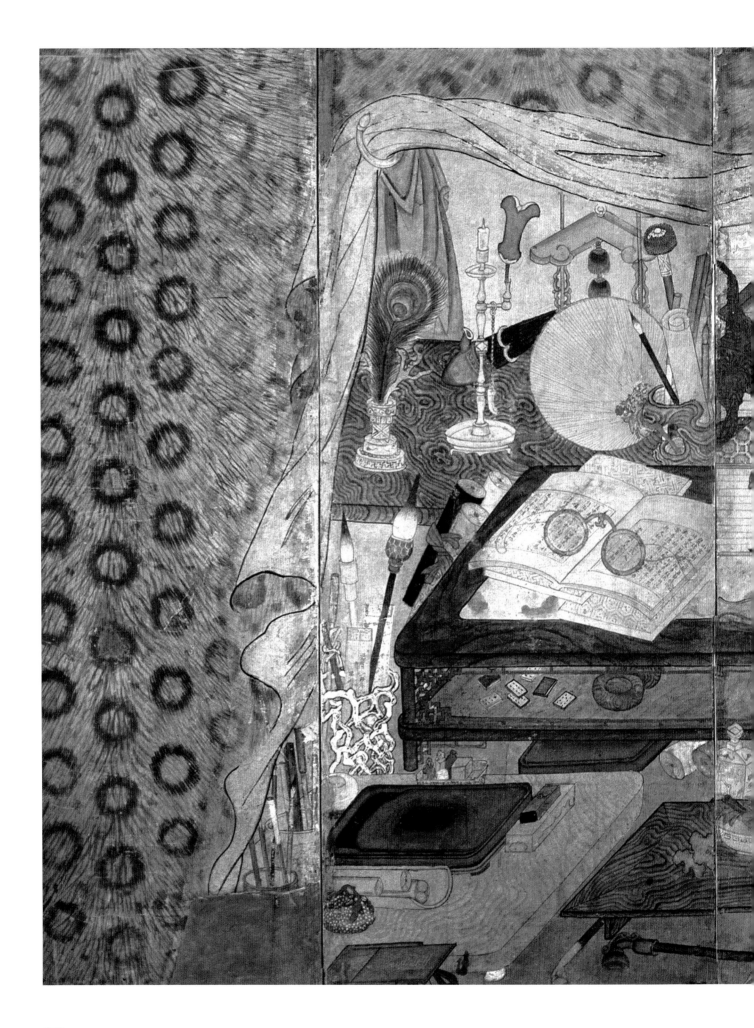

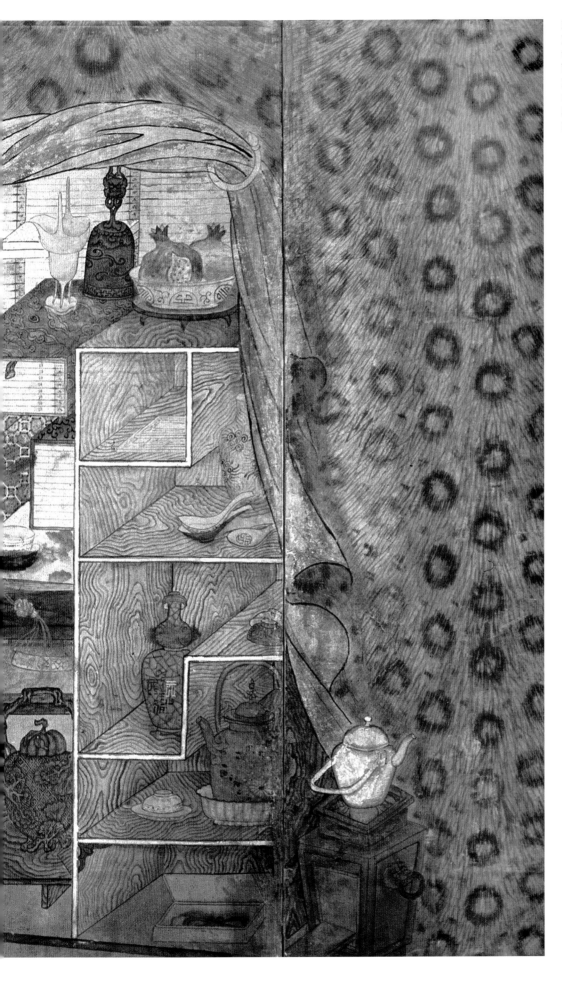

Figure 18.1
Four-panel trompe l'oeil type
theatrical *ch'aekkŏri* framed
by a tiger skin curtain.
Ink and color on paper.
128×355 cm. Leeum,
Samsung Museum of Art.
Photo courtesy of the Leeum.

created because the Chinese character for the word "four" is a homonym for the character that means death. The number four is considered bad luck in East Asia, but evidently late nineteenth-century Korean court painters of at least two theatrical *chaekkŏri* ignored this traditional superstition.[3]

NOTES

1 Although the pattern on the tiger skin resembles that of a leopard's hide, the Koreans call it "tiger skin." The reason for this is not clear.

2 These Chinese-style spoons, although rare, were made in Korea. A blue and white one in the Peabody Essex Museum in Salem, Massachusetts is proof. In 1987, Chung Yang-mo (Chŏng Yang-mo) identified the Peabody's spoon as being late nineteenth-century and having come from the Punwŏn-ri kilns in Kwangju, Kyŏnggi Province. This spoon is thinly potted with a finely drawn lotus in underglaze blue. It was purchased by the museum from Paul G. von Möllendorf, then the advisor to the minister of foreign affairs in Korea, and officially accessioned by the museum on February 10, 1884. For more on this collection, see Kay E. Black, "The Korean Ethnographical Collection of the Peabody Museum of Salem," Korean Culture 10, no. 4 (Winter 1989), pp. 12–21, 28–33.

3 A photograph taken before 1927 shows a high-ranking official seated on a chair covered by a tiger skin, in front of a folding still life type ch'aekkŏri screen. Each panel is broken into rectangular frames aligned vertically, which gives the impression that it is a trompe l'oeil folding screen. Cho P'ung-yŏn, p. 186.

19

An Eight-Panel European Palette Trompe l'Oeil Type *Ch'aekkŏri*

I dubbed an eight-panel screen at the Leeum the "European palette" *ch'aekkŏri* because of its palette of pale colors. The artist's efforts to create an illusionistic bookcase have failed because he has painted parallel orthogonals instead of convergent ones (Figure 19.1). In clinging to the East Asian tradition of isometric perspective, the artist has limited himself to the portrayal of only three sides of each compartment of the bookcase because all of the orthogonals recede in the same direction. The artist has tried to add a fourth side, in this instance a ceiling, to each compartment along the screen's top register. However, the lack of orthogonals at the top of the painting, and the extension of the vertical supports to that point, create not the look of an integrated ceiling but that of a tan strip pasted on as an afterthought.

An unusual object, a Western clock with a bell, found on the upper shelf of panel 8 of the European palette screen, provides a *terminus post quem* for the painting. Called a lantern clock on a pyramidal base, it originated in England around 1600, but it is not known when the type was introduced to Korea.[1] However, a pair of Japanese woodblock prints depicts a Korean emissary presenting one of these to the Governor of Nagasaki in 1688.[2] Both the inclusion of the small lantern clock, and the artist's failure to paint a proper ceiling, suggested an early date for the *ch'aekkŏri*—one possibly representing an eighteenth-century experimental phase of the genre.

Obviously, the lantern clocks were exotic timepieces, as they were priced beyond the means of most and were found only in temples, castles of the daimyos, and houses of the rich in Japan.[3] In Korea, too, they were probably the property of only the privileged and affluent. The small lantern clock appears in the Leeum *ch'aekkŏri* as a status symbol, and its presence means that the painting could not have been executed before 1600 when the instrument was invented. However, since there are at least two seventeenth-century Ukiyo-e woodblock prints, five eighteenth-century ones, and one early nineteenth-century example showing a lantern clock on a pyramidal base, the span of possible dates is broadened.[4]

Figure 19.1
Eight-panel European palette trompe l'oeil type *chʾaekkŏri*
by an anonymous painter, late 19th century. Ink and mineral
pigments on paper. 128.8 × 448 cm. Leeum, Samsung
Museum of Art. Photo courtesy of the Leeum.

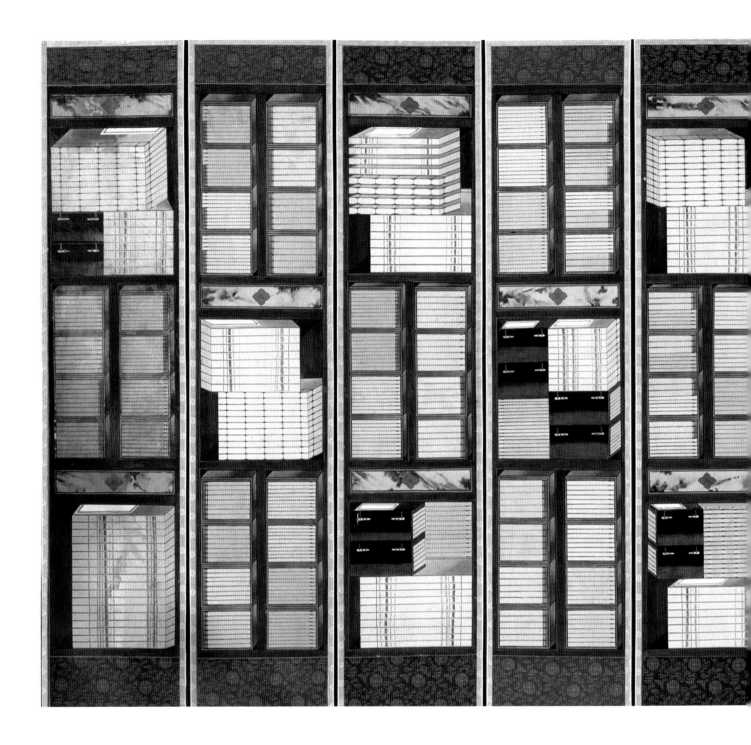

Figure 19.2
Ten-panel trompe l'oeil "Wallpaper Variety" *ch'aekkŏri* by an anonymous painter, 20th century. Ink and reduced palette mineral pigments on silk. 161.4 × 390.5 cm. Ch'angdŏk Palace Museum (catalogue no. 68). Photo by Norman Sibley.

Another European palette eight-panel screen, very similar in style to the Leeum screen, and which appears to be in its original mounting, was sold at Sotheby's in 2005.[5] However, its ceiling is depicted differently. There are orthogonals, seven go in the same direction, stopped at the right end by one opposing. The effect of the orthogonals eliminated the appearance of a pastiche strip despite the two vertical frames that penetrate the ceiling's space.[6]

Other factors must be considered before speculating on an approximate date for the European palette screen: palette, style of depiction, and subject matter. In this study, three other *ch'aekkŏri* share a palette of pale European colors. They are all

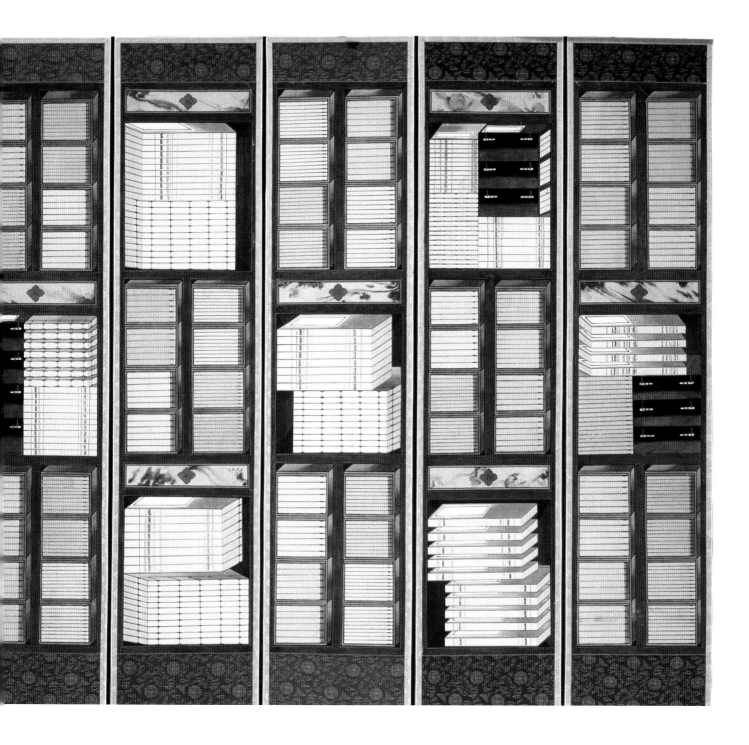

from the very late Chosŏn period, and each was painted by a different hand. One is the Leeum's theatrical work (Figure 18.1). The second is the ten-panel Ch'ang-dŏk Palace "Wallpaper Variety" *ch'aekkŏri* (Figure 19.2). The bookcase's structure features drawers with *faux marbre* facades; otherwise the subject matter is devoted completely to books—167 stacks and fourteen single volumes. Nine stacks of books are bound Korean style with five strings. The third one is the two-panel Sneider trompe l'oeil corner screen (Figure 20.1). The painter of the Sneider screen is more skilled than that of the European palette screen, but both seem somewhat less formal in style when compared with the mainstream trompe l'oeil screens of Yi

Hyŏng-nok and his followers.

A watermelon and a fan are common to the European palette *ch'aekkŏri*; both are late inclusions in the subject matter of the genre.[7] Among the other objects on the European palette screen are Korean items not usually associated with the trompe l'oeil type (Figure 19.1). A novelty from the Western world, in addition to the small lantern clock discussed earlier, is a stem-cup (panel 7, middle).[8] Other objects that do not appear in *ch'aekkŏri* of Yi Hyŏng-nok's mainstream trompe l'oeil type are a fan (panel 2, top), two mirrors (panels 4, bottom and 6, middle), a brass candlestick with a butterfly-shaped shade (panel 4), stags' antlers (panel 6, top), and a winter hat (panel 8, top). A cut-open watermelon, thought to enable the spirits to eat (panel 2, middle),[9] is frequently seen in the still life type of *ch'aekkŏri*, but is seldom seen in the trompe l'oeil type. Most curious are the tridents (panel 3, top and 8, bottom), a kind of military weapon carried by soldiers sometimes depicted in late Chosŏn painting.[10] The tridents and the watermelon are not customarily found in the trompe l'oeil type, which was primarily a court style. The *ch'aekkŏri*'s palette, subject matter, and painting style all point to it being late nineteenth-century.

NOTES

1 H. Alan Lloyd, *The Collector's Dictionary of Clocks* (London: Country Life Limited, 1964), pp. 56–57, pl. 9A. Daphne Rosenzweig drew my attention to the Sotheby's (London) auction catalogue *Japanese and Korean Works of Art* of July 14, 2005, in which Lot 1108 shows an enormous eight-panel *ch'aekkŏri* similar in style and palette to the Leeum European palette screen, which also has a lantern clock on a pyramidal base in its subject matter.

2 N. H. N. Mody, *Japanese Clocks* (Rutland, VT and Tokyo: Charles E. Tuttle Co, 1967), pl. 129. The wood-block prints were published in the *Nippon Eitai-gura*, a novel by Saikaku Ihara (1688).

3 Mody, p. 43.

4 Mody, pls. 130 (dated 1690), 131 (1708), 134 (1766), 14 (1723), 135 (1803).

5 Sotheby's, London, *Japanese and Korean Works of Art*, July 14, 2005, Lot 1108.

6 *ibid.*

7 Watermelons signify longevity because the Korean word for watermelon (*subak*) is similar to the wordfor longevity (*subok*, C. *shoufu*). So Yeon Eom, "Minhwa: A Precious Look at Traditional Korean and High Social Position Life," *Koreana* 6, no. 3 (Autumn 1992), p. 49.

8 Byung-chang Rhee, *Masterpieces of Korean Art*, vol. 3, "Yi Ceramics" (Tokyo: Byung-chang Rhee, 1978), no. 393.

9 Personal communication with Mrs. Minn Pyong-Yoo, November 1983.

10 A Chinese precedent can be seen in a mid-Qing screen. Kim Man-hŭi, *Minsok torok*, vol. 3, p. 15.

20

A Two-Panel European Palette Trompe l'Oeil Type *Ch'aekkŏri*

Prominently depicted on Lea Sneider's corner screen are two single volumes bound in the Korean fashion with five strings, and a seven-volume stack featuring three-stitch binding (Figure 20.1). Books cover much of the picture plane, and some have legible book titles written on their spines.[1] The artist has used chiaroscuro to good advantage in shading the paper holder and the fruits, including a cut-open watermelon—an unusual item in the trompe l'oeil type. He was a skilled painter, as the expertly rendered flowering *prunus* illustrates.

Pale colors are employed to depict a bookcase structure not seen previously. Only three surfaces of the interior space of the bookcase are shown, the left-hand side (facing), the back, and the bottom. The anonymous artist has designed a stepped-down shelving pattern on the top and bottom shelves in the left-hand panel, and on the middle shelf in the right-hand panel, thereby creating a triangular arrangement. A back-and-forth rhythm is established by alternating the drawing of the orthogonals defining the sides of the bookcase. These design elements contribute to an interesting and balanced composition. Design was the artist's focus. There is no attempt to employ linear perspective in a convincing manner. On the top shelf in panel 1, there are two stacks of books angled in opposite directions, their lines diverging as they recede (sometimes called inverse or trick perspective), while their leading edges remain parallel to the shelves—a requisite of isometric, or parallel, perspective. On the same shelf, the books (under and to the right of the paper holder) have their leading edges drawn at the same distance from the front of the shelf as the back of the bookcase. At the same time, the artist has pulled the books forward to the left of the paper holder; thus, their rear edges do not extend beyond the back of the case.

On the center stepped-down shelf of panel 2, the books are again pushed into the back of the bookcase, while at the same time the bronze incense burner occupies three-dimensional space. The artist's spatial manipulation is too artfully executed for it to have been accidental. Therefore, I assume it was his preference, not a

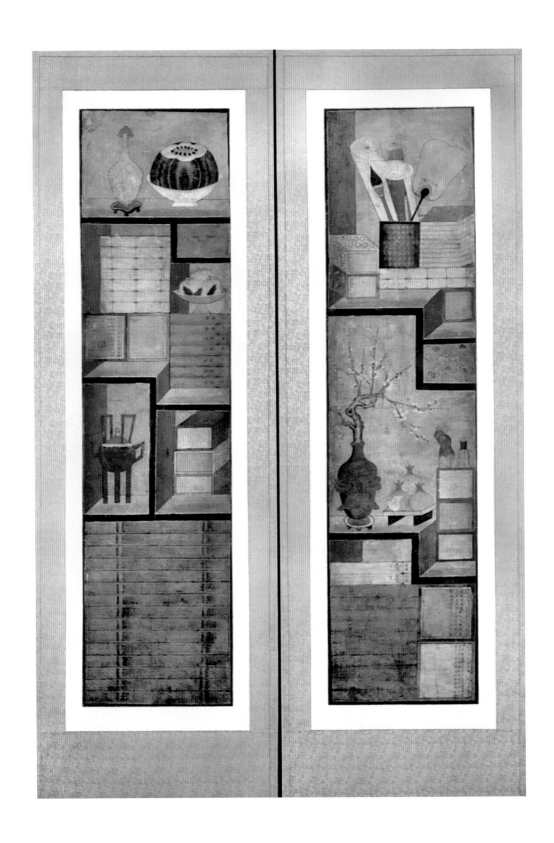

Figure 20.1
Two-panel "European palette" trompe l'oeil type *ch'aekkŏri* corner
screen by an anonymous painter in the last quarter of the 19th
century. Ink and pale mineral pigments on paper. 149 × 34.75
cm. Lea Sneider collection, New York. Photo by the author.

lack of understanding of linear perspective and trompe l'oeil, that caused this visual incoherence. The appearance of a cut-open watermelon; two volumes bound in the Korean five-stitch fashion on a screen with only two panels; the fan, a personal item; and the artist's use of three kinds of perspective together indicate that this *ch'aekkŏri* was probably painted in the last quarter of the nineteenth century. These innovations had not been seen together before.

Amy H. K. Lee, granddaughter of King Kojong, remembers "a dark multipanel *ch'aekkŏri* screen, and a two-panel corner one" on display as late as 1947 at Sadong Palace in Insa-dong where her father Lee [Yi] Kang (Prince Ŭich'in, the fifth son of King Kojong) resided.[2] Both were of the trompe l'oeil court type. Her recollection adds further evidence that both trompe l'oeil and isolated screens deserve to be called court style *ch'aekkŏri*, because they were painted under royal patronage, by court painters, for the royals, the palace circle, and the aristocrats.

NOTES
1 See Appendix I for Book Titles.
2 Personal communication with Amy H. K. Lee, September 29, 1997. Prince Ŭich'in moved from Sadong Palace to Pyŏlgung (palace annex) in 1947, after the palace in Insa-dong was sold.

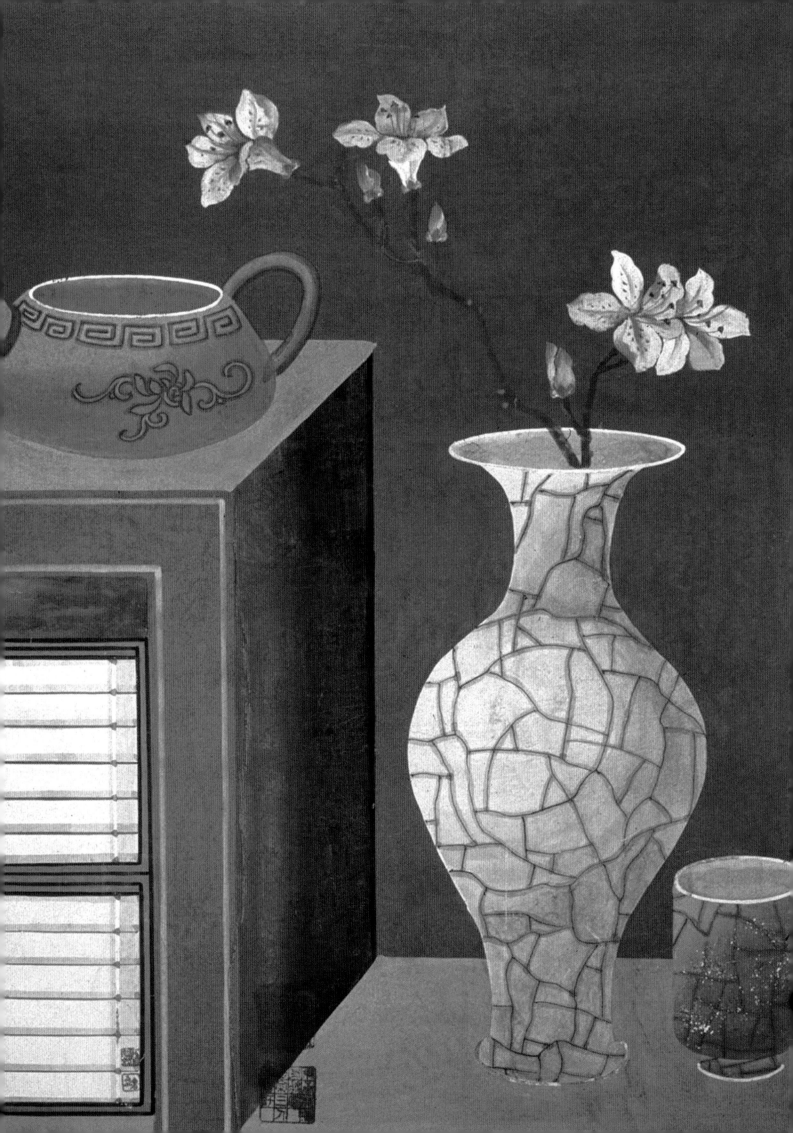

21

Yi To-yǒng: *Yangban* Artist of Court Style *Ch'aekkǒri*

Yi To-yǒng's known trompe l'oeil *ch'aekkǒri* is in the former Minn Pyong-Yoo collection in Seoul (Figure 21.1). Scattered throughout his crisply painted hori-zontal single panel, there are imprints of twenty-one seals.[1] No precedent for so many artists' seals or so many collectors' seals has been found in earlier *ch'aekkǒri*. It would seem that the practice of affixing numerous seals is a twentieth-century innovation. Though a *ch'aekkǒri* honoring Kim Ki-hyǒn does have fifteen seals, they are depicted as objects within the painting, not as imprints.

Usually, when numerous seal imprints appear on a Korean or Chinese painting, they belong to collectors, rather than the painter. The imprints of twenty-one seals on the Minn trompe l'oeil *ch'aekkǒri* appear to be those of Yi To-yǒng (see Exhibit 21.1 for Yi To-yǒng's seals and translations). Twenty-one seals would seem excessively boastful. Seventeen of the impressions clearly belonged to Yi To-yǒng himself, and an eighteenth seal, which most likely belonged to him, is a humorous one; it is understood to mean, "with painting I barter for wine." An identical pair of seals with fourteen characters—*Pultae pukhae yǒ changgun oga samin* (next character illegible) *paeksa*—poses a problem because one character in the last line is illegible. Though the bracketed word represents a guess at the illegible verb, it probably reads: "At the Terrace of the Buddha on the North Sea, three members of my family and a general [led or conquered] one hundred troops."[2] To date, I have not found any place by that name. However, there is a place called Pulchǒngdae, meaning "Terrace of the Buddha's *ushinisha*" (cranial protuberance), which is a small peak in the southeastern part of the Diamond Mountains. Possibly, the second character *chǒng (ushinisha)* of the place name was simply omitted.[3] Alternately, the seal might refer to a place called Puryǒngdae, "Terrace of the reflection of the Buddha," which happens to be near the sea. Again, the second character was perhaps omitted.[4] However, according to Ledyard, Koreans thought of east as north, so "near the North Sea" would fit the location of Puryǒngdae.[5] Since it sounds like a dedication seal, it might commemorate an historical event in the Yi family annals.

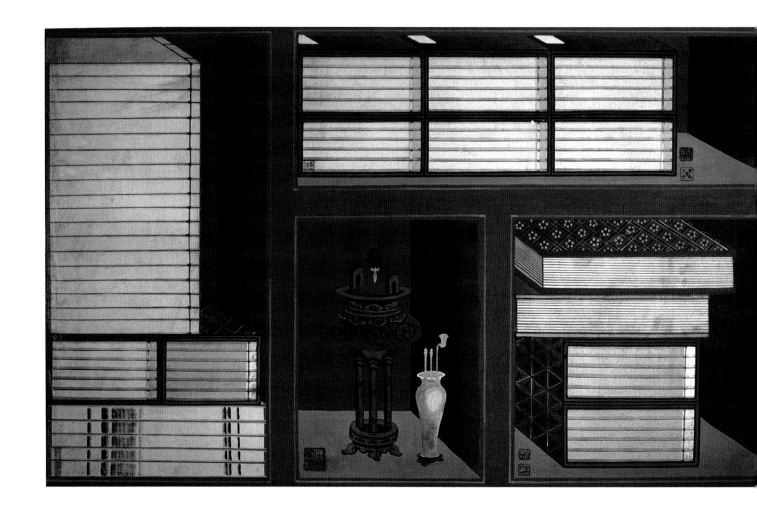

A bookplate type of stamp on the Minn screen is understood to mean, "from the Yi To-yŏng Kwanjae collection of painting, calligraphy, and epigraphic materials."[6] A second seal establishes Yi To-yŏng as the artist thus: "Kwanjae poetry without sound" (*Kwanjae musŏngsi*), which metaphorically means "Kwanjae painted this picture." A third seal, "Kwanjae's expert appraisal" (*Kwanjae kamjŏng*) is impressed twice and is evidently a seal that he used from 1922 through 1927 as a judge for art exhibitions (see Exhibit 21.1). The presence of this seal on Yi To-yŏng's trompe l'oeil painting in the former Minn collection raises the question of whether or not Yi actually judged his own *ch'aekkŏri* at one of the exhibitions. Although Yi To-yŏng had two paintings on display at the first *Sŏnjŏn* exhibition in 1922, they were considered to be "sample works," ineligible for the contest. Therefore, Yi To-yŏng had no official reason for impressing his seal on the Minn *ch'aekkŏri*. Perhaps he was flaunting his status as a judge by impressing it along with the twenty others on the Minn trompe l'oeil *ch'aekkŏri*. However, the five years he served as a judge (1922–1927) might bracket the dating of the work.

Yi To-yŏng created a new perspective device in the Minn's trompe l'oeil painting. The twenty books and nine objects depicted in the bookcase are seen from

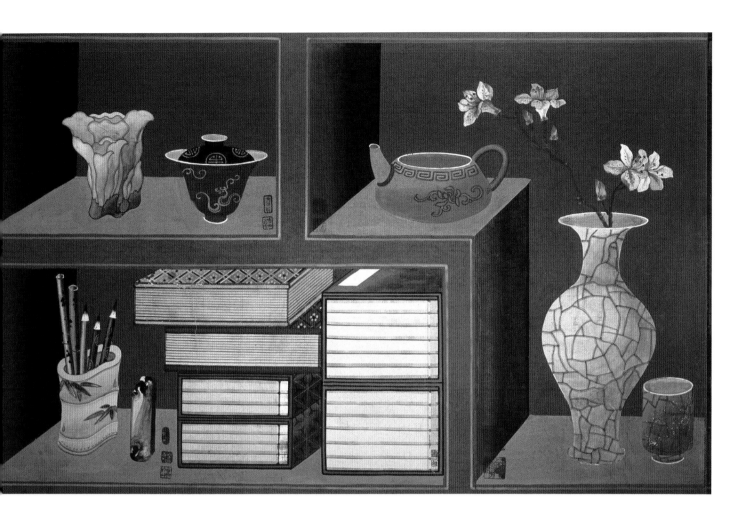

above, a viewpoint maintained throughout the painting. In the bookcase's structure he used only two vantage or station points, resulting in only two corresponding vanishing points. His trompe l'oeil *ch'aekkŏri* from the Japanese colonial period is the most radical in composition. There is no central focus; its two wings divide in the center with their orthogonals painted in opposite directions. The central focus, the usual compositional link necessary for a successful mainstream trompe l'oeil type *ch'aekkŏri*, was eliminated. This central section had been the focus of Yi Hyŏng-nok's four screens executed some fifty to seventy-five years earlier, and of the *ch'aekkŏri* painted in honor of Kim Ki-hyŏn, which has been dated to 1895. Yi To-yŏng's composition and palette were reduced and simplified, conveying a contemporary, abstract quality to his painting. Even Yi To-yŏng's format is different; he abandoned the folding screen in favor of a horizontal wall picture. This *ch'aekkŏri* could be seen as a symbol that times had changed, and that in the twentieth century it was socially acceptable for a *yangban* to appropriate a painting theme traditionally used by court painters or other *chungin* figures. Yi To-yŏng's work, lacking a central focus, executed in an elegant palette, and exhibiting a crispness of drawing, takes trompe l'oeil type *ch'aekkŏri* in a new direction.

Exhibit 21.1 Yi To-yŏng's Seals in the Minn Trompe l'Oeil *Ch'aekkŏri*

Because only five of Yi To-yŏng's seals found on the Minn's trompe l'oeil *ch'aekkŏri* are reproduced in O Se-ch'ang's book on Korean seals (*Kŭnyŏk insu* [Collection of Korean seals], Seoul: National Assembly Library of Korea, 1968), the Minn painting gives new information as to the seals used by Yi To-yŏng.

A. Illegible.

B. *Chŏngga* □ *jae* 靜嘉□齋 (□ character is either *kwan* 貫 or *to* 道, uncertain, but likely *kwan*). Understood to mean "Kwanjae's peaceful studio." The same studio name appears on another of Yi To-yŏng's seals in O Se-ch'ang's book, p. 166.

C. *Pyŏkhŏja* 碧虛子(one of Yi To-yŏng's pen names).

D. *Kwanjae kamjŏng* 貫齋鑑定 (same as the seal P) "Kwanjae's appraisal." Understood to be Kwanjae's judge seal.

E. *Yi To-yŏng Kwanjae kŭmsok tosŏ* 李道榮貫齋金石圖書 (same as the seal Q). Understood to mean, "From the painting, calligraphy and epigraphy collection of Yi To-yŏng" (personal communication with Robert Mowry and Fumiko Cranston, June 1990). Or understood to mean, "From Yi To-yŏng's epigraphy and library" or "From Yi To-yŏng's epigraphy and classical books." It is a kind of bookplate seal (personal communication with Li He, November 1996).

NOTES

1 Five seals (examples G, H, I, L, and M) are published in O Se-ch'ang, *Kŭnyŏk insu*, pp. 134–135.

2 Personal communication with He Li, November 8, 1996.

3 See Pak Ŭn-sun, *Kŭmgangsando yŏn'gu* (Seoul: Ilchisa, 1997), pl. 40-4 for an illustration of Pulchŏngdae.

4 For the interpretation of the seals, I am primarily indebted to He Li, Mao Wai Quan (seal carver of the New Unique Company, San Francisco), Robert Mowry, Fumiko Cranston (both Sackler Museum, Harvard University), and William D. Y. Wu.

5 According to Ledyard, Koreans thought of the east coast of Korea as being north. Personal communication, February 1997.

6 Yi To-yŏng painted an isolated type *ch'aekkŏri*, which was also formerly in the Minn Pyong-Yoo collection (see Chapter 7). This screen has eight panels (65 × 35 cm) and is executed in mineral colors on silk in a palette of green, yellow, blue, red, brown, and tan. An inscription reads "Yi To-yŏng Kwanjae," and a seal reads "Seal of Yi To-yŏng."

22

Overview of Still Life Type *Ch'aekkŏri*

The still life type of *ch'aekkŏri* screen painting provides by far the most numerous examples for study and is the most complicated in its use of perspective, subject matter, and written messages (see Exhibit 22.1 for a list of identified artists of the still life type). Wagner and I refer to the Korean still life type as "non-palace *ch'aekkŏri*."[1] An unusual example is a panel from a four-panel *ch'aekkŏri* in a German collection which shows a screen within a screen (Figure 22.1). A mountain landscape is depicted on an eight-panel screen within the subject matter of one composition. Different kinds of perspective, East Asian and European, are combined to create compositions of intermingled and integrated shapes on each panel. The resulting still life arrangements appear as unified architectonic constructions owing to their alignment and to the transitions from one plane to another. Painters of still life *ch'aekkŏri* were concerned with creating a colorful still life composition on each panel of a screen. Tables or other pieces of Korean furniture are usually included as props for displaying the books and other objects. Flower arrangements, fruits and vegetables, and objects appropriate to a Neo-Confucian scholar's study in the Chosŏn period are grouped on or around these tables and writing desks. (An exception to this rule is the "seal script" style, which has no furniture depicted in its compositions.) Because of the great number of examples of still life type *ch'aekkŏri*, I have divided the discussion of these screens into chapters based on the dominant elements in the composition—those that include a gnomon, one that includes a clock, those executed in a particular palette, and those with repeated patterns of seal script characters.

The subject matter in these screens is not focused entirely on scholarly accoutrements, but includes a greater range of items than are found in trompe l'oeil or isolated type *ch'aekkŏri*, including women's personal paraphernalia, bronzes used in the ancestor ritual, scientific apparatus, musical instruments, spectacles, game boards, and animate objects: birds, butterflies, deer, and other animals. Perhaps of more importance to Koreans of the time, the artists placed a greater emphasis

Exhibit 22.1 Table of Identified Artists of Still Life Type *Ch'aekkŏri*

Artist's Name	Pen Name	Date	Collection
Chang Wŏn-sam Note: This name appears in the painting, but has not been confirmed by other records	Ch'wiong?	Late 19th century	Leeum, Samsung Museum of Art (Figure 27.10 in this book)
Mistakenly attributed to Yi Ching	Hŏju	*b*1581– *d* c.1645 A colophon pasted onto the painting suggests that this screen was painted in 1603. This date is highly unlikely. The colophon and seals were probably added to perpetrate a forgery	Chŏnnam National University Art Museum (Figure 23.1)

* Although more than fifteen *Ch'aekkŏri* screens of the still life type have been studied, most of them remain anonymous, awaiting future scholarship and attribution.

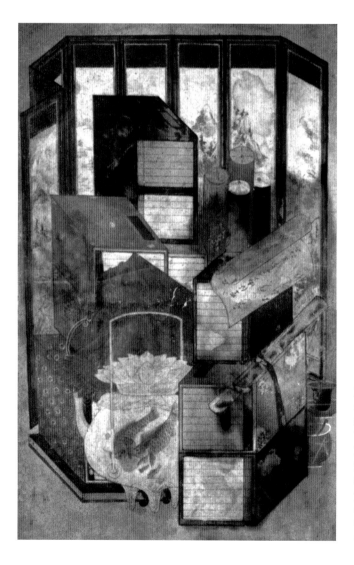

Figure 22.1
One of four still life panels from an incomplete *ch'aekkŏri* by an anonymous artist, late 19th century. The focal point is the screen within a screen. Ink and mineral pigments on paper. 54.2 × 33 cm. Gerrit and Gisela Kuelps collection, Germany. Photo courtesy of Gerrit Kuelps.

on fertility symbols than they did in either of the court styles. Mundane fruits and vegetables with many seeds—Buddha's Hand citrons, pomegranates, grapes, watermelons, eggplants, and pumpkins—symbolize wishes for many sons. Many clues about what the artists, or their patrons, wished to convey are written in Chinese characters on these still lifes, and when these messages are interpreted, some aspects of late Chosŏn period culture emerge that help to identify the beliefs of the time.

Still Life *Ch'aekkŏri* Prototypes

Korea had its own tradition of embroidered floral still lifes as early as the fourteenth century, as illustrated by a four-panel embroidered screen representing the four seasons (National Treasure no. 653).[2] Embroidered examples are also found in Song-dynasty China (960–1279). Key elements of National Treasure no. 653's composition are asymmetrically placed, whereas those of the Song still lifes are symmetrically positioned.[3] That is their compositional difference.

Other sources for Chinese still lifes are found in the embroidery medium. The Philadelphia Museum of Art has a set of Kangxi-period (1661–1722) silk tapestries depicting the four seasons, and they are similar in their compositions to the Kaempfer woodblock prints.[4] A Qianlong-period (1736–1796) embroidered screen in a circular format hanging from the National Palace Museum collection in Taipei, also originally a screen, shows the objects grouped together in tight still life compositions, whose frames suggest shapes reminiscent of the Suzhou gardens of the Ming dynasty, fan paintings, and album leaves.[5] A set of four *kesi* hangings representing the four seasons, sold at Sotheby's in 1988, demonstrates that the antiquities theme persisted in the embroidery medium at least from the eighteenth century on.[6] However, there are still no books included in the compositions, even though there are books in an eighteenth-century Chinese trompe l'oeil type *ch'aekkŏri* painting attributed to Castiglione (Figure 11.1).[7] Seemingly, it was the Korean artists who emphasized books.

Although rooted in the embroidered still life tradition, neither the Korean nor the Chinese embroideries were the main prototypes for the still life *ch'aekkŏri* genre; rather it appears more probable that inspiration for the still life type of *ch'aekkŏri* came from Chinese painting, ceramics, stationery, or the woodblock print.

The Freer Gallery of Art of the Smithsonian National Museum of Asian Art in Washington, DC, has a still life painting on silk, *A Scene from a Western Chamber*, dubiously attributed to Emperor Huizong (r. 1100–1126), which might be considered a prototype for still life type *ch'aekkŏri* as its composition includes books in addition to an arrangement of peonies and scholar's objects.[8] A handscroll by Leng Mei, a versatile court artist to the Kangxi emperor (r. 1661–1722) shows the *bogu* theme depicted in pale colors on silk (Figure 22.2).[9] Here, it would seem, Leng Mei has plucked the images from their palace context and repositioned them on the silk of the handscroll. A sense of the emperor's palatial environment has been conveyed by the manner in which Leng Mei has depicted objects from Kangxi's collection.

Figure 22.2
Hand scroll by Leng Mei,
court artist to Emperor Kangxi
(r. 1661–1723). Pale colors
on silk. Private Collection.
Photo by Daphne Rosenzweig.

Rosary beads are draped over a writing brush in the brush holder, just the way the emperor might have placed them on his desk. The Western technique of shading has been used to model the shapes of the vessels. A three-dimensional effect has been imparted to the images by the highlights and shadows thus created. What most captures the viewer's attention is the cricket that is seen on the verge of crawling out of an overturned vase, en route to feast on the delicacies placed on a plate in front of him. An interesting relationship exists between objects—they are not all spatially isolated from each other on the picture plane. For example, the narcissus arrangement overlaps the vase and its cricket. The cricket and its impending feast give animation to this still life. By sharp observation and careful disposition and interplay of objects, Leng Mei has left a record of some treasures of the emperor's everyday life in his handscroll.

Other paintings of great interest are the paintings of scholars' objects of the Huguang Huiguan Merchant's Guild House (now the Museum of Peking Opera). According to Lothar von Falkenhausen, seventeen nineteenth-century *ch'aekkŏri* still life panels decorate the Guild House's interior architraves—all but one are heavily overpainted. The reference in the name to the merchant's guild implies a commercial connection, which supports the opinion that the still life type is non-palace.[10]

There is a connection between Buddhist painting and *ch'aekkŏri* of the still life variety as well. Four Chinese *ch'aekkŏri* panels of the still life type are painted on the wall, behind a large image of the Buddha, at Huayansi in Datong, North Shanxi

Province. Smoke clouds swirl from an incense burner in each painting (Figures 22.3 and 22.4). Three panels have stacks of books, and each is framed by a curlicue ribbon depicted three-dimensionally. The objects are aligned at the bottom edge of the picture plane with only one or two shown behind another item. Since it is the practice in Buddhist temples to repaint the same picture when it wears out, whether it was painted by secular or Buddhist artists is unknown. These Huayansi *ch'aekkŏri* do not show signs of age, they probably are from the twentieth century, perhaps done after the Cultural Revolution. However, what is important is that they indicate, along with the trompe l'oeil paintings in Jinan, that there is a Buddhist equivalent to the secular *ch'aekkŏri* genre.[11]

As for stationery decorated with still lifes, the earliest extant letter papers known to me with embossed designs, white on white, are two boxes from the late Ming dynasty in the collection of the British Museum.[12] Entitled "New and Antique Designs of Letter Papers from the Wisteria Studio" (*Shizhuzhai huapu*, 1626), and "Ten Bamboo Studio Manual of Letter Papers" (*Shizhuzhai jianpu*, 1644), these collections of stationery with their chaste still lifes would have appealed to the Chosŏn scholar's austere aesthetic and his admiration for the color white. The still lifes on these letter papers appear in relief against the white paper due to an innovative technique called "blind embossing," which is done by pressing a molded relief into paper.[13] Letter papers could well have been the vehicle for the still life type's transmission from China to Korea, as letters would have gone back and forth via tribute missions and other embassies.

Another possible prototype of still life *ch'aekkŏri* is a collection in the British Museum of Chinese colored woodblock prints, known as the Kaempfer series, by the artist Ding Liangxian and others of his workshop.[14] These still life compositions include the same objects found in *ch'aekkŏri*: ceramic and bronze vessels, writing

Figures 22.3 and 22.4
Two of four *ch'aekkŏri* panels of the still life type painted on the wall behind a large image of the Buddha at Huayansi in Datong, Shanxi Province, China. These paintings show the Buddhist connections of the *ch'aekkŏri*. Mineral pigments on unknown surface. Photo by the author.

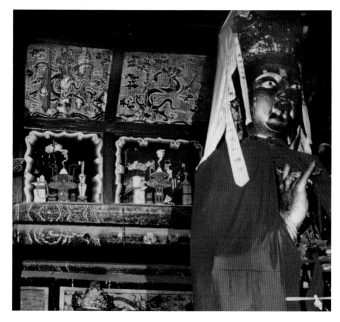
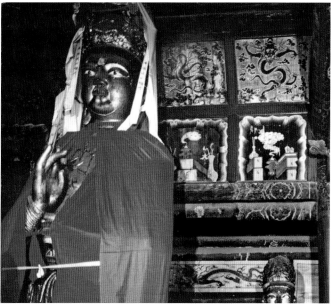

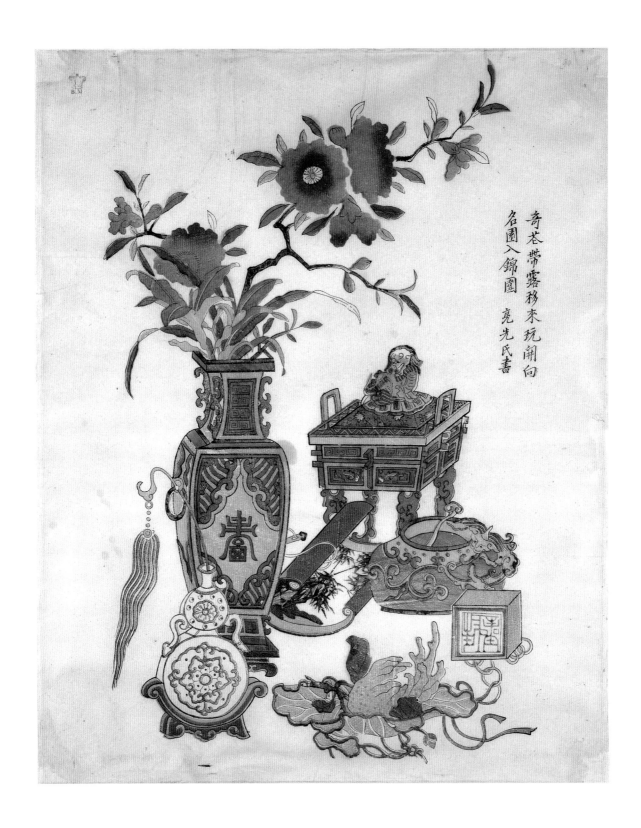

奇
蒼
帶
露
移
來
玩
閣
向

名
園
入
錦
圍

亮
先
氏
書

Figure 22.5
The scene of "summer" from a set of four Chinese
woodblock prints representing the four seasons known
as the Kaempfer series. Late 17th century. 37 × 29.5 cm.
British Museum. Photo courtesy of the British Museum.

materials, painting scrolls, fruits, and floral arrangements. Four of the prints represent the seasons: spring has a floral arrangement of mouton peony and iris, and another of camellia and narcissus; summer has a vase of day-lily and pomegranate (Figure 22.5);[15] autumn shows chrysanthemums and begonias; and winter has a bouquet of Japanese apricot and camellia. Although Chinese embroideries, ceramics, paintings, and letter papers were probable influences, it was the woodblock print that is the most relevant prototype for Korean *ch'aekkŏri*, according to the known examples. One colored woodblock print copied from a painting contains Chinese characters proclaiming it to have been published on mathematics and science by the Imperial Board in the tenth year of the Qianlong emperor (1745).[16] Auspicious objects decorated in pale colors fill the composition: a dragon-decorated fan, a floral arrangement in a bronze pitch-pot for darts (*t'uho* in Korean), Buddhist beads, a scepter, coins, and a scholar's flute. Importantly, the print pictures a book hanging on the wall. Both the fan and the book float on the picture plane without visible means of support. Could the interpretation of *ch'aekkŏri*, "to hang a book," possibly have come from this woodblock print? After all, Qianlong's imperial calendar was intended for the whole country and copies could well have been taken to Korea where they might have been seen by painters-in-waiting working in the royal library.

During the nineteenth century in China, bright New Year's woodblock prints portraying still lifes included the inventory of objects so commonly found in Korean *ch'aekkŏri* designs. One print design (late Qing), with an arrangement of peony and magnolia, symbolizes everlasting wealth.[17] Another print design (1900–1912) has a vase holding peony, pomegranate, and peach blossoms signifying good luck, peace, riches, and honor to the beholder.[18]

In the Chosŏn period, Koreans' great admiration for Chinese decorative arts is reflected in their *ch'aekkŏri*. They presumably had their own prototypes, but these models simply have not survived. Given the wars and hard usage to which the screens would have been exposed as household furnishings, this is not surprising. An educated guess is that both Korean and Chinese still life pictures developed on a parallel track after the late Ming period, but Korean artists were the only ones to use the painting medium on a folding screen format for their *ch'aekkŏri*.

NOTES

1 In a previous publication Wagner and I called this type "table *ch'aekkŏri*." We changed this name when we realized that there are no tables or other small pieces of furniture in the seal script *ch'aekkŏri*. Black and Wagner, "Ch'aekkŏri Paintings: A Korean Jigsaw Puzzle," p. 63; Black and Wagner, "Court Style *Ch'aekkŏri*." Two Korean art experts called this type "people's *ch'aekkŏri*," as opposed to "court style," because they were created for anyone who could afford them. Personal communication with Hahn Changgi and Ye Yong-hae, October 1990.

2 Hokkaidōritsu kindai bijutsukan, et al. ed., *Ri ōchō jidai no shishū to fu* (Patterns and Colours of Joy: Korean Embroidery and Wrapping Cloths from the Chosŏn Dynasty) (Tokyo: Kokusai geijutsu bunka shinkōkai, 1995), pp. 38–39. Huh Dong-hwa, *Kankoku no ko shishū* (Collection of traditional embroideries in Korea) (Kyoto: Dōhōsha, 1982), pl. 43. Huh describes a four-panel screen depicting the seasons. An arrangement of pine and the tea plant symbolize winter; grapes are shown for autumn; the lotus appears for summer; and a vase of *prunus japonica* and camellia are emblematic of spring. Various scholar's items and butterflies surround the floral displays, but they are not symmetrically placed

as they are in the Song dynasty longevity banner with the seals of three Qing emperors impressed upon it: Qianlong, Jiaqing, and Xuantong. The Song banner features a vase of chrysanthemums as its central theme, flanked by a small pair of turtle-shaped planters with orchids. Above, many butterflies and insects circle around.

3 *Cixiu tezhan tulu* (Catalogue of a special exhibition of embroidery) (Taipei: National Palace Museum, 1992), pl. 5.

4 H. L. Li, *Chinese Flower Arrangement* (Princeton, NJ and London: D Van Norstrand Company, 2002), pls. 10, 11, 14, 15.

5 Black, "Hundred Antiques," fig. 16.

6 Sotheby's, New York, *Fine Chinese Jades, Paintings and Works of Art* (auction catalogue), February 25, 1983, Lot 127. I am indebted to Daphne Rosenzweig for drawing my attention to this work.

7 Although I am aware of the problem of using the word *ch'aekkŏri*, which is essentially a Korean term for a genre in Korean painting, for its Chinese equivalents, I have decided to adopt it for Chinese examples because there are apparent similarities, and possibly a link, between the examples from Korea and China while no definite term has been established for the latter.

8 Lawton, *Chinese Figure Painting*. Personal communication with Rosenzweig, September 15, 2004.

9 Black, "Hundred Antiques," pp. 6–7. I am grateful to Rosenzweig for providing the photograph and information on Leng Mei. For more on this artist, see Daphne Rosenzweig, *Court Painters of the Kang Hsi Period*, 2 vols. (Ann Arbor: University Micro Films, 1976).

10 Personal correspondence with Lothar von Falkenhausen, 1999.

11 For another Buddhist connection to *ch'aekkŏri*, see Yi Wŏn-bok, p. 107.

12 I am indebted to Anne Farrer of the British Museum for kindly introducing me to the letter papers and the Kaempfer series in 1997 and Jane Portal and Robert H. Ellsworth for facilitating my research.

13 The *Shizhuzhai iianpu* (Ten Bamboo Studio Manual of Letter Papers) is known to have been in Korea soon after its publication in the seventeenth century. Yi, Sŏng-mi, "Southern School Literati Painting of the Late Chosŏn Period," in *The Fragrance of Ink: Korean Literati Paintings of the Chosŏn Dynasty (1392–1910) from Korea University Museum*, edited by Kwon Young-pil et al. (Seoul: Korea University Museum, 1996), p. 180; Josef Hejzlar, *Early Chinese Graphics* (London: Octopus Books, 1973), p. 35.

14 Joseph Vedlich, *The Ten Bamboo Studio: A Chinese Masterpiece* (New York: Crescent Books, 1979), pp. 10–11. The four woodblocks are among twenty-nine colored prints collected by the German Dr. Englebert Kaempfer (1651–1716) sometime after 1689 when he arrived in Batavia to work for the Dutch East India Company. The Kaempfer collection of Chinese greeting cards reached Europe via Japan in 1692. After Kaempfer's death, they were bought by the Sloane family who donated them to the British Museum at its founding, where they were locked away and forgotten for 200 years, thus preserving them in pristine condition. The Museum's prints are of varying quality, indicative of their not all having been produced by Ding Liangxian, but some by other members of his family studio. However, the only four still lifes in the collection are even in quality with their soft harmonious colors, excellent drawing, and good compositions. Technically, the Kaempfer prints are important because they represent the first time that color prints were done by woodblock; previously, they had been hand-colored. Although they, too, are from the seventeenth century, they are later than the letter papers. Beatrice M. Bodart-Bailey, "400 Years of Japanese-Dutch Relations: A Song for the Shogun, Englebert Kaempfer and 17th c Japan," *IIAS Newsletter* 22 (June 2000), p. 7; personal communication with Anne Farrar, April 22, 1997.

15 The *Shizhuzhai iianpu* (Ten Bamboo Studio Manual of Letter Papers) is known to have been in Korea soon after its publication in the seventeenth century. Yi, Sŏng-mi, "Southern School Literati Painting of the Late Chosŏn Period," p. 180; Josef Hejzlar, *Early Chinese Graphics* (London: Octopus Books, 1973), p. 35.

16 Higuchi, no. 10.

17 Yao Qian, ed., *Taohuawu nianhua* (New Year pictures of Taohuawu) (Beijing: Wenwu chubanshe, 1985), no. 36.

18 Yao Qian, no. 37.

23

Chŏnnam-Style Still Life Type *Chʼaekkŏri*

A particular screen in the Chŏnnam National University Museum in Kwangju, South Chŏlla province, has enabled Wagner and me to establish a stylistic standard, which for convenience we call "Chŏnnam" (Figure 23.1, panels 1–8).[1] Chŏnnam-style paintings present a series of still life compositions linked together to form a folding screen. Each still life is coherently presented to the viewer in a straightforward and naturalistic way, and no guesswork is needed to interpret the angles and the planes, or to identify the objects. Judging from the many similar surviving screens, the Chŏnnam style exemplified by this *chʼaekkŏri* was by far the most popular and seems to be the most "Korean" of all the diverse still life types. In fact, this eight-panel screen is quite similar to twenty-five others of the same style in this study, the earliest of which is thought possibly to pre-date the nineteenth century. Although we have so far been unable to prove the assertion conclusively, I believe that this style existed well before the nineteenth century because its palette can be traced to fourteenth-century Koryŏ Buddhist paintings,[2] although the examples in this study are all nineteenth century.

Thematically, these screens depict the usual scholarly paraphernalia seen in both the trompe l'oeil and isolated types of *chʼaekkŏri*. Depictions of some personal items have been added: a woman's rounded sewing basket with a protruding pair of scissors, women's winter hats, spectacles, stags' antlers, pitch-pots for darts (*tʼuho*), and archery bows with their quivers decorated in a grape design. An open slipcase of books, folded over at an angle, is a common and Korean (not Chinese) characteristic of this style. Although the same open slipcase appears incoherently depicted in two of the three gnomon style *chʼaekkŏri* screens, the artists of the Chŏnnam-style screens knew how to paint this feature competently, and it appears consistently in all of the screens of this style that I have studied. Vases with faceted sides and vessels and paper scrolls tied with wrapping cloths or ribbons are also characteristic of Chŏnnam-style *chʼaekkŏri*. Conspicuous by their absence are the vessels used in ancestor worship rituals. Note too that screens in this style share the predominant

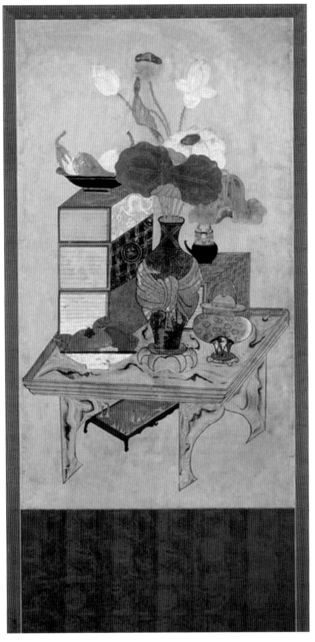

Panel 4

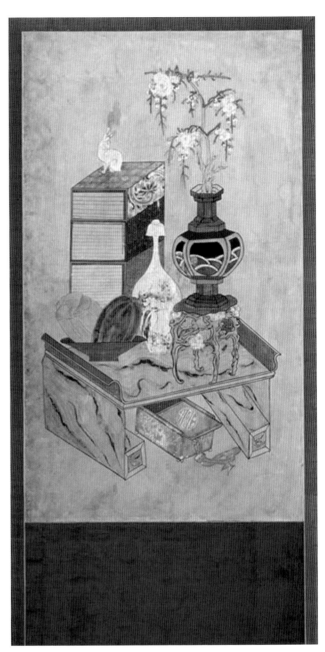

Panel 3

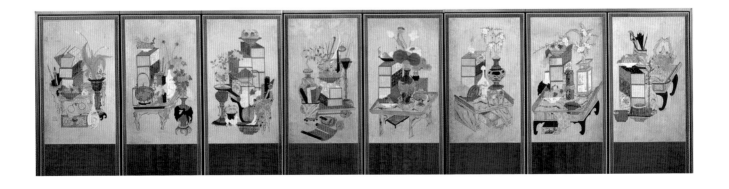

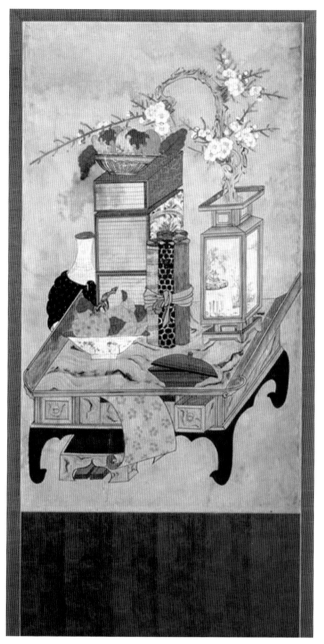

Panel 2

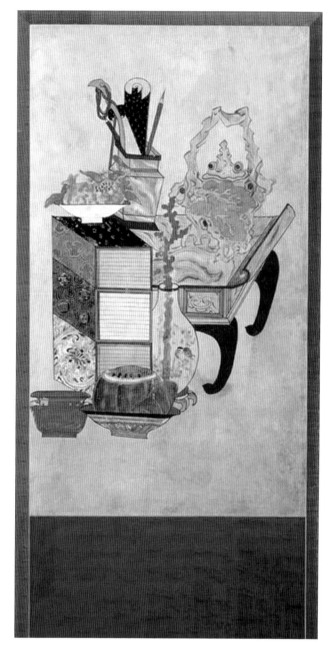

Panel 1

Figure 23.1
Chŏnnam Style *ch'aekkŏri*.
Ink, vegetable, and mineral colors on paper. 66 × 39 cm.
Photo courtesy of Chŏnnam National University
Museum.

Chŏnnam-Style Still Life Type *Ch'aekkŏri* 197

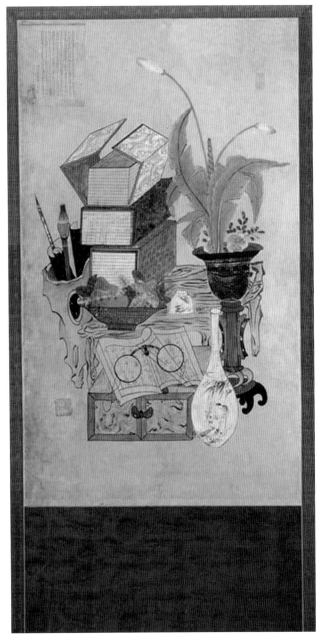

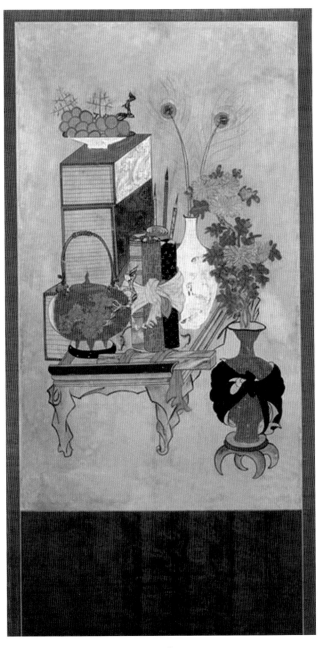

Panel 8

Panel 7

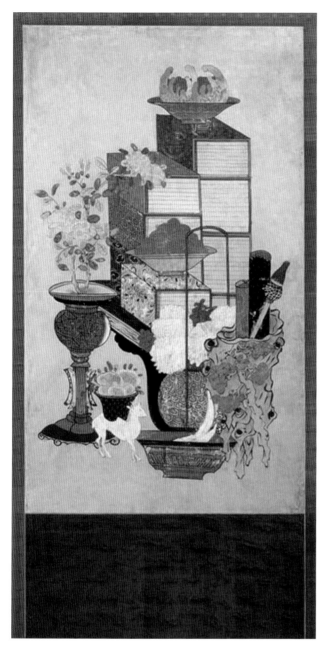

Panel 6

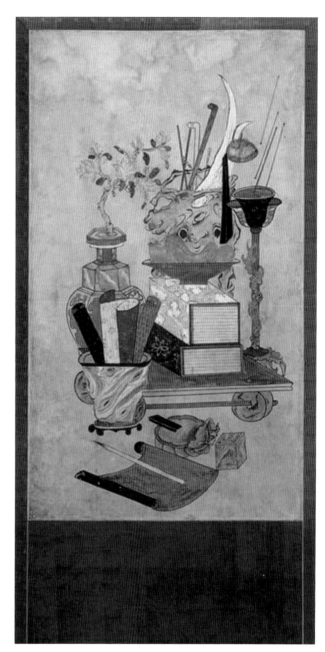

Panel 5

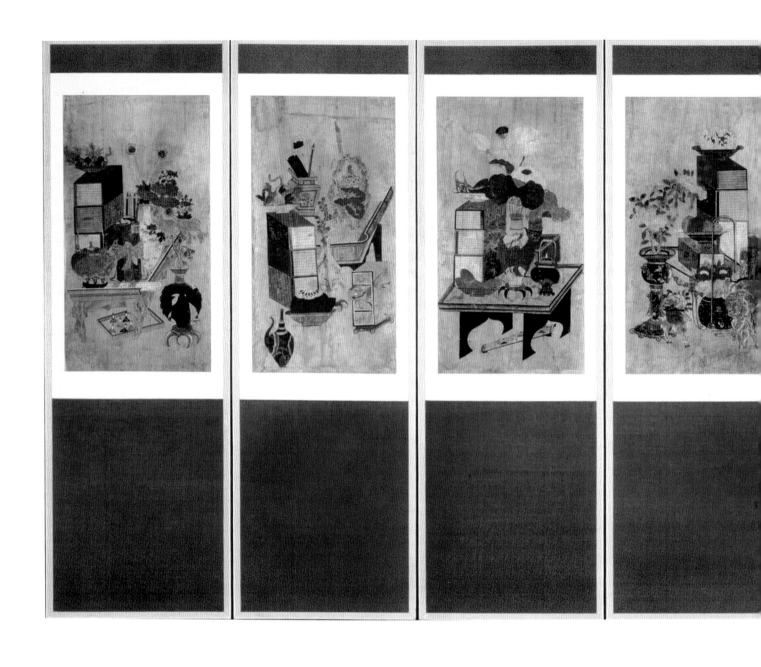

Figure 23.2
Chŏnnam Style *ch'aekkŏri*. Ink, vegetable, and mineral colors on paper.
71.4 × 39 cm. Honolulu Museum of Art. Photo courtesy of Honolulu
Museum of Art.

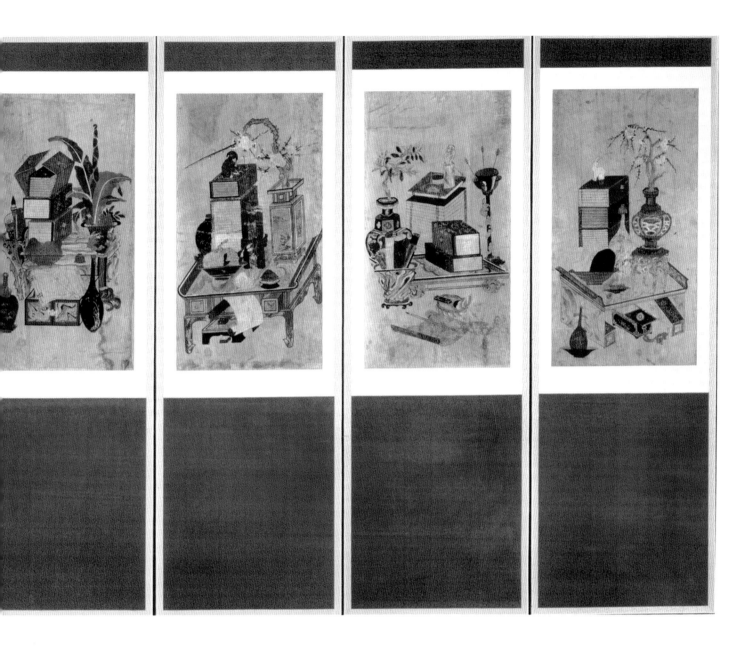

color scheme of orange, green, and black.

This chapter pieces together a chronology explaining the sequential development of the nineteenth-century Chŏnnam style of *ch'aekkŏri* by examining the perspective employed by the artists, the various subject matter, and the palette of these four screens. It further attempts to correct the common misattribution of the Chŏnnam University Museum's screen to the famous Yi Ching (1581–after 1645).

After excluding many examples of this style because they were either incomplete screens or aesthetically weak, four works were selected for comparison here: the Chŏnnam screen (Figure 23.1, panels 1–8), after which we have named this style; the Honolulu Museum of Art's (Figure 23.2, panels 1–8); the Hongik University Museum's (Figure 23.3, panels 1–8); and an unmounted screen in the Leeum (Figure 23.4, panels 1–8). The good quality of the Chŏnnam screen and its attribution

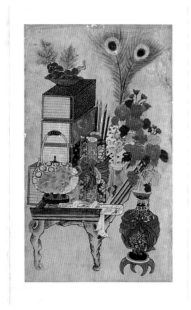 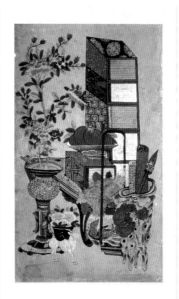 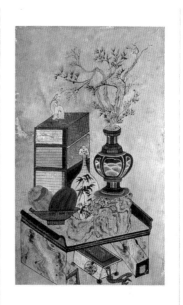 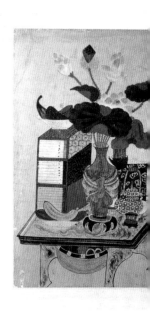

Figure 23.3
Chŏnnam Style *ch'aekkŏri*. Ink, vegetable, and mineral colors on paper. 66.5 × 39 cm. Hongik University Museum. Photo courtesy of Hongik University Museum.

to a famous artist were responsible for its selection as the standard setter for this style. All four *ch'aekkŏri* are eight-panel screens; all share the predominant color scheme of orange, green, and black; and all have similar subject matter, with only minor differences.

The orange and green color scheme has continued in use for Buddhist temple painting to the present day, but its popularity seems to have been usurped by the more garish palette of primary colors—bright blue, red, and yellow—that became the prevalent colors by the late nineteenth century.[3]

Since the gnomon and seal script style of *ch'aekkŏri* were painted in the bright blue, red, and yellow palette, it seems very likely that the Chŏnnam style predates them, although definitive proof of this is lacking. Court painters, Buddhist artists, and folk painters appear to have used the same pigments for their brightly colored works.

The compositions of the Chŏnnam, Honolulu, and Hongik *ch'aekkŏri* are strikingly similar. No dates or artists' names appear on any of the panels, and there are no *terminus post quem* present amongst the subject matter. Therefore, it is virtually impossible to establish a chronology among these three using those criteria. The many similarities suggest that these works were from the same family workshop. Because these artists lived in the center of nineteenth-century Seoul with easy access to one another, the Western idea of a workshop in which painters were physically clustered together does not necessarily apply.

In fact, the compositions of the Chŏnnam, Honolulu, and Hongik *ch'aekkŏri* are similar enough to suggest that their painters may have followed a prescribed formula to arrive at their still lifes. As there are no screens in their original mountings, it has been impossible to establish the sequential order of the eight panels. It might

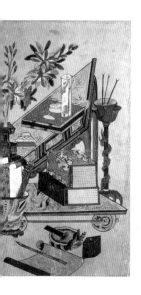 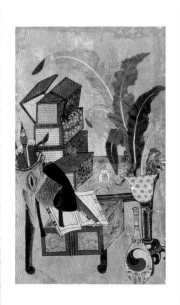 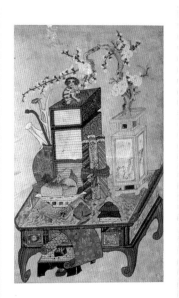 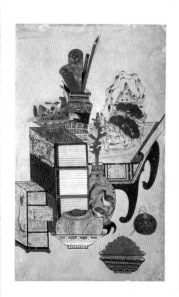

have been based on the seasons or some other theme, but based on something besides, or in addition to, auspicious wishes.

The recent discovery of eight master patterns used to produce one style of still life *ch'aekkŏri* now proves that at least one type was made from patterns, and also adds immeasurably to the understanding of how these screens were made (Figures 23.5–23.9). According to Robert E. Mattielli, the outline of the design and color descriptions and other instructions were first drawn on paper in black ink to create the pattern. Next, a coating of *Perilla frutescens* oil (*tŭlgirŭm*) was added to waterproof the surface, giving a brown cast to the paper. A fresh sheet of paper or cloth was then placed on top of the pattern, and the outlines were traced on to the new surface in diluted black ink. The pattern and new drawing were separated, and when the artist began coloring the new painting, he could refer to the instructions on the pattern.[4] Because the pattern was oiled, ink that had bled through during the tracing did not adhere and the pattern could be reused. On these screen patterns there is a cyclical date of 1812, 1872, or 1932 inscribed, as well as an inscription reading "executed at Kong-dong" (Figure 23.8 and 23.9). No corroborating clues suggest which of the dates might be correct. Although Wagner suspected that Kong-dong might have been a district in Seoul whose name underwent a change, efforts to verify this information have proven unsuccessful. The Chinese character for Yi is written in the lower right corner of pattern 5 (Figure 23.6), suggesting by its placement that it could be the surname of the person who commissioned the patterns. Further information is provided by Chinese characters denoting the colors to be used on the items in the patterns.

Mattielli elaborates:

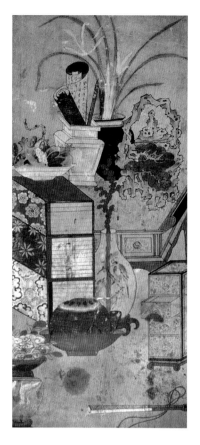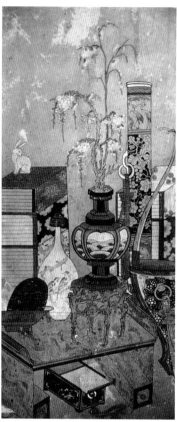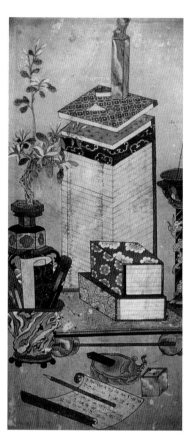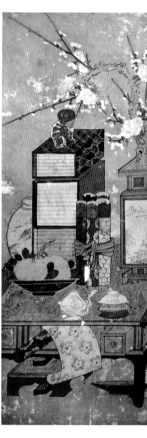

Figure 23.4
Unmounted Chŏnnam
Style *ch'aekkŏri* panels.
Ink, vegetable, and mineral
colors on paper. 63 × 47 cm.
Leeum, Samsung Museum
of Art. Photo courtesy of
the Leeum.

Unoiled cartoons were also used. They were laminated to the back of the painting surface where they absorbed paint and ink. Obviously, they were for one-time use only, and remained attached to the painting's surface. When such a painting requires restorative remounting, the color stained cartoon may partially detach. In this case it is impossible to reattach the pattern in perfect registration with the painting, so the cartoon is removed (and usually destroyed, without the owner's knowledge). This decreases the color intensity of the painting. In comparing such a painting with its detached cartoon, one can sometimes see where an artist has deviated from the original cartoon.[5]

The artists of the Chŏnnam style were draftsmen who liked to draw; they adhered for the most part to the standard East Asian system of perspective in painting the book stacks, furniture, and other blocky objects. Apparently out of preference, these *ch'aekkŏri* artists clung to their familiar isometric perspective, except for minor cases of inverse perspective, in which the lines diverge as they recede. They experimented more freely and frequently than the gnomon artists had, and their *ch'aekkŏri* exhibited a playfulness, in contrast to the more stilted gnomon paintings. For example, there is a steeply tilted tabletop in Figure 23.3, panel 4 and the low pigeon-toed tabletop in the Honolulu Museum of Art's *ch'aekkŏri* appears wider at its rear edge than at its leading one, and of course the screen's pigeon-toed runners

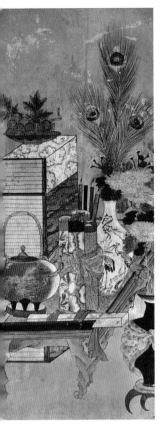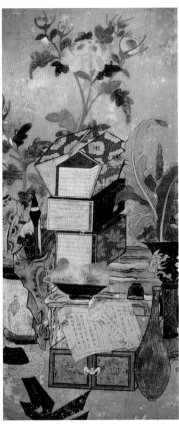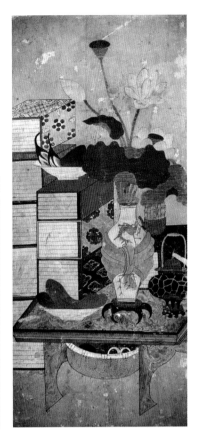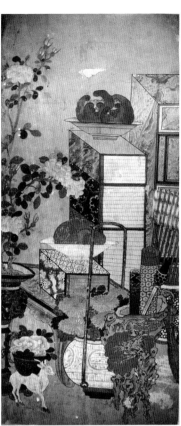

are depicted with diverging lines (Figure 23.2, panels 1–8). Overlapping and slight shading of the objects, both characteristic of European painting techniques, appear but fail to convincingly suggest the volume of objects in space. Nevertheless, the artists have cleverly implied the third dimension by giving each object its own space within the picture plane's area. In other words, the objects occupy a space within a space.

Even casual viewers need only look at the illustrations of several different Chŏnnam-style ch'aekkŏri to notice their startling similarity. For instance, compare the depictions of the rabbit (a symbol of the Moon Festival) in the Chŏnnam (Figure 23.1, panel 3), Honolulu (Figure 23.2, panel 1), Hongik (Figure 23.3, panel 6), and the Leeum ch'aekkŏri (Figure 23.4, panel 7). (Of the twenty-six Chŏnnam-style screens studied, only one has no rabbit depicted.) In each, a rabbit sits on top of three slipcases of books depicted in one stack; a low pigeon-toed table has a vase, decorated in a design of waves, holding wisteria; the stand for this vase is made from a gnarled tree root; a wine bottle decorated in monochromatic ink with cranes and other birds has an inverted cup; and a pair of watermelons is positioned in the dish in exactly the same way in all three screens. Until I found one Chŏnnam style screen without the depiction of the rabbit, I was ready to speculate that this style of Ch'aekkŏri might have been a New Year's screen, created for the year of the rabbit. Variations occur in slipcase colors, wood finishes, and sky hues of the wave

Figure 23.5
Pattern 4 (of eight) master patterns, Robert E. Mattielli collection. Photography courtesy of Robert Mattielli.

Figure 23.6
Pattern 5 (of eight) master patterns, Robert E. Mattielli collection. Photography courtesy of Robert Mattielli.

Figure 23.7
Pattern 6 (of eight) master patterns, Robert E.
Mattielli collection. Photography courtesy of
Robert Mattielli.

Figure 23.8
Pattern 8 (of eight) master patterns, Robert E.
Mattielli collection. Photography courtesy of
Robert Mattielli.

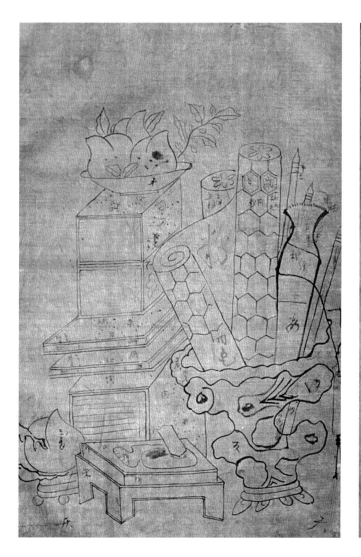

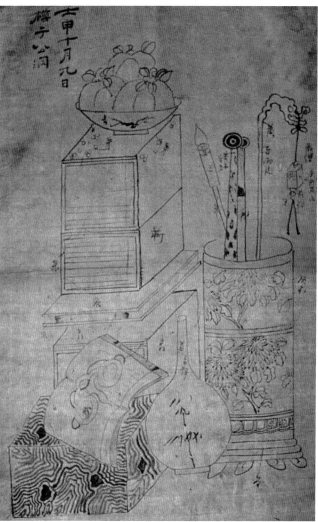

Figure 23.9
Detail of signature from
Pattern 8 (of eight) master
patterns, Robert E. Mattielli
collection. Photography
courtesy of Robert Mattielli.

design. The Leeum screen in this style also exhibits this basic design in exactly the same way, but contains more objects, including an added stack of books, and bow cases that are decorated with the grape pattern (Figure 23.4, panel 7).[6] Cranes are depicted in monochromatic ink on a vase holding peacock feathers (panel 4). Every one of the eight panels in the Leeum screen contains a composition in which a multitude of objects overflow the picture plane. This seems to reflect the artist's desire to create a larger composition to accommodate a greater number of objects, rather than merely to make a bigger screen, which he could have accomplished by changing the scale of the usual composition to suit the enlarged format.

The Chŏnnam screen displays a compositional feature that suggests it might be the earliest in the chronology for this most popular variety. In the Honolulu and Hongik screens, the direction in which stacks of books and other angular items such as chests, tables, and vases are placed changes slightly more often than in the Chŏnnam screen. This somewhat more complicated structure of the still life compositions in the Honolulu and Hongik screens might suggest that the simpler constructions of the Chŏnnam screen were executed earlier; additional indicators are needed to confirm this impression.

In each of these three *ch'aekkŏri* the compositions crowd the picture planes.

Although the margins of each panel have been cut in the remounting process, I have discounted this cropping as an explanation for the crowded arrangements. The compositions would still be crowded even if they were completely centered within roomy borders.

As the style evolved, major compositional changes occurred that are especially noticeable in the Leeum screen (Figure 23.4). These changes reflect its later date. It is the most complicated example of the Chŏnnam-style variety in this study. Its greatly elaborated still lifes reveal that the construction of each panel has more elements, possibly commensurate with its attenuated format. More personal items appear in the Leeum screen than in the others—stags' antlers, a quiver with arrows, a bow holder, and a hand lantern. Despite the numerous objects that fill each panel, the Leeum *ch'aekkŏri* retains an airy quality due to the artist's skillful use of space. He cleverly draws the viewer into each still life by using a framing device. The objects cascade from lower sides of the picture plane, and thus the viewer imagines himself in the midst of the objects.

Paintings of a pair of magpies, another pair of birds, goldfish swimming in a glass bowl, and pairs of cranes are naturalistically and skillfully executed on the Leeum *ch'aekkŏri*. A landscape with birds decorating a rectangular vase reveals that the artist excelled in ink painting. The lines are precise and flowing in their depiction throughout every composition. There is no stiffness; the painting's technique is fluid. Its artist had the ability to depict flowering *prunus* calligraphically in two panels. The goldfish really appear to be moving through the water. The compositions have a grace to them that is lacking in the other examples. The use of color is a bit awkward, probably because the artist used too much black-and-white contrast. However, this quality is offset by the strong and even brushwork throughout.

The Leeum *ch'aekkŏri* contains three written messages for the viewer. First, on the right-hand page of an open book, there is a passage from the *Yijing* describing divination (Figure 23.4, panel 3).[7] It states that through an interpretation of the eight diagrams, the sky/god is asked whether it is advantageous to do something. Unfortunately, the characters that specify what it is advantageous to do are indecipherable. The next sentence is partially obscured by a folded page placed so as to hide the qualifying characters. The unfinished sentence alludes to different aspects of the dragon: "If a great gentleman sees a dragon hiding in a ravine, then an advantage will accrue to him." On the left-hand page of the same open book the first characters are again missing, but they likely refer to "a master, in winter, compiling a book and collecting biographies. After 1,000 years [someone] resumed writing classics again. Writing a book is not so easy." The point of this quotation seems to be how difficult it was to write the Classics.

The screen's second written message is a poem visible on the handscroll that appears with a red writing brush (panel 6). It translates as:

> Gazing in the distance, in four directions on cloudy mountains,
> Everything is my own world
> Flowers and bamboos live in my home
> My heart is full of nature's good things

Only in clear and peaceful places do floating clouds appear
One thousand year old building and green pine trees[8]

The scholar's traditional ideal, the hermit's life, is expressed in the poem; for him much is nothing, and the verse conveys the scholar's feeling that his universe is like old green pines, existing forever.

The third message is also depicted on a rolled up calligraphy scroll near a red pen protruding from a vessel (panel 8). It states:

My sons are already adults
Family and fields are many[9]

By declaring that his sons are grown and that he has lots of land, the poet (or painter?) expresses the idea, "What more could I wish for?"

The Chŏnnam screen is of particular interest because it has been attributed to the famous late sixteenth-early seventeenth-century artist Yi Ching (1581–after 1645).[10] Wagner and I found this attribution startling because one would not expect a fourth-generation descendant of King Sŏngjong (r. 1469–1494)—even an illegitimate one who was a court painter—to have painted still life type chʼaekkŏri.[11] The orange and green palette of the chʼaekkŏri is consistent with that of Buddhist Temple painting of the seventeenth century. Even if a Korean court painter, an illegitimate royal descendent, did paint the chʼaekkŏri theme during the seventeenth century, it stands to reason that he would not have painted the still life type of non-palace chʼaekkŏri, but would instead have painted chʼaekkŏri of the isolated or trompe lʼoeil kinds, types known to have been produced by the palace artists.

Because this study has thus far identified eight different chʼaekkŏri artists, the earliest of whom painted at least 125 years after Yi Ching, it seems unlikely that Yi Ching executed the Chŏnnam screen. Only one of the eight artists identified was a professional court painter from the chungin class (Yi Hyŏng-nok). Kang Tal-su and Pang Han-ik were also chungin and may have been court artists; the latter was a calligrapher. Han Ŭng-suk and Chang Wŏn-sam probably belonged to the famous Han and Chang families of chungin court painters, but there is no proof. The latest, chronologically, of those identified (and the only yangban painter among them), Yi To-yŏng, was active during the twentieth century. Perhaps future scholars may discover still life chʼaekkŏri dating to the first half of the seventeenth century, but I deem this highly improbable.

With the attribution of this screen to Yi Ching widely accepted, however, it became necessary to investigate firsthand, and I arranged a trip to the Chŏnnam National University Museum.[12] There I discovered that the source of the erroneous attribution was a colophon that had been pasted onto the upper left corner of one of the Chŏnnam screen's panels (Figure 23.10 from panel 8 of Figure 23.1). The occurrence of a colophon on the Chŏnnam screen is unique among the more than 150 examples of chʼaekkŏri we have studied thus far. Another peculiarity of the Chŏnnam screen is the pasted-on-patch of the colophon itself. Colophons are encountered frequently enough on other kinds of Asian painting such as landscapes, but they are usually inscribed directly on the painting's surface, not as pastiches. (Buddhist paintings are an exception, as they frequently do display pasted-on colophons.) Clearly, the attribution to Yi Ching had been made on the basis of the pastiche colophon, purportedly written by Yi Ho-min (1553–1634);[13] a seal with his pen name, Obong, is impressed on it. A second seal, Yi Ching's pen name, Hŏju, is found on the left corner foreground of the same panel. A third seal is also impressed on the upper right of panel eight. It is interpreted to mean "serenity reaches far" (yŏngjŏng chʼiwŏn), an expression of an ideal goal that could belong to any scholar or monk and could be a pen name. Both the seals Hŏju and yŏngjŏng chʼiwŏn in all probability were impressed upon the painting to buttress the attribution to Yi Ching by whoever pasted the colophon onto the surface.

In 1603, according to the colophon, Yi Kyŏng-yun (1545–1611),[14] whose enfeoff-

ment title was Hangnim-jŏng, and his younger brother by sixteen years, Yi Yŏng-yun (1561–1611), whose enfeoffment title was Chungnim-su, went to the Manhoe Hermitage located in the Diamond Mountains to visit Yi Ching. An enfeoffment title was given to male members of the royal lineage within four generations of a reigning monarch, and as great grandsons of King Sŏngjong, both Yi Kyŏng-yun and his brother qualified for the honor.[15]

The colophon translates as follows:[16]

> Yi Kyŏng-yun (Hangnim-jŏng) and his brother Yi Hŭi-yun [known as Yi Yŏng-yun] (Chungnim-su) were descendants of King Sŏngjong. Both were good painters, as was Yi Kyŏng-yun's [illegitimate] son Yi Ching, who continued the family tradition. After Yi Ching learned to paint and became very good at it, he wandered and traveled to Manhoe Monastery— a hermitage — in the Diamond Mountains.

In 1603, Yi Ho-min went to the Diamond Mountains with three officials whose names are recorded as:

> Yi Kwang-jun (1531–1609).
> Ch'oe Lip (1539–1612), pen name Kani.
> Han Ho (1543–1605), pen name Sŏkpong.

The three gentlemen went with Yi Ho-min to a monastery.[17] Here the abbot of the monastery, Hyewŏl, aware of Han Ho's fame as a calligrapher and Ch'oe Lip's fame as a writer, asked them to write name plates for all the halls of the temple. The foursome met Yi Ching at the hermitage and saw hundreds of his paintings. The colophon reads, "I obtained eight colored panels and one monochrome with a landscape painting from Yi Ching. It is easier to become a minister than to travel in the Diamond Mountains, but it is easier to travel in the Diamond Mountains than to obtain paintings like these."

The colophon is then signed "Written by Yi Ho-min on the return-road from the Diamond Mountains." Yi Ho-min's seal, slightly obliterated, is impressed on the lower left-hand corner of the pastiche colophon. Yi Ching was twenty-three at the time (1603) when Yi Ho-min wrote about him.

The question raised by the colophon is whether it originally belonged to this ch'aekkŏri or was cut from another painting. Because the colophon's paper color is much lighter than that of the screens' panels, I conclude that the colophon was pasted onto the screen at some time after the screen's creation. Further, nowhere in the colophon does it specify that this was the eight-paneled colored painting that Yi Ho-min obtained from Yi Ching. Does the attribution to Yi Ching, based on the colophon and one seal suggest the existence of an authentic earlier ch'aekkŏri by the artist, or was the colophon pasted on the ch'aekkŏri for fraudulent purposes? Yi Ho-min's biographical record does state that he wrote a colophon on a painting, so it is possible that the colophon on the Chŏnnam screen is indeed his writing. In other words, the colophon itself could be genuine, but cut from another painting.

If that were the case, it must have been the hope of the forger that anyone reading the colophon would jump to the wrong conclusion by connecting this *ch'aekkŏri* to the "eight colored panels" referred to by Yi Ho-min in the colophon. Indeed, the colophon's authenticity is itself in question. Was it actually written by Yi Ho-min, or is it, too, a forgery?

Another argument against attributing the screen to Yi Ching is the relatively unoxidized condition of the paper panels themselves. There are many water splotches visible, indicative of exposure or hard usage, but we would expect to find the panels much darker after 350-plus years of use as a screen. A comparison with the surface color of other works on paper that have been conclusively dated to the seventeenth century reveals that they are much darker due to oxidation, except in the case of a well-cared for album leaf painting, for example, or works otherwise not exposed to much light. However, *ch'aekkŏri* screens were used as household furnishings, and not protected as treasured art works. Most importantly, the *ch'aekkŏri*'s style seems to be consistent with the nineteenth-century. In short, an abundance of evidence argues against the Chŏnnam screen being a genuine Yi Ching painting.

NOTES

1 This screen was first published by McCune, pp. 24–25.
2 Yi Tong-ju, ed., *Koryŏ pulhwa*, Han'guk ŭi mi 7 (Seoul: Chuang ilbosa, 1981).
3 Mun Myŏngdae, ed., *Chosŏn pulhwa*, Han'guk ŭi mi 16 (Seoul: Chungang ilbosa, 1984), pls. 51, 173, 174.
4 Personal communication with Robert E. Mattielli, March 30, 1996. To date, we have not identified a *ch'aekkŏri* that matches exactly the patterns in the Mattielli collection. In addition to the patterns in his collection, Mattielli has observed a contemporary artist preparing palace scene paintings for screens in the manner described.
5 *ibid*.
6 The Peabody Essex Museum in Salem, Massachusetts has a paper quiver decorated with grapes (exhibited in May 2004, catalogue no. E9742), which possibly came from the Chicago 1893 fair. Personal communication with the curator of the museum, Susan Bean, May 19, 2004.
7 Personal communication with He Li, September 5, 2003, who also provided help in translating the inscriptions on the Leeum screen.
8 See n. 7 above.
9 *ibid*.
10 Although the attribution to Yi Ching was stated by Evelyn B. McCune, she gave no basis for it. McCune, pp. 24–25.
11 Yi Ching is officially recorded as a court painter assigned to work on the folding screens, which were among the other items to be used on the occasion of the marriage of the crown prince in 1627. Yi Sŏng-mi, Kang Sin-hang, and Yu Song-ok, *Changsŏgak sojang karye togam ŭigwe* (Changsŏgak Records of the Superintendency for Conducting Royal Weddings) (Seoul: Academy of Korean Studies, 1994), pp. 79, 95.
12 In October 1991, I was able to visit the museum of the Chŏnnam National University and examine the screen. I would like to thank then the director of the museum, Prof. Im Yŏng-jin, for facilitating my research, as well as Chung Yang-mo (then the director the National Museum of Korea in Seoul), Ji Gon-gil (then the director of the National Museum in Kwangju), and Sin Sang-su (Honam University) for offering help in arranging my visit.
13 Yi Ho-min is from the powerful Yŏnan Yi clan, the same one as Yi To-yŏng.
14 Ahn Hwi-joon, "The Origin and Development of Landscape Painting in Korea," in *Arts of Korea*, edited by Judith G. Smith (New York: The Metropolitan Museum of Art, 1999), p. 319.

15 Wagner outlines the succession of the descendants of King Sŏngjong (r. 1469–1494) as follows:

King Sŏngjong's son: Yi Hoe (*b.* 1488)

Yi Hoe's son: Yi Su-han (1505–1546)

Yi Su-han's son: Yi Kŏl (*b.* 1525)

Yi Kŏl's sons: Yi Kyŏng-yun (1545–1611) and Yi Yŏng-yun (1561–1611)

Yi Kyŏng-yun's son: Yi Ching (1581–after 1645)

Koreans use a character to denote enfeoffment and another one to denote illegitimacy; and the two tend to balance each other. Personal communication with Edward W Wagner, August 16, 1996.

16 I am indebted to Rhi Juhyung for the translation of this colophon.

17 Verification exists that Yi Ho-min, Ch'oe Lip, and Han Ho were together in the Diamond Mountains. See Yi Ho-min's account in his *Obongjip* compiled in *Obongjip Injaejip* (Seoul: Asea Munhwasa, 1984), p. 40. Personal communication with Wagner.

24

The Royal Ontario Museum Cycle-Dated *Chʼaekkŏri*

A remarkable screen at the Royal Ontario Museum (ROM) in Toronto contains the remnants of what must have been an important work in the *chʼaekkŏri* genre (Figure 24.1, panels 1–6).[1] Its style is an elaborate version of the Chŏnnam University Museum's screen and twenty-six others in this study. Although currently mounted as a six-panel folding screen, only five painted panels remain of, presumably, an original eight-panel *chʼaekkŏri*, and these show much wear and tear. A solid field of gold leaf substitutes for a sixth still life composition. It must have lost three of its panels before being remounted in Korea during the Japanese occupation (1910–1945), or in Japan itself; the gold leaf paper is a Japanese mounting characteristic. The screen was donated to the ROM in 1994 by a Montreal couple in whose possession it had been since the 1920s.[2]

Chinese characters on an ink stick, found within the composition on panel 3, proclaim *sangwŏn kapcha*, which translates as "full moon of the first month of the lunar calendar" in the sixty-year cycle (which includes the years 1804, 1864, and 1924) (Figure 24.2). Wagner and I can almost certainly favor the date of 1864 for two reasons. First, the style is typical of the nineteenth century, and second, King Kojong (r. 1863–1907) ascended the throne shortly before the beginning of 1864 at age eleven.[3] In addition, 1864 was a *kapcha* year: the beginning of a new sixty-year cycle. It seems likely that the ROM *chʼaekkŏri* was specially created to commemorate the New Year of a new reign, and a new cycle. However, the date of 1924 during the Japanese colonial period, also a *kapcha* year, is possible, but not probable. Thus, I date the ROM screen to the year 1864, and identify it as a work of historical importance because it celebrated the next-to-last king's accession to the throne.

The ROM *chʼaekkŏri* shows certain departures from the basic formula for this type as illustrated by the Chŏnnam, Hongik, Honolulu, and Leeum screens. Theoretically, these departures are appropriate for its creation to mark King Kojong's accession to the throne, and in a *kapcha* year to boot.[4]

The ROM screen's artist chose some floral types that deviate from the standard

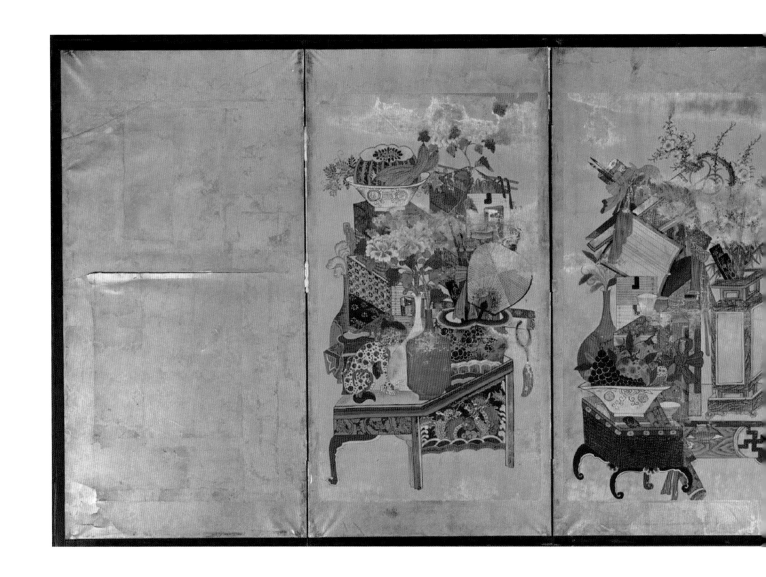

Figure 24.1
Five panels of a six-panel still life *ch'aekkŏri*.
Late 19th century. Ink colors on paper. 78×40.6 cm.
Royal Ontario Museum (acc. no. 995.38.1). Photo
courtesy of the Royal Ontario Museum.

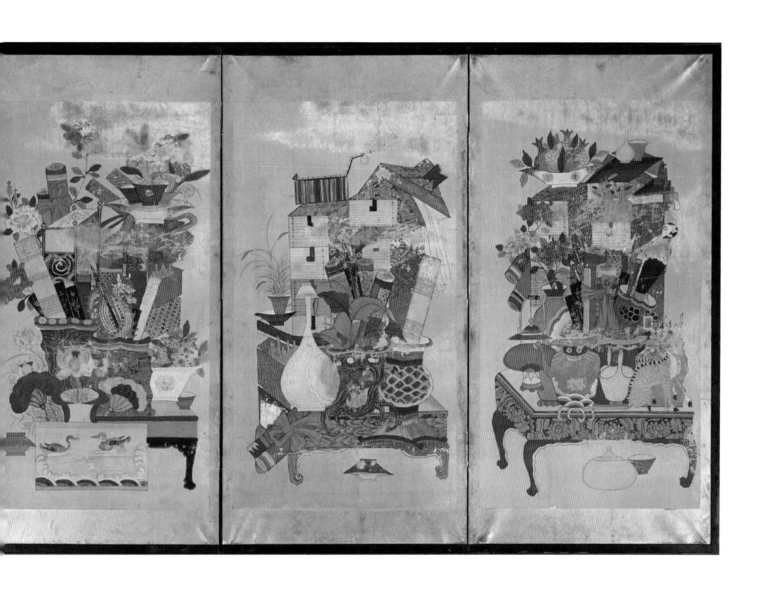

Figure 24.2
Detail of Figure 24.1. Ink stick on panel 3. The inscription reads "*sangwŏn kapcha*." Photo courtesy of the Royal Ontario Museum.

Chŏnnam style: the tree peony (Figure 24.1, panel 1), for example, was substituted for the usual rose or chrysanthemum. Panel 5 lacks a peacock feather in a vase in conjunction with a chrysanthemum, a grouping used to denote official promotion. The ever-present rabbit (panel 4) is shown brown here with an arrangement of *prunus* instead of the usual wisteria found in other examples. Written across a stack of books are Chinese characters that translate as "three books." This work might have been painted by a court artist as a private commission, but because it is a still life type *ch'aekkŏri*, small in format, it is unlikely that it was painted for a palace. One might speculate that a rich commoner could have purchased it for his house, perhaps to honor his new king and to flaunt his own success.

By following the pattern established in other Chŏnnam-style *ch'aekkŏri*, I would expect that the flowers depicted on the lost panels to have included one with wisteria, one with another flower, and one without a flower. Since the ROM screen diverges from the usual pattern, however, there is really no way of knowing. The pronounced differences in the objects inhabiting each still life can almost certainly be attributed to the special occasion for which the ROM *ch'aekkŏri* was created.

Other innovations are seen in the subject matter, too. The ROM *ch'aekkŏri* is the only one I have observed that includes pairs of dragons, ducks, and deer—the last painted very naturalistically. A depiction of the Diamond Mountains, which every Korean wished to visit, is found in three of the five remaining panels. The longevity su character is omnipresent, a particularly appropriate sentiment for King Kojong, a child monarch.

The ROM *ch'aekkŏri* also departs from the established palette and compositional format of the standard Chŏnnam style. The artist was a colorist who used a wider range of bright tones than other artists. The elements forming the composition of each panel are so tightly woven that it is sometimes difficult to identify a given object, for they are compressed into a solid mass. Surface abrasion has made interpretation of certain parts ambiguous at best. All five of the surviving panels reveal a more complex arrangement of angular objects than is the case with any of the other

examples I have encountered.

In panels 1, 2, and 4, the tables seem to recede to the left, but the book stacks that they hold recede in the opposite direction; in panel 5, the table recedes to the right while its books recede to the left, suggesting that the missing three panels had followed the same pattern. Although densely packed with overlapping compositional elements, the forms themselves are flat, not three dimensional, with a few exceptions where shading has been used to model the fruits, flowers, and the coats of the deer. All books stacked upon tabletops, as well as most of the objects, are viewed from an elevated perspective, yet some items are seen straight on. For example, ceramic vessels (in multiple panels), wedding ducks, and the dragon, as well as a scholar's stationery brush, are all depicted frontally. Further complicating the composition are a few instances of items detached from the jumble: cups with inverted cup lids and other items under the tables of panels 1, 2 and 3 are examples. However, the most pronounced difference noted in the constructions is that the artist has enmeshed the whole in a plethora of flower arrangements, teapots, and other scholarly paraphernalia. The effect is of a composition impossible to pull apart on the one hand, and seemingly ready to explode on the other.

The discovery of the ROM's cyclically-dated *ch'aekkŏri* greatly helped establish a stylistic chronology for the following reasons. A grape-decorated quiver (panel 1) appears for the first time in the ROM screen; it is not present in the subject matter of the Chŏnnam, Hongik, and Honolulu screens. There is a grape-decorated quiver seen on the sequentially later Leeum *ch'aekkŏri* of the Chŏnnam type, which also has a complex composition of many items displayed across the panels of its large format (Figure 23.4, panels 1–8). The ROM *ch'aekkŏri* has more blue in its palette, another indication that 1864 is the correct date, because the predominant use of bright blue in the trompe l'oeil style of *ch'aekkŏri* does not appear until around 1860. The sequence of palettes in dated Buddhist paintings indicates that an emphasis on blue is a later trait; the predominantly green and orange color scheme was popular much earlier. In conclusion, its complex composition, so crammed with objects, suggests that the ROM screen is later than the Chŏnnam *ch'aekkŏri*, which began with simpler constructions.

NOTES

1 I was introduced to the screen by Koh Wŏnyoung shortly after it had been received by the Museum in 1994.

2 I am indebted to the late Hugh Wylie, the former curator of Japanese and Korean Art at the ROM, for photographing the screen for me and giving me such provenance as he had.

3 According to a note from Wagner, although kings usually had to wait through the remainder of the year of a late king's demise before ascending the throne, in this particular instance the previous king had died on the very last month of the lunar calendar, 1863. Therefore, King Kojong had to assume the throne virtually at the beginning of 1864.

4 Mun Myŏngdae, pls. 51, 173, 174.

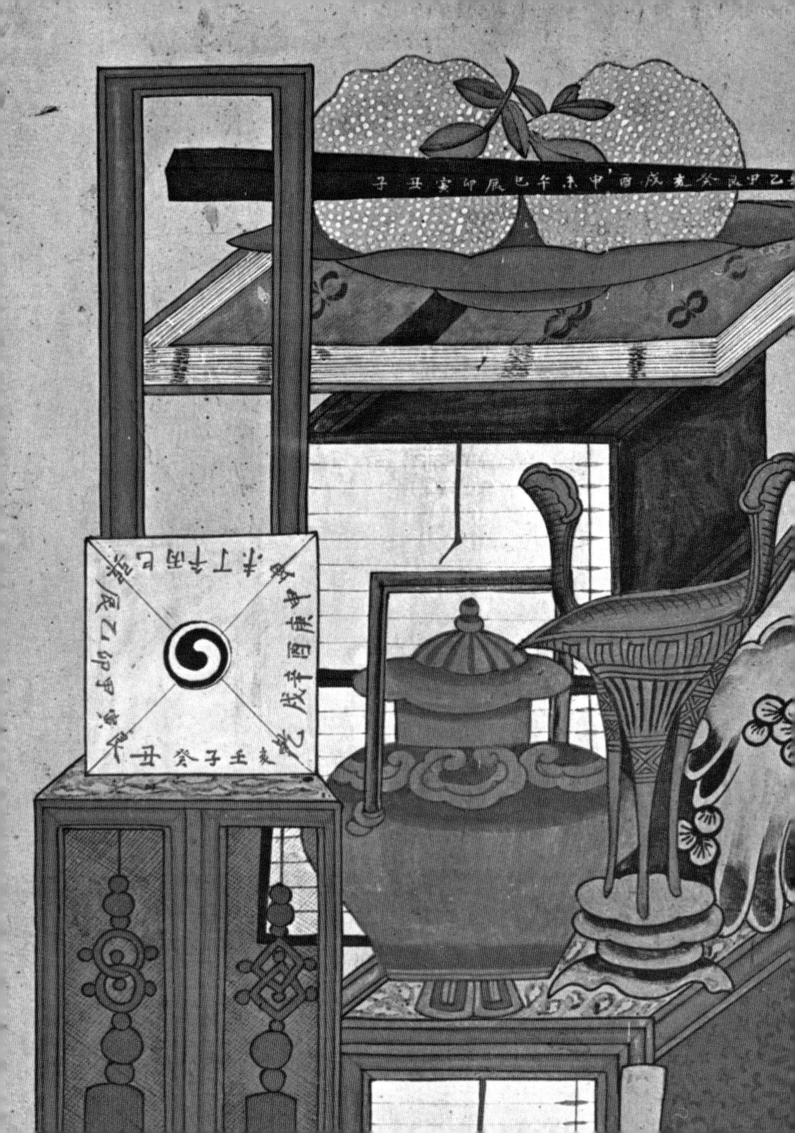

25

Gnomon *Ch'aekkŏri*

A special group of still life type *ch'aekkŏri* depicts China's oldest astronomical instrument, the gnomon, in one panel of each screen. Gnomons (*kwip'yo* in Korean), which date back to the Shang dynasty (eighteenth to sixteenth century BC),[1] were used to measure the length of the sun's shadow to determine the solstices, and the transit of stars by night in order to observe the revolution of the sidereal year.[2] Known in Korea as an astronomical instrument as early as the Paekche dynasty (18 BC–660 AD), the device consisted of a vertical pole, usually about two and a half meters high, with a gnomon shadow template—a projecting arm whose shadow could be measured. The shadow template was a narrow rectangular foot-rule placed at a right angle to the pole. Sometime between 1432 and 1437 a large observatory was built on the grounds of Kyŏngbok Palace, and King Sejong (r. 1418–1450) installed a 7.5-meter-high gnomon to provide basic data for the production of calendars.[3] By the nineteenth century, however, judging by the instruments depicted on *ch'aekkŏri* panels, the gnomon's design had changed dramatically; the shadow template was still positioned at a right angle to the pole, but it was now near the top of the instrument. Gnomons depicted on *ch'aekkŏri* seem to reflect a degree of artistic license, because I have not found any actual gnomons in Korean museums similar in style to those shown on *ch'aekkŏri*, and written descriptions of Chosŏn period gnomons do not match the images depicted on the screens.[4]

I have selected three still-life type *ch'aekkŏri* screens and two additional single panels depicting a gnomon to compare in terms of composition, perspective, palette, and identification of objects. For simplicity's sake I will refer to the three *ch'aekkŏri* screens as follows:

> Private collector's *ch'aekkŏri* (in the U.S.) (Figures 25.1, panels 1–8 and 25.2)
> Lim *ch'aekkŏri* (Lim Okki Min collection, Seoul) (Figure 25.3, panels 1–4 of 8 panels)
> Ahn *ch'aekkŏri* (formerly Ahn Paek Sun collection) (Figure 25.4, panels 1–8 and 25.5)

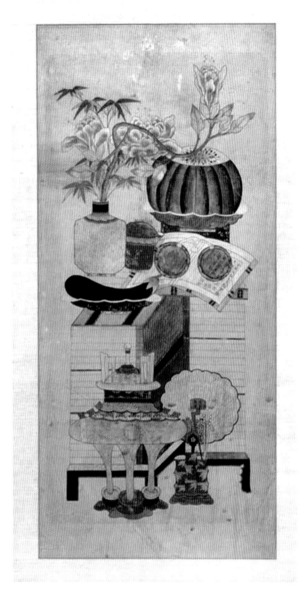

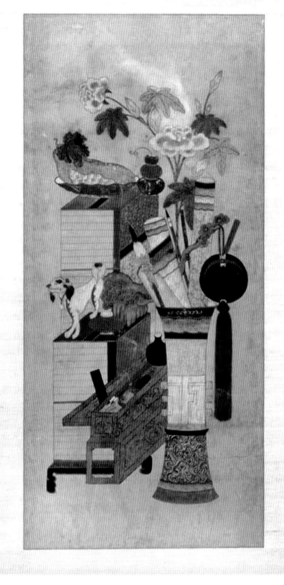

Panel 4 Panel 3

 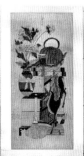 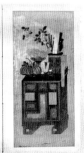 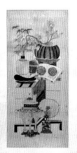 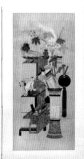

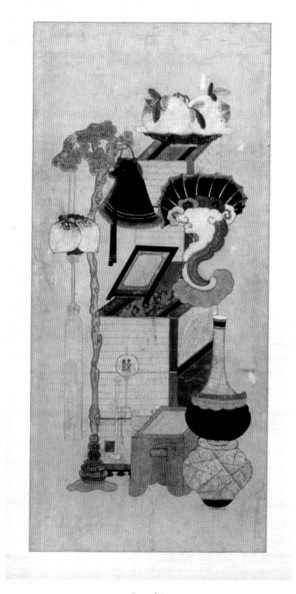

Panel 2

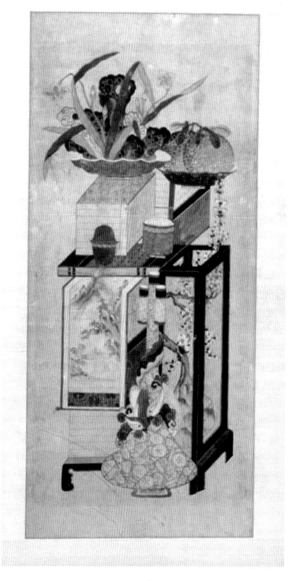

Panel 1

Figure 25.1
Gnomon style eight-panel still life type *ch'aekkŏri*.
The tablet dangling from template arm says, "Sun Shadow
Tower," panel 8. Ink, vegetable, and mineral colors on paper.
67 × 31.5 cm. Private collection, U.S. Photo by Dan Morse.

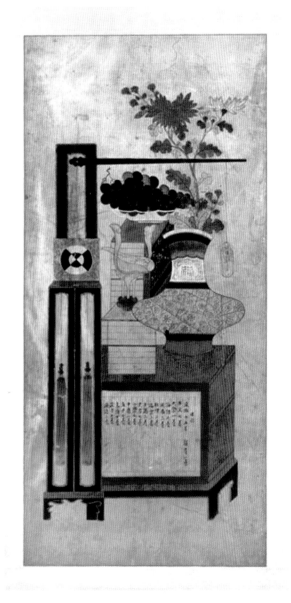

Panel 8

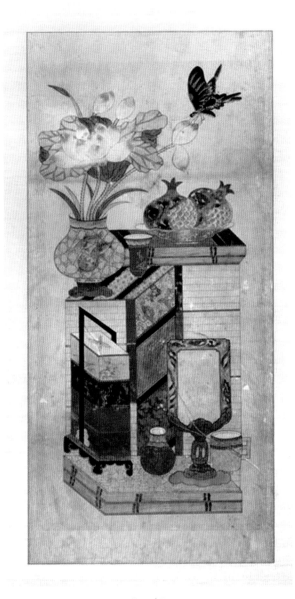

Panel 7

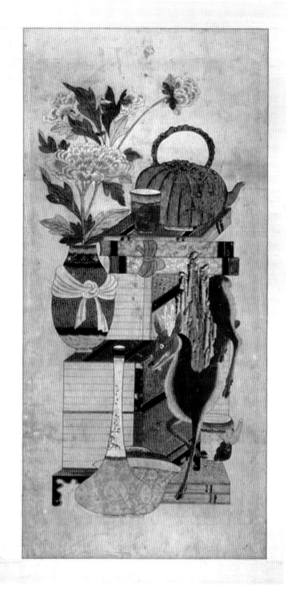

Panel 6

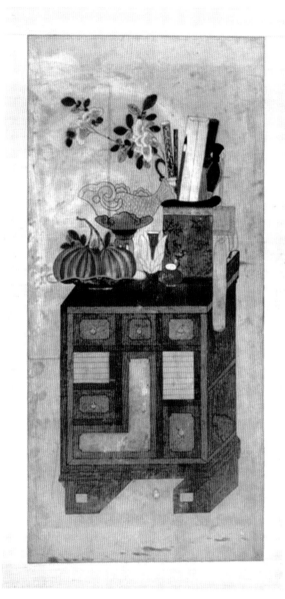

Panel 5

Figure 25.2
Detail of Figure 25.1, panel 8. Bookcase with sixteen titles depicted from right to left on the spines of the volumes. Photo by Dan Morse.

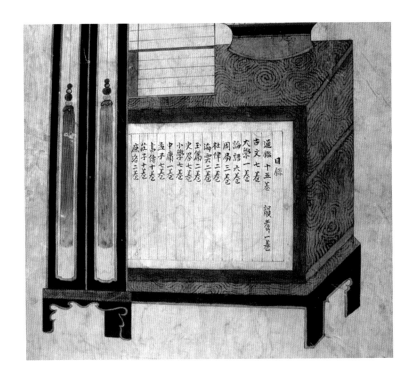

I was able to establish a chronology aided by two dates—one a reign date of 1871 depicted as a book title in the Ahn screen (Figure 25.5 from panel 8), the other a cyclical date of 1851 or 1911 found on an ink stick in the Lim screen (Figure 25.3, panel 2). The private collector's *ch'aekkŏri* has no date or pen name visible (Figure 25.1). Although vestiges of Chinese characters appear on an ink stick (panel 3) and on the gnomon's frame (panel 1), sophisticated photographic techniques have failed to make them legible. Through identification of book titles (Figure 25.2 and 25.5) included in the compositions and an analysis of the subject matter in the screens, new information about the late nineteenth-century Chosŏn period emerges, which in turn provides insight into its societal values.

The private collector's screen shows the gnomon's stand decorated with a *t'aegŭk* (C. *taiji*, Diagram of the Supreme Ultimate) comprised of two concentric circles broken into alternating black and white fan shapes on the outer ring and intermittent black and white wedges in the inner circle, symbolic of the *yin-yang* (Figure 25.1, panel 8); these are juxtaposed against a tan square decorated with bats outlined in black. In Chinese cosmology, the circle within a square symbolizes heaven and earth. This black and white *t'aegŭk* is a variant of the more popular design of double interlocking commas.[5]

The *ch'aekkŏri* in the Lim collection also includes a decorated gnomon, but the design motif of the *yin-yang* roundel is quite different from that of the alternating black & white shapes in the private collector's screen. It is composed of double commas, a design adopted by the Koreans for their national flag at the end of the nineteenth century (Figure 25.3, panel 1). The *t'aegŭk* roundel as

a symbol expresses the concept of balancing opposites; interlocking commas form a perfect circle.[6] This motif of commas became popular in China during the late Song period (1127–1279), and is a later style than the design of concentric circles.[7] "Sun Shadow Tower" (*iryŏngdae*), written in Chinese characters on a tablet dangling from the shadow template, identifies the gnomon in each of the three screens under discussion.[8] Surrounding the *yin-yang* roundel on the Lim screen are nineteen Chinese characters with solstice information written in gold, though some are too faded to be legible. The twelve branches representing the zodiac are depicted along the shadow template. It is the cyclical date inscribed in Chinese characters on an ink stick, however, that provides the most important information on the Lim screen (panel 2).

The gnomon in the Ahn *ch'aekkŏri* is similar to those in the other two screens, except for the Chinese characters depicted around the red and blue commas on the *t'aegŭk*'s roundel (Figure 25.4, panel 8). A twin of the red and blue *t'aegŭk* design on the Ahn screen can be seen on the gate at the Sosu sŏwŏn, Korea's oldest private Confucian academy, near Yŏngju, North Kyŏngsang Province (Historical Monument No 55).[9] The characters encircling the roundel are legible, and they have been identified as those found on a geomancer's compass (*yundo*), a device used to select auspicious sites for settlements and buildings, and for fortune telling.[10] It has twenty-four segments, as in Chinese models.[11]

I have found other examples of the geomancer's compass decorating the *yin-yang* emblem on two single panels, presumably both remnants of original *ch'aekkŏri* screens. One is in the Joo Kwan Joong and Rhee Boon Ran collection Figure 25.6), and the other is in the Yu Chae-ŭng collection (Figure 25.7), both in Seoul.[12] The four Chinese characters visible on the tablet dangling from the shadow template on the Yu collection painting say "Spring, Summer, Autumn, and Winter" (*ch'un-hach'udong*) not "Sun Shadow Tower" as in the three screens discussed earlier. A *t'aegŭk* with two interlocking commas similar to that shown on the Lim screen also decorates gnomons on the panels from the Joo/Rhee collection and the Yu collection. These two panels are very similar; their main difference is that the Joo/Rhee painting has no shadow template shown. Perhaps the lack of a shadow template of any kind simply indicates artistic license. The colored beads, knots, and the pair of long, rose-colored tassels seen on the bottom half of the stands would appear to be counterbalances for the horizontal arms, though in the Joo/Rhee painting there is no template arm; their purpose, other than decorative, remains in doubt.

Of the five *ch'aekkŏri* panels that include images of gnomon described above, four have double interlocking commas decorating their *t'aegŭk*; three surround this emblem with Chinese characters from the geomancer's compass; a fourth encircles the *t'aegŭk* with solstice information; and a fifth has no characters visible around its variant style of *t'aegŭk*. The Chinese characters decorating the *t'aegŭk* are from *the Book of Changes*, and they are placed in the same panel with the scientific instrument, thus demonstrating a Neo-Confucian mix of science and the occult.

The Chinese characters decorating the Ahn screen's *t'aegŭk* roundel, its inverted U-shaped bracket, and its attached shadow template represent a simplified version of the "Day Long, Day Short Diagram" (*Iryŏngildando*), which illustrates the sun's

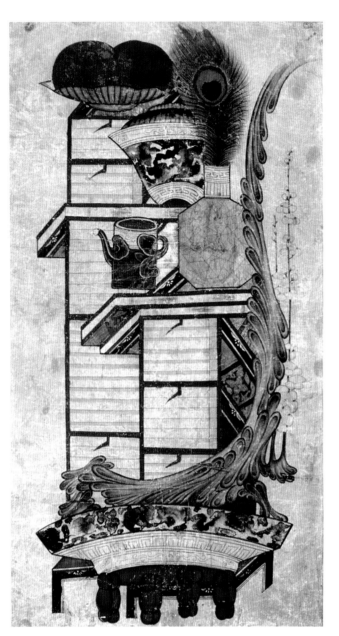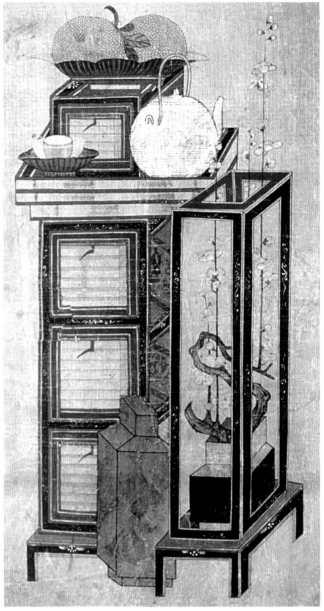

Figure 25.3
Four panels of an eight-panel Gnomon style still life type *ch'aekkŏri*. In panel 1, the tablet dangling from the gnomon's template arm says, "Sun Shadow Tower." Ink, vegetable, and mineral colors on paper. 59 × 29.5 cm. Lim Okki Min collection, Seoul. Photo by Norman Sibley.

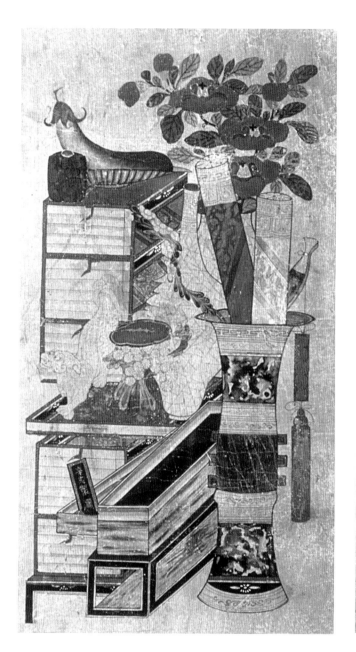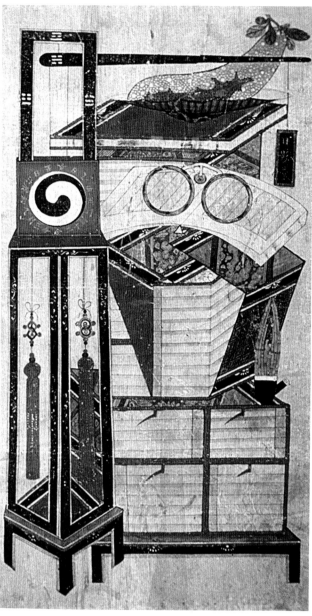

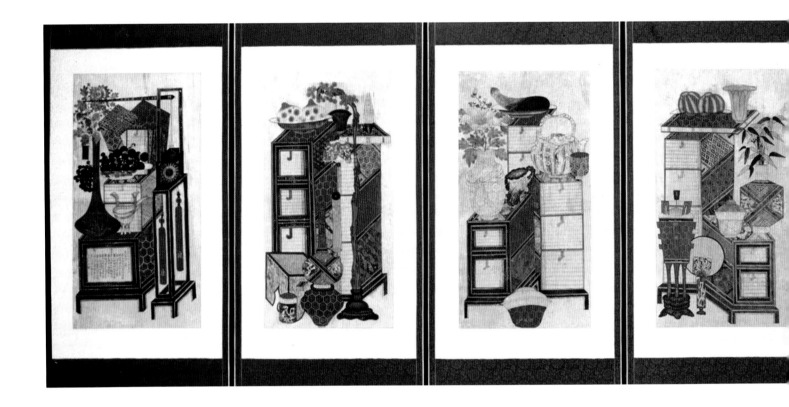

Figure 25.4
Gnomon style eight-panel
still life type *ch'aekkŏri*.
In panel 8, the gnomon's
decoration is symbolic of
a book on astronomy. Ink,
vegetable, and mineral colors
and gilt on paper. 54.5×28.3 cm.
Formerly Ahn Paek Sun
collection, Seoul.
Photo by Norman Sibley.

position as it moves, and reflects the astronomical belief of the time—the sun circling the earth (see Figure 25.8).[13] According to Ko Ŭng-bae and Pak Ch'an-ho of the Confucian Academy (Sŏnggyun'gwan), the artist's drawing of the gnomon and its decoration symbolize an entire book on astronomy.[14]

The Chinese characters on the right side of the U-shaped bracket represent the sunrise in hours, minutes, and seconds, while those on the opposite side show the same for the sunset. Each of the figure's twelve curving lines represent twenty-four different climates by the solar calendar and serve as important agricultural aids. The twelve lines from the sunrise side meet the twelve from the sunset side at the apex of the curve. Thus, winter is seen to have the shortest line, and summer the longest. In ancient times, the uppermost and shortest line, was the beginning of the new year. In other words, the shortest day and longest night marked the new year.

Although both sides of the "Day Long, Day Short Diagram" could be used for fortunetelling, provided that the year, month, and hour of a person's birth were known, it was primarily used for agricultural purposes and was of great value to an agrarian society. The sixth line from the bottom, for example, indicates when the first freeze will occur, and thus when the harvest should be brought in. Another line indicates a rainy period, when seeds should be sown.

In addition to the writing used to decorate the gnomon, both the Ahn and the private collector's *ch'aekkŏri* screens also include book titles written in Chinese characters along their spines. The books are arranged vertically in the manner of the

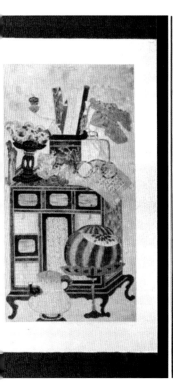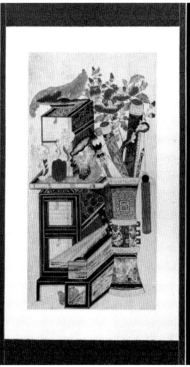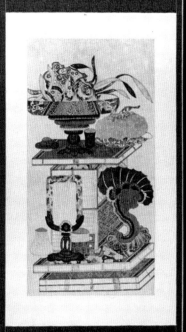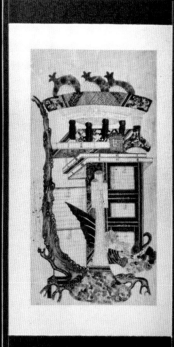

Western system. Only seven screens in this study of over 150 Korean *ch'aekkŏri* have book titles depicted. Five of these are of the still life type, and one is of the trompe l'oeil variety. The seventh screen (in Brooklyn) is the most unusual as it combines the two types produced by government artists—the isolated and trompe l'oeil styles. King Chŏngjo's (r. 1776–1800) interest in books, and the inclusion of books with discernible titles on still life type *ch'aekkŏri*, suggest that government painters for the king may also have painted in the still life genre. The high quality of some still life examples makes this a distinct possibility, although this author did not find any still life *ch'aekkŏri* catalogued or in storage at Ch'angdŏk Palace during research trips there in 1985 and 1986.

Perhaps the artists drew the viewer's attention to titled books because they wished to emphasize the educational importance of the printed book, which in turn promoted scholarship as an aid to better government, and certainly enabled the student in passing exams. The Ahn, Lim, and private collector's screens all have books. One guesses that at least one of the sixteen titled tomes depicted on the private collector's screen might be a scientific text, in keeping with its gnomon theme (Figure 25.2, detail from panel 8 of Figure 25.1). However, the book titles from the private collector's screen disappoint in this regard because they contain no such reference. One concludes the painting's purpose might have been didactic, and the screen meant as a constant reminder of Neo-Confucian values.

Of relevance to the Confucian tradition is the written passage seen beneath a pair of spectacles lying on an open book in the private collector's screen

(Figure 25.1, panel 4). (Koreans are fond of saying that the spectacles symbolize a scholar who has left his study for a moment.) The prose poem is *The Red Cliff (Chibifu)*,[15] the highly popular Song dynasty classic by the poet Su Dongpo (1037-1101), an outstanding scholar who was greatly admired by Chosŏn-period literati. Its opening passage translates:

> In the autumn of the year *jen-hsu* [*renxu*, 1082 AD], on the sixteenth day
> of the seventh month, I took some guests on an excursion by boat under *the*
> *Red Cliff*. A cool wind blew gently, without starting a ripple. I raised
> my cup to pledge the guests; and we chanted the full moon ode…[16]

In the Ahn *ch'aekkŏri*, also visible under a pair of spectacles placed on top of an open book, is a Daoist text written in Chinese (Figure 25.4, panel 4). I have not located a text that exactly matches this passage (and a literal translation of it makes no sense), but its meaning to those who understand the Dao is:

> Non-Polar (*wuji*) and yet Supreme Polarity (*taiji*)! The Supreme Polarity
> in activity generates *yang*; yet at the limit of activity it is still. In stillness
> it generates *yin*; yet at the limit of stillness it is also active. Activity and
> stillness alternate; each is the basis of the other. In distinguishing *yin* and *yang*,
> the Two Modes are thereby established.[17]

William Theodore de Bary states that the *Taijitu shuo (Explanation of the Diagram of Supreme Polarity)* is a basic text of Neo-Confucian tradition, a superb

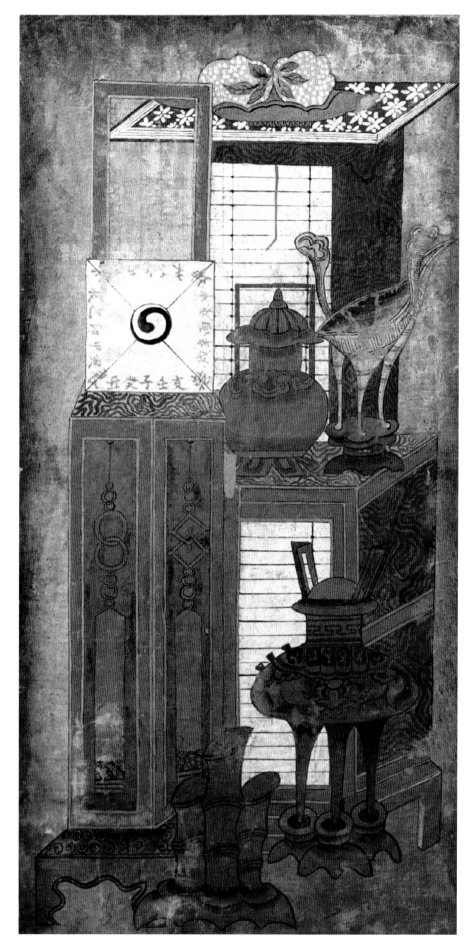

Figure 25.6
Single-panel gnomon *ch'aekkŏri*.
Ink and watercolors on paper.
Note lack of shadow template.
73.3 × 35.6 cm. Joo Kwan Joong and
Lee Boon Ran collection, Seoul.
Photo by Norman Sibley.

Figure 25.7
Single-panel gnomon
ch'aekkŏri. Tablet dangling
from shadow template says,
"Spring, Summer, Autumn,
Winter." Mineral pigments
on paper. 38.5 × 58.2 cm. Yu
Chae-ŭng collection, Seoul.
Photo from: Kim Ho-yŏn, ed.,
Han'guk minhwa (1977), p. 204,
pl. 144.

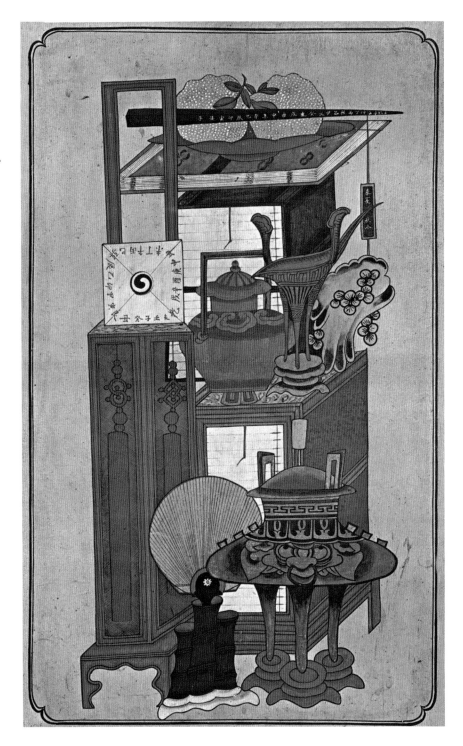

example of the integration of Confucian ethics and Daoist naturalism.[18]

Both the Daoist text from the Ahn screen and the Su Dongpo poem from the private collector's screen add to our information about what types of literature were important to these *ch'aekkŏri* artists and their patrons. The theme of *The Red Cliff* was a particularly popular one during the Chosŏn period. The Su Dongpo prose poem and the book titles on the private collector's screen are not unexpected for a Neo-Confucian didactic *ch'aekkŏri*, nor do the Daoist text, book titles, and astro-

Figure 25.8
Day Long, Day Short Diagram

nomical information in the Ahn screen come as surprises in a *yangban*-designated society. What is surprising is that the books are all stacked vertically—a Western influence—in an otherwise Confucian screen.

Disappointingly, the private collector's screen lacks astronomy book titles or any other titles related to scientific instruments, which would have corroborated the gnomon *ch'aekkŏri* theme of this painting. There is a single Korean book, *Haeun (Sea and Cloud)*, but it is unclear whether this refers to one of the three greatest Silla statesman, Ch'oe Ch'i-wŏn (857–?), or to a nineteenth-century Chosŏn Buddhist monk, both of whom used the same pen name, Haeun.[19] One might guess it to be Ch'oe Ch'i-wŏn because of the Confucian context of most of the subject matter. (If it refers to Haeun the monk, who was also a painter and the student of the monk painter P'unggye, it is the only allusion to Buddhism found on the screen.)

There are no titles on the book spines in the Lim *ch'aekkŏri*. However, fifteen

titles, including an index and date, are visible on the book spines in the Ahn screen (Figure 25.5). The calligrapher was inept as the characters are sloppily written. Importantly, a reign date of 1871 (*tongch'i simnyŏn sinmi chungch'un il*) is shown on the last book to the right in the case. In panel 3, of Figure 25.4, an ink stick bears the Chinese characters *Yongmundang* (Dragon Gate Hall), thought possibly to have been the name of a building at Kyŏngbok Palace destroyed in 1932.[20] Additionally, there are two Korean titles, five Chinese titles, five unidentified ones, and one text on astronomy (*Chŏnmunji*) in keeping with the painting's theme. A direct connection exists between the title *Chŏnmunji* and the gnomon's decoration, which has been interpreted as a symbol for an entire book on astronomy. Only one of the Five Classics, *The Spring and Autumn Annals*, is included, and none of the Four Books. These book titles, unlike those in the private collector's screen, were intended to be read vertically from left to right, possibly suggesting that a Buddhist monk might have been the *ch'aekkŏri*'s artist, since *Sŏn* monks are known to have written from left to right on occasion.[21] Other details suggest a possible Buddhist connection as well. As late as the 1970s, monks at Buddhist temples were said to have been trained in the Confucian Classics, and although they would usually deny that they were skilled in divination, they nonetheless had an acquaintanceship with it through the *Book of Changes*.[22]

There is no difficulty in reading the subject matter in the private collector's *ch'aekkŏri* (Figure 25.1, panels 1–8). Every item is clearly defined by consistent brushwork in a straightforward manner. The blocky rectangular and cubelike objects in six still lifes angle back to the right; only one panel (panel 7) shows the cubes and rectangles co-joined from different directions. For instance, the composition with the butterfly shows that one blocky element recedes to the left, colliding with another receding to the right. Many of the curvilinear objects are depicted frontally. Each composition is simple and depicted naturalistically, which makes it easy to spot the different objects included in each panel's theme. When looked at singly, some of the objects in the private collector's screen are anchored to the picture plane and read clearly; others do not. Three examples of this are found: in panel 2, a book stand balances miraculously on two legs; in panel 3, a gift box floats in the air inches above the ground plane, and in panel 6, the deer has no hoof on the ground.[23] However, when considered together, these ungrounded images form a lacy outline. The airiness evoked by the seemingly floating objects contributes to the delicacy and liveliness of the private collector's *ch'aekkŏri* still life, compared to the more compact and complicated constructions in both the Ahn and Lim screens. Although they too share the "floating" characteristic, it is less obvious.

One object in panel 2 of the Ahn *ch'aekkŏri* (Figure 25.4) and panel 2 of the private collector's *ch'aekkŏri* (Figure 25.1) mystified the author for years. Shaped like a reverse letter S, it is crowned by a black ribbed and webbed fin resembling that of a sea horse. At the fin's base, there are overlapping cloud designs in yellow, blue, red, green, and white. Suspended from this is a white body in the shape of a whorl that is outlined in the cloud motif and has vertical curvilinear bands of red and green in cloud patterns. The whole is nested in a tan, kidney-shaped base decorated in black waves.

Identification of this mysterious object was finally made upon closer examination of Chinese porcelains, which showed that it was a wedding cup. The earliest of these *Blanc de Chine* (*dehua*) porcelain ceremonial wedding cups belong to the second half of the seventeenth century. Believed to have been made originally from the horn of a rhinoceros, the horn-shaped cup has conventional decoration in which the top portion represents the sky, and the bottom portion represents the earth or the sea. In the sky is seen part of a dragon emerging from the clouds—a conventional motif for depicting the heavens. The tan kidney-shape on the bottom of the object is most probably a sea slug, for convention called for some marine creature at this location.

Although the Chosŏn dynasty wedding cups of the Mount Kyeryong blue-and-white, and white porcelain types are known to have existed—as did Qing dynasty horn cups—when the *ch'aekkŏri* was painted, the vessel in question is patterned after the Chinese tradition and shows artistic license.[24]

Even though all three *ch'aekkŏri* have about the same total number of objects—books and other scholar's treasures—a greater variety is displayed in the private collector's screen. The repetition of objects and the use of the color black adds to the static quality of both the Ahn and Lim screens, while the greater variety of lively and colorful objects furthers the effect of activity in the private collector's superior compositions. Furthermore, the complex palette of primary, secondary, and tertiary colors is very balanced and harmonious in this painting. In contrast, both the Ahn and Lim *ch'aekkŏri* have clumsy and stark color contrasts between large blocks of light and dark. Awkward and static constructions are the result. The Ahn painter's heavy rounded shapes and repeated geometric patterns keep the eye grounded, and he uses only primary colors and stark contrasts of light and dark. However, in panel 2 of the private collector's *ch'aekkŏri* (Figure 25.1), its artist placed a light-colored pot underneath a dark one at the ground plane in order to move the viewer's eye upward. He repeats this technique in other constructions, too, as a device to sweep the eye up, creating an impression of images-in-the-air. There is more variety of patterns, too, in the private collector's *ch'aekkŏri*. For example, one decorative motif, a black mottled or *faux marbre* pattern, appears only twice: on a mirror frame (panel 7) and on the bottom register of a Chinese-style *hu* vase (panel 3). In contrast, this pattern is repeated over and over in six panels of the Ahn screen (Figure 25.4) and in panel 4 in the Lim painting (Figure 25.3); it is loose and blotchy in both, demonstrating less artistic prowess.

One compositional element differentiating the Ahn screen from the Lim and private collector screens is the artist's emphasis on geometric pattern. The Ahn screen's artist created his objects in flat angular patterns with many diagonals. He painted black bands along the top edges of the slipcases of books to emphasize these diagonals. The foreground items are depicted as flat shapes only. The fruits and vegetables seen at the tops of the compositions are depicted three-dimensionally through shading. He used the longevity motif (*su*) and the hexagonal turtle pattern as unifying devices. His *ch'aekkŏri* has a very hard-edged overall effect that is due in part to the heavy use of black and white. This artist has achieved with his fluid brushwork a dramatic painting full of contrast. He also introduces a Chinese

Exhibit 25.1 Comparison Table of Three Gnomon *Ch'aekkŏri*

Gnomon *Ch'aekkŏri* Features	Private collection Figure 25.1	Lim Okki Min collection Figure 25.2	Ahn collection Figure 25.3
Parallel perspective constructions	8 out of 8 panels	8 out of 8 panels	8 out of 8 panels
Linear perspective constructions	1 out of 8 panels	1 out f 8 panels	
Rectangular objects co-joined from different directions as they recede	2 out of 8 panels	5 out of 8 panels	4 out of 8 panels
Overlapping of rectangular objects best seen in *paduk* game	Recedes in parallel perspective in the same direction as other rectangular objects	Recedes in opposite direction	Recedes in opposite direction
Perspective from above	Consistent throughout 8 panels	Consistent through-out 8 panels	Consistent throughout 8 panels
Perspective from below	1 out of 8 panels	2 examples, both in the same panel	
Shift of vertical vantage point	1 out of 8 panels	1 out of 8 panels	1 out of 8 panels
Frontal depictions	8 out of 8 panels	8 out of 8 panels	8 out of 8 panels
Glass terrarium with plum branch	1 out of 8 panels	1 out of 8 panels	
Old gnarled plum branch with tall side shoots sweeping down one side and across the panel		1 out of 8 panels	1 out of 8 panels
Square chests	1 out of 8 panels; different style than Ahn and Lim paintings – no wings and square legs	1 out of 8 panels; with wings on top and curvilinear legs	1 out of 8 panels; with wings on top and curvilinear legs

sea serpent in one of his still lifes (Figure 25.4, panel 1), a harbinger of what is to come as the gnomon style evolves into the full blown seal script pattern style.

The inclusion of the cyclical date in the Lim painting indicates that it was probably painted in 1851 or 1911. In considering the chronology, a case should be made for 1911. The architectonic alignment of the predominant rectangles, cubes, furniture, books, and terrarium in the Lim *ch'aekkŏri* is more complicated than that of the Ahn screen, which includes the reign date of 1871. Therefore, a date after 1871 is required, and so the year 1911 can be considered the date of the Lim screen's execution. The two largest items of subject matter, the sweeping plum branch from one composition in the Ahn screen, and the terrarium from a panel in the private collector's painting, are both found in the Lim *ch'aekkŏri*. Therefore, it would appear that the Lim screen's artist had seen both the Ahn and private collector's still life gnomon *ch'aekkŏri*, or ones similar to them, before he painted his own because he has drawn considerably from both. The Lim *ch'aekkŏri* bridges the two styles, and clinches its date for 1911.

NOTES

1 Joseph Needham, *Science and Civilization in China*, vol. 3: *Mathematics and the Sciences of the Heavens and the Earth* (Cambridge: Cambridge: University Press, 1959), p. 84.

2 Needham, fig. 110 and p. 284.

3 Chŏn Sang-un (Jeon Sang-woon), "Astronomy and Meteorology in Korea," *Korea Journal* 13, no. 12 (December 1973), pp. 15–16; Nha Il-seong, "Development of Science and Technology in the Early Chosŏn Period," *Koreana* 11, no. 3 (1977), p. 25. Nha's article includes a good picture of a gnomon, but one that does not look at all like those depicted in known *ch'aekkŏri* screens.

4 Chŏn Sang-un, pp. 15–16; Sang-woon Jeon, *Science and Technology in Korea: Traditional Instruments and Technique* (Cambridge, MA and London: The MIT Press, 1974), pp. 38, 49–51.

5 Similar *t'aegŭk*, but with three rings instead of two, decorate the back of a letter case in the collection of Tŏksŏng Women's University Museum, and hat and comb boxes in the Onyang Folk Museum. This design is derived from the circular Figure symbolizing the *yin-yang* theory from the *Book of Changes* (*Yijing*). Developed by the Chinese cosmological philosopher Zhou Dunyi (1017–1073) in the eleventh century, the figure of concentric circles (figure of the Supreme Ultimate) was designed to illustrate the process of cosmic evolution. Zhou used the concept of *yin-yang* to interpret certain passages in the appendices of the *Book of Changes*, the classic Chinese manual of divination. Simply stated, the *yin-yang* and its respective trigrams—*kun*, symbolic of the female principle; and *qian*, symbolic of the male principle—unite mysteriously with the Five Elements: wood, fire, earth, metal, and water. The ensuing interaction causes all things to be produced and reproduced endlessly, so that transformation and change continue without end. According to Fung Yu-lan, Zhou Dunyi's interpretation of a passage found in Appendix III of the *Book of Changes* provides the basic outline for the cosmology of Zhu Xi (1130–1200). Since Zhu Xi's philosophy was of prime importance to the Chosŏn period Neo-Confucians, it is not surprising to find a graphic reference to it on this *ch'aekkŏri*. An Sang-su, ed., *Han'guk chŏnt'ong munyangjip I: Kiha munŭi* (Korean Motifs I: Geometric Patterns) (Seoul: Ahn Graphics & Book Publishers, 1986), p. 204, no. 116 (this variant of the *t'aegŭk* is called "Nested Circle" [*t'aegŭk munŭi*]); An Sang-su, ed., *Han'guk chŏnt'ong munyangjip V: T'aegŭk munŭi* (Korean Motifs V: T'aegŭk Patterns) (Seoul: Ahn Graphics & Book Publishers, 1989), nos. 1, 3; Fung Yu-Lan, *A Short History of Chinese Philosophy*, edited by Derk Bodde (New York: Free Press Books, 1948), pp. 269–270.

6 Paul S. Crane, *Korean Patterns*, Royal Asiatic Society, Korea Branch Handbook Series 1 (Seoul: Hollym, 1967), pp. 4, 122. The upper comma is *yang* (male), hence red; the lower comma is *yin* (female), hence blue.

7 Keith Pratt and Richard Rutt, *Korea: A Historical and Cultural Dictionary* (Richmond, Surrey: Curzon Press, 1999), p. 489.

8 The character for *shadow* (*yŏng*) on the tablet that reads "Sun Shadow Tower" on the private collector's screen has the water radical depicted on the right side instead of the left, as it should be.

9 An Sang-su, ed., *T'aegŭk munŭi*, no 6.

10 Pratt and Rutt, p. 373.

11 Pratt and Rutt, p. 488. "Twelve of these [24 segments] are named after the zodiacal animals. Four more are variously known as the inter-cardinal points (NE, SE, SW, NW.) from the King Wen order of the trigrams, or four of the eight elements (*bagua*). The remaining eight segments are filled by eight of the heavenly stems from the sixty-fold cycle, omitting the fifth and sixth."

12 Kim Ho-yŏn, pl. 144.

13 *Sŏjŏn pu ŏnhae* (Seoul: Hangmin munhwasa, 1989), vol. 1, p. 26.

14 Personal communication with Ko Ŭng-bae and Pak Ch'an-ho, Sŏnggyun'gwan, October 22, 2002. Of possible relevance to the symbols of a book on astronomy decorating the Ahn *ch'aekkŏri*'s gnomon is a Chinese woodblock print. This still life depicts a book on science and mathematics published by the Board of Astronomy as a Qianlong calendar. Dated 1745, the woodblock print may be seen in Higuchi, pl. 10.

15 The most likely accepted site for the Red Cliff/Cliffs is on the Yangzi river between Lake Dongting and Wuhan in Hubei Province.

16 Cyril Birch, ed., *Anthology of Chinese Literature* (New York: Grove Press, 1965), p. 381.

17 William Theodore de Bary and Irene Bloom, eds., *Sources of Chinese Traditions*, 2nd ed., vol. 1 (New York: Columbia University Press, 1999), p. 673. For a different expression with the same meaning, see Stephen Little with Shawn Eichman, *Taoism and the Arts of China* (Chicago: The Art Institute of Chicago, 2000), p. 368.

18 De Bary and Bloom, p. 671.

19 Kim Yŏng-yun, pp. 8–9, 382; Yu Pok-nyŏl. *Han'guk hoehwa taegwan* (Pageant of Korean painting) (Seoul: Mun'gyowŏn, 1979), p. 614. I am indebted to Gari Ledyard for this information.

20 E-mail communication with Frank Hoffmann, December 2, 2003.

21 Personal communication with Ahn Hwi-joon, September 1999.

22 Personal communication with Ahn Hwi-joon, November 2002.

23 An illustration to the poem *Lisao* (Song of Unending Sadness) shows a deer in front of a turtle with a mountain on its back. This could have been the artist's inspiration for painting a deer with a mountain on its back. *Zhongguo gudai banhua congkan* (Collection of ancient Chinese prints), vol. 10, *Lisaotu* (Illustrations to the Poem of Unending Sadness) (Shanghai: Zhonghua Shuju, 1961) is part of a collection of songs written by Qu Yuan (332–295 BC).

24 For *Blanc de Chine* ceremonial wedding cups (1650–1700), see P. J. Donnelly, *Blanc de Chine: The Porcelain of Têhua in Fukien* (New York and Washington DC: Frederick A. Praeger, 1969), no. 25.

26

Seal Script *Ch'aekkŏri*

Another group of still life type *ch'aekkŏri* is distinguished by the repeated patterns of Chinese characters in seal script that are depicted on book covers in the paintings. I labeled this the "seal script" type. The predominant Chinese character is *hŭi* (*xi* in Chinese), meaning "happiness," but occasionally an artist substituted *hoe* (*hui* in Chinese), meaning "return to" or "from." Either one is most probably used as a decorative meander rather than a symbol. Chronologically, seal script *ch'aekkŏri* reveal a natural progression from the gnomon style, but display a great departure from it as well. Artists increasingly focused on repeated patterns, abstraction, and flatness of forms, creating a highly sophisticated design. Animate objects replaced the previously prevalent gnomons as focal points. Furniture is rarely included. These changes reflect different interests on the part of certain *ch'aekkŏri* patrons and their artists.

The Hongik University *Ch'aekkŏri*

Several patterns and motifs encountered in the Ahn collection's gnomon style ch'aekkŏri reappear in an undated example of a transitional seal script ch'aekkŏri at the Hongik University Art Museum (Figure 26.1, panels 1–8). These include patterns formed by the repeated Chinese seal script characters forming a meander, square chests with wings, and an open slipcase, a hard-backed cover used to contain soft-cover volumes.[1] Additionally, the Hongik screen's palette—blues, greens, rosy reds, orange, yellow, black, beige and white—is similar to that used in the private collector's gnomon ch'aekkŏri.

The compositions fill the picture planes in a cluttered fashion and are not clearly defined. The organization of slipcases is quite simple. No individual panel has more than four slipcases of books, stacked two and two. Five of the compositions recede from left to right, and three from right to left, but they are always depicted

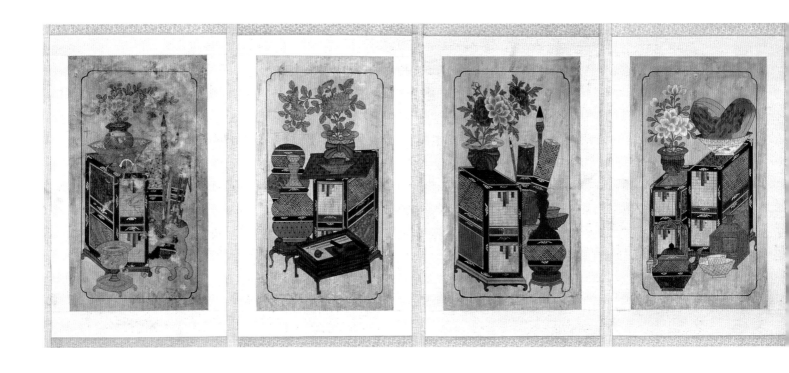

Figure 26.1
Eight-panel still life type *ch'aekkŏri*, which shows a transitional style from gnomon to seal script. The focal point is an object symbolic of the *Doctrine of the Mean* (panel 2). Ink, vegetable, and mineral colors on paper. 57 × 33 cm. Hongik University Art Museum (acc. no. 2297). Photo by Lee Jung Ae.

in isometric perspective. While many thematic items are depicted frontally, others are shown from an elevated vantage point. There is a minor attempt to present the vessels three-dimensionally. Many pots have domed lids and bulging bodies, but the pots are still painted with flat bottoms, as if seen from the front. In panel 4 the chest's open cubbyhole is seen to be flat because it lacks orthogonals, although its body is shown three-dimensionally. The dishes and vase found in the chest's cubbyhole appear like pieces of paper pasted to the back wall of the furniture, behind the drawer. Isometric perspective was used to paint the other blocky items; their lines remain parallel as they recede. The Hongik screen contains a strangely shaped instrument (panel 2). Initially, Wagner and I found it was impossible to determine whether it was a gnomon or an alarm clock because it combines features of both. It was only after a visit to the Sŏnggyun'gwan that I learned that the object drawn by the artist was a symbolic summary of the *Doctrine of the Mean* (*Zhongyong*), one of the Four Books.[2] Earlier, the three characters depicted on black vertical tabs projecting upward from the square body had been identified as three of the Twelve Branches, or Horary Characters: Rat (*cha*), Ox (*ch'uk*), and Tiger (*in*). However, the three zodiac symbols have quite different meanings in the context of the *Doctrine of the Mean*: the rat represents the sky, the ox represents the earth, and the tiger represents human beings. The character *chung* (C. *zhong*; "middle"), visible at the center of the uppermost rectangle, stands for *Zhongyong*, one of the most important Korean Confucian concepts.[3] Together the four characters stand for balance, correctness, courage, and what is right in the sky, on the earth, and with human beings. A ruler divided into eight segments, subdivided into ten, with a weight dangling from it, is a scale by which human beings, the earth, and the sky should

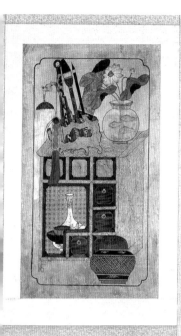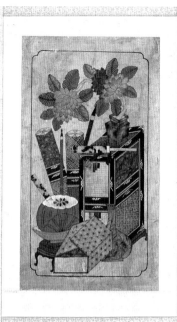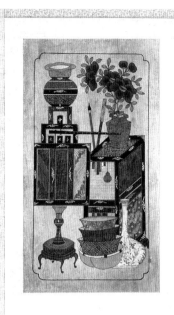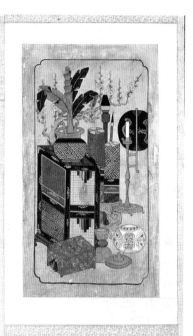

be seen to balance. Thus, the scale symbolizes harmony. As did the gnomon, this object represents an important aspect of Korean culture. By including the scale, the artist changed the focus of the *ch'aekkŏri* from a scientific one, represented by a gnomon, to a specifically Confucian concept, based on the *Doctrine of the Mean* and represented by the scale.

According to the *Doctrine of the Mean*, a human being has seven basic feelings: happiness, anger, sorrow, pleasure, love, hate, and fear. While one feels all seven emotions, it is only when these feelings are enacted that it can be determined whether each one is good or bad. The imaginative artist of the Hongik screen has illustrated the concept of *Doctrine of the Mean* in the *ch'aekkŏri* genre by depicting this symbol. Perhaps he had seen the Ahn gnomon *ch'aekkŏri*, or one like it, and had been inspired by its symbolic depiction of a book on astronomy. The shape of the instrument featured in the Hongik screen had changed from the vertical, rectangular body of the gnomons to a square body supported on a pedestal base.

Both the book on astronomy and the *Doctrine of the Mean* had, by the 1800s, become part of Korean knowledge. Significantly, the subject matter of these two books, symbolically depicted on *ch'aekkŏri* screens, reflects topics of interest to the patrons of the genre and their artists during the nineteenth century. The messages contained in the symbolic painting of the book on astronomy and in the one on the *Doctrine of the Mean* suggest they were far more important to the beholders than were the aesthetics of the screens.

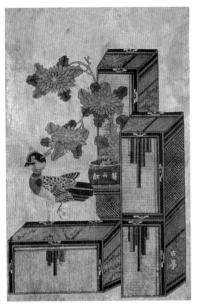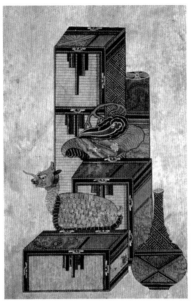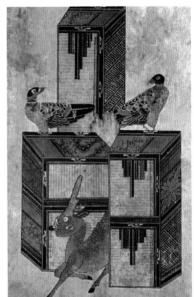

Figure 26.2
"Alarm clock" seal script
style eight-panel still life type
ch'aekkŏri. The "alarm clock"
is in the hourglass shape
(panel 5). Ink, vegetable,
and mineral colors on paper,
unmounted. 54 x 33.5 cm.
Private collection, Seoul.
Photo by the author.

The "Alarm Clock" *Ch'aekkŏri*

Next in this chronology that I am proposing, based on the development of stylistic features, is what I labeled the "Alarm Clock" ch'aekkŏri, an anonymous seal script style screen (Figure 26.2, panels 1–8). In every panel's composition, the decorative seal script motif appears very stylized, as though it might have been done in needlepoint, on book cover patterns or on vessels. This eight-panel ch'aekkŏri is a wonder of design. There is no hierarchy of objects; all have equal importance. New to the still life type is the fact that approximately forty percent of the theme is made up of animate objects. Of the twenty-one book stacks measurable, whose leading and rear edges are completely visible, fifteen are drawn in inverse perspective in which the lines diverge as they recede—inverse perspective seems to have been this artist's preference. There is depth to the compositions, they are busier due to elaborate decoration, and their subdued colors show age. Other characteristics of this ch'aekkŏri are labelled objects and a dearth of floral arrangements.

The paucity of flower arrangements is quite a departure from the still life type as a whole. For instance, the three *ch'aekkŏri* screens with gnomons in their themes, the Ahn, Lim, and private collector's screens, have a flower in almost every panel. The numerous examples of the Chŏnnam style have at least one flower in each panel. In contrast, this "Alarm Clock" screen includes only two flowers. Branches of flowering plum burst from behind a vase's shoulder and from under the crane (panel 1). Here, the flowering plum branch has become an integral part of this *ch'aekkŏri* panel's composition; it is depicted not as an arrangement, but as if it were growing naturally. There is only one other flower represented on the entire eight-panel *ch'aekkŏri*, a very stylized chrysanthemum in a vase (panel 8).

 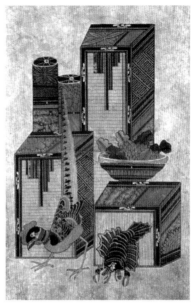 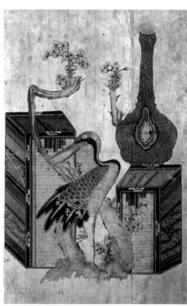

The "Alarm Clock" *chʾaekkŏri* derives its name from the prominent hour-glass-shaped instrument with a familiar protruding frame and a weighted balance arm (panel 5). The three Chinese characters on the waist of the hourglass-shaped pot identify the instrument as an "automatic singing bell" (*chamyŏngjŏng*). The wide end of its arm is labeled *kam* (C. *kan*; one of the Eight Trigrams). Alarm clocks reached Korea in 1631[4] when Chŏng Tu-wŏn brought one back from China. They began to be manufactured in Korea between the time of King Chŏngjo (1776–1800) and King Chŏlchong (1849–1863).[5] These Chosŏn-period automatic clocks were copied from Chinese and Japanese replicas of European originals.[6]

Additional labels written in white pigment help the viewer identify other objects, both animate and otherwise. For example, a vase relating to a crane (panel 1) is labeled "Bird Calls Out [Strikes] Nine" (*myŏngugu*),[7] while another creature, first seen in the Ahn gnomon *chʾaekkŏri*, is labeled a "Chinese sea serpent" (*sin*) (panel 2). Other examples of labeled images that aid in identification are: "My Heart Brush Holder" (*osimmotʾong*) and an elephant supporting a vase labeled with two characters (panel 3). The first character is "Fire Medicine or High Explosives" (*chak*), and the second character is "stand" (*tae*): together, *chaktae*.[8]

A circular chart is presented in panel 4. It is formed of two concentric circles, the outer one divided into sixteen alternating red and black wedges decorated with eight of the earthly branches, four heavenly stems, and four of the eight elements. The red segments are embellished with symbols of the stars. The inner circle is devoid of decoration.[9] This circular chart has been identified as the *chʾaekkŏri* artist's version of a star chart. One first appeared at the end of the twelfth century in Song China, and by 1247, it was considered the most advanced celestial map in the world. According to Stephen Little, it was meaningful in a Daoist context because it shows the home of many gods in the Daoist pantheon, centering on the circumpo-

lar region with the Northern Dipper and the Pole Star, the most important stars in the Daoist heavens.[10] The artist must have used the chart to transform an aspect of Chosŏn culture into art, demonstrating the importance of Daoist thought to the ever-changing *yin-yang* relationships from the *Book of Changes*.

A number of creatures, real and mythical, are depicted in the "Alarm Clock" screen: deer, turtles, and cranes (longevity symbols), as well as an elephant, a *haet'ae*, and a Chinese sea serpent. A variety of birds are represented, including a pair labelled "Kingfisher" (*ch'wi*) in panel 6. A turtle and a quite unrecognizable object labeled "Parrot in a Pine Tree" (*musong*) are shown in panel 7. Since the object resembles neither a bird nor a pine tree, perhaps "Parrot in a Pine Tree" might be the artist's pen name. It is possible that the mystery object could be an Yixing teapot modelled in the form of the "fungus of immortality" (*pulloch'o*), with a bent branch for a handle. Panel 8 features a chrysanthemum whose container reads, "Blossom (or hero) of the Red Mountain" (*hongsanyŏng*). The lowest slipcase of books is labeled "Ancient Events" (*kosa*), presumably the title of the slipcase.

The "Cubist" *Ch'aekkŏri*

A very static eight-panel seal script style *ch'aekkŏri* in the Leeum helps to establish a chronology of stylistic development (Figure 26.3, panels 1–8). In this abstract work, the constructions are simpler and more compact than those of the anonymous "Alarm Clock" screen with its circular chart. Thirty-three slipcases of books and twenty-nine objects fill the compositions. Of the objects depicted, twenty-eight percent are fauna and twenty-four percent are flora.

All of the book stacks measurable were rendered in inverse perspective where lines diverge as they recede, a characteristic of this seal script style.[11] Compositional depth is achieved through overlapping slipcases of differing heights and through the use of divergent perspective, which lends a cubist effect. Hence, this screen will be referred to as the "Cubist" one.

In theme, this *ch'aekkŏri* moves away from science and technology, and instead emphasizes design. The artist's focus on geometric design manifests itself in curvilinear objects juxtaposed against flat planes. For example, a curvilinear crane becomes the focus in panel 1. The artist has brought it forward in the composition by painting its breast yellow and contrasting its curvilinear form against a backdrop of angular book stacks. The repetitious geometric forms in the background and the slipcases with their unified horizontal lines emphasize the objects in front. The artist has shown no interest in the third dimension; instead, he has focused on flat forms and patterns. His vases appear pasted on in collage fashion. Straight lines are interrupted only by the outlines of birds' feet, a turtle, and rolls of decorated book cover paper.

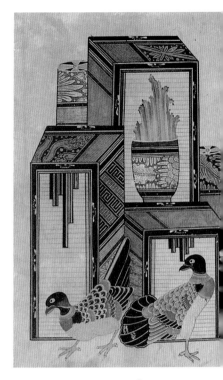

Panel 4

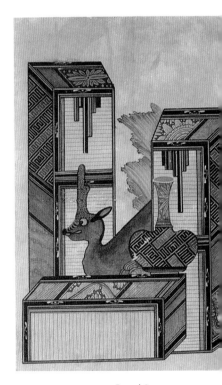

Panel 8

Figure 26.3
"Cubist" seal-script style eight-panel still life type *ch'aekkŏri*. Ink, vegetable, and mineral colors on paper. 47 × 37 cm. Leeum, Samsung Museum of Art. Photo courtesy of the Leeum.

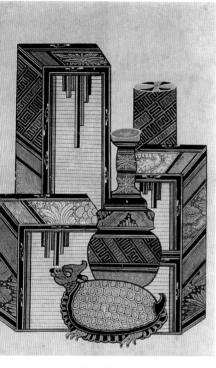

Panel 3

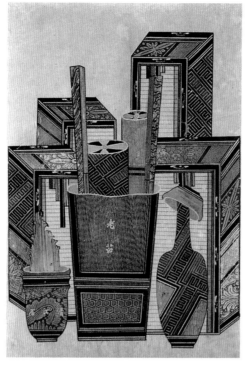

Panel 2

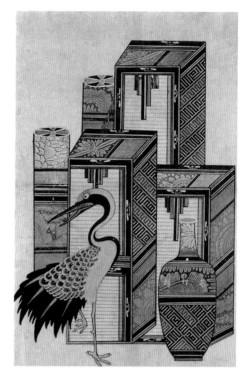

Panel 1

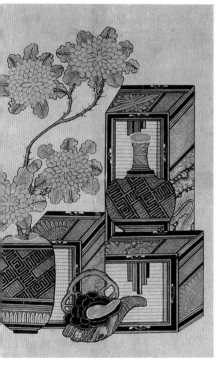

Panel 7

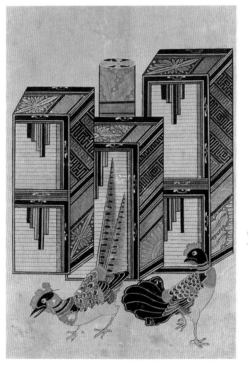

Panel 6

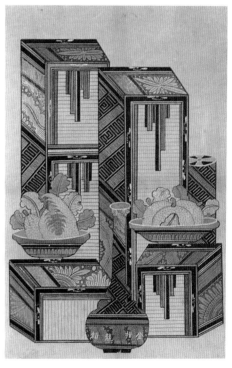

Panel 5

 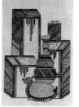 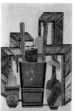 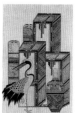

Labels are written in white pigment on some of the objects, both fauna and flora, in this "Cubist" *ch'aekkŏri*, just as they were on the "Alarm Clock" screen, but some of the labels seem unrelated to the objects. A vase (panel 1) has a three-character label, "A Vessel for Green Plants" (*ch'angch'odam*). A paper holder (panel 2) is labeled "Old Vegetable Food" (*noch'ŏn*), a kind of madder that is used as a red dye. Although a roll of red paper is seen in the brush holder, the connection seems tenuous. Included in the same panel is a small vase filled with a kind of clubmoss (*selaginella involvens*) with a three-character label, "Stone from Clear River" (*chŏnggangsŏk*).[12] A label of two sets of two characters each, "Golden Mandarin Orange" (*kŭmgam*)[13] and "Dragon Face" (*yongan*) appears on the vase (panel 5) with the Buddha's Hand citron and oranges. Panel 7 depicts a chrysanthemum and the same unrecognizable object that appeared in panel 7 of the "Alarm Clock" screen (Figure 26.2), where it was labeled a "Parrot in a Pine Tree" (*musong*)—a mirror image. This image in the "Cubist" *ch'aekkŏri* also has a two-character label, but the strokes are intercepted by lines of patterns, rendering them illegible, although enough can be made out to ascertain that they are not the same as those which read "Parrot in a Pine Tree" on the "Alarm Clock" screen.

Two characters (*todu*) depicted vertically on the side of a slipcase of books may be translated in different ways, but their meaning seems related to a particular style of pottery, because six of the vessels are similar in shape: bulbous bottoms on low foot rims, with necks of various lengths. They are not reminiscent of traditional forms. I am inclined to translate the two characters as "A kiln restricted to firing earthenware"; a loose translation might be "Locally produced pottery."

Somber colors of red, blue, yellow, and green are repeated in the "Cubist" seal script *ch'aekkŏri*. However, these colors seem bolder than those in the "Alarm Clock" screen because of large areas of dark blue, unrelieved by equal areas of light color. Patterns and flatness of forms define these two seal script style *ch'aekkŏri*; both of these characteristics were first seen in the Ahn gnomon *ch'aekkŏri* dated to 1871 (Figure 25.4), and they have reappeared and become predominant in both the "Alarm Clock" and "Cubist" screens.

Except for "Fire Medicine Stand" (*chaktae*) and "Parrot in a Pine Tree" (*musong*), the labels in the "Alarm Clock" *ch'aekkŏri* are relevant to the subject matter, whereas the opposite is true in the "Cubist" *ch'aekkŏri*. (Although some labels seem unrelated to the objects, it is possible that their meaning might have been better understood by early twentieth-century Koreans than they are today.) However, the big difference between the two is that the "Cubist" screen's subject matter is devoted to animate objects, fruits, and plants. Gone are the star charts from Chinese astronomy and the alarm clocks from the Western world.

The Hongik seal script *ch'aekkŏri* switches its theme from a gnomon to a symbol of *The Doctrine of the Mean*, which is similar in shape to the gnomon and to the alarm clock. Otherwise, it reveals a transitional style, combining elements that the artists of the Ahn and private collector's gnomon screens had employed. Its palette is like the private collector's gnomon *ch'aekkŏri*; its seal script design comprising Chinese seal script characters is like the pattern apparent in the Ahn gnomon-themed *ch'aekkŏri*. By the time of the "Alarm Clock" seal script screen,

subject matter had altered radically, with two-thirds of its images showing fauna, a reduced number of floral arrangements, and the inclusion of a circular star chart. Although the screen is very flat-patterned, the appearance of birds makes it a lively painting. In contrast is the static "Cubist" screen, which has neither scientific nor technological instruments; instead, it has big, blocky book stacks and only a single, very mannered flower. All elements are unified and simplified, creating the most abstract *ch'aekkŏri* in this study. Yet another shared characteristic of the gnomon and seal script styles of still life *ch'aekkŏri* painting is the emergence of tabs depicted on the slipcases of books.[14] For instance, in the Ahn and Lim gnomon screens, they are drawn as single ribbons. These tabs become more elaborate in the "Alarm Clock" seal script screen where they are shown with five or six differently colored straight ribbons of varying length on each slipcase; each set of tabs is different. They become most elaborate in the "Cubist" tapestry screen where up to seven ribbons per slipcase are visible. Another common feature of the gnomon and seal script screens is the framing device of black bands seen on the tops and edges of the book stacks and other blocky objects. The bands emphasize the constructions they outline, becoming more prominent as the chronology progresses.

The gnomon, a Chinese invention, marked the times of the seasons; the alarm clock, of European innovation, told the hours. Therefore, a *ch'aekkŏri* picturing a gnomon or a striking clock might be seen to reflect influence from the tradition of Northern Learning (*Pukhak*) and its interest in things scientific or technological. For nineteenth-century Koreans both instruments were important; otherwise, they would not be found on *ch'aekkŏri* screens. Cranes, turtles, and deer symbolize longevity, and the other birds and creatures depicted seemingly reflect the artists' and their patrons' increased interest in the natural world.

There are sufficient differences between the Hongik, "Alarm Clock," and "Cubist" *ch'aekkŏri* to suggest that they are not from Yi Hyŏng-nok's mainstream family workshop.

NOTES

1 This same open slipcase is characteristic of the Chŏnnam-style *ch'aekkŏri*, and is also found in the Ahn and Lim gnomon screens.

2 Personal communication with Ko Ŭng-bae and Pak Ch'an-ho at the Sŏnggyun'gwan, October 22, 2002.

3 *ibid.*

4 Lee Ki-baek, p. 241.

5 Jeon, p. 164. For dates of the kings, see Lee Ki-baek.

6 Jeon, p. 164.

7 The alarm struck every hour (every two hours by Western time) in the following manner: it struck nine times at *cha*, the hour of the rat (Jeon, p. 163). The hour of the rat signifies the time between 11:00 p.m. and 1:00 a.m. Paul Carus, *Chinese Astrology* (1907; reprint, La Salle, IL: Open Court, 1974), p. 111.

8 The elephant carrying a vase is a Chinese rebus, or a kind of puzzle in which the meaning is indicated by means of different objects whose names share a common sound. In this instance, *ping* is a general term for bottles or vases and is a homonym for peace, while *xiang*, meaning elephant, is a homonym for omen, or phenomenon. Hence, the Chinese saying "When there is peace, there are signs" is conveyed by this rebus. It is unknown whether or not Chosŏn period Koreans shared this

Chinese symbolism. The label on the vase in the Korean *ch'aekkŏri*, "fire/explosives stand," would seem to be the opposite of the meaning of the Chinese rebus. For explanation of the rebus, see Bartholomew, *Hidden Meanings in Chinese Art*, p. 238. There are many prototypes for the elephant with a vase on its back. For one example, a ceramic *kendi* dated to the late sixteenth century or early seventeenth century, see He Li, *Chinese Ceramics from the Asian Art Museum of San Francisco* (New York: Rizzoli, 1996), pl. 445. Also based on personal communication with He Li, November 2002; James C. W. Watt, *Chinese Jades from the Collection of the Seattle Art Museum* (Seattle: Seattle Art Museum, 1989), pl. 82.

9 The circular star chart on this screen has only sixteen ideograms total. Some are the same as those on the geomancers' compasses found on earlier *ch'aekkŏri* of the gnomon style. However, the geomancer's compass includes all twelve of the earthly branches, and eight of the heavenly stems, excluding the fifth and sixth stems, and four of the eight elements for a total count of twenty-four ideograms.

10 Little, p. 144, pl. 19.

11 "Measurable" means those books stacks whose leading and trailing edges are not obscured by an overlying object, thereby leaving its dimensions uncertain.

12 Liberty Hyde Bailey, *Hortus Third* (New York: MacMillan, 1976), p. 1030. Interestingly, examples of *salaginella involvens* appear in all three types of *ch'aekkŏri*: the isolated, trompe l'oeil, and still life types. An abstracted rendition of the clubmoss, from the gnomon style of *ch'aekkŏri*, reappears in the Leeum "Cubist" seal script *ch'aekkŏri* three times—in panels two, four, and eight. This is one of the 700 species of "little clubmosses" which grow in shady, moist sites in China, Korea, and Japan. The greenish stems grow straight for one foot or more (like a bunch of asparagus), and are capped differently depending on the species.

13 Terese Tse Bartholomew, *Fruits and Flowers for the Chinese New Year* (San Francisco: Asian Art Museum, 2000).

14 There is a mid-Qing trompe l'oeil type *ch'aekkŏri* with simple tabs depicted on its slipcases of books. *Zhongguo meishu chuanji: huihua bian* (Complete works of Chinese art: painting), vol. 21, *Minjian nianhua* (Popular New Year pictures) (Beijing: Wenwu chubanshe, 1987), pl. 10.

27

The Leeum "Door" *Ch'aekkŏri*

I first encountered this eight-panel *ch'aekkŏri* screen, an excellent example of the still life genre, at the Leeum in 1983 (Figure 27.1–27.8). It depicts eight different still lifes of scholarly paraphernalia and is distinguished by three things. First, it is stylistically unusual, if not unique; no similar examples are known to this author. The artist has incorporated an innovative painting device that acts not only as a unifier for the screen, but more importantly as a way to bring the viewer right up to the painting itself, although he is blocked from entering it. There is no room for him because he is cut off by the objects in the foreground cascading off the picture plane into his space. Second, the still lifes reveal a masterful integration of natural forms and geometric shapes whose overall effect is an abstract design. A combination of Western and Eastern painting techniques is responsible for this effect: the artist has used overlapping objects to indicate spatial recession and East Asian isometric perspective to depict the book stacks. Third, many intriguing written clues provide tantalizing hints about the sociological fabric of the period. Also worth investigating are the obvious references to the painting style of Chŏng Sŏn (1676–1759; pen name Kyŏmjae), the most celebrated of Korea's landscape artists in his time and to his follower, Kim Yun-gyŏm (1711–1775; pen name Chinjae). This work challenged Wagner and me to discover the artist, establish an approximate date for the painting, and interpret the subject matter.

I refer to this screen as the Leeum "Door," a reference to one of the screen's dominant elements, a wooden latticework door covered in mulberry paper that appears in Figure 27.8, and suggests a painting by Chŏng Sŏn.[1] The subject matter is unusual because it includes items not generally included in earlier *ch'aekkŏri*. For example, Figure 27.4 depicts some garments, including a winter hat, hanging over a rack.[2] In the same panel, a lifelike dog is seen carrying the Diamond Mountains on its back. Animate objects enhance the composition in Figure 27.6. A pair of magpies is depicted as if one bird is flying through the still life painting to join his mate perched in a plum tree. The magpies and plum branch are a Chinese wedding

Figure 27.4
Panel 4 of the Leeum "Door"
eight-panel still life type *ch'aekkŏri*.
Photo courtesy of the Leeum.

Figure 27.3
Panel 3 of the Leeum "Door"
eight-panel still life type *ch'aekkŏri*.
Photo courtesy of the Leeum.

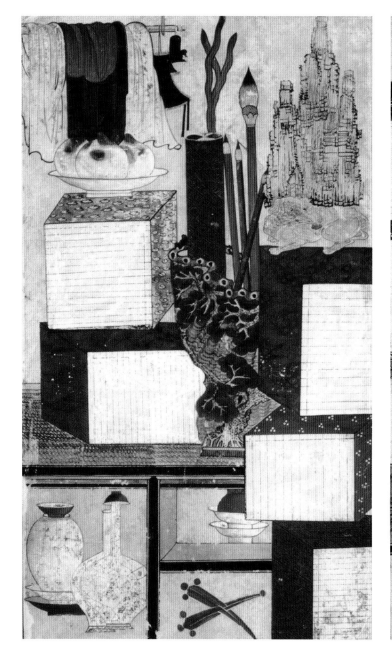

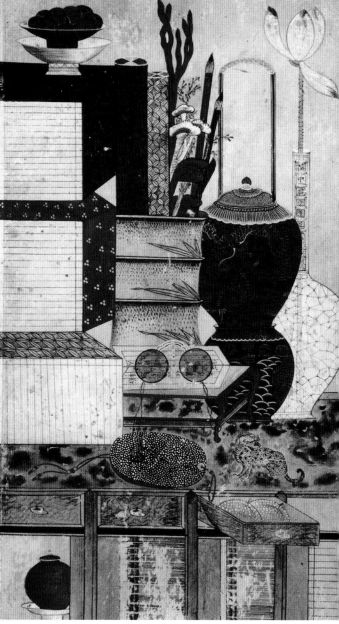

Figure 27.2
Panel 2 of the Leeum "Door"
eight-panel still life type *ch'aekkŏri*.
Photo courtesy of the Leeum.

Figure 27.1
Panel 1 of the Leeum "Door"
eight-panel still life type *ch'aekkŏri*. Ink,
vegetable, and mineral colors on paper.
62.5×36 cm. Leeum, Samsung Museum
of Art. Photo courtesy of the Leeum.

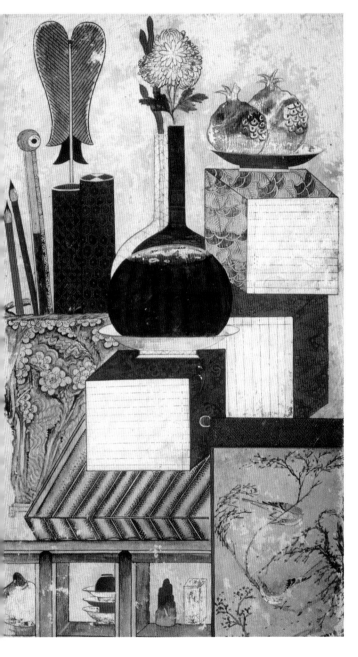

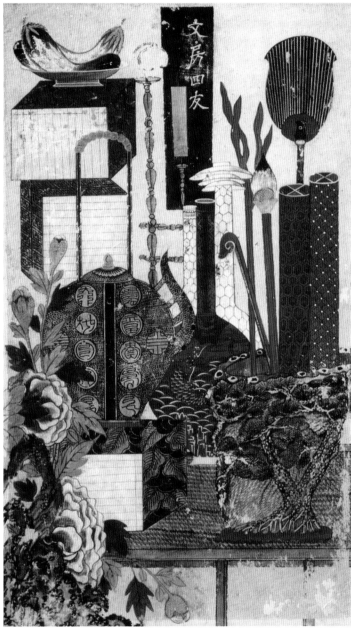

Figure 27.8
Panel 8 of the Leeum "Door"
eight-panel still life type *ch'aekkŏri*.
Photo courtesy of the Leeum.

Figure 27.7
Panel 7 of the Leeum "Door"
eight-panel still life type *ch'aekkŏri*.
Photo courtesy of the Leeum.

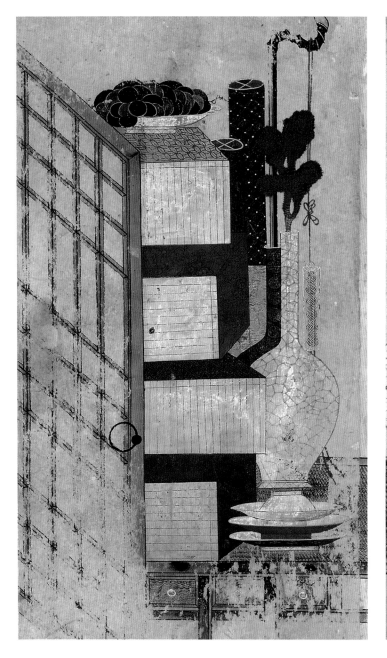

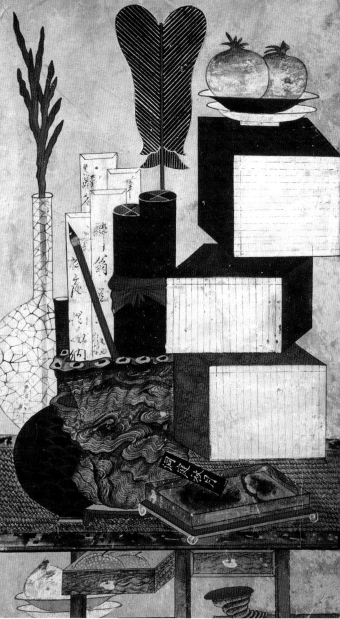

Figure 27.6
Panel 6 of the Leeum "Door"
eight-panel still life type *ch'aekkŏri*.
Photo courtesy of the Leeum.

Figure 27.5
Panel 5 of the Leeum "Door"
eight-panel still life type *ch'aekkŏri*.
Photo courtesy of the Leeum.

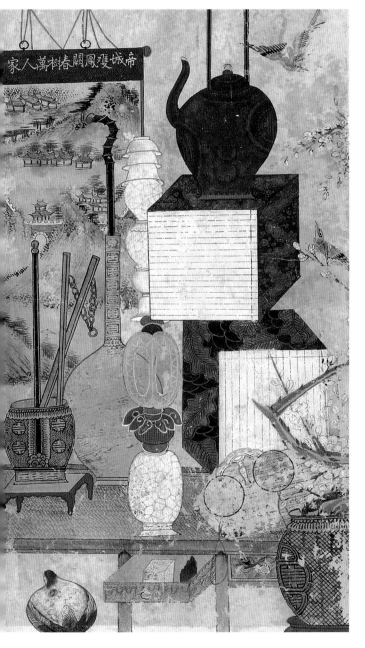

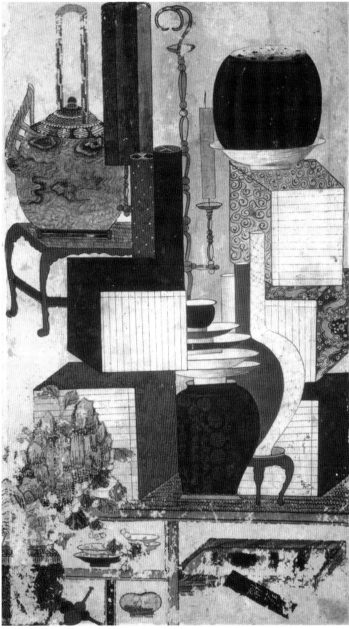

motif because the magpie is called *xique* (K. *hŭijak*) and the first character *xi* (*hŭi*) is the same as the one for happiness. Therefore, a pair of magpies on a plum branch (*hŭijak*) symbolizes double happiness/conjugal bliss *(ssanghŭi,* C. *shuangxi*).³ An archaic style fan, plantain-shaped, which appears in both Figure 27.2 and Figure 27.7, is an attribute of Daoist Immortal Zhongli Quan, thus symbolizing his presence in the painting.

Though the Leeum "'Door" screen presents such innovative forms, many previously seen thematic elements recur as well: the Four Friends of the Scholar's Room, miniature landscapes, flower arrangements, symbolic fruits and vegetables, stacks of books' slipcases with decorative covers, sea coral, fungus of immortality, a rhinoceros horn libation cup, and two name seals with characters painted in seal script. These objects are typical of those found in all three types of *ch'aekkŏri* painting. Objects more specifically associated with the still life type appear as well. There are two pairs of ladies' spectacles with string-loops shown lying on top of the pages of open books with Chinese characters (Figures 27.3 and 27.6); the painting also includes two hanging scrolls, one a landscape, the other a bird and flower painting.

One of the challenges that the Leeum "Door" screen presented to the author was the original arrangement of the panels. Because they are neither in their original mountings, nor even uniformly mounted, it is presumed that the set has been reordered. I undertook an analysis of all eight still lifes, hoping to discover the original sequence of the compositions, but I was unable to do so. Initially, it seemed that the artist himself might have facilitated a reconstruction of the sequence by the innovative device he used to bring the viewer up to, but not into, the screen's still lifes. He did this by depicting objects along the bottom edges, and by placing an object, partially obscured, in the foreground corner of each painting. For example, abraded miniature mountains (Figures 27.1 and 27.5) are crammed into the lower left corner of the composition, cascading off the picture plane in a position closest to where a spectator could imagine himself to be. There simply is no room left in the painting for the viewer's feet, whereas in the Leeum Chŏn-nam-style *ch'aekkŏri* (Figure 23.4, panels 1–8), its artist left a little wiggle room for the viewer by not aligning all of the foreground objects with the edge of the picture plane in some panels. In the Leeum "Door" *ch'aekkŏri*, similar compositions were used (Figure 27.6), with its partially obscured pot containing an arrangement of a plum branch and a pair of magpies extending upward along the painting's right edge, and where a hanging scroll is crowded into the painting's upper left corner of the background, again falling off the picture plane. In Figure 27.8, the artist has brought the viewer seemingly up to the scene itself by partially obscuring the door, the leading edge of which has its front bottom corner cut off as it opens to the left, exactly in the viewer's face. However, the artist's device of placing objects along the bottom edge, one of which overflows the picture plane to block the viewer from entering the painting, failed to provide an aid in establishing the intended sequence of the panels.

There are indications that the artist understood something of Western painting technique. Throughout the entire screen, he has properly used the Western system of overlapping objects to indicate recession, but he seemingly does not understand

Western linear perspective, or has deliberately chosen to ignore it. It would certainly be natural for a Korean artist to use multiple vantage points, a prevalent practice in East Asian painting. The artist paints some objects frontally; some blocky ones he depicts abutting one another; and he shows all from an elevated view. No item is painted from a worm's-eye view. In Figure 27.2, the viewer sees a striped tabletop, or shallow box, tilted crazily toward him at much too steep an angle to hold the books and objects placed on its surface. Perhaps the artist purposely created the table's irrational tilt to emphasize its striped surface design. Slipcases are consistently suspended in air throughout all eight still lifes; the resulting triangular voids create an interesting unity of geometric forms. Compared with the Chŏnnam-style ch'aekkŏri paintings, the forms of the Leeum "Door" screen are much flatter and the constructions more complicated. There is an implied third dimension in the Chŏnnam's ch'aekkŏri because each object occupies a space within that of the picture plane, whereas the "Door"s' compositions are only surface decoration on the picture plane.

The result of this integration of natural forms and geometric shapes is a fantastic abstract design. Still lifes tend to be static paintings: the Leeum "Door" ch'aekkŏri is an anomaly; all eight of its compositions are very lively, as must have been the artist's intent. The artist has stacked pots in tall unstable columns (Figures 27.5 and 27.8) totally without rationale. Shallow fruit bowls are depicted on the rear edges of slipcases, at the very top of each painting where only the picture plane keeps the objects from crashing to bits.

The compositions, so full of vitality, are densely packed with objects. Almost unbelievably, there are 263 individual items of sixty-one different types. Slipcases of stacked books account for over ten percent of the total number of the objects represented, but spatially they occupy a quarter to a third of the picture plane. Thus, their visual impact is far greater than their percentage would indicate. Although other items are often duplicated, neither they nor the books appear as fragmented bits of the ch'aekkŏri's theme due to the unification resulting from the subdued palette of blue, red, yellow, black, green, and tan. Repeated patterns of decoration on slipcases and paper rolls, Chinese seal script characters, crackle glazes, and other familiar motifs of embellishment are found on the vessels. The drawing of these objects and their decorations is representational, with great attention to detail. For instance, the cane (Figure 27.6) is so realistically painted that one can see its handle is made of jointed bamboo. Wobbly towers of pots and floating cases of books produce an unsettling effect upon the viewer. This restless quality in the paintings is further enhanced by the agitated brushwork seen in some of the ch'aekkŏri theme's objects.

Included among the many objects is a wealth of written clues found on the eight panels, discussed here from right to left as they appear on the screen in its present arrangement. All of the clues found on an individual panel will be discussed together in an effort to link a meaning by proximity, though at present their collective meaning is unknown.

The name Chang Wŏn-sam, presumably that of the artist, was discovered cached inside a stationery chest's open drawer (Figure 27.6). Painted in seal script characters on the face of a seal depicted as part of the still life, not as an imprint, it

is displayed next to a tiny blue-green rock, probably a ceramic water dropper. The color scheme of this object reflects the blue-and-green style of Chinese painting of the eighth century. However, the exclusive use of malachite (green) and azurite (blue) pigments to twice depict a miniature rock next to his name suggests that Chang Wŏn-sam was emphasizing a Daoist connection. In alchemy, the malachite and azurite minerals were used as elixirs in the Daoists' search for immortality.[4] Thus, one might visualize the tiny rocks as Mountains of Immortality.

The hanging scroll in Figure 27.6 shows a Buddhist temple in a mountainous landscape in the style of Chŏng Sŏn and Kim Yun-gyŏm. A poem in Chinese characters is inscribed across its top. The poem is from Wang Wei's (c. 699–759) Tang dynasty collection, clumsily titled *Written at Imperial Command to Harmonize with His Majesty's Spring-Detaining Poem, "Spring View in the Rain."* It was inscribed on the arcade connecting the Penglai Hall to Xingqing Palace.[5]

> . . . the sovereign city: twin phoenix turrets (*chesŏng ssangbonggwŏl*)
> . . . spring trees: ten thousand peoples' homes (*ch'unsu manin'ga*)

This poem originally had two lines of seven characters each; however, the *ch'aek-kŏri* artist chose to write only two lines of five characters each, omitting the first two characters in each line. Even though incomplete, the poem's meaning is unchanged: "The capitol is covered with clouds and twin phoenix pillars, rain brings longevity and peace to society." The theme of twin pillars with phoenixes inscribed on architectural elements dates back to the Han dynasty (206 BC–AD 189). The poem itself has been used ubiquitously in recent times in China to promote peace in the country.[6]

The passage under the spectacles (Figure 27.3) is illegible due to abrasion on the painting's surface. However, three characters can still be made out, which translate, "One's thoughts are miles away" (*sabaewŏn*). In the context of the panel, the only possible connection between the book passage and the poem is that a scholar alludes to his longing for a peaceful life of retirement in the countryside far from the so-called dirt of the world. Because Chang Wŏn-sam's name seal appears in the stationery chest's drawer, in front of the hanging scroll on this panel, perhaps it was he who was yearning for country tranquility. When all the clues are assembled in context, it seems possible that the landscape depicted after the style of Chŏng Sŏn and Kim Yun-gyŏm might be a "True View" painting of a real mountain haven in Korea.[7] The tiny "Mountain of Immortality," rendered in colors associated with Daoist alchemy, might further corroborate the theory that both the tiny water dropper and the painting could refer to a specific mountain retreat. Certainly, Chang's connection to the painting should not be denied; his name seal and a painting have been found next to each other in two still lifes, suggesting that he was its artist.

Although the text of the passage under the spectacles in Figure 27.3 is partially obscured, the legible characters read, "Fish changing [into a dragon]" (*yongnŭng pyŏnhwa*). This passage is probably a reference to the Asian myth of a carp jumping the rapids and turning into a dragon at the Dragon Gate on the upper reaches of the Yellow River. However, it could also mean that one had passed the civil service

examinations. As such, it would symbolize success and fertility. Panel 3 also has two objects decorated with Chinese characters. One is a lotus in a wine bottle with a glaze of cracked-ice pattern; its decoration of six legible characters reads, "The lotus is the gentleman among flowers" (*hwajung kunja yŏnhwa*), a metaphor for a gentleman of honor because the lotus remains pure even though it is grown in very dirty water.[8] This is from Zhou Dunyi's (1017–1073) essay *Love of the Lotus*. By the late Chosŏn period, it is said to have signified a high government official.[9] The other object, a vessel under a bail-handled wine pot, is decorated with waves and a dragon; this is the "rain-begging" ceremonial dragon used in times of drought as a personification of the rain spirit.[10] The wine pot is embellished with Chinese characters that read, "the Chinese Parasol Tree and Autumn Moon" (*odong ch'uwŏl*). Contextual interpretation of these clues, other than their auspicious connotation, is unclear.

The writing in cursive Chinese on four envelopes in Figure 27.7 (nine of the fourteen characters are legible), from right to left reads:

> Line 1: The character *hwa* (flower?) is legible, but its proper meaning cannot be determined without another character.
> Line 2: The characters for *ch'wiong* (drunken old man) can be read, but the rest is illegible. Ch'wiwong is possibly a pen name. However, it might belong to a Buddhist or Daoist monk of a temple because the character *kok* (gorge) is visible in the following line.[11]
> Line 3: The character *kok* is frequently associated with monks or a temple.
> Line 4: *unsongam kŭnhoenap*, which means that the contents of the envelopes are dedicated to the Cloud-Pine Monastery.
> Line 5: Four characters written on an ink stick, *tongjŏng ch'uwŏl*, reads, "Autumn moon over Lake Dongting." [12]

Perhaps these written messages refer to a specific Daoist's or Buddhist monk's pen name, who was living at Unsongam, Cloud-Pine Hermitage, during the autumn, but, if so, we have yet to discover a particular person with whom to positively link this description. We might suggest Kim Kyu-jin (1868-1933), a noted calligrapher and bamboo painter. In addition, Ch'wiong is one of his twelve pen names; he was a contemporary and fellow founder of a society for the arts (Sŏhwa hyŏphoe). Furthermore, his dates coincide with the period when the Leeum "Door" *ch'aekkŏri* was probably painted.

Figure 27.5 has a three-character inscription on its ink stick and an illegible fourth character. The first character has one element partially obscured by abrasion, but it almost surely was the character *pu*, "floating." Together with the other two characters, the passage translates as "Floating Jade Tower" (*Pubyŏngnu*), the name of a famous pagoda in P'yŏngyang. This provides a possible association with the donor of the envelopes seen in panel Figure 27.7, perhaps a lady, as it is well known that from the mid-sixteenth century on it was primarily women who were the patrons of Buddhism.[13]

Another bail-handled wine pot in panel one has ten seal script Chinese charac-

ters painted in two vertical columns of five each flanked by the character *su*, "longevity" (Figure 27.1). The right column reads, "Long life, happiness, wealth, forever" (*subokkwi mansang*). The left-hand column translates as, "Heaven and earth, sun, moon, forever" (*chŏnji irwŏl chang*). Again, auspicious symbolism is all that can be made of the above. A symbol of the literati is found on a label depicted on this panel, "Four Friends of the Scholar's Room."

In Figure 27.4, a clothes rack, with four items of clothing draped over it, is shown: a woman's black winter hat edged in white fur and a Confucian scholar's cap both dangle by their ties. The same motif of clothing hanging from a rack appears depicted in a single-panel dressing screen in the Onyang Folk Museum (Figure 1.5).[14] However, it is said that rather than clothing hanging from the rack, this represents wrapping cloths for the books, which are similar to those used to wrap packages.[15] Dressing screens were used in women's quarters.[16] Feminine apparel on a clothes rack, rarely seen in a still life *ch'aekkŏri*, recalls Japanese painting of the Momoyama (1573–1615) and early Edo (1615–88) periods called *tagasode* ("Whose sleeves…?").[17] One wonders whether the artist intended an allusion to a beautiful courtesan (*kisaeng*) by his inclusion of the clothing, or if it is perhaps merely a general allusion to women and their living quarters. At the bottom center of Figure 27.4 is a pair of crossed rhinoceros horns. These are from the "seven treasures pattern" and are Buddhist in origin.

Chang Wŏn-sam's name seal appears inside the open compartment of another stationery chest (Figures 27.2 and detail, 27.9). In an open drawer in Figure 27.6 and detail, 27.10, the position of the tiny blue-green rock has changed from the left side of the name seal, as one faces the painting, to the right side, and the lower halves of both seal and rock-shaped water dropper are obscured by the face and side of the drawer; otherwise the images are quite similar. This is the only example I have seen in which an artist's name is emphasized by the inclusion of two of the same name seals as part of the subject matter of one *ch'aekkŏri* screen. A painting of a pair of magpies and a plum branch, in the Northern Song style of Emperor Huizong hangs next to Chang's seal in the composition, and the close proximity of these two objects suggests an association between Chang Wŏn-sam and bird and animal painting.

The detail that provides the title for this Leeum "Door" *ch'aekkŏri* is a wooden latticework door covered in mulberry paper, which opens to reveal a still life composed of a scholar's possessions (Figure 27.8). Rather than depicting an actual scene inside a scholar's study as had both Wen Zhengming in the sixteenth century (the most influential artist of the Wu School of Chinese painting) and Chŏng Sŏn in the eighteenth century, Chang Wŏn-sam created still lifes that were abstractions of the same subject. It is possible that Chang drew his inspiration from one of Chŏng Sŏn's paintings. A rare figure painting by the artist, thought by some to be a self-portrait of Chŏng Sŏn, shows a scholar lounging on a veranda. Looking into the study, beyond the scholar, one sees an open wooden latticework door that reveals a deciduous tree outside.[18] The open door is decorated with the artist's specialty—a landscape painting; inside are seen five slipcases of books, a roll of paper, a bottle, and a candle stand occupying two shelves of a bookcase. Both the bookcase and the

Figure 27.9
Detail of Figure 27.2. Seal of
Chang Wŏn-sam seen in an
open compartment on panel
2. Photo courtesy of the
Leeum.

door are read as abstract geometric shapes because the perspective does not work
in either. Importantly, in both Chŏng Sŏn's and Chang Wŏn-sam's paintings, it is as
though the artists have depicted an open door to lure the spectator into the schol-
ar's inner sanctum. Seen as a metaphor, Chang Wŏn-sam's Leeum "Door" *ch'aekkŏri*
presents a portrait of the scholar and an invitation to his world.

Many *chungin* court painters were named Chang. To date, neither the family ge-
nealogies, nor examination rosters have divulged a Chang Wŏn-sam. Occasionally,
a number was used for a courtesy name, or even for a given name plus a generation
specifier. For instance, *ch'aekkŏri* painter Kang Tal-su's courtesy name included the
numeral three (*sam*) as an integral part of his courtesy name, Chasam. Similarly,
the name Wŏn-sam includes the numeral three (*sam*), so Chang Wŏn-sam may
well have been the courtesy name of one of the twenty-seven artists of the Chang
painting family. It may be possible that there was a relationship to Chang Sŭng-ŏp
(1843–1897), who was one of the last famous court painters of the Chosŏn period.
According to Gregory Henderson, a *ch'aekkŏri* signed Chang Sŭng-ŏp was auctioned
off in Seoul in 1960/61.[19] Future scholarship may someday unravel the mystery of
Chang Wŏn-sam's identity.

The eight panels of the Leeum "Door" *ch'aekkŏri* portray visual abstractions of
the literati world by their imagery. Auspicious wishes for the ideal life of a Korean
Confucian scholar of the Chosŏn period are symbolically pictured over and over
again.[20] Thematically, the artist has placed an emphasis on stacked slipcases of
books. These books represented the hard study necessary to pass the examination
to become an official; thus, they became a symbol of high rank, a highly sought
goal. Their slipcases and paper rolls were decorated with seven different patterns:

Figure 27.10
Detail of Figure 27.6. Seal of
Chang Wŏn-sam seen in an
open drawer on panel 6. Photo
courtesy of the Leeum.

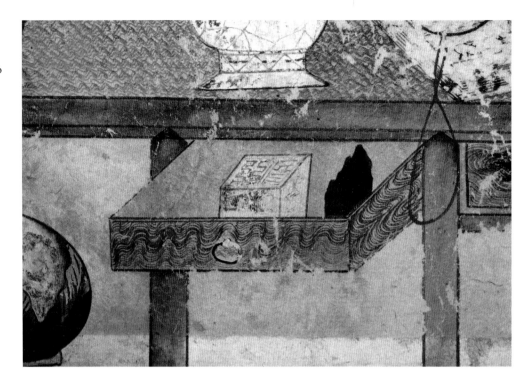

three-star pattern (*samsŏngmun*); auspicious cloud pattern (*unmun*); tortoise
shell pattern (*kwigammun*); water caltrop pattern (*nŭnghwamun*); grape pattern
(*p'odomun*); "ten-thousand" character pattern (*manchamun*); and seven treasures
pattern.[21] The seven treasures pattern is a common slipcase pattern in the *ch'aekkŏri*
genre.

Graphically, the artist has used the subject matter as a design element. To this
end, he has pared down, or reduced, the objects' shapes and colors, so that they
lack importance except as part of the construction's design. Chosŏn period artists
almost always clung to the East Asian painting convention of parallel perspective,
except infrequently when they used inverse perspective, where lines diverge as they
recede, in the still life type of the *ch'aekkŏri* genre. Unusual angles are created by the
isometric perspective, and they enhance the compositions by imparting a graphic
simplicity to the whole. Surely, this was intentional; such a masterful integration of
natural forms and geometric shapes could not have happened by accident.

Is the Leeum "Door" *ch'aekkŏri* an eighteenth-century work, or does the ab-
stract quality of the still lifes' constructions, their overflowing the picture planes,
and the technique of bringing the viewer up to the edge of each panel indicate a late
nineteenth-century date for the screen? The multiple vantage points, fine brush-
work, harmonious palette, and above all, its abstraction suggest this screen was the
work of an artist who was active in the second half of the nineteenth century. It is
seen as late because of the many painting conventions the artist used to articulate
the objects relative to each other, and to the space surrounding them. Its technical
aspects suggest the screen was the work of an accomplished professional artist. The
author places the Leeum "Door" screen late in the still life *ch'aekkŏri* chronology

and awards it high honors for its overall aesthetic appeal, technical achievement, and interesting subject matter.

NOTES

1 *Kansong munhwa* 54 (1998), nos. 18, 19.

2 The Onyang Folk Museum screen is the only other example known to me that includes a clothes rack. For an illustration of this screen, see the catalogue of *Han'guk minhwajŏn* (The Korean Folk Paintings: An Exhibition) held at *Ilsin chegang* from June 23–29, 1981, p. 43.

3 Bartholomew, *Hidden Meanings in Chinese Art*, p. 52.

4 Little, p. 368. See also John Hay, *Kernels of Energy, Bone of Earth: The Rock in Chinese Art* (New York: China Institute of America, 1985), pp. 45–50.

5 Pauline Yu, *The Poetry of Wang Wei: New Translations and Commentary* (Bloomington: Indiana Press, 1980), pp. 92–93, 214.

6 Personal communication with He Li, August 30, 2002.

7 For more on the term "True View," see Yi Sŏng-mi, "Artistic Tradition and the Depiction of Reality: True-View Landscape Painting of the Chosŏn Dynasty," in *Arts of Korea*, edited by Judith G. Smith (New York: The Metropolitan Museum of Art, 1999), pp. 331–365.

8 An Sang-su, ed., *Han'guk chŏnt'ong munyangjip* II: *Kkot munŭi* (Korean Motifs II: Floral Patterns) (Seoul: Ahn Graphics & Book Publishers, 1990), p. 16.

9 So Yeon Eom, p. 45.

10 Zo Za-yong (Cho Cha-yong), *Introduction to Korean Folk Painting* (Seoul: Emille Museum, 1977), p. 34.

11 It is possible that Ch'wiong or "Drunken Old Man" could refer to the famous Song dynasty scholar, collector, and archeologist Ouyang Xiu (1007–1072) because it was his pen name. Since Ouyang Xiu was the founder of connoisseurship, it would seem appropriate to associate him with a painting displaying a scholar's collection—albeit a make-believe one. Black, "Hundred Antiques," p. 4. A more likely possibility is that Ch'wiong refers to Kim Kyu-jin (1868–1933), a famous calligrapher and bamboo painter who was a contemporary of Yi To-yŏng. Both were members of Sŏhwa hyŏphoe. Ch'wiong is one of Kim's twelve pen names. Notes of Wagner, June 1996.

12 The last phrace "Autumn moon over Lake Donting" refers to one of the Eight Views of the Xiao and Xiang. The earliest version of this Chinese painting theme is said to date to 1160 of the Southern Song dynasty (1127–1279) and was based on the scenery at the confluence of the Xiao and Xiang rivers where they form Lake Dongting in Hunan Province. Richard Barnhart, "Shining Rivers: Eight Views of the Hsiao and Hsiang in Sung Painting," in *International Colloquium on Chinese Art History, 1991: Proceedings*, vol. 1 (Taipei: National Palace Museum, 1992), p. 61.

13 Lee Ki-baek, pp. 199–200.

14 *Han'guk minhwajŏn*, p. 43.

15 *ibid.*

16 Personal communication with Kim Nam-kyu, curator of the Onyang Folk Museum, October 1987.

17 Margo Paul, "A Creative Connoisseur: Nomura Shōjirō," in *Kosode: 16th–19th Century Textiles from the Nomura Collection*, edited by Amanda Mayer Stinchecum (New York: Japan Society and Kodansha International, 1984), p. 18.

18 *Kansong munhwa* 54.

19 Personal correspondence with Gregory Henderson, November 5, 1986.

20 Auspicious symbolism: book cover patterns, paper roll patterns, archaic fan, coral, peach, pomegranate, citron, grapes, double gourds, eggplants, watermelon, seven treasures pattern, rhinoceros horn libation cup, pair of magpies, fungus of immortality, *haet'ae*, plum, chrysanthemum, and lotus. For more on symbolism, see So Yeon Eom, "Minhwa"; An Sang-su, ed., *Kkot munŭi*; Zo Za-yong, *Introduction to Korean Folk Painting*.

21 It occurred to me that a system of organizing book cover patterns in each ch'aekkori might corroborate genealogical records and bolster the proof of the family workshops. For an example in a different context of how this sort of research could be useful, see Patricia Rieff Anawalt, "Riddle of the Aztec Robe," *Archaeology*, May-June 1993, pp. 31–36; Anawalt, "The Emperor's Cloak: Aztec Pomp, Toltec Circumstances," *American Antiquity* 55, no. 2 (1990), pp. 291–307.

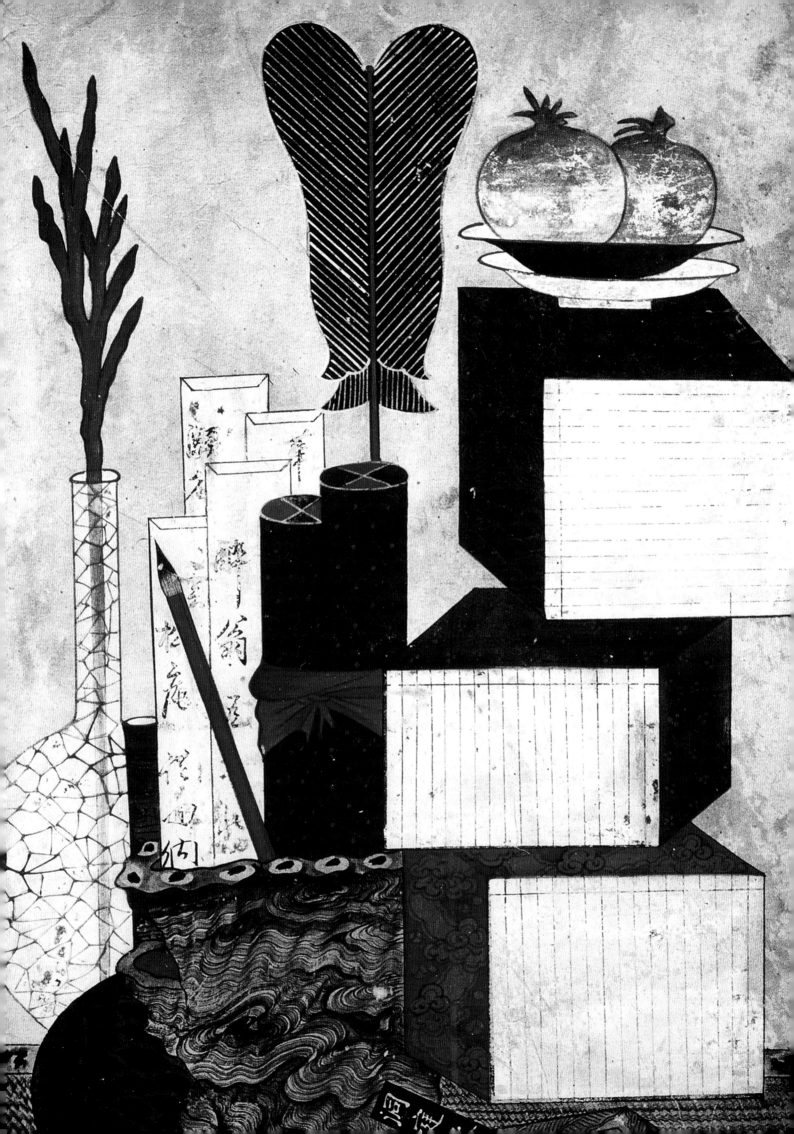

28

Former Gruber Collection Eight-Panel *Ch'aekkŏri*

In an eight-panel still life *ch'aekkŏri* from the former collection of John Gruber, the artist presents decorative compositions of attenuated forms skillfully executed on coarse, silver-flecked brown paper—an anomaly (Figure 28.1, panels 1–8). One would expect to see a folk-style primitive painting done on coarse paper, but not the work of a skilled artist who would more likely work on fine quality paper, silk or hemp, depending on the means of whoever commissioned the screen. There are other anomalies, too. In two instances, a book is pulled forward from the others in the stack (panels 5 and 7). Seven-string binding is used—a most unusual occurrence (panel 2).

Each panel is logically constructed with smaller objects in front gradually gaining height as each stack of books recedes into one final towering pile of slipcases or a tall display stand. The vessels arranged here and there are all attenuated in form. Nothing particularly unusual strikes the viewer regarding the subject matter except in two instances. A floral arrangement shoots out of the mouth of a rabbit (panel 2), and a tiny animal, maybe a lamb, stands on all four feet (panel 7).

Sixteen books on the screen are titled, and the titles are depicted in three different ways. Nine are written across the exposed edge of the top book in the slipcase, six are labeled on top of a volume, and one is written on a book's spine. Mencius is missing from the Four Books, and only the *Book of Changes* and *the Spring and Autumn Annals* appear from the Classics. There are three books by Zhu Xi: *Xingli (Sŏngni), Jinsilu (Kŭnsarok),* and *Zhuzi daidian (Chuja taejŏn).*

Based on its attenuated style, one might tentatively date the screen between the 1930s and the 1960s. According to John Gruber, he collected it while working in Asia, where he was based in Tokyo, Japan between 1963 and 1972, so it could not have been executed any later.

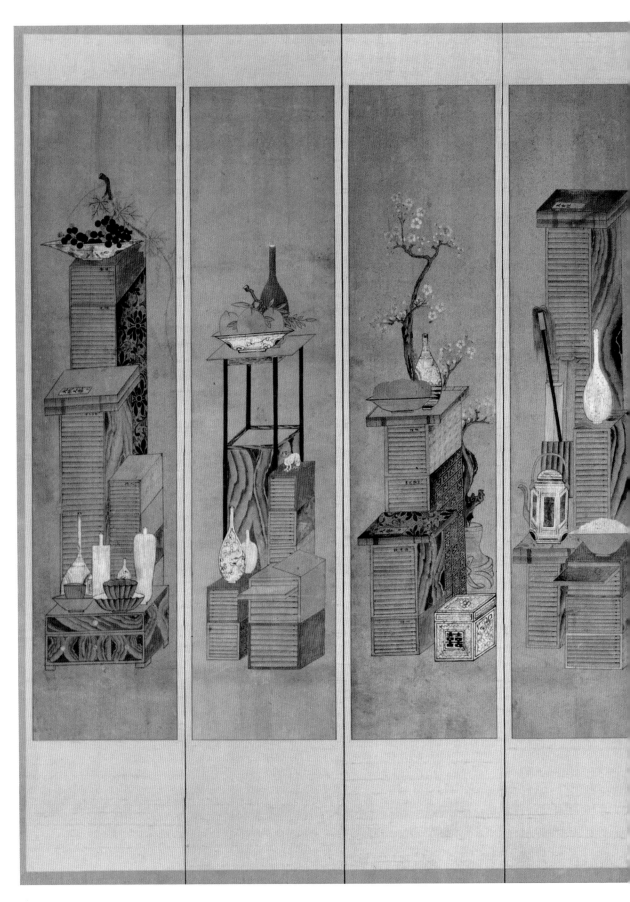

Figure 28.1
Eight-panel still life *ch'aekkŏri*. Ink, vegetable, and mineral pigments on silver-flecked brown paper.
149 × 37.25 cm. Formerly John Gruber collection. Photo courtesy of David Hill.

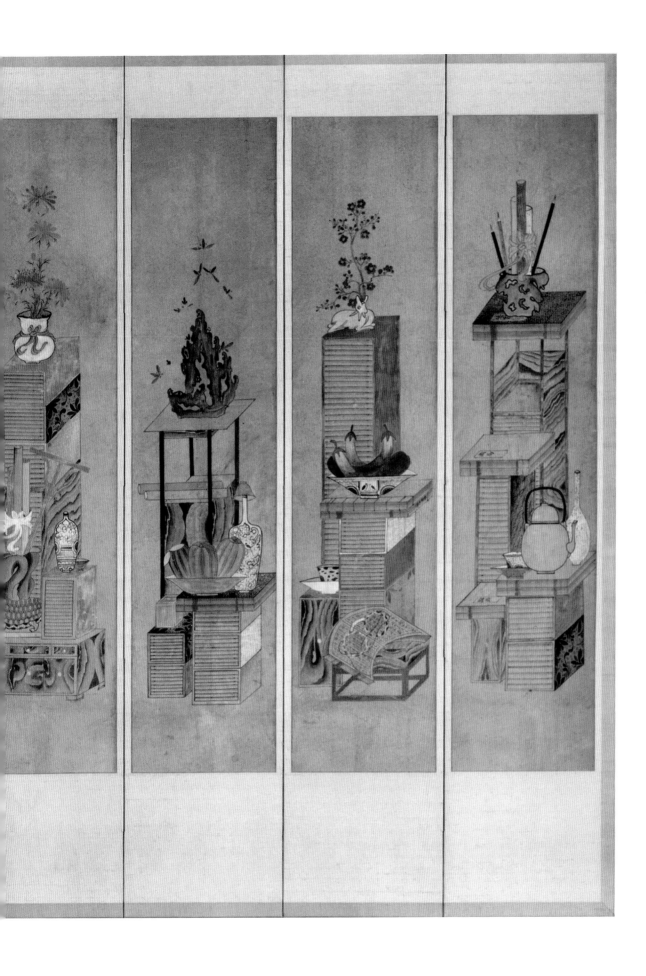

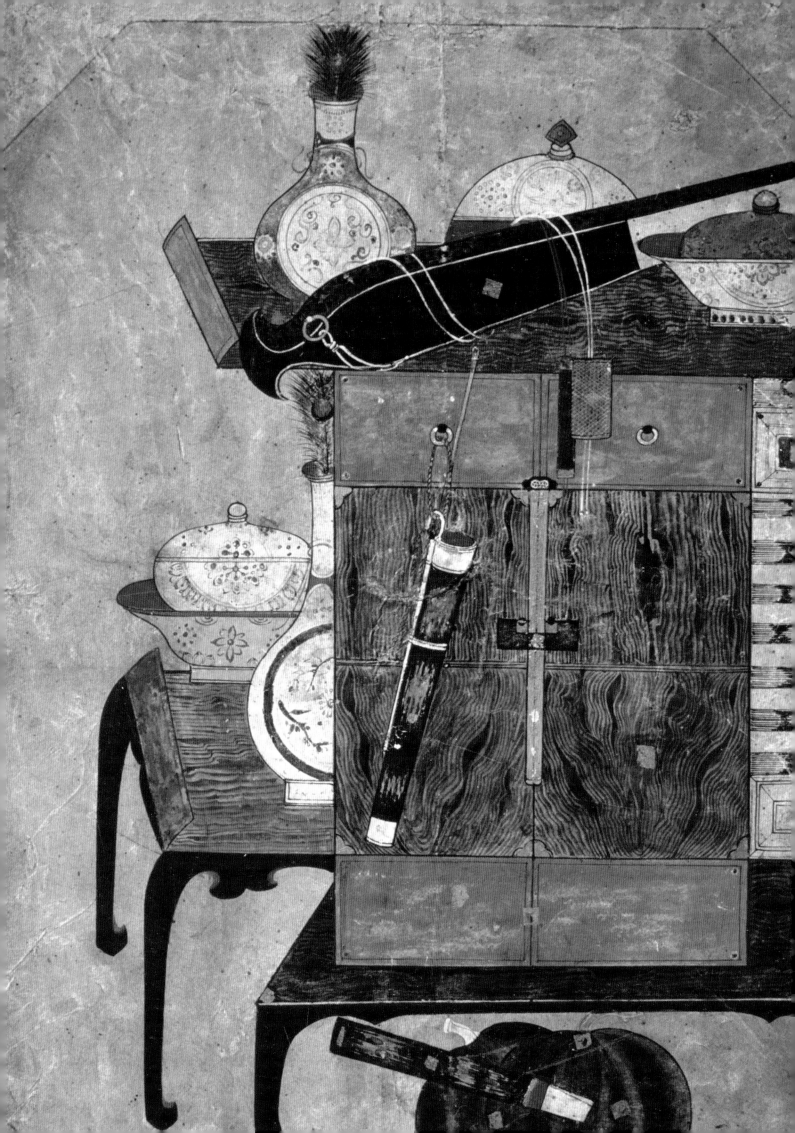

The Elegant *Ch'aekkŏri*

Design was the artist's focus on the eight-panel *ch'aekkŏri* in the Joo Kwan Joong and Rhee Boon Ran collection in Seoul (Figures 29.1–29.8). The objects found in each still life are compressed into tight arrangements delineated by straight lines and angles, and curvilinear ones and circles. All are depicted from an elevated view. Although the objects are overlapped and are seen to recede on each panel, overall, they appear very flat, as their artist made no attempt to portray them three-dimensionally.

Even though he was not interested in using linear perspective throughout his *ch'aekkŏri* compositions, he did include three detailed examples of it in the depictions of box-like arm pillows. The uppermost square in the third panel is a perfect diagram of a peep box, in which five sides of an interior space are depicted, as was possible with European perspective, but not in the East Asian system.

One quickly notices in the Joo/Rhee *ch'aekkŏri* that not one of the still lifes is centered on its picture plane; five crowd to the right, three to the left. In the many examples of the still life type in this study, I have never before encountered compositions that were intentionally lopsided. As they are remounted, the six inner panels—2 through 7—are paired so that one whose composition is crowded to the left faces one whose still life is crammed to the right. Opposite compositions are paired with each other. That arrangement could balance the screen except that the still lifes on the panels at either end of the screen are both weighted to the right instead of both facing in opposite directions. They both should face inward toward the center, or outward, for a balanced overall composition.

The artist unified the panels of his screen by repeating the objects he depicted, emphasizing flat forms, and by using the same palette in all of the panels. Perhaps the palette is the most obvious unifier; harmonious tones of russet or bittersweet, black, brown, yellow, blue, ink wash, grey-green, jade green, turquoise, and gilt are used throughout this work.[1] Examples of his unifying elements include the box-like pillow (panel 5); a plethora of gilt squares decorating many of the objects and

Figure 29.4
Panel 4 of an eight-panel still life type
ch'aekkŏri. Square pillow on a stack of
books. Paper rolls tied with a circular
bowknot. Gold-decorated tortoise shell
spectacles dangle from a drawer pull.
Photo by Norman Sibley.

Figure 29.3
Panel 3 of an eight-panel still life type
ch'aekkŏri. Square pillow on a stack of
books. An ink stone, brush and ink
stick (the three friends of the scholar)
are under the chest. Photo by Norman
Sibley.

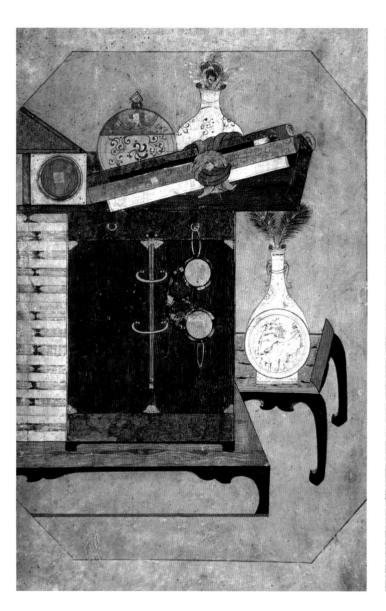

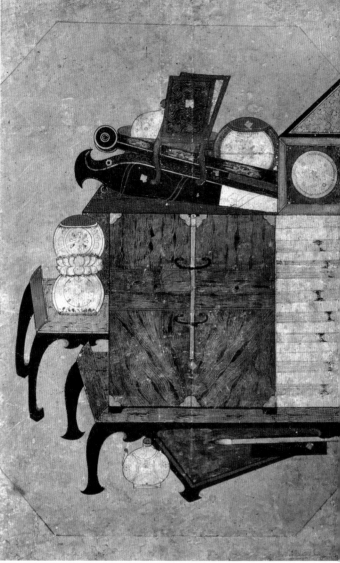

Figure 29.2
Panel 2 of an eight-panel still life type *ch'aekkŏri*. Square pillow on top of chest. Ink stick on ink stone under table translates, "Three Pleasing Fragrances." Photo by Norman Sibley.

Figure 29.1
Panel 1 of an eight-panel still life type *ch'aekkŏri*. Melons pierced by knife; its sheath dangles from chest's drawer pull. Ink, vegetable, and mineral colors on brown paper. Joo Kwan Joong and Rhee Boon Ran collection, Seoul. Photo by Norman Sibley.

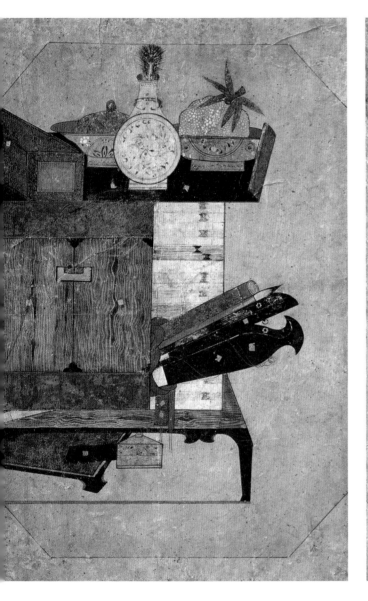

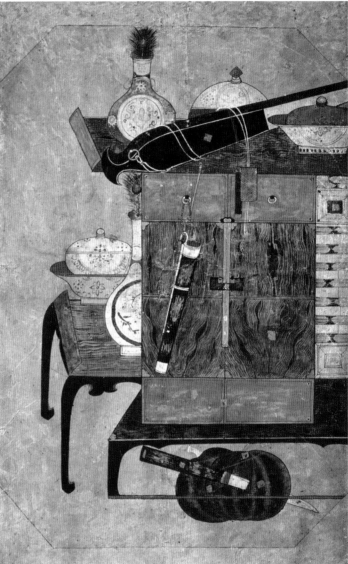

Figure 29.8
Panel 8 of an eight-panel still life type *ch'aekkŏri*. Gnarled wood paper holder with red lacquered interior and gold decorated black lacquered fans. Unidentified long feathers resting on square pillow. Photo by Norman Sibley.

Figure 29.7
Panel 7 of an eight-panel still life type *ch'aekkŏri*. Gnarled wood paper holder with red lacquered interior and peacock feathers. Photo by Norman Sibley.

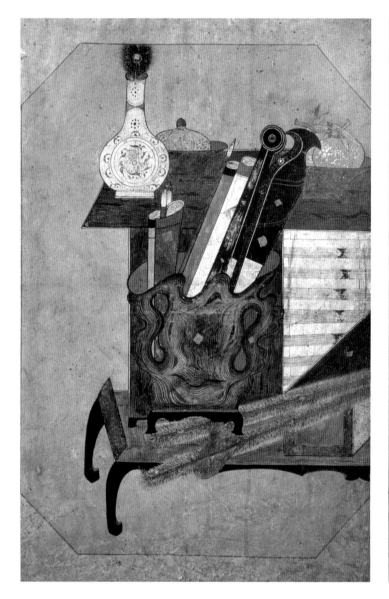

Figure 29.6
Panel 6 of an eight-panel still life type *ch'aekkŏri*. Tortoise-shaped gunpowder flask dangles from chest's drawer pull. Photo by Norman Sibley.

Figure 29.5
Panel 5 of an eight-panel still life type *ch'aekkŏri*. 18th century official's seal box, gnarled wood paper holder, and women's shoes. Photo by Norman Sibley.

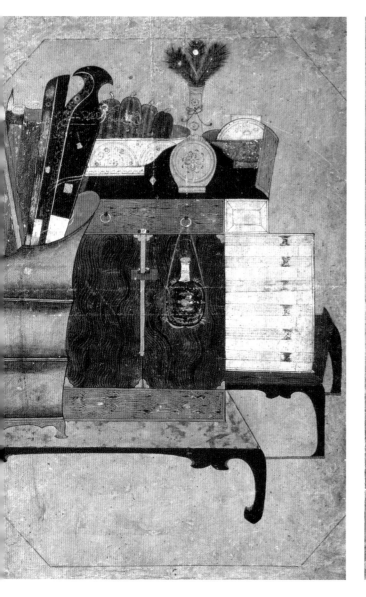

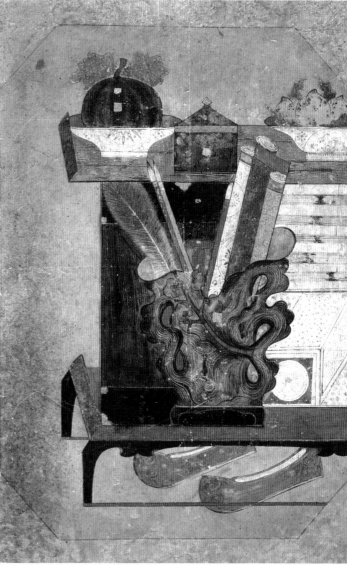

x-shaped binding marks in each panel; nine black-lacquered fans embellished with gold; three inkstones and ink sticks (two shown with water droppers and a third with a writing brush) (panels 2, 3, and 7)[2]; three gnarled burl-wood paper holders, and a bamboo one in the unadorned scholar's taste; eight finely grained wooden tables with dogs' legs; and most important, peacock feathers, a symbol of official promotion, in every one of the eight *ch'aekkŏri* panels, except panel 3.

Objects that are unusual in the *ch'aekkŏri* genre appear here and there in the Joo/Rhee screen. For example, a Korean eighteenth-century official's seal box, decorated in fish skin (panel 5), is a rare item in the still life type of *ch'aekkŏri* painting, and it does not appear in either of the court styles.[3] Instead, the Chinese-style seal box where seals are displayed on top is prevalent in both court styles. Also not seen before in this genre are the five square pillows (panels 2, 3, 4 and 5) associated with a scholar's study. Panel 5 also has a pair of women's shoes, which do appear elsewhere in the genre, but only infrequently. The tortoise-shaped gunpowder flask, replete with feet (panel 6) is an item not seen before in the *ch'aekkŏri* genre.[4] The gold-decorated tortoise shell spectacles dangling from a chest's drawer pull (panel 4) and the knife's sheath in panel 1 represent departures too.

Achieving European perspective was not the painter's main concern. This anonymous artist's focus was on depicting the objects so that they stood out in their compositions. Technically, all eight paintings are finely executed. For example, the wood graining of the furniture in grey on tan, and the gnarled brush holders are both strongly and naturalistically depicted. The knot tying the paper rolls in panel 4 is elaborately done, as are the peacock feathers in panels 5 and 7. The surfaces of the circular ceramic flasks are finely and delicately painted, yet their very flatness gives them an abstract quality. Only panel 5 lacks one of these bottles. The tabletops with their wings bent back on themselves also lend an abstract air to this *ch'aekkŏri*. These wings are reminiscent of Chosŏn era country scholars' furniture.

The first things that strike the eye are 129 individual books, one layered stack per panel. There is no hint of a Chinese-style slipcase, nor are the books arranged vertically in the European manner.[5] Books are stacked in a pattern of alternating horizontals: white and a white with finely inked lines; the latter are decorated with a darker ink hourglass, or X shape.[6] Here, softcover books are stacked, but not enclosed in a Chinese-style hardback cover, as is the case with other *ch'aekkŏri* of the still life type. There are no book cover patterns depicted. Strangely, the book stacks play only a minor role in the subject matter of this screen—accounting for a mere ten percent of the objects and one stack per panel.

No real flower arrangements are found in this *ch'aekkŏri*; its artist focused on the peacock feather instead. This is yet another departure from the still life genre. Fewer fruits appear—and the knife plunged into the pair of pumpkins has not been seen in previous *ch'aekkŏri* (panel 1).

The overall design has an abstract, flat patterned quality that suggests Japanese influence, as does the asymmetry of the design. The artist is interested in creating a design of flat patterns, not in depicting a coherent three-dimensional composition. This is art for art's sake.

Despite the seemingly unbalanced overall composition, the artist has presented

a perfect interplay of squares and circles, angles and curves; vertical, horizontal, and diagonal lines in the most sophisticated composition within the *ch'aekkŏri* genre. The palette is harmonious, and the monochrome ink painting finely executed. The Korean-style chests and writing tables, with their wood grain and simple Korean-style brass locks and drawer pulls, show the restraint and the elegance of proportion that would have been favored by scholars of the eighteenth and nineteenth centuries. The official's seal box is in the Korean, not Chinese, style, and the scholar's furniture, as well as the cosmic imagery—the heaven/earth symbol—represent the scholars/officials of that period. Perhaps the screen's outstanding feature is that all books are stacked flat in the Korean fashion. This individual screen seems the most "Korean" of all *ch'aekkŏri* in the study.

With all the peacock feathers, symbolic of officialdom, the official's seal box, five square pillows of the kind appropriate to a scholar's study, and a plethora of gold decorations, an expensive touch, one wonders whether the screen might have been commissioned by a rich merchant aspiring to emulate the aristocratic style.

NOTES

1 Personal communication with Joo Kwan Joong, October 1986. According to Professor Joo, "Merchants say that gold squares are age squares." A scattering of gold squares decorates every panel of the Joo/Rhee screen. One might speculate that this *ch'aekkŏri* could have been commissioned to celebrate a sixtieth, seventieth, or eightieth birthday.

2 One ink stick (panel 2) depicted in red reads "Three Pleasing Fragrances" (*samyŏlhyang*) and the other (panel 3) translates as "Fragrant Moonlight" (*hyangwŏlgwang*).

3 See Ch'oe Sun-u (Choi Sunu) and Pak Yŏng-gyu, *Han'guk ŭi mokch'il kagu* (Korean wood lacquer furniture) (Seoul: Kyŏngmi munhwasa, 1981), p. 215, pl. 238, for a seal box in the eighteenth-century style.

4 Black, "The Korean Ethnographic Collection of the Peabody Museum in Salem," pp. 12–21.

5 Korean books are larger than Chinese or Japanese ones. Personal communication with Yi Kyŏm-ro, October 1986. See also An Ch'un-gŭn, p. 17.

6 Decoration could possibly be in the shape of the traditional Korean hourglass drum. For a drum illustration, see Huh Dong-hwa and Park Young-sook, p. 108.

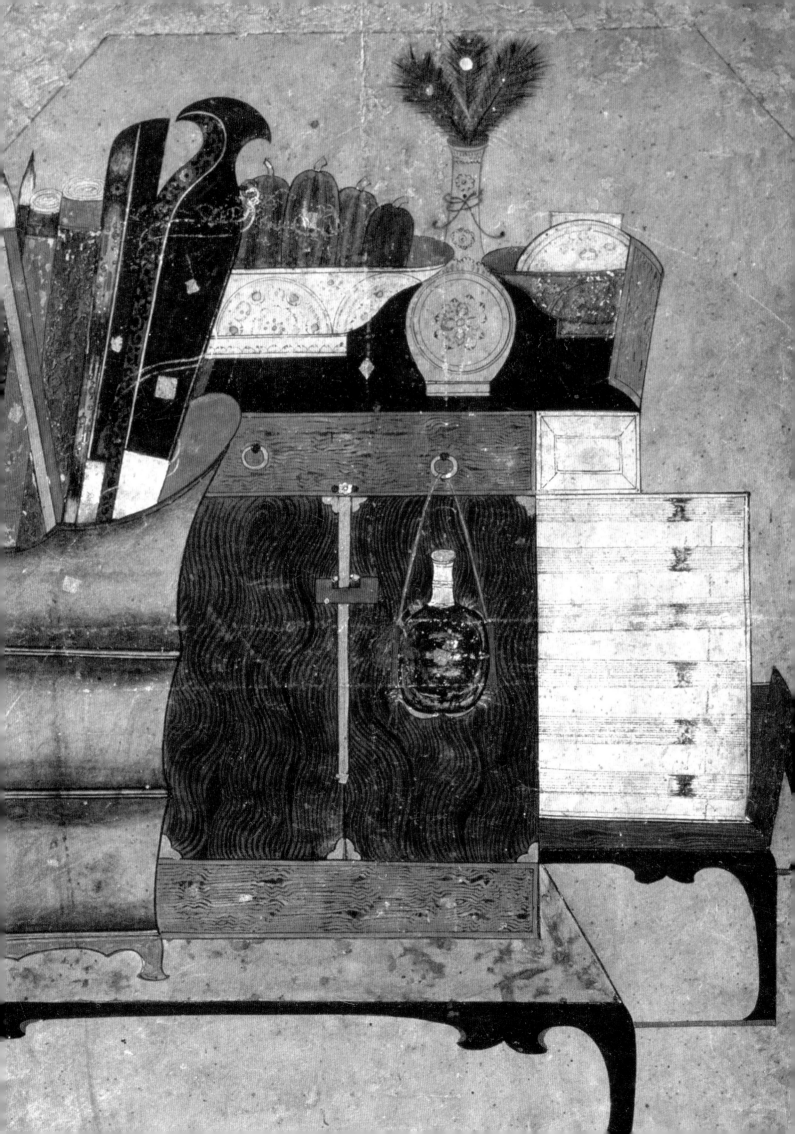

30

Conclusion

Since I initiated my study of Korean *ch'aekkŏri* in the late 1970s, I have been able to answer a number of questions about the paintings—some tentatively, many more conclusively. Other issues remain a mystery, awaiting the attention of future researchers.

In the previous chapters, the reader has encountered the essence of the author's twenty-five-year study of the *ch'aekkŏri* genre. One hundred and fifty examples of Korean *ch'aekkŏri* have been examined, and their general characteristics described. The format is usually a folding screen; the medium is mineral and vegetable colors with a touch of monochrome ink, rarely all ink. Seven-eighths of isolated type screens were painted on silk, half of the trompe l'oeil type were done on silk or hemp, and only one-fifth of still life *ch'aekkŏri* were done on fabric, an indication that the still life type was not for the court circle, but perhaps for the rich *chungin*. That makes sense, as the nineteenth century was when money was changing hands. The objects depicted are scholarly paraphernalia, generally secular in nature. *Ch'aekkŏri* paintings were household furnishings created for decoration and in screen format to keep the floor-sitting Koreans from drafts. Small folk art panels decorated cupboards, and horizontal ones possibly adorned doors to attic spaces and ornamented interiors of Buddhist temples. *Ch'aekkŏri* were not considered art to be treasured. When they wore out, they were discarded and replaced.

A system was devised to classify the screens into three types: isolated, still life, and trompe l'oeil. They developed at different times: the isolated type came first with the still life type a close second, and the trompe l'oeil type last. I have established a pictorial source for isolated type *ch'aekkŏri* objects in the depictions of Chinese imperial collections of antiquities (*bogu*). Although the original catalogues have disappeared, their contents are found in the 1752 edition of the Illustrated Catalogue of Antiquities (*Bogu tulu*). Coupled with the influence of the Song dynasty's connoisseurship movement, the development of Chinese and Korean paintings of scholarly objects was stimulated. I have identified, as Chinese prototypes for the

isolated type, one set of Ming embroidered panels originally in screen format in the National Palace Museum, Taipei. Without the patronage of Chinese emperors of the twelfth, seventeenth, and eighteenth centuries, the genre would probably never have taken hold. One need look only at the remaining hand scroll, one of a set, from the Percival David Foundation on loan to the British Museum, with its scene of the Emperor Yongzheng's (r. 1723–1736) throne and part of his collection of treasures, to imagine its importance to him. Similarly in Korea, King Yŏngjo (r. 1724–1776) and his grandson King Chŏngjo (r. 1776–1800) gave royal patronage to European painting techniques through the *ch'aekkŏri* medium. Their support of this genre accounts for its popularity to this day.

The still life, or non-palace *ch'aekkŏri*, began to appear at about the same time as the isolated type. Prototypes for the still life type are found in the Kaempfer series of seventeenth-century woodblock prints depicting the seasons, and in Ming dynasty embossed white-on-white stationery. This type offers a seemingly endless variety. Although many of the items illustrated are Chinese, some of the subject matter is comprised of Korean everyday items and household furnishings: bows, arrows, quivers, a carrying lantern, fans, winter hats, shoes, spectacles, mirrors, lamps, a clothes rack, tables, chests, game boards, and animate objects such as birds, butterflies, deer, and other animals. Their artists placed a greater emphasis on fertility symbols consisting of fruits and vegetables with numerous seeds (all symbolic wishes for many sons) than they did in either of the court styles. The subject matter was more personal, and more informal, than that of either the trompe l'oeil or isolated types, suggesting that the selection of items might have come from the persons who commissioned the *ch'aekkŏri*. Of the two styles of still life *ch'aekkŏri* with enough examples for comparison, the Chŏnnam style is more Korean, and the gnomon variety is the more Chinese.

The trompe l'oeil type, the last to appear, developed in the eighteenth century at the court of the Qianlong emperor as a result of an exposure to linear perspective and contact with European paintings: pictures of treasure rooms and "fool-the-eye" scenes painted on church walls in Beijing by Jesuit artists. I have attributed to the Jesuit artist Father Giuseppe Castiglione (Lang Shining), who served at the court of Emperor Qianlong (r. 1736–1796), a prototypical painting for Korean trompe l'oeil *ch'aekkŏri*. The Korean artists' concept of linear perspective was rational, but their application was intuitive, not mathematical. Hence, I named the type "trompe l'oeil" or "fool-the-eye." It has been shown that both the isolated and trompe l'oeil types enjoyed royal patronage. Indeed, even today in Korea they are referred to as court style *ch'aekkŏri*.

The parallel development of Chinese and Korean *ch'aekkŏri* took different stylistic paths. The most significant difference discernible between the subject matter of Korean and Chinese *ch'aekkŏri* is found in the proportion of books to the other objects shown. With some exceptions, Korean artists of mainstream *ch'aekkŏri* painting emphasized books, while the Chinese artists favored objects. Additionally, Chinese artists painted fewer objects, in larger scale, and with more convincing shading and more elaborate bookcases in their trompe l'oeil paintings than did their Korean counterparts. The prominence of books in Korean *ch'aekkŏri* is due to

King Chŏngjo's efforts to promote literary culture at his court, as well as the Korean reverence for education which persists today. However, less than five percent of the screens in this study include entitled books, and I have found no screen earlier than the second half of the nineteenth century. On the screens that do present legible book titles, there is a representative group of Chinese Classics, Neo-Confucian works, and some Korean titles. The entitled books are sufficiently eclectic to assume that there was no set list, and that the choice was up to the artist, or his patron, or maybe a combination of the two.

Embedded seals in the subject matter led us to the discovery of seven artists' surnames with given names (three of which belong to the same person), and four pen names. Only eighteen *ch'aekkŏri* have surname or pen name seals out of over 150 screens in this study, slightly fewer than seven percent. Traditionally, government artists were reputed not to have signed their work. Yet Yi Hyŏng-nok did paint his three different name seals on seven *ch'aekkŏri*. Why did a few other artists include their names, or their pen names, on seals in the subject matter? Were they also court painters? Were they asked to do so? The criteria for signing a *ch'aekkŏri*, or not, by inclusion of a seal as part of the subject matter remains a topic for further investigation.

This study reveals that much of the subject matter in Korean *ch'aekkŏri* is Chinese and auspicious in connotation. The scholar's objects are all appropriate articles for a Chinese or Korean Neo-Confucian. According to Ledyard, however, it is doubtful that many of the elite possessed any of these valuable objects unless they had been to China, and had negotiated with traders in order to acquire them. The most obvious Chinese item, and the one that takes up the most space on the picture plane, is the hard cover slipcase. Koreans never had covers for their books during the Chosŏn period; therefore, when slipcases are depicted, they, too, are assumed to be Chinese. A number of screens depict wrapping cloths or ribbons tied around slipcases of books, vessels, scrolls, and paper rolls—an image that came straight from the Chinese court, gaining popularity in the Kangxi reign. Other items in the Kangxi style are the bright green brush washer shaped like a peach half, and the small water pot shaped like a folded magnolia blossom. Additionally, faux finishes simulating metal, wood grain, or marble are a Qianlong innovation of Qing potters. Objects are also frequently Chinese in court style *ch'aekkŏri*. A prime example of Chinese influence is seen in the screen that I attribute to Pang Han-ik, where vessels are illustrated with an exaggerated white crackle-glaze (*ge* or *guan*), which enjoyed a revival in China during the eighteenth and nineteenth centuries. Another instance is the Chinese New Year flower, a narcissus called a "paper white," which is depicted in most of the Korean trompe l'oeil and isolated types, but surprisingly does not appear in any of the Chinese works in this study.

The prominence of books in Korean *ch'aekkŏri* compositions reflects the Confucian view of the importance of study. The scholar's objects depicted are all appropriate articles for a Chinese or Korean Neo-Confucian scholar. Perhaps the most striking Confucian item is a strangely shaped object found depicted on the Hongik screen, which I interpret as a symbolic summary of the *Doctrine of the Mean*. Cheng Yi's (1033–1107) name on a painting scroll is a reference to one of the revered pio-

neers of Song Neo-Confucianism. The Chinese characters surrounding the *t'aegŭk* that decorate the gnomon are from the *Book of Changes*, thus demonstrating a Neo-Confucian mix of science and the occult (Daoist). Bronze wine vessels, and incense burners with their tools, used in the ancestor worship rituals, are other Confucian accoutrements. These are found in court style *ch'aekkŏri*, but seemingly only appear in *ch'aekkŏri* of the still life type featuring gnomon. A wine vessel (*jue*) used in the ancestor worship ceremony and in Confucian temples is found only in the gnomon style of *ch'aekkŏri* (with one known exception—a *jue* is also seen in the tiger skin theatrical screen). The peacock feather in a vase symbolizes a successful Confucian civil service examination passer.

Some screens also reflect Daoist thought. For example, the Brooklyn Museum screen, the private collector's gnomon screen, and the former Gruber *ch'aekkŏri* all contain Daoist books among their subject matter. The star chart depicted in the "Alarm Clock" *ch'aekkŏri* is significant in a Daoist context because it is home to many gods in their pantheon. A fan, the Daoist immortal Zhongli Quan's attribute, appears twice in the Leeum "Door" *ch'aekkŏri* along with two tiny blue-and-green mountains of immortality. A Daoist text is seen under spectacles in the Ahn gnomon style *ch'aekkŏri*.

Graphic references to Buddhism are few. The title *Myŏngsim pogam* (Treasured Mirror of the Clear Heart), visible in the Ahn *ch'aekkŏri*, refers to a book of morals and life values, generally from a Buddhist perspective, but in later times sections were added that also reflected Confucian themes. Many slipcases are decorated with the seven treasures pattern, which is Buddhist in origin, but by the nineteenth century probably carried only an auspicious connotation.

On the whole, Wagner and I have used the clues contained in the subject matter of the paintings themselves to attribute authorship to particular screens. Other sources that substantiate our attributions are the *chungin* and *yangban* genealogies, and the examination rosters, but only courtesy names, no pen names, are listed. In some cases, Wagner was able to match the seals with names listed in genealogical records and examination rosters. The tendency of artists to switch names during their careers complicated his research.

Wagner identified twenty-two court painters within six generations of the apex figure from whom Yi Hyŏng-nok descends, and he found additional court painters among the immediate marriage connections of Yi Hyŏng-nok's family. Eight members of his family also had the distinction of being painters-in-waiting—an astonishing lineage and a veritable talent bank. Furthermore, four members of his family were active concurrently with Yi Hyŏng-nok as painters-in-waiting at Ch'angdŏk Palace. In fact, there may well have been a tradition of the trompe l'oeil and isolated types of *ch'aekkŏri* painting in Yi Hyŏng-nok's family. However, I have none of the other family members' *ch'aekkŏri* in this study as far as I know. Because similar heavy concentrations of professional painters can be found in a number of other *chungin* lineages, it seems safe to assume that in these *chungin* families the painting profession was learned at the father's knee or within the walls of a family workshop. Multiple versions of more than one style of *ch'aekkŏri* screen also support the workshop theory. For example, there are many Chŏnnam style screens: three by Sŏktang;

two in the Baroque style; two by Hyech'un/Ch'unhye; two with a European palette; five gnomon; and three (unsigned) in the style of Yi Hyŏng-nok or his followers or by someone else in the family workshop. An anthropological approach might be a way to further investigate the kinship and family workshop relationship. It had always struck me that book cover patterns might reflect the intermarriage patterns of the *chungin* painters. For example, Yi Hyŏng-nok used the same patterns in all his screens, yet his follower and kinsman Kang Tal-su added some slightly different ones, possibly introducing ones from another side of his family and from another workshop. The artist of the Leeum "Door" *ch'aekkŏri* used totally different patterns, (except for the seven treasures pattern) to decorate his book covers and paper rolls.

It is intriguing that another main line of *ch'aekkŏri* painting might have been founded by Sin Han-p'yŏng. Both he and Yi Hyŏng-nok were expelled by King Chŏngjo for not having selected *ch'aekkŏri* as an optional painting subject for an exercise ordered by the King. Perhaps eventually future scholarship will uncover Sin Han-p'yŏng's genealogy, facilitating the identification of *ch'aekkŏri* made by some of his descendants. There is also the possibility that Kim Hong-do and his heirs might have formed another line of *ch'aekkŏri* painters: again, an investigation for future scholarship. There is, in storage at the National Museum of Korea in Seoul, an eight-panel court style trompe l'oeil *ch'aekkŏri* (acc. no. 5644) with two indecipherable seals, one in gold, and one with two characters, probably a pen name. This screen should be re-examined. Perhaps forensic photographic methods could be used to read the Chinese characters on the seals. The whole *ch'aekkŏri* looks brown and dark. Shading on the interior of the bookshelves changes abruptly from russet to black on this screen. The different vessel styles depicted in no. 5644 make it seem unlikely that it was painted by Yi Hyŏng-nok's father or grandfather, but that is not impossible and should be investigated. This might possibly lead to the discovery of an eighteenth-century trompe l'oeil court style *ch'aekkŏri* by Sin Han-p'yŏng, or even by Kim Hong-do. I hope that more *chungin* genealogies will be published. These documents might provide the information necessary to locate surnames and given names for the artists whom I can now identify only by their pen names: Sosŏk/Susŏk, Hyech'un/Ch'unhye, Sŏkch'ŏn, and Sŏktang. The genealogies might also help clarify the issues of family workshops, establish chronologies, and date the paintings.

It has been demonstrated that the court patronized artists who painted both the isolated and trompe l'oeil types, but not to my knowledge the still life type. Although the majority of *ch'aekkŏri* painters were *chungin*, there were exceptions as in the case of the *yangban* Yi To-yŏng of the Japanese colonial period, and some itinerant folk painters.

Changes in *ch'aekkŏri* mirrored changes in society. At the end of the eighteenth century, Seoul was the cultural center of Korea with the government and commerce at its hub. A great urbanization movement was in progress. Now there were rich *chungin*, the hereditary class of technical specialists, who had amassed fortunes through private trading activities, and some commoners who had become rich merchants. With money in new hands, *ch'aekkŏri's* patronage expanded, and wealthy merchants and prosperous *chungin* had the means to commission *ch'aekkŏri* paint-

ings. The pigments, silk, hemp and paper were all expensive. Furthermore, despite their newfound wealth, many of the objects depicted in these screens were quite beyond the reach of most people, so *ch'aekkŏri* may have represented a visual "wish list" for their owners.

Another puzzle that remains to be solved is the original sequencing of the panels of numerous screens. There are many extant Chŏnnam style *ch'aekkŏri*, yet none known to me to be in the original mounting. Indeed, it would be lucky to discover a Chŏnnam style *ch'aekkŏri* still in the original mounting. Lacking that, I suspect that an examination of the arrangement of seasonal flowers and plants within the overall composition might aid in reconstructing the intended order of the panels. However, this approach requires research into what flowers and plants were popular at different seasons and periods and when they were introduced to Korea. Solving these problems might help in the dating of the screens, too.

Although this study found no two *ch'aekkŏri* that are identical—on the contrary, there are infinite varieties—some resemble one another so closely as to make one suspect that there might have been a basic pattern for a given style. The recent discovery of eight master patterns in the Robert E. Mattielli collection, used to produce one style of still life *ch'aekkŏri*, now strongly bolsters the notion that some *ch'aekkŏri* artists used patterns. I have yet to find a finished *ch'aekkŏri* screen that matches exactly the patterns in Mattielli's possession. Locating such a screen would be a valuable goal for future researchers.

Despite my having answered several questions about *ch'aekkŏri*, others remain. Why did artists of some screens include their names, or their pen names (or possibly a courtesy name as might be the case with Chang Wŏn-sam) on seals in the subject matter? Why are there other versions of Yi Hyŏng-nok's trompe l'oeil type *ch'aekkŏri* and one of Hyech'un/Ch'unhye's without seals? There are multiple versions of different styles of the three *ch'aekkŏri* types, but no two are exactly identical. Some are sealed with surnames and given names, some with pen names, and many not sealed at all. The criterion for signing a *ch'aekkŏri*, or not, by inclusion of a seal as part of the subject matter remains a subject for further investigation.

Wagner and I have shown that *ch'aekkŏri* paintings were also commissioned to celebrate special occasions: birthdays (including Kim Ki-hyŏn's seventieth birthday), *kapcha* years, and accession to the throne. The genre developed concurrently under the patronage of King Chŏngjo with the commercialization of society. The popularity of *ch'aekkŏri* continues, and reproductions of nineteenth- and early twentieth-century screens, clearly copies of Chosŏn period ones, are being produced to this day.

In presenting this pioneer work, Wagner and I have used a jigsaw puzzle metaphor. The facts now at hand have been placed as small pieces in a larger framework with many vacant spaces. Wagner and I had both hoped that by revealing our discoveries in this manner it would inspire others to help fill out the puzzle, thereby further advancing scholarship in this field.

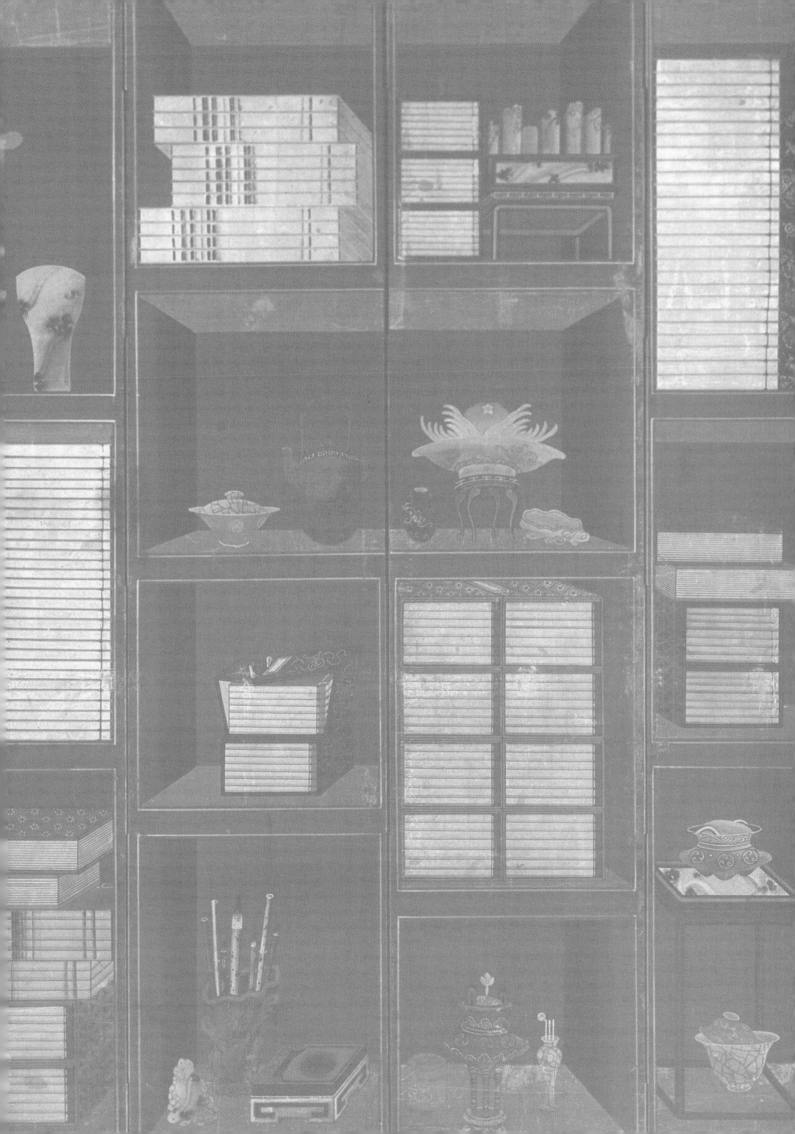

Book Titles and Related Inscriptions in *Ch'aekkŏri* Screens

* The book titles are given primarily in Korean pronunciations, but when they are originally Chinese, Chinese pronunciations are provided in the parentheses. For the descriptions of individual book titles, see Appendix II.

1. Eight-Panel Screen formerly in the Ahn Paek Sun Collection (Figure 25.4)(According to the list written on a book box in panel 8)

LEFT SIDE

Book box 1 *Samgukchi (Sanguozhi)* 三國志
Book box 2 *Yemunji (Yiwenzhi)* 藝文志
Book box 3 *T'onggam (Tongjian)* 通鑑
Book box 4 *Komun chinjin (Guwen zhenzhen)* 古文眞珍
Book box 5 *Ch'unch'u Chwajŏn (Chunqiu Zuozhuan)* 春秋左傳
Book box 6 *Myŏngsim chin'gam* 明心珍鑑

RIGHT SIDE

Book box 1 *Komun kigwan (Guwen qiguan)* 古文奇觀
Book box 2 *Pongsin wanŭi (Fengshen wanyi)* 封神完義
Book box 3 *Ch'ŏnmunji (Tianwenzhi)* 天文誌
Book box 4 *Chiji (Dizhi)* 地誌
Book box 5 *Tongguk yakki* 東國略記
Book box 6 *Chanmun* 棧文

2. Six-Panel Screen in the Brooklyn Museum (Figures 15.1–15.4)

Panel 1 *Igan (Yijian)* 易簡
Panel 2 *Ch'uch'ŏp* 秋帖
　　　　Mich'ŏp 眉帖
　　　　Chŏngam 靜庵
　　　　Kaŏ (Jiayu) 家語
　　　　Ich'ŏn sŏnsaeng hwach'uk 伊川先生畵軸
Panel 3 *Yŏl (Lie)* 列, abbreviation for *Yŏlcha (Liezi)* 列子
　　　　Sŏsang (Xixiang) 西廂, abbreviation for *Sŏsanggi (Xixiangji)* 西廂記
　　　　Wang Sŏkkok songjukch'ŏp kŭp naesŏan 王石谷松竹帖及來書案
　　　　* Ledyard reads "Osŏkkong 五石公" instead of "Wang Sŏkkok."
Panel 4 *Sŏ (Shu)* 書, an abbreviation for *Sŏgyŏng (Shujing)* 書經
　　　　Si (Shi) 詩, an abbreviation for *Sigyŏng (Shijing)* 詩經
Panel 5 *Chungyong (Zhongyong)* 中庸
　　　　Yonghae 庸解
　　　　Hongmun 或問
　　　　Yŏnŭi 演義

Taehak (Daxue) 大學
Hongmun 或問
Yŏnŭi 演義
Maengja (Mengzi) 孟子
Maengyŏn 孟演
Nonŏ (Lunyu) 論語
Nonyŏn 論演
Ch'unch'u (Chunqiu) 春秋
Panel 6 *Chŏnmun (Tianwen)* 天文
Samnyak 三略
Churimnyŏk 周林易? (hardly legible)

3. **Gnomon Eight-Panel Screen in a Private Collection in the U.S. (Figures 25.1, 25.2) (In the order presented in the list written on a book box in Panel 8)**

T'onggam (Tongjian) 通鑑
Komun (Guwen) 古文
Taehak (Daxue) 大學
Nonŏ (Lunyu) 論語
Chuyŏk (Zhouyi) 周易
Tuyul 杜律
Haeun 海雲
Okp'yŏn (Yupian) 玉篇
Saryak 史略
Sohak (Xiaoxue) 小學
Chungyong (Zhongyong) 中庸
Maengja (Mengzi) 孟子
Sŏjŏn (Shuzhuan) 書傳
Changja (Zhuangzi) 莊子
Yŏmnak (Lianluo) 廉洛？

4. **Eight-Panel Screen formerly in the Gruber Collection (Figure 28.1)**

Panel 1 *Pŏbŏn (Fayan)* 法言
Chuyŏk (Zhouyi) 周易
Nonŏ (Lunyu) 論語
Panel 2 *Ch'unch'u Chwajŏn (Chunqiu Zuozhuan)* 春秋左傳 ？
Panel 5 *T'aehyŏn'gyŏng (Taixuanjing)* 太玄經
Panel 6 *Chungyong (Zhongyong)* 中庸
Sŏngni 性理
Hwanggŭk sesŏ (Huangji shishu) 皇極世書
Taehak (Daxue) 大學
Kŭnsarok (Jinsilu) 近思錄
Simgyŏng (Xinjing) 心經
Panel 8 *Saryak* 史略
Hongsa 鴻史
Chŏn'gi taeyo 天機大要
Chuja taejŏn (Zhuzi daquan) 朱子大全
Immun 入門

5. Eight-Panel Screen in a Private Collection in Seoul

Panel 1　Line from a poem
Panel 2　*Sohak (Xiaoxue)* 小學
　　　　Yŏktae (Lidai) 歷代
　　　　Ch'ungnyŏlp'yŏn 忠烈篇
Panel 3　*Samgukchi (Sanguozhi)* 三國志
　　　　Sangnye 喪禮
　　　　Tongŭi pogam 東醫寶鑑
Panel 4　*Komunjip* 古文集
　　　　Hanhwŏn ch'arok 寒暄箚錄
　　　　Sijŏn (Shizhuan) 詩傳
　　　　Mubiji (Wubeizhi) 武備誌
Panel 5　*Chuja karye (Zhuzi jiali)* 朱子家禮
　　　　Masa (Mashi) 馬史
　　　　Kaŏ 家語
Panel 6　*Sangsŏ (Shangshu)* 尙書
Panel 7　*Maengja (Mengzi)* 孟子
　　　　Nonŏ (Lunyu) 論語
　　　　Taehak (Daxue) 大學
Panel 8　*Yegi (Liji)* 禮記
　　　　Chwajŏn (Zuozhuan) 左傳
　　　　Ch'unyayŏn toriwŏn sŏ (Chunyeyan taoliyuan xu) 春夜宴挑李園序

6. Eight-Panel Screen formerly in the Minn Pyong-Yoo collection (Figure 5.1)

Panel 1　*Ch'o-Hanjŏn kandok* 楚漢傳簡牘
　　　　Tongmong sŏnsŭp Yuhap 童蒙先習類合
　　　　Kuksagi 國事記
　　　　Tuyul 杜律
Panel 2　*P'alchin torok* 八陣圖錄
　　　　Chidosŏ 地圖書
　　　　Kangsan'gam 江山鑑
　　　　Sansurok 山水錄
　　　　Ŭigam chŏnjil 醫鑑全秩
Panel 3　*Pyŏngpŏp* 兵法
　　　　Chirigyŏng 地理經
　　　　Chŏnmundo (Tianwentu or Tianwenhua) 天文圖(畵)
　　　　Taejŏn t'ongp'yŏn 大典通編
　　　　Yukto Samnyak (Liutao Sanliie) 六韜三略
Panel 4　*Sangnye* 喪禮
　　　　Samun 三韻
　　　　Agŭk 兒戟, possibly meant *Ahŭi* 兒戲 (Ledyard)
　　　　Wŏnhyŏn 原賢
　　　　Paeksumun 白首文
　　　　Kosasŏng 古事成
　　　　*Ch'unch'u (Chunqiu, *5, 13)* 春秋
　　　　Komunbo 古文寶
　　　　*Yegi (Liji, *5, 13)* 禮記
Panel 5　*Chungyong (Zhongyong, *4)* 中庸
　　　　*Chuyŏk (Zhouyi, *5, 13)* 周易
　　　　*Maengja (Mengzi, *4, 13J)* 孟子
　　　　*Sijŏn (Shizhuan, *5, 13)* 詩傳

> *Sohak (Xiaoxue)* 小學
> *Taehak (Daxue, *4)* 大學
Panel 6 *Chusŏ* 朱書
> *Nonŏ (Lunyu, *4, 13)* 論語
> *Samun yuch'wi (Shiwen leiju)* 事文類聚
> *Sŏjŏn (Shuzhuan, *5, 13)* 書傳
Panel 7 *Hansŏ (Hanshu)* 漢書
> *Chŏndŭng sinhwa (Qiandeng xinhua)* 剪燈新話
> *T'onggam (Tongjian)* 通鑑
> *Yegi yojip* 禮記要集
Panel 8 *Chuja taejŏn (Zhuzi daquan)* 朱子大全
> *Hwiŏ* 彙語
> *Myŏnghyŏp (Mingjie)* 蓂莢
> *Tongnae (Chwassi) Pagŭi (Donglai Zuoshi boyi)* 東萊左氏博議
> *Ŭmyang sŏ (Yinyang shu)* 陰陽書

7. Two-Panel Screen in the Sneider collection (Figure 20.1)

Right panel *Chŏnun okp'yŏn* 全韻玉篇
> *Suhoji (Shuihuzhi [sic])* 水滸誌
> *Sŏngt'an sŏ (Shengtan shu)* 聖嘆書
Left panel *Nonŏ (Lunyu)* 論語
> *Sŏsanggi (Xixiangji)* 西廂記

8. Eight-Panel Screen in the Leeum, Samsung Museum of Art (Figure 18.1)

Panel 5 *Si (Shi)* 詩
> *Tuyul* 杜律
Panel 6 No title, but a book opened under the spectacles

Appendix II

Titles of Books on Shelves and Tables:
Introductory Notes

By Gari Ledyard

Of the many Korean *ch'aekkŏri* screens showing shelves or stacks of books and other objects, relatively few indicate the actual titles of the books. Seven such screens have been examined in this study, and individual lists for each screen have been given in the appropriate place. The following is a composite listing of all the ninety-five titles reported from those seven screens, alphabetically arranged. By my reckoning, the titles break down to forty-four Chinese, twenty-nine Korean, sixteen mostly incomplete or ambiguous titles that could be either Chinese or Korean, and six for which it was impossible to make any identification.

Headings for all entries are romanized in Korean regardless of whether the titles are Korean or Chinese. This was the only way to proceed given that the titles all come from Korean screens in the context of a Korean genre, and that some titles cannot be distinguished between Chinese or Korean or identified at all. However, for titles that are definitely Chinese or reasonably suspected to be, the Chinese Romanization (Pinyin) is given in parentheses. The Korean romanization is standard McCune-Reischauer, with the added refinement that internal apostrophes are occasionally used to clarify ambiguous syllabification. In alphabetization, all words with aspirated initial consonants come after words with unaspirated initial consonants. Thus *Tuyul* comes before *T'aehyŏn'gyŏng*. That done, all words in which the first vowel has a diacritic will come after first vowels without a diacritic. The first rule takes priority over the second. This is intended to aid Korean readers unfamiliar with romanization.

In the case of the Confucian classics, an * plus the numbers 4, 5, and/or 13 mark whether the indicated title is one of the Four Books, the Five Classics, and/or the Thirteen Classics. At the end of all entries, references are provided to the screens, and where known to the panels, on which they occur. Thus, "2/Brooklyn-5" indicates the Brooklyn screen, panel 5 listed in Appendix I, no. 2. An example that requires an exceptional treatment is the "1/Ahn" screen, in which all the names of books are written on a book box in panel 8 classified into the left and right groups. Thus, in this case, "1/Ahn-L3", for example, indicates the name of the books written as being in book box 3 on the left side.

A persistent problem in identifying titles and organizing them alphabetically is that many well known works, and even some that are not well known at all, are given abbreviated titles. Koreans traditionally laid shelved books on their side, with abbreviated forms of the title, usually one or two characters, written on the edges of the pages. Although many of these were conventional and easily recognized by anybody, some were idiosyncratic and not transparent to the stranger. A book titled, for example, *Yŏktae ch'unghyorok* (Records of Loyalty and Filial Piety Throughout History) could be abbreviated simply as *yŏktae*, which was enough for the owner. The trouble is that many book titles begin with the word *Yŏktae*, "throughout history," and viewers seeing these titles on a screen a century or so later might have no idea as to which title is intended. This practice has caused many problems of identification, and not all of them have been satisfactorily solved.

In the same way and understandably, the characters in many of these informal tags were written in idiosyncratically abbreviated forms, and sometimes Korean abbreviations were different from Chinese ones. Two modern-day analysts might disagree with one another as to the full character intended. In all such cases I have made my own judgments and indicated what I have done.

In the case of unusual or unrecognized titles, I have sought them out in comprehensive Korean bibliographies. Many times I came up dry, and could make no positive identification. However, I was often successful. Rather than burden the lists with precise references, I decided to simply give here the titles of the three works that I consulted. When I refer generally to "bibliographies," the reference will be to one or more of the following: 1) *Kyujanggak tosŏ Han'gukpon ch'ongmongnok* 奎章閣圖書韓國篇總目錄, (Comprehensive Catalogue of Korean Editions in the Kyujanggak Collection [at Seoul National University]), Seoul National University Press, Seoul, 1965; 2) *Changsŏgak tosŏ Han'gukp'an ch'ongmongnok* 藏書閣圖書韓國版總目錄 (Comprehensive Catalogue of Korean Editions in the Changsŏgak Collection [at the Academy of Korean Studies]), Han'guk chŏngsin munhwa yŏn'guwŏn, Seoul, 1972, reprint 1984; and 3) *Han'guk kosŏ ch'onghap mongnok* 韓國古書綜合目錄 (Comprehensive Catalogue of Old Books of Korea), National Assembly Library of the Republic of Korea, Seoul, 1968. Of these, the last was of the most use in tracking obscure items, since it canvassed many different libraries and private collections in Korea and other countries.

<p style="text-align:center">* * * * *</p>

* The titles or pronunciations in Chinese are presented in parentheses. The references for the *ch'aekkŏri* screens in which these book titles appear are given in the following abbreviations:

> 1/Ahn: the Ahn Paek Sun eight-panel screen
> (no. 1 in Appendix I; Figure 25.4 in this book)
> 2/Brooklyn: the Brooklyn six-panel screen
> (no. 2 in Appendix I; Figures 15.1–15.4)
> 3/PrivateUS: Eight-panel screen in a private collection in the U.S.
> (no. 3 in Appendix I; Figure 25.1, 25.2)
> 4/Gruber: the Gruber eight-panel screen (no. 4 in Appendix I; Figure 28.1)
> 5/PrivateSeoul: Eight-panel screen in a private collection in Seoul
> (no. 5 in Appendix I)
> 6/Minn: the Minn Pyong-Yoo eight-panel screen
> (no. 6 in Appendix I; Figure 5.1)
> 7/Sneider: Two-panel screen in the Sneider collection
> (no. 7 in Appendix I; Figure 20.1)
> 8/Leeum: Eight-panel screen in the Leeum
> (no. 8 in Appendix I; Figure 18.1)

Ahŭi 兒戲, Children's Games. I have emended the character *kŭk* 戟, meaning "a two pointed lance," or "to point" (making no sense whatever) to *hŭi* 戲, "games." 6/Minn-4.

Changja (*Zhuangzi*) 莊子, 10 *kwŏn* 卷 (*juan*). Zhuangzi, the major Daoist classic after the *Laozi*. 3/PrivateUS-8.

Chanmun 栈文, 70 *kwŏn*, Light Writings? Uncertain, but very much doubt that it has anything to do with bamboo. Taken phonetically, *chanmun* might mean "small writings"—perhaps lesser literature, light writings, perhaps a humbling reference to the writings of the patron of the painting. But seventy *kwŏn* of them? A puzzle. The placing of this entry may also seem baffling. There seem to be six items in both the left and the right sides (*pyŏn* 边), but the right side has only five items, while "No. 6" is placed outside the sequence. However, it obviously belongs to the group on the right side, most likely as the remaining lesser literature. 1/Ahn-R6.

Chidosŏ 地圖書, Book of Maps. Generally, map albums were very popular in the eighteenth and nineteenth centuries. Typically, they would contain maps of the world, maps of China, Japan, and the Ryūkyūs, and maps of Korea's eight provinces, often with written details on local administration. However, the title *Chidosŏ* is very uncommon. 6/Minn-2.

Chiji (*Dizhi*) 地誌, 16 *kwŏn*, Monograph(s) on Geography. This is either a generic title, or perhaps one or more works on administrative geography copied from more general works. 1/Ahn-R4.

Chirigyŏng 地理經 , "Geographical Classic," not seen in bibliographies. However, there are entries for a *Chiri chŏnggyŏng* 地理正經, Correct Geographical Classic, date and author unknown. 6/Minn-3.

Chŏndŭng sinhwa (*Qiandeng xinhua*) 剪燈新話, a Ming collection of short tales, edited by Qu You 瞿佑 early in the fifteenth century. Influenced by it, Kim Si-sŭp 金時習 (1435-1493) wrote four stories of his own in Chinese in a collection called *Kŭmo sinhwa*, an early Korean example of fictional writing. 6/Minn-7.

Chŏnun okp'yŏn 全韻玉篇, *Okp'yŏn* to Accompany the "Complete Rimes." The word *okp'yŏn* is the Sino-Korean derivative from *Yupian*, a dictionary arranged by graphic classifiers (see under *Okp'yŏn*, below). In the 1790s, King Chŏngjo ordered the librarians of his Kyujanggak library to compile a riming dictionary with an accompanying *okp'yŏn*, which was apparently a revision and re-editing of an earlier work by Hong Kye-hŭi 洪啓禧 (see under *Un'go*, below). The result was published in 1796 as *Ŏjŏng Kyujang chŏnun* 御定奎章全韻, Royally Sanctioned Complete Kyujang Rimes. The book indicated in this entry was originally a graphically organized guide to the riming dictionary, but it was frequently republished as a separate work throughout the nineteenth century. 7/Sneider-1.

Chŏngam 靜庵, the pen name of Cho Kwang-jo 趙光祖 (1482–1519), purged reformer and martyr, hero of the self-withdrawn and out-of-power scholars (*sarim* 士林) of the sixteenth century. Since he figures in a panel devoted to calligraphic samples of famous people, some album should probably be indicated, but none is in the data given me. 2/Brooklyn-2.

Chuja karye (*Zhuzi jiali*) 朱子家禮, The Household Rituals of the Philosopher Zhu, customarily attributed to Zhu Xi 朱熹 (1130–1200). 5/PrivateSeoul-5.

Chuja taejŏn (*Zhuzi daquan*) 朱子大全, Complete Works of Zhu Xi. This exact title cannot be found in Chinese bibliographies available to me, but it is closely similar to *Zhuzi quanshu* 朱子全書, 66 *juan*, which suggests a similar coverage. In Korea, the title is frequently seen, in versions all the way from four *ch'aek* 冊 (physical volumes) to 95 *ch'aek*. 6/Minn-8, 4/Gruber-8.

Ch'uch'ŏp 秋帖, Ch'usa Album. Ch'usa was the pen name of Kim Chŏng-hŭi (1786–1856), famous epigrapher and calligrapher. 2/Brooklyn-2.

Chusŏ 朱書, Zhu's Letters. Abbreviation for *Chujasŏ chŏryo* 朱子書簡要, Concise Collection of the Letters of Zhu Xi, by Yi Hwang 李滉 (1501–1570). No such compilation was ever produced in China, according to the late Neo-Confucian scholar Wing-Tsit Chan. 6/Minn-6.

Chungyong (*Zhongyong*, *4) 中庸, 1 *kwŏn*, The Doctrine of the Mean. 3/PrivateUS-8, 6/Minn-5, 4/Gruber-6, 2/Brooklyn-5.

Chuyŏk (*Zhouyi*, *5, 13) 周易, 3 *kwŏn*, The Book of Changes or the Zhou Changes. The structure of this work is so complex that a standard number of *kwŏn* would be hard to arrive at. But all things considered, 3 *kwŏn* (as in 3/PrivateUS) suggests an abridged text. 3/PrivateUS-8, 6/Minn-5, 4/Gruber-1.

Chwajŏn (*Zuozhuan*,*5, 13) 左傳. Abbreviation of *Ch'unch'u Chwassijŏn* (*Chunqiu Zuoshizhuan*) 春秋左氏傳, Zuo's commentary to the Spring and Autumn Annals. See *Ch'unch'u Chwajŏn*. 5/PrivateSeoul-8.

Ch'o-Hanjŏn kandok 楚漢傳簡牘, Letters from the *Ch'o-Hanjŏn* (?). This was a popular Korean novel, based on the famous struggle between the Ch'u and Han Regions at the beginning of the Han dynasty. There were multiple editions of this work in the early part of the twentieth century; see W. E. Skillend, *Kodae sosŏl* (London, 1968), pp. 218–219. Perhaps it presented much of its story in letters? 6/Minn-1.

Ch'ŏn'gi taeyo 天機大要, The Great Essence of Heaven's Moment. Apparently a work on the importance of Heaven in human fate. There is a book of this title authored by Im So-ju

林紹周, no date. 4/Gruber-8.

Ch'ŏnmun (*Tianwen*) 天文, 5 *kwŏn*. See *Ch'ŏnmunji* or *Ch'ŏnmundo/Ch'ŏnnumhwa* below. 2/Brooklyn-6.

Ch'ŏnmundo or Ch'ŏnnumhwa (*Tianwentu* or *Tianwenhua*) 天文圖(畵). Available data as to the exact title of this entry are unclear. The first would be Astronomical Charts, the second Astronomical Drawings or Painting of the Heavens. 6/Minn-3.

Ch'ŏnmunji (*Tianwenzhi*) 天文誌, 12 *kwŏn*, Monograph(s) on Astronomy. Same comments as on *Chiji*, above. 1/Ahn-R3.

Ch'unch'u (*Chunqiu*, *5, 13) 春秋, Spring and Autumn Annals. See *Ch'unch'u Chwajŏn*, below. 2/Brooklyn-5, 6/Minn-4.

Ch'unch'u Chwajŏn (*Chunqiu Zuozhuan*, *5, 13) 春秋左傳, 10 *kwŏn*, Zuo's commentary to *the Spring and Autumn Annals*. Historically the Annals had three commentaries, of which Zuo Qiuming's 左丘明 is the most important. The Annals, believed to have been compiled by Confucius, never appear without one of the commentaries attached. See also *Chwajŏn*. 1/Ahn-L5, 4/Gruber- 2.

Ch'ungnyŏlp'yŏn 忠烈篇, Compilation of (the Lives and Deeds) of the Loyal and Faithful. The referent is uncertain. There are a number of Korean works entitled *Ch'ungnyŏllok* 忠烈錄, Records of the Loyal and Faithful. 5/PrivateSeoul-2.

Ch'unyayŏn toriwŏn sŏ (*Chunyeyan t'aoliyuan xu*) 春夜宴桃李園序, Preface to (the poem) Banqueting on a Spring Evening in the Peach and Plum Garden, by Li Bo (Bai) 李白, the eighth century Tang poet. The opening lines of this preface (not itself part of the poem) are shown through the spectacles lying over the pages of a book open on the table. 5/PrivateSeoul-8.

Haeun (*Haiyun*) 海運, 2 *kwŏn*. Referent uncertain. There were minor Ming and Qing poets as well as one Korean writer, Hong Kye-ha 洪啓夏 (1714–1784) who used this pen name. 3/PrivateUS-7.

Hanhwŏn ch'arok 寒暄箚錄, Detailed Listing of Conventional Expressions. A classified guide to conventional terms, epistolary style and literary formats used in public and private Korean letters and other communications. Author and date of compilation unknown. 5/PrivateSeoul-4.

Hansŏ (*Hanshu*) 漢書, History of Han, the second of the dynastic histories, c. 100 CE. 6/Minn-7.

Hongsa 鴻史, Vast History, by Chi Kwang-han 池光翰 (1659–1756). This book comprises dynastic history of China up to Ming and biographies. 4/Gruber-8.

Hwanggŭkkyŏng sesŏ (*Huangjijing shishu*) 皇極經世書, The Regulation of the World by the Illustrious Ultimate. A work of cosmic chronology by Shao Yong 紹雍 (1011–1077), a scholar of the early Neo-Confucian School. The Korean form in the entry lacks the important element *kyŏng* (*jing*), which should be there and which is supplied in the Chinese form. 4/Gruber-6.

Hwiŏ 彙語, Collected Expressions, evidently vocabularies of some sort. A book of this title by Kim Chin 金搢 (b. 1585) is found in bibliographies. 6/Minn-8.

Ich'ŏn sŏnsaeng hwach'uk (*Yichuan xiansheng huazhu*) 伊川先生畵軸, Painted Scroll of Ich'ŏn (Cheng Yi 程頤, Chinese Neo-Confucian philosopher, 1033–1107). 2/Brooklyn-2.

Igan... (*Yijian*) 易簡, Easy and Simple... Not by itself likely to be a book title. Some have read the entry word as *Yŏkkan*, concluding that this is an alternate name for the *Yijing* or Book of Changes. However, this character has two readings, *i*, "easy," and *yŏk*, "change," and in this compound, the former is the correct choice. Even though the phrase *igan* appears in a famous passage in the *Yijing*, no authority can be found for making it a by-name of that classic. On the other hand, there is a hand-copied text in a Korean bibliography of an item titled *Igan yangbang* 易簡良方, Good Recipes, Easy and Simple, no author, no date, apparently a short herbal. Unfortunately, it is in only one *ch'aek*, whereas the work depicted on the screen is a sizeable one, consisting of 12 *ch'aek*. It happens that Zhu Xi's edition of the Book of Changes, *Zhouyu benyi* 周易本義, and several other works related to it, are in 12 *kwŏn*. The case for *Igan* as a name for the *Yijing* is

circumstantial and weak, but still open. 2/Brooklyn-1.

Immun 入門, Introduction to... Book titles with this element usually have some name or phrase before it as an object for the introduction. 4/Gruber-8.

Kangsan'gam 江山鑑, The Mirror of Rivers and Mountains. "*Kangsan*" is the core part of a widely popular metaphor for Korea itself, seen as "three thousand li of rivers and mountains" (*samch'ŏlli kangsan* 三千里江山). Although this work does not appear in bibliographies available to me, it has the look of a likely title. 6/Minn-2.

Kaŏ (*Jiayu*) 家語. Abbreviation of *Kongja kaŏ* (*Kongzi jiayu*) 孔子家語, Household Sayings of Confucius, a collection of utterances and anecdotes of Confucius recorded in a wide variety of ancient books, compiled supposedly in Han times but known only from a Tang version; not to be confused with the *Nonŏ* (*Lunyu*, *4, 13), Analects of Confucius. 5/PrivateSeoul-5, 2/Brooklyn-2.

Komun (*Guwen*) 古文, 7 *kwŏn*, Ancient Literature. Either this refers to ancient writings in general, or to the *Guwen* literary style made famous in Tang and Song times. In either case, in itself it would have to be an incomplete title on the order of *Komunbo, Komunjip, Komun chinbo, Komun kigwan,* all below, or some other such compounding. 3/PrivateUS-8.

Komun chinbo (*Guwen zhenbao*) 古文眞寶, 10 *kwŏn*, Genuine Treasures of Ancient Literature. The second phrase of this title is given as *chinjin* (*zhenzhen*) 眞珍, of which the second syllable is a common synonym of *po/bo* (*bao*) 寶, "treasure." It could be that the latter character was tabooed in the family of the patron, and in such cases *chin* (*zhen*) 珍 could be a plausible substitute. The *Guwen zhenbao*, 20 *juan*, a very important anthology, is attributed to the great Song poet Huang Jian 黃堅. 1/Ahn-L4.

Komun kigwan (*Guwen qiguan*) 古文奇觀, 5 *kwŏn*, Unusual Selection of Ancient Literature. Not found in any Korean or Chinese bibliography available to me. 1/Ahn-R1.

Komunbo 古文寶, probably an abbreviation for *Komun chinbo*, q.v. 6/Minn-4.

Komunjip 古文集. Referent uncertain. *Munjip* (C. *wenji*) is a common term for the literary collection of an individual, often compiled by descendants or disciples after his death; in this sense the intended meaning here could be, "(various) old literary collections." On the other hand, *komun* (*guwen*) on a general sense means "ancient literature", but can also refer to a literary prose style that flourished in the Tang and Song periods; in that sense the meaning here could be, an "anthology of *guwen* writings," probably selected from the writings of the canonically sanctioned group of eight writers from the Tang and Song periods. See *Komun*, above. 5/PrivateSeoul-4.

Kosasŏng 古事成, Compendium of Precedents (?). Not found in bibliographies available to me, but entries for *Kosa sŏngŏ* 古事成語, Precedents and Fixed Phrases, and *Kosa sŏngŏ ko* 古事成語考, Investigation of Precedents and Fixed Phrases, are found. 6/Minn-4.

Kuksagi 國事記. Referent uncertain. If this title was meant to represent the *Samguk sagi* 三國史記, History of the (Korean) Three Kingdoms, then it is an unheard-of abbreviation and a pointless one besides (why abbreviate out the simple three-stroke character for "three"?). Other than that, however, it is hard to imagine what book could be meant. 6/Minn-1.

Kŭnsarok (*Jinsilu*) 近思錄, Reflections on Things at Hand, by Zhu Xi and Lü Zuqian 呂祖謙 (1137–1181). A basic anthology of core Neo-Confucian writings. 4/Gruber-6.

Maengja (*Mengzi*, *4, 13) 孟子, Discourses of Mencius. 3/PrivateUS-8, 5/PrivateSeoul-7, 6/Minn- 5, 2/Brooklyn-5.

Masa (*Mashi*) 馬史, Abbreviation of Sima 司馬 and *Sagi* 史記, indicating the father of Chinese historians, Sima Qian 司馬遷, and his great work *Shiji*, Records of the Historian—the first of the dynastic histories, finished c. 90 BCE). 5/PrivateSeoul-5.

Mich'ŏp 眉帖, Misu Album. Misu was the pen name of Hŏ Mok 許穆 (1595-1682). Long a retired scholar and an expert on ritual, he emerged in the 1660s as a leader of the Namin 南人 (Southerners) faction and one of the chief debaters in the important ritual disputes of that era. 2/Brooklyn-2.

Mubiji (*Wubeizhi*) 武備誌, Monograph on Military Preparedness, compiled by Mao Yuanyi

茅元儀 (1594?–1641), preface dated 1621, presented to Ming Emperor Chongzhen in1628. A vast, illustrated compendium of classified discourses on military history and strategy. 5/PrivateSeoul-4.

Myŏnghyŏp (*Mingjie*) 蓂荚, The Mingjie Plant. A marvelous plant said to have grown in the palace of the ancient sage King Yao. From the first day of the month to the fifteenth it produced a new pod every day, and from the sixteenth to the last day of the month it lost one every day. It is said to have suggested the 30-day calendrical unit. On that ground it may have something to do with calendrical studies. One Korean bibliography lists a work of this title in 3 *ch'aek*, hand copied text, no author, no date. 6/Minn-8.

Myŏngsim pogam 明心寶鑑, 10 *kwŏn*, Treasured Mirror of the Clear Heart. It is attributed to Ch'u Chŏk 秋適, who served in the court of King Ch'ungnyŏl 忠烈王(r. 1274–1308) of the Koryŏ dynasty. It is a book of morals and life values, generally from a Buddhist perspective, but in later times sections were added that also reflected Confucian themes. As in the title *Komun chinbo* (see above), the syllable *po/bo* (*bao*) is replaced by the synonym *chin* (*zhen*) 珍, again raising the possibility of a possible taboo avoidance. 1/Ahn-L6.

Nonŏ (*Lunyu*, *4, 13) 論語, 6 *kwŏn*, Analects of Confucius. The *Nonŏ* is conventionally divided into 20 chapters or *chang* (*zhang*) 章, and this is reflected in Zhu Xi's commentary, which is in 20 *juan* (K. *kwŏn*). It is likely that the edition in 3/PrivateUS is complete, though bound in longer and therefore fewer *kwŏn*. The other screen citations do not indicate the number of *kwŏn*. 3/PrivateUS-8, 5/PrivateSeoul-7, 6/Minn-6, 4/Gruber-1, 2/Brooklyn-5, 7/Sneider-2.

Okp'yŏn (*Yupian*) 玉篇, 2 *kwŏn*, The Jade Compendium, an early dictionary by Gu Yewang 顧野王, dating from 573. It was one of the earliest dictionaries to be arranged according to graphic classifiers ("radicals," though his particular system has been obsolete at least since it was replaced by the Kangxi system in the 1720s), and the first to record tones. However, in Korea, *okp'yŏn* is more commonly a generic name for a dictionary arranged according to graphic elements (as opposed to one arranged by rime). No specific referent can be indicated here, but the *Chŏnun okp'yŏn*, q.v., published in two *ch'aek* by the Kyujanggak in 1796 and frequently reprinted thereafter, is the most likely possibility. 3/PrivateUS-8.

Osŏkkong sujukch'ŏp kŭp naesŏan 五石公石竹帖及來書安? His Excellency Osŏk's album of River Bamboos, with a Registry of Letters Received. Osŏk, "Five Rocks," seemingly a pen name, is to be preferred to Wang Sŏk 王石 (surname and given name, not found in reference works) as the interpretation of the first two characters of the entry, since the honorific suffix *kong* is more likely with the former. However, a search through the usual Korean pen name lists could not turn up an Osŏk. The letters are presumably ones sent to Osŏk. 2/Brooklyn-3.

Paeksumun 白首文, The White Head Text. This was a nickname for the "Thousand Character Classic" (*Chŏnjamun*, C. *Qianziwen*). It is said that its author, Zhou Xingsi of the Later Liang dynasty (907–923), worked so hard night and day on this riming text—in which not a single character is repeated—that his hair turned white. 6/Minn-4.

P'alchin torok 八陣圖錄, Illustrated Record of the Eight Formations. This title evokes the famous strategies of Zhuge Liang 諸葛亮 during the wars among the Three Kingdoms in the third century. A version entitled *Palchindo* 八陣圖 is found in comprehensive bibliographies. 6/Minn-2.

Pongsin yŏnŭi (*Fengshen yanyi*) 封神演義, 10 *kwŏn*, The Romance of the Gods' Enfeoffment, a Ming novel, variantly titled *Fengshen zhuan* 封神傳. The title as given is *Pongsin wanŭi* 封神完義, which makes no sense and looks like an error. 1/Ahn-R2.

Pŏbŏn (*Fayan*) 法言, Model Sayings, by *Yang* Xiong 揚雄 of the former Han dynasty. An eclectic work, basically respectful of the Confucian school but with a Confucian-Daoist eclecticism. Mentioned along with this work is another book said to be by Yang Xiong, entitled *Zhuanji*. No characters are given however, and efforts to find a referent for it in lengthy accounts of Yang's thought proved fruitless. 4/Gruber-1.

Pyŏngpŏp 兵法, Military Methods. This is the name of a genre, but I cannot find in either Chinese or Korean bibliographies a book of this title. It did appear in one Korean book title, *Pyŏngpŏp taeji* 兵法大旨, The Gist of Military Method, no author, no date. 6/Minn-3.

Samgukchi (*Sanguozhi*) 三國志, 20 *kwŏn*. In all probability this is an abbreviation for *Samgukchi yŏnŭi* (*Sanguozhi yanyi*) 三國志演義, the famous historical novel Romance of the Three Kingdoms, attributed to Luo Guanzhong 羅貫中, a fourteenth century Chinese writer of the late Yuan and early Ming periods. The "20 *kwŏn*" comes from 1/Ahn. This fits neither the novel (240 *juan* or 120 *hui*, K. *hoe*, chapters) nor the history (65 *juan*). Still, it is much more likely that references to the *Samgukchi* on screens are to the novel than to the history. 1/Ahn-L1, 5/PrivateSeoul-3.

Samnyak (*Sanlüe*) 三略, 5 *kwŏn*, Three Strategies, by Huang Shigong 黃石公. More properly called *Huang Shigong Sanlüe*. A text on military strategy. Also see *Yukto Samnyak* below. 2/Brooklyn-6.

Samun 三韻, The Three Rimes. This could well be the *Samun sŏnghwi* 三韻聲彙, Phonetic Compendium Arranged in Three-rime Format, a riming dictionarycompiled in 1751 by Hong Kye-hŭi 洪啓禧 (1703–1771), which became the basis of the *Ŏjŏng Kyujang chŏnun*, Royally Sanctioned Complete Rimes of the Kyujang (Library). See under *Un'go*, below. 6/Minn-4.

Samun yuch'wi (*Shiwen leiju*) 事文類聚. Full title, *Kogŭm samun yuch'wi* (*Gujin shiwen leiju*) 古今事文類聚, Classified Groupings of Factual and Literary Affairs Ancient and Modern, a famous Chinese encyclopedia for examination candidates, compiled by Zhu Mu 祝穆 in 1246, and twice extended and supplemented by Fu Dayong 富大用 and then Zhu Yuan 祝淵, both of the Yuan dynasty (1260–1368). 6/Minn-6.

Sangnye 喪禮. A generic term for mortuary rituals. It could refer to the work *Sangnye piyo* 喪禮備要, Complete Essentials of Mortuary Ritual, by Sin Ŭi-gyŏng 申義慶, who is said to have been the teacher of the famous ritualist Kim Chang-saeng 金長生 (1548–1631); or to *Sangnye piyo* po 喪禮備要補, Supplemented Mortuary Rituals, by Pak Kŏn-jung 朴建中, an eighteenth century physician. 5/PrivateSeoul-3, 6/Minn-4.

Sangsŏ (*Shangshu*, *5, 13) 尚書, The Book of History, or The Book of Documents. See also the *Sŏjŏn*, below. 5/PrivateSeoul-6.

Sansurok 山水錄, Catalogue of Landscape Paintings. Hand copies of such a book are known in bibliographies, but there are no details of date or authorship. 6/Minn-2.

Saryak 史略. 7 *kwŏn*. Probably an abbreviation of *Tongguk saryak* by Kwŏn Kŭn 權近 and others, compiled on the order of King T'aejong (r. 1400–1418). This was a short, general history of Korea from legendary times to the end of the Koryŏ dynasty, in 6 *kwŏn*. There were various continuations to reflect the history of the Chosŏn dynasty as well; these were in seven or more *kwŏn*. Bibliographies indicate many versions in 7 *kwŏn*. 3/PrivateUS-8, 4/Gruber-8.

Si (*Shi*, *5, 13) 詩, The Poetry. More formally, the Book of Poetry or Songs, also referred to elsewhere in this list as *Sijŏn*, q.v. 2/Brooklyn-4; 8/Leeum-5.

Sijŏn (*Shizhuan*, *5, 13) 詩傳. A common Korean abbreviation for the *Sigyŏng* (*Shijing*) 詩經, Book of Poetry, with commentary by Zhu Xi. Koreans of the late Chosŏn period tended to disdain other commentaries on this classic. 5/PrivateSeoul-4, 6/Minn-5.

Simgyŏng (*Xinjing*) 心經, Classic of the Mind-and-Heart, by Zhen Dexiu 眞德秀 (1178–1235). A Neo Confucian work focusing on the importance of having a true Mind-and-Heart. There is also a popular Buddhist work of the same title, called the Heart Sutra. However, it is likely that it would be the Neo-Confucian one that would appear on this screen. 4/Gruber-6.

Sohak (*Xiaoxue*) 小學, 7 *kwŏn*. The Lesser Learning, often attributed to Zhu Xi but actually compiled by Liu Zizheng 劉子澄 at his direction. A primer for students on Confucian learning and practice. 3/PrivateUS-8 (*kwŏn* indication), 5/PrivateSeoul-2, 6/Minn-5.

Sŏ (*Shu*, *5, 13) 書, The Book. More formally, the Book of History or Documents, also referred to elsewhere in this list as *Sangsŏ* and *Sŏjŏn*. 2/Brooklyn-4.

Sŏjŏn (*Shuzhuan*, *5, 13) 書傳, 10 *kwŏn*. Zhu Xi's commentary to the *Shujing* 書經 or *Shang-shu*, the Book of History or Book of Documents. See also *Sangsŏ*, above. 3/PrivateUS-8, 6/Minn-6.

Sŏngni... (*Xingli*) 性理, Nature and Principle. Neo-Confucian concepts which together stand as a byword for the school in general. As such, it appears in the titles of many works on Neo Confucianism. However, there is no title in which it appears by itself, and as given here must be judged incomplete. The *Xingli daquan* 性理大全, Great Compendium of Neo-Confucian Writings, is a well known example of the general usage. 4/Gruber-6.

Sŏngt'an sŏ (*Shengtan shu*) 聖嘆書, 13 *ch'aek*. The writings and editions of Jin Shengtan 金聖嘆, a mid-seventeenth century eccentric and fiction critic. His texts of the *Shuihuzhuan* and the *Xixiangji* (see next two items) were very popular in Korea. 7/Sneider-1.

Sŏsanggi (*Xixiangji*) 西廂記, The Western Chamber. A Yuan play. 2/Brooklyn-3, 7/Sneider-2.

Suhoji (*Shuihuzhi* [sic]) 水滸誌, 2 *ch'aek*, The Water Margin. A famous Chinese novel written during the fourteenth century, and very popular in Korea as well. This Korean title is in error; it should be *Suhojŏn* (*Shuihuzhuan*). 7/Sneider-1.

Taehak (*Daxue*, *4) 大學, 1 *kwŏn*, The Great Learning. 3/PrivateUS-8, 5/PrivateSeoul-7, 6/Minn- 5, 4/Gruber-6, 2/Brooklyn-5.

Taejŏn t'ongp'yŏn 大典通編, Comprehensive Legal Code (of Chosŏn). The great reediting of Korean laws ordered by King Chŏngjo in 1784, of which many editions were printed during the eighteenth and nineteenth centuries. 6/Minn-3.

Tongguk yakki 東國略記, 20 *kwŏn*, General Notes on Korea. This title not found in bibliographies available to me. It might be a variant title for *Tongguk saryak*; see *Saryak*, above, 1/Ahn-R5.

Tongmong sŏnsŭp yuhap 童蒙先習類合, Glossary for "First Studies for the Young Boy." A school primer current in late Chosŏn at least from the seventeenth century on. It is possible that two titles have been run together here. A book called the *Yuhap*, Classified Vocabularies, was common throughout the Chosŏn dynasty, and *Tongmong sŏnsŭp* is usually seen as a title by itself. 6/Minn-1.

Tongnae (Chwassi) Pag'ŭi (*Donglai Zuoshi Boyi*) 東萊左氏博議, Donglai's Learned Arguments on the *Zuozhuan*, by the Song scholar Lü Zuqian 呂祖謙 (*hao* Donglai, 1137-1181). The title on the screen, slightly abbreviated, is filled out here. 6/Minn-8.

Tongŭi pogam 東醫寶鑑, The Treasured Mirror of Korean Medicine. A large classified compendium of Korean and Chinese medical and pharmacological practice compiled by the physician Hŏ Chun 許浚 (1539–1615), completed in 1613 and published in 1615. This book was and still is much consulted in China and Japan. 5/PrivateSeoul-3.

Tuyul 杜律, 2 *kwŏn*, Regulated Poems (*lüshi*, K. *yulsi*, 律詩) of Du Fu (K. To Po) 杜甫. "Regulated" verse consists of a minimum of two four-line stanzas, either with lines of five syllables or with lines of seven syllables. Riming patterns and internal tonal structure follow flexible rules. The title suggests that only Du Fu's regulated verse is in this collection. However, it is possible that it also includes some of the famous poet's gems in other forms as well. 3/PrivateUS-8, 6/Minn-1, 8/Leeum-5.

T'aehyŏn'gyŏng (*Taixuanjing*) 太玄經, Grand Mystery Classic, by the Former Han scholar Yang Xiong (see under *Pŏbŏn*). Another work of Confucian-Daoist eclecticism. 4/Gruber-5.

T'onggam (*Tongjian*) 通鑑, 15 *kwŏn*. In all probability, this is an abbreviation for *Chach'i t'onggam kangmok* (*Zizhi tongjian gangmu*) 資治通鑑綱目, Comprehensive Mirror of History, Text and Commentary, by Zhu Xi. Zhu's book was an abridgment of the *Zizhi tongjian* of Sima Guang 司馬光 (1019–1086), with judgments congenial to Neo-Confucian views appended. Sima Guang's original work was in 294 *juan* (*kwŏn*), while Zhu's abridgment was in 59 *juan*. However, it is indicated here that this Korean edition was in 15 *kwŏn*, seemingly only a quarter of the length of Zhu's work. This is undoubtedly an abridgment of an abridgment. 1/Ahn-L3, 3/PrivateUS-8, 6/Minn-7.

Un'go 韻考, 1 *kwŏn*, Rime Investigations. In all probability, this refers to one of the riming dictionaries that were produced in Korea during the seventeenth and eighteenth

centuries. The oldest was the *Samun t'onggo* 三韻通考, of which a movable type edition is known from King Hyŏnjong's reign (1659–1674), with an undated woodblock edition from a later time. The last character of each of the two title words results in a form *ŭn'go*, which matches our title and passes for a plausible abbreviation. The phrase *samun,* "three rimes," alludes to a format whereby words were listed in riming groups, with the "even" tone words arrayed at the top of the page, the "rising tone" words in the middle, and the "going" tone words at the bottom (with the "entering" tone words appended at the end of the book or in a fourth section squeezed in at the bottom of the page). At least three riming dictionaries formatted on this or a similar plan were published during the eighteenth century, the last and the most prestigious being the *Ŏjŏng Kyujang chŏnun,* The Royally Sanctioned Complete Kyujang Rimes, compiled in 1796. One of these must be behind the *Un'go* of our entry. 3/PrivateUS-8. * Despite Ledyard's note here, this title is not found in this screen.

Ŭigam chŏnjil 醫鑑全秩, The Complete Mirror of Medicine. *Ŭigam* is a common abbreviation of the major Korean medical encyclopedia *Tongŭi pogam*, q.v. The *chŏnjil* simply indicates a complete copy with nothing missing. In the original entry, there was an extra character *chŏn,* "complete," following *chŏnjil.* This was a conventional usage to indicate that the book was complete within a single stiff wrapper. 6/Minn-2.

Ŭmyang sŏ (*Yinyang shu*) 陰陽書, Book (or Books) of *Yin* and *Yang.* This could mean anything, and might not actually be referring to a specific book but a group of books on the general subject. 6/Minn-8.

Wŏnhyŏn 原賢. No listing in bibliographies available to me; nor is it a plausible book title. 6/Minn-4.

Yegi (*Liji,* *5, 13) 禮記, The Book of Rites. 5/PrivateSeoul-8, 6/Minn-4.

Yegi yojip 禮記要集, Abridged Book of Rites (*Liji,* *5, 13). Not found in biblio-graphies available to me. 6/Minn-7.

Yemunji (*Yiwenzhi*) 藝文志, 15 *kwŏn. Yemunji* is a standard term for "biblio-graphy" and could refer to a number of works either Chinese or Korean. In itself it is simply a generic term. 1/Ahn-L2.

Yŏktae... (*Lidai...*) 歷代. A term common in book titles indicating "throughout history" or "historical," but, by itself, it is incomplete. Some typical uses of the form are in *Yŏktae sihwa* 歷代詩話, Poetic Criticism Throughout History, or *Yŏktae myŏngsin ŏnhaengnok* 歷代名臣言行錄, Records of the Words and Deeds of Historical Famous Officials. 5/PrivateSeoul-2.

Yŏlcha (*Liezi*) 列子. Daoist philosopher of the Warring States period, and the author of a book of that name. 2/Brooklyn-3.

Yŏmnak (*Lianluo*) 濂洛, 2 *kwŏn.* The title, which appears to be incomplete, is an ordinary abbreviation of the Chinese place names Lianqi 濂溪 and Luoyang 洛陽, the homes of the Neo-Confucian philosophers Zhou Dunyi 周敦頤 and the brothers Cheng Yi 程頤 and Cheng Hao 程顥, respectively. The entry title was written with a character that looked very much like *sŏ* 庶; I concluded it had to be wrong, and finally decided that it was as I have indicated above. "Lianluo" was usually combined with "Guanmin 關閩," an abbreviation of Guanzhong 關中 and Minzhong 閩中, respectively the homes of the other principal Neo-Confucian philosophers Zhang Zai 張載 and Zhu Xi. A short anthology of Neo Confucian writings seems to be what is meant by this incomplete form. 3/PrivateUS-8.

Yuhap 類合, Classified Vocabularies for students. There were many editions and types throughout the span of the Chosŏn dynasty. See under *Tongmong sŏnsŭp,* above. 6/Minn-1.

Yukto Samnyak (*Liutao Sanlüe*) 六韜三略, The Six Scabbards and the Three Stratagems. Originally two separate works on military strategy purportedly written in the pre-Han era, but now universally acknowledged as the forgeries of a later figure named Huang Shigong 黃石公. 6/Minn-3.

Glossary

Ahn Hwi-joon (An Hwi-jun) 安輝濬
Ahn Paek Sun (An Paek-sun) 安伯淳
ajŏng 雅正
An Chi (K. An Ki) 安岐
An Chong-wŏn 安鍾元
An Chung-sik 安中植
Bao Youguan (Anton Gogeisl) 鮑友官
Beitang 北堂
Beixue 碑學
bi 璧
Bogu tulu 博古圖錄
bogu 博古
Cao Zhao 曹昭
cha (courtesy name) 字
cha (rat) 子
ch'abi taeryŏng hawŏn 差備待令畫員
Chaehwa 載化
ch'aek 冊
ch'aekkado 冊架圖
ch'aekkŏri 책거리
chak 炸
chaktae 炸臺
chamyŏngjŏng 自鳴鐘
chang (C. *zhang*) 丈
Chang Han-jong 張漢宗
Chang Sŭng-ŏp 張承業
Chang Tŏk-chu 張德冑
Chang Wŏn-sam 張元三
ch'angch'odam 蒼草罈
Ch'angdŏk (Palace) 昌德(宮)
changmusangmang 長母相忘
changnakmiang 長樂未央
chapkwa 雜科
Chasam 子三
cheil kangsan 第一江山
Cheng Yi 程頤
chesŏng ssangbongwŏl ch'unsu
 manin'ga 帝城雙鳳月 春樹萬人家
Chibifu 赤壁賦
chich'u 知樞
ch'ilbomun 七寶文
ch'ilch'on 七寸
Chinjae 眞宰

Chinju Kang (family) 晉州 姜
Chisan 芝山
Cho Chŏ-dŏk 趙著德
Cho Kwang-jo 趙光祖
Cho Sŏk-chin 趙錫晋
Cho U-yŏng 趙友泳
Ch'oe Ch'i-wŏn 崔致遠
Ch'oe Lip 崔岦
Ch'ŏlchong (King) 哲宗
Chŏlla (province) 全羅(道)
Chŏn Ch'ang-yŏl 全昌烈
Chŏn Hyŏng-p'il 全鎣弼
Chŏn Kye-hun 全啓勳
Chŏn Sŏng-u (Chun Sung-woo)
 全晟雨
Chŏn Yŏng-gi 全泳基
chŏnch'u 千秋
Chŏng Hak-kyo 丁學敎
Chŏng Sŏn 鄭歚
Chŏng Tae-yu 丁大有
Chŏngam 靜庵
chŏnggangsŏk 淸江石
Chŏngjo (king) 正祖
Chŏngju Han (family) 淸州 韓
chŏnji irwŏl chang 天地日月長
Chŏnju Yi (family) 全州 李
Chŏnmunji 天文誌
chŏnsŏ (C. *chuanshu*) 篆書
Chŏnsŏk 泉石
Chosŏn misul chŏllamhoe 朝鮮美術展
 覽會
Chosŏn 朝鮮
chuanshu 篆書
Ch'uchŏp 秋帖
Ch'udang 秋堂
ch'uk (ox) 丑
Chukchan 竹澖
Chukhŏn 竹軒
Chukkye 竹稽
chung (C. *zhong*) 中
Chungch'uwŏn 中樞院
Chungil 仲一
chungin 中人

Chungnim-su 竹林守
ch'unhach'udong 春夏秋冬
Ch'unhye 春惠
Chunqiu 春秋
Ch'usa 秋史
ch'wi 翠
ch'wijae 取才
Ch'wiong 醉翁
Datong 大同
dehua 德化
Ding Liangxian 丁亮先
ding 鼎
Dong Beiyuan 董北苑
Dong Yuan 董源
fangding 方鼎
ge 哥
Gegu yaolun 格古要論
guan 官
guwantu 古玩圖
Guwen 古文
Haeju Kim (family) 海州 金
Haeju O (family) 海州 吳
haengsŏ (C. *xingshu*) 行書
haet'ae (C. *xiezhai*) 獬豸
Haeun (book) 海雲
Haeun (person) 海雲
Han Ho 韓濩
Han Ŭng-suk 韓應淑
Hangnim-jŏng 鶴林正
Hanyang Yu (family) 漢陽 劉
Hŏ Mok 許穆
ho 號
hoe (C. *hui*) 回
Hŏju 虛舟
Hong Ŏk 洪檍
Hong Tae-yong 洪大容
hongding hualing 紅頂花翎
hongsanyŏng 紅山英
hu (K. *ho*) 壺
Huayansi 華嚴寺
Huguang Huiguan 湖廣會館
hŭi (C. *xi*) 喜
hŭijak ssanghŭi 喜鵲雙喜

Huizong (emperor) 徽宗
hwajung kunja yŏnhwa 花中君子蓮花
hwap'ung kamu 和風甘雨
hwawŏn 畫員
hyangwŏlgwang 香月光
Hyech'un 惠春
Hyegak 慧覺
Hyewŏl 慧月
Hyŏpchŏn 協展
Ichŏn sŏnsaeng hwachŏp 伊川先生畫帖
Ihyang kyŏnmun nok 里鄉見聞錄
Ilmonggo 一夢稿
Ilsŏk 一石
in (tiger) 寅
Indong 仁同
Insa-dong 仁寺洞
iryŏngdae 日影臺
Iryŏngildando 日永日短圖
Jiaqing 嘉慶
Jinan 濟南
Jinsilu (K. *Kŭnsarok*) 近思錄
jue 爵
kam (C. *kan*) 坎
kan 間
kang (boundary) 疆
kang (health) 康
Kang Chin-hŭi 姜璡喜
Kang Tal-su 姜達秀
kangnam ilp'yŏn 江南一片
Kangxi (emperor) 康熙(帝)
Kani 簡易
kapcha 甲子
kesi 緙絲
Kim Chae-gi 金在璣
Kim Che-do 金齊道
Kim Chŏm-sun 金點順
Kim Chŏng-hŭi 金正喜
Kim Chŏng-hyo 金正孝
Kim Hong-do 金弘道
Kim Ki-hyŏn 金基顯, 金箕顯
Kim Kyu-jin 金圭鎭
Kim Ton-hŭi 金敦熙
Kim Ŭn-yŏng (Kim Eun-young) 金銀暎
Kim Ŭng-wŏn 金應元
Kim Yun-gyŏm 金允謙
kisa 耆社
kisaeng 妓生
kiyŏngch'angin 祈永昌印
Ko Hŭi-dong 高義東
Ko Ŭng-bae 高應培
Kojong (king) 高宗
kok 谷
kŏlda 걸다

Kong-dong 公洞
kŏri 거리
Koryŏ 高麗
kosa 古事
Kosong 古松
kŏsu 居岫
kŭmgam 金柑
kŭmgwan 金冠
kŭmsŏn 琴線
Kwanghwamun 光化門
Kwanjae kamjŏng 貫齋鑑定
Kwanjae musŏngsi 貫齋無聲詩
Kwanjae 貫齋
kwigammun 龜甲文
kwip'yo 晷表
Kwŏn Tong-jin 權東鎭
Kyeryong (mountain) 鷄龍(山)
Kyŏmjae 謙齋
Kyŏngbok (palace) 景福(宮)
Kyŏnghoeru 慶會樓
Kyujanggak 奎章閣
Lang Shining (Giuseppe Castiglione) 郎世寧
Lantingji xu 蘭亭集序
Lanzhou 蘭州
Lee [Yi] Kang (Prince Ŭich'in) 李堈
Leng Mei 冷枚
lingding huihuang 翎頂輝煌
Lingyansi 靈巖寺
lisao 離騷
lisaotu 離騷圖
Liu Songling (August von Hallerstein) 劉松齡
man 萬
manchamun 卍字文
Manhoe (hermitage) 萬灰(庵)
mansong paeksam segang 萬松栢杉歲疆
mansu mugang 萬壽無疆
Maruyama Ōkyo 圓山應擧
mi (sheep) 未
Michŏp 眉帖
Misu 眉叟
munbang sau 文房四友
munbangdo 文房圖
musong 鵡松
Myŏngsim pogam 明心寶鑑
Myŏngsŏng (queen) 明聖(皇后)
myŏngugu 鳴于九
Myŏnso 莭巢
Naegak illyŏk 內閣日歷
Nagan Kim (family) 樂安 金
Naksŏn-jae 樂善齋
Namp'o cheil 南浦第一

Nantang 南堂
nochŏn 老茜
nokch'wijae 祿取才
nŭnghwamun 稜花文
nyŏng 寧
O Se-ch'ang 吳世昌
obaekkŭn yu 五百斤油
Obong 五峰
odong ch'uwŏl 梧桐秋月
oja tŭnggwa yŏnjung samwŏn 五子登科連仲三元
Okchŏn 玉泉
Oksan 玉山
Okumura Masanobu 奧村政信
oryun 五倫
osimmot'ong 吾心毛桶
Ouyang Xiu 歐陽修
paek 柏
Paekche 百濟
paekt'aek (C. *baizi*) 白澤
Pak Ch'an-ho 朴贊昊
p'albun (C. *bafen*) 八分
p'alsebo 八世譜
Pang Han-ik 方漢翼
Penglai (hall) 蓬萊
pip'a 琵琶
p'odomun 葡萄文
pok (C. *fu*) 福
Pŏmgyŏng 範卿
Pongnae 蓬萊
pu (C. *fu*) 富
pu (C. *fu*) 浮
Pubyŏngnu 浮碧樓
Pukhak 北學
pultae pukhae yŏ changgun oga samin□　*paeksa* 佛臺北海與將軍吾家三人□百師
Pulchŏngdae 佛頂臺
pulchoch'o 不老草
P'unggye 風溪
Puryŏngdae 佛影臺
pusu (C. *fushou*) 富壽
Pyŏkhŏja 碧虛子
Pyŏn Sang-byŏk 卞相璧
P'yŏngan (province) 平安(道)
P'yŏngyang 平壤
Qianlong (emperor) 乾隆(帝)
ruyi 如意
sabaewŏn 思排遠
Sadong (palace) 寺洞(宮)
saeng 笙
saja (C. *xiezi*) 獅子
sam (C. *shan*) 杉
Samgyŏng 三經

samjongjido 三從之道
samsŏngmun 三星文
samyŏlhyang 三悅香
Sancai tuhui 三才圖會
sangwŏn kapcha 上元甲子
Saryak 史略
Sasŏ 四書
se (C. *sui*) 歲
Sejong (king) 世宗
Shanhaijing 山海經
Shaoxing 紹興
Shiba Kōkan 司馬江漢
Shizhuzhai huapu 十竹齋畫譜
Shizhuzhai jianpu 十竹齋箋譜
Simjŏn 心田
Sin Han-p'yŏng 申漢枰
sin 蜃
Sirhak 實學
Sŏ Pyŏng-o 徐丙五
Sŏgwang (monastery) 釋王(寺)
Sohŏn 小軒
Sŏhwa hyŏphoe chŏllamhoe 書畫協會展
 覽會
Sŏhwa hyŏphoe 書畫協會
Sŏhwa misulhoe 書畫美術會
Sŏhwa yŏn'guhoe 書畫研究會
sojŏn (C. *shaochuan*) 小篆
Sŏkchŏn 石泉
Sŏkchŏng 石丁
Sŏkpong 石峯
Sŏktang 石堂
Sŏn (C. Chan) 禪
song (C. *song*) 松
Sŏnggyun'gwan 成均館
Sŏngho sasŏl 星湖僿說
Sŏngho 星湖
Sŏngjong (king) 成宗
Songsŏk 松石
Sŏngwŏnnok 姓源錄
Sŏnjŏn 鮮展
Sorim 小琳
Sorim (Monastery) 少林(寺)
sosin Yi T'aek-kyun in 小臣李宅均印
Sosŏk 小石
Sosu sŏwŏn 紹修書院
ssanghŭi (C. *shuangxi*) 雙喜
su (C. *shou*) 壽
Su Dongpo 蘇東坡
su munbangdo 繡文房圖
subak 水珀
subok (C. *shoufu*) 壽福
subokkwi mansang 壽福貴萬象
Suk Joo-Sun (Sŏk Chu-sŏn) 石宙善
Sukchong (king) 肅宗

Susŏk 水石
tae 臺
t'aegŭk (C. *taiji*) 太極
taejŏn (C. *dachuan*) 大篆
tamch'ae 淡彩
Tamhŏn yŏn'gi 湛軒燕記
Tangshi 唐詩
Tianxia yudi tu 天下輿地圖
todu 陶杜
Tohwasŏ 圖畫署
tongch'i simnyŏn sinmi chungch'un il
 同治十年辛未仲春日
T'ongdosa 通度寺
tongjŏng ch'uwŏl 洞庭秋月
t'uho 投壺
tŭlgirŭm 들기름
Udang 憂堂
Uhyang 又香
Ŭich'in (prince) 義親(王)
ŭigwe 儀軌
Un'go 韻考
unmun 雲文
Ŭnp'a 隱波
unsongam kŭnhoenap 雲松庵謹回納
Wang Hui 王翬
Wang Sŏkkok sujukch'ŏp kŭp naesŏan
 王石谷水竹帖及來書案
Wang Sŏkkok 王石谷
Wang Wei 王維
Wang Xizhi 王羲之
Wansan 完山
Wen Zhengming 文徵明
Wich'ang 葦滄
Wŏlsa-gong 月沙公
Wu (school) 吳(派)
wuji 無極
Wuyi 武夷
xi (K. *hŭi*) 喜
xiang (C. *sang*) 象
Xiang (river) 湘
Xiao (river) 瀟
xiezhai 獬豸
Xingli (K. *Sŏngni*) 性理
Xingqing (palace) 興慶(宮)
xique (K. *hŭijak*) 喜鵲
Xixiangji 西廂記
Xuanhe bogutu 宣和博古圖
Xuantong (emperor) 宣通(帝)
yang 陽
yangban 兩班
yesŏ (C. *lishu*) 隷書
Yi Chae-sŏn 李在善
Yi Ch'ang-hyŏn 李昌鉉
Yi Ch'ang-ok 李昌玉

Yi Ching 李澄
Yi Chŏng-gwi 李廷龜
Yi Chong-gyu 李宗圭
Yi Chong-hyŏn 李宗賢
Yi Ho-min 李好民
Yi Hoe 李懷
Yi Hŭi-yun 李喜胤
Yi Hyŏng-nok 李亨祿
Yi Ik 李瀷
Yi In-mun 李寅文
Yi Ku 李玖
Yi Kwang-jun 李光俊
Yi Kŏl 李傑
Yi Kyŏng-yun 李慶胤
Yi Kyu-sang 李奎象
Yi Su-han 李壽鷴
Yi Su-min 李壽民
Yi Sun-min 李淳民
Yi T'aek-kyun 李宅均
Yi T'aek-nok 李宅祿
Yi To-yŏng 李道榮
Yi Ŭi-rok 李宜祿
Yi Ŭng-nok 李膺祿/李應祿
Yi Yŏng-yun 李英胤
Yi Yun-min 李潤民
Yichuan (K. Ich'ŏn) 伊川
Yijing 易經
yin-yang 陰陽
yin 陰
Yixing 宜興
Yŏnan Yi (family) 延安 李
yongan 龍顏
Yŏngjo (king) 英祖
yŏngjŏng ch'iwŏn 寧靜致遠
Yŏngju 榮州
Yongmundang 龍門堂
yongnŭng pyŏnhwa 龍能變化
Yongzheng (emperor) 雍正(帝)
Yŏnhyang 研香
Yŏnp'ung 延豊
Yŏt'ong 汝通
yu (chicken) 酉
Yu Chae-gŏn 劉在建
Yu Chae-ŭng 劉在應
Yu Un-p'ung 劉運豊
Yuch'un 有春
yundo 輪圖
Yusu 流水
Zhongli Quan 鍾離權
Zhongyong 中庸
Zhou Dunyi 周敦頤
Zhu Xi 朱熹
Zhuzi daidian (K. *Chuja taejŏn*) 朱子大全

List of Figures

List of Exhibits

Bibliography

Ahn Hwi-joon. "The Origin and Development of Landscape Painting in Korea." In *Arts of Korea,* edited by Judith G. Smith, pp. 294–329. New York: The Metropolitan Museum of Art, 1999.

An Ch'un-gŭn 安春根. *Och'im anjŏngbŏp* 五針眼訂法 (Method of five-stitched book-binding). Seoul: Chŏnťong munhwa, 1983.

An Sang-su 안상수, ed. *Han'guk chŏnťong munyangjip I: Kiha munŭi* 한국전통문양집 I 기하무늬 (Korean Motifs I: Geometric Patterns). Seoul: Ahn Graphics & Book Publishers, 1986.

An Sang-su, ed. *Han'guk chŏnťong munyangjip V: Ťaegŭk munŭi* 한국전통문양집 V 태극무늬 (Korean Motifs V: Ťaegŭk Patterns). Seoul: Ahn Graphics & Book Publishers, 1989.

An Sang-su, ed. *Han'guk chŏnťong munyangjip II: Kkot munŭi* 한국전통문양집 II 꽃무늬 (Korean Motifs II: Floral Patterns). Seoul: Ahn Graphics & Book Publishers, 1990.

Anawalt, Patricia Rieff. "The Emperor's Cloak: Aztec Pomp, Toltec Circumstances." *American Antiquity* 55, no. 2 (1990), pp. 291–307.

Anawalt, Patricia Rieff. "Riddle of the Aztec Robe." *Archaeology,* May–June 1993, pp. 31–36.

Bailey, Liberty Hyde. *Hortus Third.* New York: MacMillan, 1976.

Barnhart, Richard. "Shining Rivers: Eight Views of the Hsiao and Hsiang in Sung Painting." In *International Colloquium on Chinese Art History, 1991: Proceedings,* vol. 1, pp. 45–95. Taipei: National Palace Museum, 1992.

Bartholomew, Terese Tse. *Fruits and Flowers for the Chinese New Year.* San Francisco: Asian Art Museum of San Francisco, 2000.

Bartholomew, Terese Tse. *Hidden Meanings in Chinese Art.* San Francisco: Asian Art Museum of San Francisco, 2006.

Beurdeley, Cécile and Michel Beurdeley. *Giuseppe Castiglione (1688–1766): A Jesuit Painter at the Court of the Chinese Emperors.* Translated by Michael Bullock. Rutland, VT and Tokyo: Charles E. Tuttle, 1971.

Beurdeley, Michel. *Chinese Furniture.* Translated by Katherine Watson. Tokyo and New York: Kodansha International, 1979.

Birch, Cyril, ed. *Anthology of Chinese Literature.* New York: Grove Press, 1965.

Black, Kay E. "Hundred Antiques." *Journal of the International Chinese Snuff Bottle Society* 20, no. 4 (Winter 1988), pp. 4–22.

Black, Kay E. "The Korean Ethnographical Collection of the Peabody Museum of Salem." *Korean Culture* 10, no. 4 (Winter 1989), pp. 12–21, 28–33.

Black, Kay E. and Edward W. Wagner. "Ch'aekkŏri Paintings: A Korean Jigsaw Puzzle." *Archives of Asian Art* 46 *(1993),* pp. 63–75.

Black, Kay E. and Edward W. Wagner. "Court Style Ch'aekkŏri." In *Hopes and Aspirations: Decorative Paintings of Korea,* edited by Kumja Paik Kim, pp. 29–33. San Francisco: Asian Art Museum of San Francisco, 1998.

Bodart-Bailey, Beatrice M. "400 Years of Japanese-Dutch Relations: A Song for the Shogun, Englebert Kaempfer and 17ᵗʰ c Japan." *IIAS Newsletter* 22 (June 2000).

Bogu tulu 博古圖錄. By Wang Fu 王黼. 1752 edition.

Cambon, Pierre. *L'Art Coréen au Musée Guimet.* Paris: Réunion des musée nationaux, 2001.

Carus, Paul. *Chinese Astrology.* 1907. Reprint, La Salle, IL: Open Court, 1974.

Chao, Ts'ao. *Chinese Connoisseurship: The Ko Ku Yao Lun, the Essential Criteria of Antiquities.* Edited and translated by Sir Percival David. New York and Washington DC: Praeger Publishers, 1971.

Cho P'ung-yŏn 趙豊衍. *Sanjin ŭro ponŭn Chosŏn sidae: saenghwal kwa p'ungsŏk* 사진으로 보는 朝鮮時代: 생활과 풍속 (Daily life and custom in the Chosŏn period as seen in photographs). Seoul: Sŏmundang, 1986.

Cho Sŏn-mi 趙善美. *Han'guk ch'osanghwa yŏn'gu* 韓國肖像畵硏究 (Study of portrait paintings in Korea). Seoul: Yŏlhwadang, 1983.

Ch'oe Sŏk-ťae 최석태. "Yi To-yŏng yŏnbo 李道榮 年譜" (Chronology of Yi To-yŏng's life). *Han'guk kŭndae misulsahak* 韓國近代美術史學 1 (1994), pp. 105–123.

Ch'oe Sun-u 崔淳雨 (Choi Sunu) and Pak Yŏng-gyu 朴榮圭. *Han'guk ŭi mokch'il kagu* 韓國의 木漆家具 (Korean wood lacquer furniture). Seoul: Kyŏngmi munhwasa, 1981.

Chŏn Sang-un (Jeon Sang-woon). "Astronomy and Meteorology in Korea." *Korea Journal* 13, no. 12 (December 1973), pp. 13–18.

Chōsen bijutsu hakubutsukan 朝鮮美術博物館 (Chosŏn Fine Arts Museum). Tokyo: Chōsen kabosha, 1980.

Chōsen sōtokufu 朝鮮總督府, ed. *Chōsen bijutsu tenrankai zuroku* 朝鮮美術展覽會圖錄 (Catalogue of a special exhibition of Chosŏn art). 1922–1940; reprint. Seoul: Kyŏngin munhwasa, 1982.

Christie's New York, 23 March 1990.

Christie's New York, 29 and 30 March 1990.

Cixiu tezhan tulu 刺繡特展圖錄 (Catalogue of a special exhibition of embroidery). Taipei: National Palace Museum, 1992.

Clark, Allen D. and Donald N. Clark. *Seoul Past and Present: A Guide to Yi T'aejo's Capital.* Royal Asiatic Society Korea Branch Guidebook Series, no. 1. Seoul: Hollym Corporation, 1969.

Crane, Paul S. *Korean Patterns.* Royal Asiatic Society Korea Branch Handbook Series 1. Seoul: Hollym, 1967.

Cultural Heritage Administration of Korea, ed. *The 1990 Exhibition of Works by Important Traditional Handicraft Holders.* Seoul: Cultural Heritage Administration of Korea, 1990.

De Bary, William Theodore and Irene Bloom, eds. *Sources of Chinese Traditions.* 2nd ed. New York: Columbia University Press, 1999.

Desroches, Jean Paul. "Beijing–Versailles: Relations between Qing Dynasty China and France." *Oriental Art* 43, no 2. (1997), pp. 32–40.

Donnelly, P. J. *Blanc de Chine: The Porcelain of Têhua in Fukien.* New York and Washington: Frederick A. Praeger, 1969.

Eom, So Yeon. "Minhwa: A Precious Look at Traditional Korean and High Social PositionLife." *Koreana* 6, no. 3. (Autumn 1992), pp. 42–49.

Fong, Wen C. and James C. Y. Watt, eds. *Possessing the Past: Treasures from the National Palace Museum, Taipei.* New York: Metropolitan Museum of Art, 1996.

French, Cal. *Through Closed Doors: Western Influence on Japanese Art 1639–1853.* Rochester, MI: Meadow Brook Art Gallery, Oakland University, 1977.

Fung, Yu-lan. *A Short History of Chinese Philosophy.* Edited by Derk Bodde. New York: Free Press Books, 1948.

Grant, Bruce K. and Chinman Kim, trans. *Han joong nok: Reminiscences in Retirement.* New York: Larchwood Publications, 1980.

Gugong bowuyuan gujianzhu guanlibu 故宮博物院古建築管理部, ed. *Zijincheng gongdian jianzhu zhuangshi neiyan zhuangxiu tudian* 紫禁城宮殿建築裝飾飾內檐裝修图典 (Illustrated catalogue of the architectural decoration and interior design of the Imperial Palace). Beijing: Zijincheng chubanshe, 1995.

Guoli gugong bowuyuan: kesi, cixiu 國立故宮博物院 緙絲刺繡 (Tapestry and embroidery in the collection of the National Palace Museum). 4 vols. Tokyo: Gakken Co, Ltd., 1970.

Handler, Sarah. *Austere Luminosity of Chinese Classical Furniture.* Berkeley and Los Angeles: University of California Press, 2001.

Han'guk chŏngsin munhwa yŏn'guwŏn 韓國精神文化研究院 (Academy of Korean Studies). *Yŏkchu Kyŏngguk taejŏn* 譯註 經國大典 (Annotated translation of *Kyŏngguk taejŏn*). 2 vols. Sŏngnam: Academy of Korean Studies, 1985–1987.

Han'guk misul yŏn'gam 韓國美術年鑑. 1979 edition. Seoul: Han'guk misul yŏn'gamsa.

Hay, John. *Kernels of Energy, Bone of Earth: The Rock in Chinese Art.* New York: China Institute of America, 1985.

Hejzlar, Josef. *Early Chinese Graphics.* London: Octopus Books, 1973.

Higuchi Hiroshi 樋口弘. *Chūgoku hanga shūsei* 中国版画集成 (Collection of Chinese woodblock prints). Tokyo: Hitō shoten, 1967.

Hobson, R. L. *A Catalogue of Chinese Pottery and Porcelain in the Collection of Sir Percival David.* London: The Stourton Press, 1934.

Hokkaidōritsu kindai bijutsukan 北海道立近代美術館, et al. eds. *Ri ōchō jidai no shishū to fu* 李王朝時代の刺繡と布 (Patterns and Colors of Joy: Korean embroidery and wrapping cloths of the Chosŏn dynasty). Tokyo: Kokusai geijutsu bunka shinkōkai, 1995.

Hôtel Drouot auction catalogue. *Succession Pierre Landy.* Paris, 24 June 1987.

Hough, Walter. "The Bernadou, Allen, and Jouy Korean Collections in the US National Museum." In *Report of the United States National Museum for the year ending June 30, 1891,* pp. 429–488. Washington DC: GPO, 1893.

Huh Dong-hwa 許東華 (Hŏ Tong-hwa). *Kankoku no ko shishu* 韓国の古刺繡 (Collection of traditional embroideries in Korea). Kyoto: Dōhōsha, 1982.

Huh Dong-hwa and Park Young-sook. *Crafts of the Inner Court.* Seoul: Museum of Korean Embroidery, 1988.

Hwang, Kyung Moon. *Beyond Birth: Social Status Emergence in Modern Korea.* Cambridge, MA: Harvard University Asia Center, Harvard University Press, 2004.

Jeon, Sang-woon (Chŏn Sang-un). *Science and Technology in Korea: Traditional Instruments and Technique.* Cambridge, MA and London: MIT Press, 1974.

Kang Kwan-sik 姜寬植. *Chosŏn hugi kungjung hwawŏn yŏn'gu* 朝鮮後期宮中畵員研究 (Study of court painters of the late Chosŏn period). 2 vols. Seoul: Tolbegae, 2001.

Kansong munhwa 11: hoehwa VII sagunja 澗松文華 11: 繪畵 VII 四君子 (1976).

Kansong munhwa 12: hoehwa VIII sŏnmyŏn 澗松文華 12: 繪畵 VIII 扇面 (1977).

Kansong munhwa 43: hoehwa XXV kŭndae hoehwa 澗松文華 43: 繪畵 XXV 近代繪畵 (1992).

Keith, Elizabeth and E. K. Robertson Scott. *Old Korea: the Land of the Morning Calm.* New York: Philosophical Library, 1947.

Kim Chŏl-sun 金哲淳, ed. *Minwha* 民畫. Han'guk ŭi mi, vol. 8. Seoul: Chungang ilbosa, 1978.

Kim Ho-yŏn 金鎬然, ed. *Han'guk minhwa* 韓國民畫 (Korean folk painting). Seoul: Kyŏngmi munhwasa, 1977.

Kim Man-hŭi 金萬熙. *Minsok torok* 民俗圖錄 (Illustrations of Korean folklore). 20 vols. Seoul: Sangmisa, 1973–1984.

Kim Yŏng-yun 金榮胤. *Han'guk sŏhwa inmyŏng sasŏ* 韓國書畫人名辭書 (Biographical dictionary of Korean painters and calligraphers). 3rd ed. Seoul: Yesul ch'unch'usa, 1978.

Kim, Kumja Paik. "New Acquisitions in Korean Painting." *Orientations* 34, no. 1 (January 2003), pp. 64–69.

Kim, Youngna. *20th Century Korean Art.* London: Laurence King Publisher, 2005.

Korea National Commission for UNESCO, ed. *Traditional Korean Painting.* Korean Art 2. Seoul: Si-sa-yong-o-sa, 1983.

Kungnip chungang pangmulgwan 國立中央博物館 (National Museum of Korea), ed. *Han'guk kŭndae hoehwa paengnyŏn 1850–1950* 韓國近代繪畫百年 1850–1950 (One hundred years of modern Korean painting, 1850–1950). Seoul: Samhwa sŏjŏk, 1987.

Kungnip chungang pangmulgwan 國立中央博物館 (National Museum of Korea), ed. *Chosŏn sidae munbang chegu* 朝鮮時代文房諸具 (Diverse objects of the study in the Chosŏn period). Seoul: National Museum of Korea, 1992.

Kungnip minsok pangmulgwan 國立民俗博物館 (National Folk Museum of Korea), ed. *Kŭndae paengnyŏn minsok p'ungmul* 近代百年民俗風物 (Folk customs of 100 years in modern Korea). Seoul: National Folk Museum of Korea, 1995.

Kurashiki mingeikan 倉敷民藝館, ed. *Kurashiki mingeikan zuroku* 倉敷民藝館図錄 (Catalogue of Kurashiki Museum of Folk Craft), vol. 3. Okayama: *Kurashiki mingeikan,* 1988.

Lai, C. T. *Chinese Seals.* Seattle: University of Washington Press, 1976.

Lawton, Thomas. *Chinese Figure Painting.* Washington DC: Smithsonian Institution, 1973.

Ledderose, Lother. "Some Observations on the Imperial Art Collection in China." *Transactions of the Oriental Ceramic Society* 43 (1978–79), pp. 33–46.

Ledyard, Gari. "Hong Taeyong and His Peking Memoir." *Korean Studies* 6 (1982), pp. 63-103.

Lee, Ki-baek. *A New History of Korea.* Translated by Edward W. Wagner with Edward J. Shultz. Cambridge, MA and London: Harvard-Yenching Institute, Harvard University Press, 1984.

Lee, Peter H. and Wm. Theodore de Bary, ed. *Sources of Korean Tradition,* vol. 1: *From Early Times through the Sixteenth Century.* New York: Columbia University Press, 1997.

Li, H. L. *Chinese Flower Arrangement.* Princeton, NJ and London: D. van Nostrand Company, 2002.

Li, He. *Chinese Ceramics from the Asian Art Museum of San Francisco.* New York: Rizzoli, 1996.

Little, Stephen. with Shawn Eichman. *Taoism and the Arts of China.* Chicago: The Art Institute of Chicago; Berkeley: University of California Press, 2000.

Lloyd, H. Alan. *The Collector's Dictionary of Clocks.* London: Country Life Limited, 1964.

Lyons, Elizabeth. *Thai Traditional Painting.* Thai Culture New Series 1. Bangkok: Fine Arts Department, 1963.

March, Benjamin. "A Note on Perspective in Chinese Painting." *China Journal of Science and Arts* 7, no. 2 (August 1927), pp. 69–72.

McCune, Evelyn B. *The Inner Art: Korean Screens.* Berkeley: Asia Humanities Press; Seoul: Po Chin Chai, 1983.

Milman, Miriam. *Trompe l'Oeil Painting.* New York: Skira and Rizzoli, 1983.

Mody, N. H. N. *Japanese Clocks.* Rutland, VT and Tokyo: Charles E. Tuttle Co, 1967.

Moss, Hugh. *By Imperial Command: An Introduction to Qing Imperial Painted Enamels.* Hong Kong: Hibiya, 1976.

Mun Myŏngdae 文明大, ed. *Chosŏn pulhwa* 朝鮮佛畫. Han'guk ŭi mi, vol. 16. Seoul: Chungang ilbosa, 1984.

Murray, Julia K. *The Last of the Mandarins: Chinese Calligraphy and Painting from the F. Y. Chang Collection.* Cambridge, MA: Arthur M. Sackler Museum, Harvard University, 1987.

Na Chih-liang. *The Panoramic View of Chinese Seal Development.* Taipei: China Cultural Enterprises, 1972.

Needham, Joseph. *Science and Civilization in China,* vol. 3: *Mathematics and the Sciences of the Heavens and the Earth.* Cambridge: Cambridge University Press, 1959.

Nha, Il-seong. "Development of Science and Technology in the Early Chosŏn Period." *Koreana* 11, no. 3 (1977), pp. 20–25.

O Chu-sŏk 吳柱錫. "Hwasŏn Kim Hong-do kŭ in'gan kwa yesul 畫聖 金弘道 그 人間과 藝術" (The painter immortal Kim Hong-do: the person and his Art). In *Tanwŏn Kim Hong-do: t'ansin 250 chunyŏn kinyŏm t'ŭkpyŏljŏn nonmunjip* 檀園 金弘道: 誕辰250周年紀念特別展 (Tanwŏn Kim Hong-do: a collection of papers for the exhibition on the 250th anniversary of his birth), edited by National Museum of Korea, pp. 5-112. Seoul: Samsung Culture Foundation, 1995.

O Se-ch'ang. *Kŭnyŏk insu* 槿域印藪 (Collection of Seals of Kŭnyŏk [Korea]). Seoul: National Assembly Library of Korea, 1968.

O Se-ch'ang. *Kŭnyŏk sŏhwajing* 槿域書畫徵 (Illumination on painters and calligraphers of Kŭnyŏk [Korea]). Reprint,

Seoul: Hyŏptong yŏn'gusa, 1975.

O Se-ch'ang 吳世昌. *Kŭnmuk* 槿墨 (Calligraphy of Kŭnyŏk [Korea]). 2ⁿᵈ ed. Seoul: Chŏngmunsa, 1981.

Olson, Eleanor. *Catalogue of the Tibetan and Other Lamaist Articles in the Newark Museum,* vol. 1. Newark, NJ: Newark Museum, 1950.

Onyang minsok pangmulgwan 溫陽民俗博物館 (Onyang Folk Museum), ed. *Tosŏl han'guk ŭi minsok* 圖說 韓國의 民俗 (Illustrated survey of Korean folklore). Onyang: Onyang Folk Museum, 1980.

Pak Chŏng-hye 朴廷蕙 (Park Jung-hye). "Ŭigwe rŭl t'onghaesŏ pon Chosŏn sidae ŭi hwawŏn 儀軌를 통해서 본 朝鮮의 畵員" (Court painters of the Chosŏn dynasty examined through ceremonial records). *Misulsa yŏn'gu* 美術史研究 9 (1995), pp. 203–290.

Pak Ŭn-sun 朴銀順. *Kŭmgangsando yŏn'gu* 金剛山圖研究 (Study of paintings of the Diamond Mountain). Seoul: Ilchisa, 1997.

Paul, Margo. "A Creative Connoisseur: Nomura Shōjirō." In *Kosode: 16ᵗʰ–19ᵗʰ Century Textiles from the Nomura Collection,* edited by Amanda Mayer Stinchecum, pp. 12–21. New York: Japan Society and Kodansha International, 1984.

Pratt, Keith and Richard Rutt. *Korea: A Historical and Cultural Dictionary.* Durham East Asia Series. Richmond, Surrey: Curzon Press, 1999.

Rhee, Byung-chang. *Yi Ceramics.* Masterpieces of Korean Art, vol. 3. Tokyo: Byung-chang Rhee, 1978.

Rosenzweig, Daphne Lange. *Court Painters of the Kang Hsi Period.* 2 vols. Ann Arbor: University Microfilms, 1976.

Rutt, Richard. "The Chinese Learning and Pleasures of a Country Scholar." *Transactions of the Korea Branch of the Royal Asiatic Society* 36 (1960), pp. 1–100.

Rutt, Richard and Kim Chong-un, trans. *Virtuous Women: Three Classic Korean Novels.* Seoul: Royal Asiatic Society Korean Branch, 1979.

Schlosser, Julius von. *Die Kunst- und Wunderkammern der Spätrenaissance: ein Beitrag zur Geschichte des Sammelwesens.* Leipzig, 1908; reprint, Braunschweig: Klinkhardt & Bermann, 1978.

Shanhaijing 山海經. Shanghai: Hui Wen Tang, 1917.

Sheaf, Colin and Richard Kilburn. *The Hatcher Porcelain Cargoes: The Complete Record.* Oxford: Phaidon, 1988.

Shen Congwen 沈从文, ed. *Zhongguo gudai fushi yanjiu* 中国古代服饰研究 (Studies of Ancient Chinese Clothing). Hong Kong: Shangwu, 1981.

Shin Young-hoon (Sin Yŏng-hun) et al. *Kyŏngbokkung Palace.* Translated by Hahn Chul-mo, et al. *Korean Ancient Palaces 1.* Seoul: Youl Hwa Dang (Yŏlhwadang), 1986.

Smithsonian Gift Catalogue of Spring 1979. Washington, DC: Smithsonian Institution, 1979.

Sŏjŏn pu ŏnhae 書傳 附諺解. 3 vols. Seoul: Hangmin munhwasa, 1989.

Sotheby's, London. *Chinese Ceramics and Works of Art.* 8 November 2006.

Sotheby's, London. *Japanese and Korean Works of Art.* 14 July 2005.

Sotheby's, New York. *Fine Chinese Jades, Paintings and Works of Art.* 25 February, 1983.

Strassberg, Richard E., trans. *A Chinese Bestiary: Strange Creatures from the Guideways through Mountains and Seas (Shanhaijing).* Berkeley and Los Angeles: University of California Press, 2002.

Sullivan, Michael. *The Meeting of Eastern and Western in Art.* Revised and expanded edition. Berkeley and Los Angeles: University of California Press, 1989.

Taehan min'guk yesulwŏn 大韓民國藝術院 (National Academy of Arts of Korea), ed. *Han'guk misul sajŏn* 韓國美術事典 (Dictionary of fine arts of Korea). Seoul: National Academy of Arts, 1985.

Tian Jiaqing. "Early Qing Furniture in a Set of Qing Dynasty Court Paintings." *Orientations* 24, no. 1 (January 1993), pp. 32–40.

T'ongdosa sŏngbo pangmulgwan 通度寺聖寶博物館 (T'ongdo Monastery Sacred Treasure Museum), ed. *T'ongdosa: Han'guk ŭi myŏngch'al* 通度寺 韓國의 名刹 (T'ongdosa, a great monastery in Korea). Yangsan: T'ongdosa sŏngbo pangmulgwan, 1987.

T'ongdosa sŏngbo pangmulgwan, ed. *Hyegak sŏnsa kijŭng sŏhwa myŏngp'um* 慧覺禪師寄贈書畵名品 (Masterpieces of painting and calligraphy donated by Sŏn Master Hyegak). Yangsan: T'ongdosa sŏngbo pangmulgwan, 1989.

van Gulik, R. H. *Chinese Pictorial Art: As Viewed by the Connoisseur.* Serie Orientale Roma 19. Rome: Istituto italiano peril Medio ed Estremo Orientale, 1958.

Vedlich, Joseph, ed. *The Ten Bamboo Studio: A Chinese Masterpiece.* New York: Crescent Books, 1979.

Vinograd, Richard. *The Boundaries of Self: Chinese Portraits, 1600–1900.* Cambridge: Cambridge University Press, 1992.

Wagner, Edward W. *Chosŏn wangjo sahoe ŭi sŏngch'wi wa kwisok* 朝鮮王朝 社會의 成就와 歸屬 (Achievement and ascription in the Chosŏn dynasty). Translated by Yi Hun-sang and Son Suk-kyŏng. Seoul: Ilchogak, 2007.

Wan Yi 万依 et al. *Qingdai gongting shenghuo* 清代宮廷生活 (Life in the court of the Qing dynasty). Hong Kong: The Commercial Press, Hong Kong Branch, 1985.

Wang, Shixiang and Curtis Evarts. *Masterpieces from the Museum of Classical Chinese Furniture.* Chicago and San Francisco: Chinese Art Foundation, 1995.

Watt, James C. W. *Chinese Jades from the Collection of the Seattle Art Museum.* Seattle: Seattle Art Museum, 1989.

Wilson, Keith. "The Origin and Development of Landscape Painting in Korea." *The Bulletin of the Cleveland Museum of Art* 77, no. 8 (1990), pp. 286–323.

Yao Qian 姚迁, ed. *Taohuawu nianhua* 桃花坞年画

(New Year pictures of Taohuawu). Beijing: Wenwu chubanshe, 1985.

Yi Ch'ang-hyŏn 李昌鉉. et al. comp. Sŏngwŏnnok 姓源錄 (Records of [chapkwa-chungin] lineage origins). Korea University Central Library reprint series 13. Seoul: Osŏngsa, 1985.

Yi Ho-min 李好閔 and Ch'oe Hyŏn 崔晛. Obongjip Injaejip 五峰集 認齋集. Seoul: Asea munhwasa, 1984.

Yi Hŭi-dŏk. "Formation of Confucian Ethics in Korea." Korea Journal 13, no. 2 (1973), pp. 10-16.

Yi Hun-sang 李勛相. "Ch'aekkŏri kŭrim chakka ŭi kaemyŏng munje wa chejak shigi e taehan chae goch'al 책거리 그림 作家의 改名 問題와 製作 時期에 대한 再考察" (Reexamining the problem of the renaming of ch'aekkŏri artists and the dating of some works). In E. W. Wagner, Chosŏn wangjo sahoe ŭi sŏngch'wi wa kwisok (Achievement and ascription in the Chosŏn dynasty), pp. 477–492. Seoul: Ilchogak, 2007.

Yi Ik 李瀷. Kugyŏk Sŏngho sasŏl 國譯 星湖僿說. Seoul: Minjok munhwa ch'ujinhoe, 1982.

Yi Kyŏm-no 李謙魯. Munbang sau 文房四友 (Four friends of scholar's room). Seoul: Taewŏnsa, 1989.

Yi Sŏng-mi. "Southern School Literati Painting of the Late Chosŏn Period." In The Fragrance of Ink: Korean Literati Paintings of the Chosŏn Dynasty (1392–1910) from Korea University Museum. Edited by Kwon Young-pil et al., pp. 177–191. Seoul: Korea University Museum, 1996.

Yi Sŏng-mi. "Artistic Tradition and the Depiction of Reality: True-View Landscape Painting of the Chosŏn Dynasty." In Arts of Korea, edited by Judith G. Smith, pp. 331–365. New York: The Metropolitan Museum of Art, 1999.

Yi Sŏng-mu 李成茂, Ch'oe Chin-ok 崔珍玉, and Kim Hŭi-bok 金喜福, eds. Chosŏn sidae chapkwa hapkyŏkcha ch'ongnam 朝鮮時代雜科合格者總覽 (Complete record of successful candidates to the chapkwa examinations in the Chosŏn period). Kojŏn charyo ch'ongsŏ 90-5. Sŏngnam: Academy of Korean Studies, 1990.

Yi Tong-ju 李東注, ed. Koryŏ pulhwa 高麗佛畫. Han'guk ŭi mi, vol. 7. Seoul: Chungang ilbosa, 1981.

Yi Wŏn-bok 李源福. "Ch'aekkŏri sogo 책거리 小考" (Note on ch'aekkŏri). In Kŭndae han'guk misul nonch'ong: Yi Kuyŏl sŏnsaeng hoegap kinyŏm nonmunjip 근대한국미술논총: 이구열선생회갑기념논문집 (Papers on modern Korean art: festschrift in honor of Yi Ku-yŏl on his sixtieth Birthday), pp. 103-126. Seoul: Hakkojae, 1992.

Yu Chae-gŏn 劉在建, Ihyang kyŏnmunnok 異鄉見聞錄 [and] Cho Hŭi-ryong 趙熙龍, Hosan oegi 壺山外記. Seoul: Asea Munhwasa, 1974.

Yu Pok-yŏl 劉復烈. Han'guk hoehwa taegwan 韓國繪畫大觀 (Pageant of Korean painting). Seoul: Mun'gyowŏn, 1979.

Yu, Pauline. The Poetry of Wang Wei: New Translations and Commentary. Bloomington: Indiana Press, 1980.

Zhongguo gudai banhua congkan 中国古代版画叢刊 (Collection of ancient Chinese prints), vol. 10, Lisaotu 離思图 (Illustrations to the Poem of Unending Sadness). Shanghai: Zhonghua shuju, 1961.

Zhongguo meishu chuanji: huihua bian 中国美术全集 绘画編 (Complete works of Chinese art: painting), vol. 21, Minjian nianhua 民間年畫 (Popular New Year pictures). Beijing: Wenwu chubanshe, 1987.

Zo Za-yong (Cho Cha-yong). Introduction to Korean Folk Painting. Seoul: Emille Museum, 1977.

Zo Za-yong and Lee U Fan (Yi U-hwan). Traditional Korean Painting: A Lost Art Rediscovered. Translated by John Bester. Tokyo and New York: Kodansha International, 1990.

Index

KAY E. BLACK is a pioneering specialist on Korean *ch'aekkŏri* painting. Starting her academic work relatively late in her life during the 1970s, she received her master's degree from the University of Denver. Since then, she devoted herself to studying various areas of Korean art, predominantly researching Korean *ch'aekkŏri* and painstakingly examining numerous extant works all over the world. Through the timely collaboration with the late Edward W. Wagner, she produced groundbreaking scholarly articles on the subject. This book is the summation of her love for Korean art and research on *ch'aekkŏri* that spanned the last four decades.

EDWARD W. WAGNER is the late professor and founder of Korean Studies at Harvard University. He was a specialist on Chosŏn dynasty history and the foremost expert on Korean genealogies.

GARI LEDYARD is Sejong Professor Emeritus of Korean History at Columbia University. He wrote on diverse aspects of the Koryŏ and Chosŏn dynasties including the invention of the Korean alphabet, Han'gŭl, during the fifteenth century.